PIONEERS OF
SOVIET
PHOTOGRAPHY

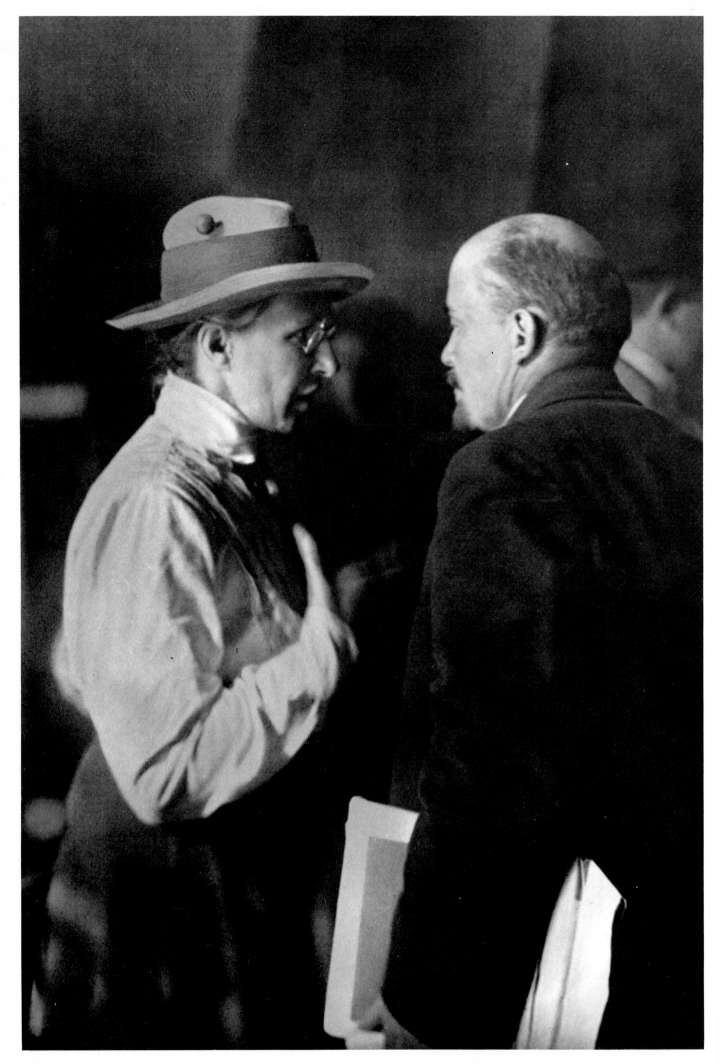

Viktor Bulla. *Elena Stasova and Vladimir I. Lenin*, Moscow 1920

PIONEERS OF SOVIET PHOTOGRAPHY

Grigory Shudakov

Olga Suslova and Lilya Ukhtomskaya

Foreword by
François Mathey
Conservateur en Chef du Musée des Arts Décoratifs, Paris

THAMES AND HUDSON

The poems by Vladimir Mayakovsky on pages 29, 97 and 161 are
from *Mayakovsky*, translated and edited by Herbert Marshall and
published in 1965 by Dobson Books Ltd, Durham; that by Aleksandr
Blok on page 117 is from *The Twelve, and the Scythians*, translated
and introduced by Jack Lindsay and published in 1982 by The
Journeyman Press, London and West Nyack; and that by Sergey
Yesenin on page 213 is from *Confessions of a Hooligan*, translated
and introduced by Geoffrey Thurley and published in 1973 by
Carcanet Press Ltd, Manchester. All appear here by kind permission of
the respective publishers.

The notes on the plates were prepared by Brigitte Hermann
with the collaboration of Valentin Vasilenko and Aleksandr
Lavrentiev

Translated from the French
Pionniers de la photographie russe soviétique
by Paul Keegan.

© 1983 Philippe Sers éditeur, Paris
English translation © 1983 Thames and Hudson Ltd, London
First published in the USA in 1983 by Thames and Hudson Inc.,
500 Fifth Avenue, New York, New York 10110

Library of Congress Catalog Card Number 83-50103

Printed and bound in France

Contents

Foreword

François Mathey

These photographs conjure up events which are part of an already distant history, yet one which is still haunting us today. For this reason, we cannot approach them dispassionately, as if memory were a slate wiped clean. Instead, we must defer to their apparent objectivity while giving free rein to the unconfessed subjectivity of our responses. When photographs such as these are exhibited in a museum, an additional problem is raised by the temptation to consider them aesthetically. In the final analysis, they may well be works of art, but to take this as a starting point would be to misunderstand them completely, for it runs entirely counter to the motives which inspired the photographers themselves.

What is presented is a collection of images which illustrate the annals of the Soviet Revolution. All kinds of specialists – historians, political analysts, activists – will find food for thought here. For those of us who are less directly concerned with Soviet Russia, the twenties and thirties are the stuff of legend and myth: a little-known country, in a bygone era, about which we accumulate scraps of knowledge as pretexts for all kinds of ready-made ideas which the combination of time and space implant and fertilize according to our individual whim. And then there suddenly appear a mass of photographs which transcend time and space, revealing what once was, as if we had been eyewitnesses or even the participants themselves. More than a return to the past, it is this abrupt interruption of reality by a resurrected present which confounds and shatters our prejudices. Space and time are grasped simultaneously, so that henceforth the event can never become dated. The image encroaches upon us as if we were there. It both excites our attention and catches us unawares. As Roland Barthes has said: 'I am the measure of every photograph. For this reason photography astonishes me, by prompting me to ask of myself the fundamental questions: why am I alive, and why now?'

Essentially, this was the issue confronting the artists who were directly involved in the Revolution; their artistic commitment had to be placed at the service of the cause, because art, the expression of the new Soviet reality, was seen as a means of agitation, propaganda and education. In effect, the notion of a realist and social mission for art had been established for too long not to discover a use for photography. The programme of the Peredvizhniky Society, which in 1870 assumed responsibility for the immense ideological task of educating the masses, was echoed in 1920 by the Proletkult group's dream of a combative and functional art comprehensible to ordinary people. The difference between the paintings of the one group and the photographs of the other was that the ideological aspirations of the first were confined to the exercise of a traditional métier, while the revolutionary programme of the second was implemented and extended through the exercise of an entirely modern expressive medium: that of the seeing eye, the shutter-release. Clearly, some of its

practitioners – though well aware that it is not a self-sufficient art – were strongly tempted to lead photography in the direction of more purely aesthetic pursuits, but their use of photomontage and oblique focus was sporadic and quickly forgotten. While specialists can readily recognize the work of each photographer on the basis of such formal considerations, the real miracle was that a common language – shared by professional and amateur alike – asserted itself, as if the events themselves had generated the talent and inspired the eye which recorded them. On the occasions when men reveal themselves to each other, they create a need for such knowledge at the deepest levels of consciousness. Hence, the photographer, an indigent artist, but at the same time fascinated by the prodigious power which his camera gives him to satisfy the need for knowledge, is much more than a reporter, a collector of the visible. He becomes, as it were, an unwitting generator of myths. Half a century later, in contemplating this mythical reality which has not lost a fraction of its impassioned truth, we have the sense that the photographic document goes beyond literal representation as such. More than the picturesque elements (which distract) and more than the facts of the Revolution (which draw but do not sustain our interest), it is the expression of a profound belief in the future, a grave tenderness, an unfailing determination, which inspires these images and bestows upon them an almost biblical evocative power.

There is a constant return to sources. The portrait of Rodchenko's mother (1924; see page 33) is the most striking example, for it has all the virtues of a symbol. We know that the artist – with that mastery in centring an image that was so characteristic of him – had originally photographed his mother sitting in a room reading a newspaper, her head resting lightly against her raised right forearm, her left hand lying on the table. Without question, a rigorously architectural composition, but evidently too cluttered for his purposes; for Rodchenko decided to eliminate the incidentals (though these were already reduced to a bare minimum) and to focus upon the solitary figure, who finally occupies the whole image. The result is truly a monumental sculpture, without being a figure of eternity. It is also an icon, because this is Russia; but as much Romanesque as Gothic in feeling, the type of all mothers, who knows all there is to know of life, has loved and suffered, is at once indulgent and severe, and who will always stand up to events with a calm serenity which acts as a refuge and a consolation. In photographs such as this one, workers and peasants, but also buildings, construction sites and even nature itself in its transformed state, all take on a universal dimension. It is as though they were the dumbfounded witnesses of an adventure which, according to their secret premonitions, will turn the world upside down – as those crowds must have felt who followed Moses into the wilderness. Messianism is suited to pioneers.

In the numbered captions to the plates, the international phonetic transcription from the Russian has been adopted. Elsewhere, the standard English form of transliteration has been retained.

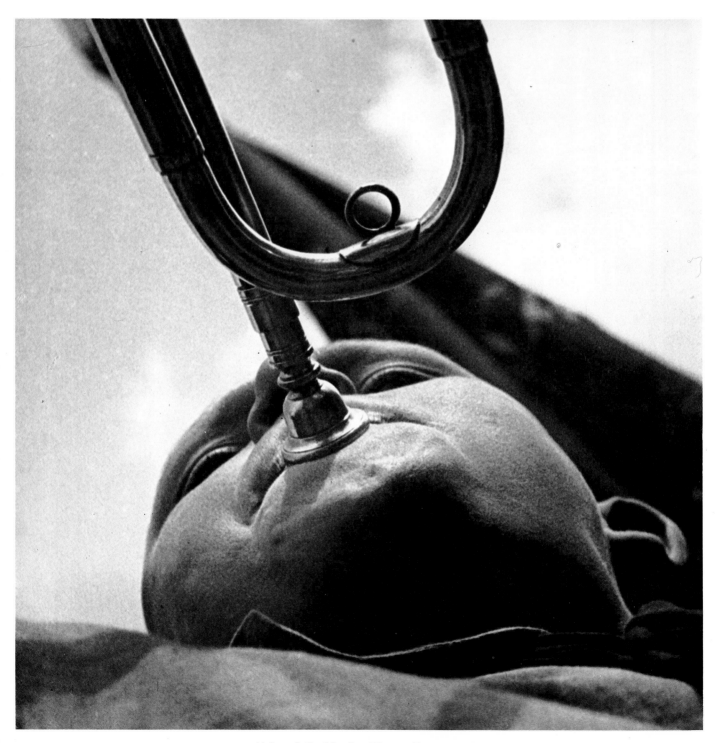

Aleksandr Rodchenko. *Pioneer Trumpeter*

Soviet Photographers, 1917–1940

Grigory Shudakov

Daguerreotype was being used in Russia only a few months after François Arago had delivered his report on the new process to the Académie Française des Sciences, thus announcing the birth of photography. In October 1839, the Russian Colonel Teremin photographed the Cathedral of St Isaac in St Petersburg. In the same year, two slim volumes were published in Russian, explaining the basic elements of this new technique for reproduction. These were the beginnings.

Soon afterwards, Sergey Levitzky, a Russian amateur photographer who was subsequently to become one of the first professional photographers, opened a studio for daguerreotype portraiture. Levitzky, together with his colleagues, students and successors, the most famous of whom was Andrey Denier, created the Russian school of portrait photography. Next to become established, by virtue of their exceptional visual qualities, were the genres of ethnographic, applied and landscape photography. Their most gifted practitioners were William Carrick, Andrey Karelin, Nikolay Prokudin-Gorsky, Nikolay Petrov and Ivan Barshchevsky.

The first great photographer of Russian society was Maksim Dmitryev, whose name is indelibly associated with the birth of Russian social photography. In a series of portraits and genre scenes entitled *Volga Characters*, Dmitryev documented the life of the peasants of the Volga basin, victims of hunger and of cholera and typhoid epidemics. His documentary photographs constitute a testimony to the misery and subjection of the Russian people under tsarist rule, as convincing as the work of such famous American social photographers as Dorothea Lange, Jacob Riis and Lewis Hine, who in a later period drew attention to the catastrophic predicament of farmers and workers during the Depression.

Towards the end of the nineteenth century, the Russian Society of Photography (RFO) was set up in Moscow, and the Photographic Department of the Russian Technical Association in St Petersburg – public institutions whose activities contributed to the scientific, technical and artistic development of photography, and which were greeted with strong moral support by the artists themselves. Moreover, the most august artistic institution in the land – the Academy of Fine Arts – officially recognized photography, placing it on the same level as other forms of figurative art and allowing photographers to participate in its exhibitions.

Parallel with the development of social photography on the one hand and pictorial photography (landscapes, portraiture) on the other, the beginning of the twentieth century saw a rapid growth in photographic journalism. Its most brilliant practitioners were Karl Bulla, Jakob Steinberg, Pyotr Otsup and Aleksandr Savelyev. It is these men who were primarily responsible for the emergence of Russian photographic journalism and its dissemination in the pages of illustrated publications such as *Solntse Rossii*, *Niva*, *Ogonyok* and others.

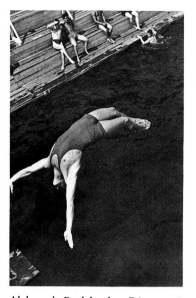
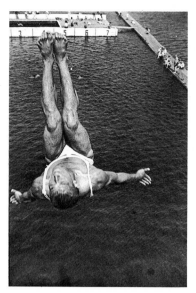
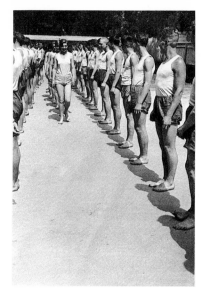

Aleksandr Rodchenko. *Dive* 1936 Aleksandr Rodchenko. *Dive* 1936 Aleksandr Rodchenko. *Making Way for Women* 1935

These are the bare outlines of the prehistory of Soviet photography, which was born as such in 1917, when a defiant people, by overthrowing tsardom and bringing about a socialist revolution, proclaimed the power of the soviets and the creation of a worker and peasant state. Profoundly committed, the journalistic photography of the early years of the Revolution was unique of its kind, not only in terms of subject-matter but also by the very nature of its relationship to the popular masses. At this time, there were only two illustrated publications on the market: *Plamia* in Petrograd and *Khronika* in Moscow. Yet, without any recourse to the medium of the written press, photography managed to establish a dialogue with a new public – mostly uneducated workers, peasants and Red Army soldiers – through billboards and window displays which were mounted in streets, public squares, railway stations, riverside wharfs, Red Army clubs, factories and other places of work.

The young Soviet state needed, above all, a photography in the service of information and propaganda – a documentary photography. This is what underlies V. I. Lenin's famous declarations in his addresses to education workers, photographers, and to specialists in film and photography: 'The production of new films, imbued with communist ideals and reflecting Soviet reality, must take as its starting point the news columns.' By the phrase 'broadly informative news reports', Lenin referred not merely to coverage of facts and events, but to 'a political and social journalism infused with images'.[1]

Lenin's concept of photography as a medium of agitation, propaganda, education and information found expression in the governmental decree of 27th August 1919 concerning the 'Transfer of Photographic and Cinematographic Trade and Industry under the People's Commissariat for Enlightenment'. At this time, the Commissar for Education was Anatoly Lunacharsky, a profoundly cultured man with an encyclopaedic knowledge of the history and theory of literature and art. Significantly, it is to him that we owe certain statements which later became the basis for the creative programme of Soviet photographic art and of the amateur photography movement.

'It is my belief', said Lunacharsky, 'that our mental apparatus is nevertheless far superior to any photographic apparatus, and that it alone is capable of synthesis, reflection, feeling. An image is not merely a chemically treated plate – it is a profound act of social and psychological creation.'[2]

In the early months of the Revolution, leaders of the progressive intelligentsia – including distinguished members of the Russian Society of Photographers such as V. Sreznevsky, N. Yermilov and N. Prilezhayev – took the initiative and founded an Institute of Photography and Photographic Techniques. Set up by D. Leshchenko, a chemistry professor and prominent figure within the Bolshevik party, this higher-education establishment, unique of its kind in Europe, was soon admitting its first

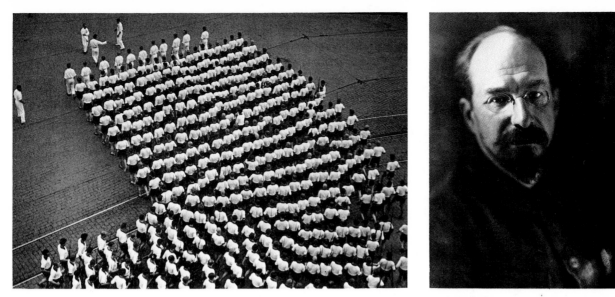

Aleksandr Rodchenko. *The Column* 1935 Pavel Zhukov. *Anatoly Lunacharsky*

students. The Institute also introduced courses in photography for municipal school teachers. At the opening ceremony, Lunacharsky announced that in Soviet Russia every citizen would have a general education and, in particular, a training in photography, so that technical, scientific and artistic skills in this field would be within reach of the whole population.

In addition to the Higher Institute of Photography and Photographic Techniques, within a year of the Soviet accession to power, the State Institute for Optics (GOI) and the Moscow Committee for Photography and Photographic Techniques had both been established. Such initiatives testified to an enormous growth of interest in photography and to the fact that, through the efforts of worker and peasant councils, photographic techniques, education and information were being developed on a national scale. This would have been inconceivable in tsarist Russia, when photography was the passion and the preserve of a small élite within the progressive intelligentsia, and of a handful of scattered enthusiasts from the propertied classes.

Hence the need for 'informative news reports' – a journalistic photography which would appear in the press, on billboards and on exhibition stands – during the historical turning-point of the Revolution itself, during the harsh trials of the civil war and, later, during the years of social and economic transformation. The figure who typified such an approach to photography, and the undisputed master of photographic reportage in this period, was Pyotr Otsup.

Like many of his colleagues, the reporter Pyotr Otsup (1883–1963) served his apprenticeship in a photographic studio, as an assistant to established portrait photographers. His first attempt appeared in a St Petersburg magazine in 1901, after which his name gradually became familiar. There was probably not a single important event, not a single well-known politician or representative of Russian science, culture or the arts, who managed to elude the exacting lens of Otsup's unwieldy camera.

During the Russo-Japanese war, Otsup was sent to cover the front as a war correspondent for the magazine *Chronicle of the War with Japan*. Among his many shots were pictures of the renowned Admiral Makarov and the famous battle painter Vereshchagin, taken only a few days before their deaths.

At the request of the Parisian magazine *L'Illustration*, Otsup managed to photograph the notorious adventurer Grigory Rasputin, in the company of Metropolitan Pityrim, by secretly entering the latter's apartments with the help of a servant.

Otsup's experience as a reporter and photographer stood him in good stead on the German-Russian front during the First World War, on the front lines of the Russian civil war, and at the outbreak of the Revolution. He photographed the abdication of Tsar Nicholas II, the street demonstrations and meetings during the February Revolution, the hectic life of the Smolny military headquarters and the assault on the

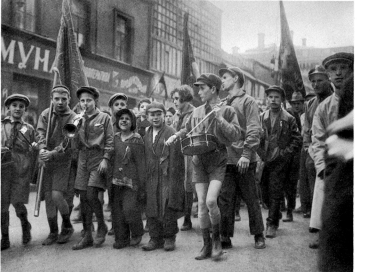

Boris Ignatovich. *May Day in Moscow* 1927

Aleksandr Rodchenko.
Two Generations 1935

Winter Palace during the October Revolution, and the second Congress of Russian Soviets when the first decrees of the new Soviet power were being proclaimed.

According to his colleagues, Otsup's personal courage as a reporter was exceptional. He photographed the charge of the First Cavalry troops, narrowly escaping death under the hooves of a horse. He was with the front line of combatants during the Revolution and on the ice floes of the Gulf of Finland when the Kronstadt mutiny was crushed. He also photographed every stage of the struggle against the Basmachi bandits in Central Asia.

We are further indebted to Pyotr Otsup for an important series of portraits depicting civil war heroes and prominent figures of the Revolution. However, the cycle on Lenin (*Leniniana*) occupies a special place in his oeuvre – almost seventy portraits or scenes in which Lenin figures. Here is the reporter's own account of how he took two photographs which were to become famous:

'In addition to a cardboard box of photos [on the historic events of 1917], I had brought with me – "just in case" – a camera, a tripod and twelve plates in double frames. All this equipment was terribly heavy. Comrade Lenin received me in his office.... I assured him the operation would take no more than ten minutes. While I was setting up the camera, he picked up a copy of *Pravda* and started reading. Not wishing to disturb him or waste time, I took three shots one after the other. His reading finished, Vladimir Ilyich apologized for keeping me waiting and invited me to start the session. So I then took some more shots. The results are now well-known – Lenin at his work desk and in front of his bookshelves.'

The following day, Otsup returned to show the results of his work. 'Where do these photos come from, the ones with the newspaper?' asked Lenin in amazement. 'You are dangerous fellows, you photographers', he said jokingly, examining the photographs. As a present to the reporter, Lenin signed one of the photographs, 'To comrade Otsup, V. Ulyanov (Lenin)', and on another copy, which was destined for publication, he wrote the date on which it had been taken.[3]

During the era of peaceful consolidation, Pyotr Otsup continued to be frenetically active. He photographed all the most significant events in the life of the country, and his work was published in innumerable illustrated magazines in the Soviet Union and abroad. His prolific output as a reporter over a period of decades gained him high distinctions from the State – he was decorated with the Order of the Red Flag and, on the occasion of the fiftieth anniversary of *Pravda*, received the Order of Lenin.

The careers of the photographic chroniclers of the Revolution and the civil war coincide at many points. All of them served their professional apprenticeship in the years preceding the Revolution, all participated in and witnessed many momentous events, all photographed the leading figures of the time. But it was during the

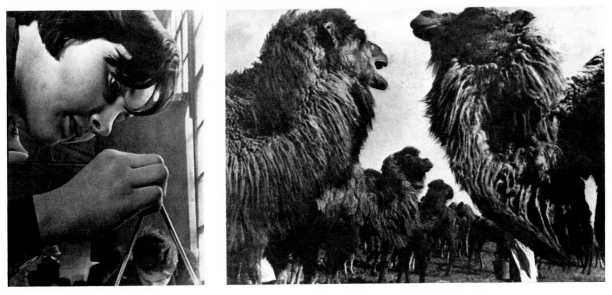

Eleazar Langman. *Student* 1934 Eleazar Langman. *Herd of Camels* 1935

Revolution and the civil war that their talent found its true expression and shone in all its facets.

Jakob Steinberg (1880–1942) photographed the headquarters of the October Revolution (based at the Smolny Institute), the first volunteers enlisting in the Red Guard, the celebrations of 1st May 1918, and the revolutionary and civil war heroes. During the era of peaceful consolidation, he recorded the major events in the cultural and economic life of the country.

The diversity of his subject matter and the documentary rigour which underlined the beauty of his images gained Steinberg his reputation as a photographer who perceived reality with the eyes of an artist, skilfully utilizing the photographic process to treat political and social themes creatively. His collection of negatives, which was bequeathed to the National Archives of Film and Photographic Documents in Leningrad, comprises more than six thousand items.

Viktor Bulla, like his brother Aleksandr, belonged to a dynasty of photographers that originated with his father Karl. Viktor Bulla (1883–1944) began his photographic career on the magazine *Niva*, taking pictures of military operations in the Russo-Japanese war. On returning to St Petersburg, he was drawn to the cinema, but stayed nonetheless with his chosen profession. During the February Revolution, he photographed the demonstration by the St Petersburg workers, the barricades near the Liteiny Prospect, the destruction of the police archives in the Yekaterininski Canal, and the artillery fighting of the Gostiny Dvor. It is to him that we owe the photograph showing the troops of the provisional bourgeois government firing on a peaceful demonstration.

Immediately after the armed uprising of October, Viktor Bulla took over as director of the Soviet photographic studios in Petrograd, while continuing his activities as a reporter. He took a series of photographs which have become part of the Leninist legend, depicting various episodes of the revolutionary fighting of October and of the civil war. Viktor Bulla entrusted the State with the safe-keeping of some 130,000 negatives: his own, and those of his father and brother.

Pavel Zhukov (1870–1942) belonged to this same group of photographic chroniclers. Before the Revolution, he had already produced many works, notably portraits and genre scenes which were recognized by his contemporaries for their considerable photographic quality. Immediately after the October Revolution, he was named chief photographer to the militarized zone of Petrograd, after which he concentrated on the events of the civil war and portraits of Red Army commanders and soldiers.

In 1920, Zhukov was sent to Moscow, where he executed more than fifty portraits of State figures and Red Army leaders. During this period, he also took a portrait of Lenin which is remarkable for its artistic qualities. In the opinion of many specialists,

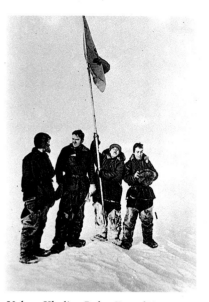

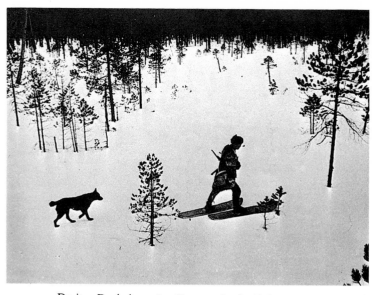

Yakov Khalip. *Polar Expedition* 1938 Dmitry Dyebabov. *Fur-Trapper in the Taiga* 1935

historians of photography and art historians, it remains one of the most beautiful examples of portrait photography.

In the following years, Pavel Zhukov took many photographs of factories, workshops, construction sites, clubs and educational establishments. Unfortunately, in the Second World War, during the Siege of Leningrad, his apartment was destroyed by a shell and a large number of precious negatives were lost.

The creative activity of photographic journalists in the early years of the Russian Revolution is interesting today, not merely from the historiographic point of view – as the chronicle of an epoch – but also in terms of the theory of photo-journalism and of photographic art. Clearly, the photographic coverage of news events does not require a particularly personal or subjective approach, or a profound insight into the nature of the facts or the events observed. In certain cases, shots taken at an unusual angle, or foreshortenings, serve only to diminish the value of the documentary testimony. What matters to the public is the ascertainment of a fact, not its interpretation. However, even at the birth of photo-reportage in Soviet Russia, its most outstanding practitioners perceived that the artistic dimensions of this kind of report influence the spectator's response, drawing his attention and generating an active relationship to the image.

The traditions of news photography and on-the-spot reporting formulated in the early years of the Revolution were subsequently developed by such virtuosi of photographic journalism as Arkady Shaikhet, Max Alpert, Dmitry Dyebabov, Nikolay Petrov, Yakov Khalip and Ivan Shagin. Their driving principle was to be first on the scene of an event, to take the photograph whatever the circumstances, and to make sure that it reached the editorial office of the agency or newspaper as rapidly as possible.

It was thanks primarily to this code of journalistic practice that photographic news coverage in the 1930s was enriched by a whole corpus of fascinating images, depicting the development of the Arctic, the first intercontinental flights to America, the launching of hot-air balloons, army and navy life, the world of sport, and so on. Today, many of these photographic documents of the past are no longer seen as objective information but as subjective comment, illuminated by the personal brilliance of their creators. If the original audience often considered the information afforded by a photograph as complete, without 'enlarging' the frame in order to see beyond the surface meaning of an event, our own scrutiny of the same photograph can sometimes reveal many more signs of the period in which it was taken. We have the impression that the photographer provides answers to our innumerable questions, that he emphasizes, makes suggestions, offers clues. This is indeed the case, given that the modern spectator is to some extent the co-author of such a photograph, adding to it an element of subjectivity which perhaps its creator did not originally possess. At the same

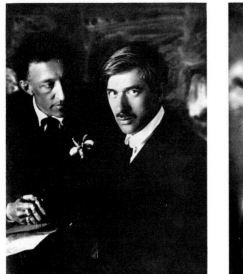

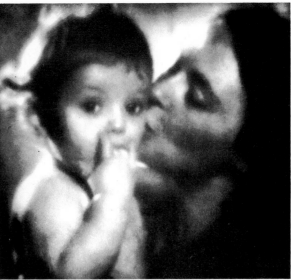

Mikhail Nappelbaum.
Aleksandr Blok and Korney Chukovsky

Abram Shterenberg. *Maternity*

time, the artistic qualities of the original (that is, those which increase the value of the best documentary photographs from the past) are clearly the source of this collaboration, because they underlie our modern awareness of the photograph's documentary and representational nature; and it is through this awareness that such images become true works of art.

The photographic portrait – a genre whose popularity in Russia dates primarily from the end of the nineteenth and the beginning of the twentieth century – found its most brilliant exponent in the figure of Mikhail Nappelbaum (1863–1958). Nappelbaum served his apprenticeship in a photographic studio in Minsk, worked in various towns, then moved to New York and on to Philadelphia, before finally settling in St Petersburg. As a photographer, he was fascinated by eccentric or brilliant people, his portraits of whom rapidly gained him fame. Immediately after the October Revolution, he executed a large number of remarkable portraits, including the magnificent one of V. I. Lenin (January 1918).

Mikhail Nappelbaum, a master of the secret art of portraiture, summed up his long career in a book entitled *From Craft to Art*. Many of the ideas expressed by this experienced photographer, whose output covered a period of more than seventy years, are still of considerable interest today: 'It is more difficult to photograph a face with regular features than one with irregular features. I have always used the subject's hands both to suggest a psychological atmosphere and to serve as a secondary element in the composition of the image. At the same time, they give a finishing touch to the design.... I firmly ruled out the use of entirely white or entirely grey backgrounds as being too monotonous and unexpressive.... I gradually came round to using a single light source – one 1000 watt lamp housed in a batten which took the form of an overturned bucket.... In this way I obtained a directional light which gave depth to the compositions.... If I have achieved anything in the art of portrait photography, it has been largely thanks to this lamp of fairly primitive construction.'

Mikhail Nappelbaum always stressed that photography has an obligation to study painting, not in order to repeat its achievements mechanically, but to rethink them in a creative spirit, by taking into account the laws – such as composition and lighting – of the new art form. However, he also believed that the notion of an identity of aims between photography and painting concealed great dangers. The photographer who slavishly derives his effects of lighting and composition from the great painters, or, even worse, attempts to create the illusion of painterliness, has taken the wrong path.

Nappelbaum exerted an enormous influence over the development of portrait photography in the Soviet Union, affecting not only the photographers who channelled their creative energies into studio work, but also the press photographers. Of the latter, the most talented and stylistically original was Abram Shterenberg (1894–1979).

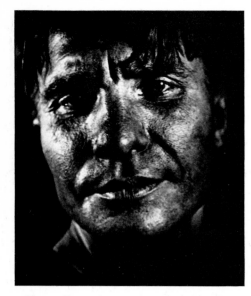

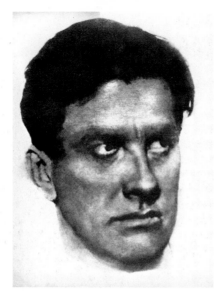

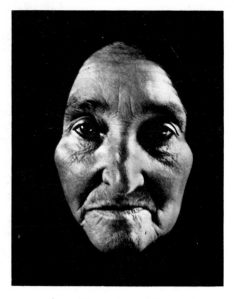

Abram Shterenberg. *Portrait of a Worker* Abram Shterenberg.
Vladimir Mayakovsky Abram Shterenberg. *The Mother*

Having started, like so many others, on the lowest rung of the ladder as an apprentice to a photographer, Abram Shterenberg became a portrait photographer and then a photographic reporter for the 'Unionfoto' and 'Soyuzfoto' agencies. His experience in journalism and in the sphere of reportage, and his studies of children, landscapes and theatre life, all undoubtedly enriched his conception of the specific conditions which obtain in portraiture. Not that his portraits were restricted to the confines of the studio. They were taken under all kinds of circumstances, often unpredictable and extreme, such as are part and parcel of a reporter's work. Nevertheless, in spite of the extraordinary diversity of his output as a photographer, it was primarily as a portraitist that Abram Shterenberg participated in Soviet and foreign exhibitions over several decades, and as a portraitist that he was repeatedly awarded honours.

Painterly landscapes and still lifes, portraits which emphasized figurative values, and in which the influence of such and such a school of painting was clearly apparent – these were the models for the art photography of the twenties. And alternatively, in perpetual conflict with these values, there was the journalistic photography of news, facts, events – everyday phenomena captured by a lens that was socially orientated.

It seemed as if there was no third path. However, the Russian Revolution, having produced a whole group of avant-garde figures in the field of visual arts – Eisenstein and Vertov in cinema, Mayakovsky in poetry, and Meyerhold in theatre – with the same largesse now gave to the world of photography the figure of Aleksandr Rodchenko (1891–1956). Many years later, one of Rodchenko's comrades-in-arms – Viktor Shklovsky, who is still very much alive today – said of him: 'I don't know whether Rodchenko was a genius, but he was a great photographer, somebody whom we were in dire need of, who created a new photographic culture.' Authors of recent studies which have appeared both in the Soviet Union and in other countries have all formulated their different opinions about Rodchenko, and given their various assessments of his innovatory role in the history of photography. However, if we recall that, not only was Rodchenko a Constructivist painter, graphic artist and designer, theatrical producer, leading figure of Soviet photomontage, art teacher in a higher-education establishment and, above all, photographer, but that he was also the author of a whole series of texts on photography, then it will seem advisable to let him speak for himself. Both in the unequivocal clarity with which Rodchenko formulated his judgments, and in the passion and sincerity with which he defended them, it is the whole man who speaks, without need of explanation. This, it is hoped, will justify the inclusion of the following lengthy quotations:

'We see millions of stereotyped photographs which differ from each other solely in that some are more or less successful than others, or that some are executed in the

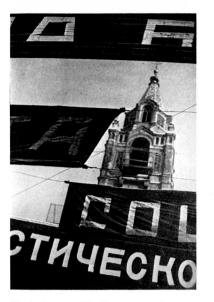
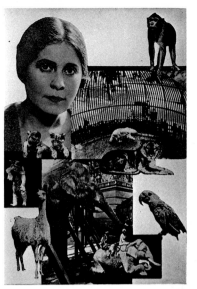
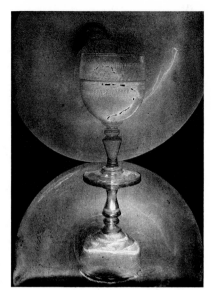

Boris Ignatovich. *Strastnaya Square*

Aleksandr Rodchenko.
About This 1926

Aleksandr Rodchenko.
Glass and Light 1928

manner of etchings, others in the manner of Japanese prints, others still in the manner
of Rembrandt.

'Landscapes, faces and nudes are referred to as art photos, whereas images of
contemporary events are called "photo-reportages". And in the world of photography,
photomontage is regarded as something inferior.

'And yet this something which is utilitarian and inferior, ... through its energy and
usefulness, ... has brought about a revolution in photography.

'Of course photomontage is not always successful either.... It is difficult to take
photographs without any warning, whereas it is quick and easy in a studio. No
misunderstandings with the user.... We must not ... make photo-pictures but rather
photo-moments, imbued with a documentary rather than artistic value.... In order to
teach people to see things in a new light, it is essential to photograph normal objects
with which they are familiar from entirely unexpected angles and positions, and to
photograph unfamiliar objects from a series of different viewpoints so as to give a
complete representation....

'The most instructive viewpoints from which to depict modern life are those from
above, from below, and on the diagonal.'[4]

The son of a theatre props man and a laundress, the young Rodchenko, thanks
entirely to his exceptional gifts and passion for work, was accepted at the Stroganov
art school in Moscow, where he first made a name for himself as a Constructivist
painter in 1913. Soon after the Revolution, he became a teacher in the Higher Institute
of Art and Technique (VKHUTEIN). The range of his creative interests was
extraordinarily broad. Thus, with his friend and intellectual colleague Mayakovsky, he
designed and produced posters and books; with Meyerhold he created stage sets; with
Kulechov and Barnett he worked in the cinema. Rodchenko became the first grand
master of photomontage in Soviet Russia, which led him along the path towards
photography.

One of his earliest photographs, *Portrait of the Artist's Mother*, immediately drew
the attention of experts. After this, Rodchenko rapidly passed from private subjects to
themes of broader social significance and created his own school, founded on new
aesthetic principles. His colleagues in the 'photography workshop', the theoreticians of
the photographic art of the twenties, while recognizing Rodchenko's great mastery,
frequently qualified his achievement as being 'leftist', formalist, derivative of Western
avant-garde photography and in particular of Moholy-Nagy's experimentalism.

Nevertheless, even Rodchenko's most virulent opponents among the press and art
photographers, who vigorously attacked him in debate or in newspaper articles, could
not escape his influence. Today, we may reasonably conclude that his enormous
influence upon photographers such as Boris and Olga Ignatovich, Eleazar Langman

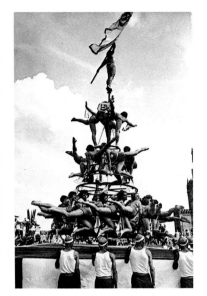

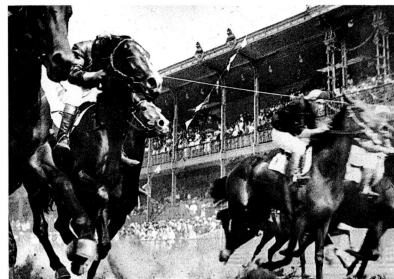

Aleksandr Rodchenko. *Pyramid* 1936 Aleksandr Rodchenko. *Horse Race* 1935

and others was natural and inevitable, not merely because of the 'hypnotic' character of his formal creations, but more importantly because he was equally original in his treatment of social content. It was Rodchenko who revealed the uses of this content, which had been perceived and understood by journalistic photographers, but ignored by the art photographers who had succumbed to a narrow and one-sided conception of the subject-matter appropriate to artistic photography. Without their social framework and their innovatory content, Rodchenko's creations would probably be considered in the history of photography as no more than the work of a virtuoso experimenter of formalist tendencies.

To establish beyond any doubt that Rodchenko considered the social orientation of a photograph to be a crucial, signifying factor, another of his most characteristic statements may be called into evidence:

'We must seek and find, and (rest assured) we shall find, a new aesthetic, together with the enthusiasm and pathos necessary to express our new reality, the Soviet reality, through the medium of photography. For us, the photograph of a newly constructed factory is not merely a picture of a building, not merely the record of a fact, but an expression of pride and joy in the industrialization of the land of the Soviets. This is what we must discover how to capture in a photograph.... It is our duty to experiment.'[5]

Aleksandr Rodchenko, who referred to the camera lens as 'the ideal eye of man in a socialist society', also noted with bitterness that photography as such, by virtue of its very accessibility, was not deemed to be a worthy medium of prophecy, and was still denied the possibility of certain of its practitioners being recognized as artists of genius. He believed that it was essential to nurture a more widespread love of photography, by creating photographic libraries and organizing exhibitions on a much larger scale.[6]

The extremely rich creative heritage left by Rodchenko, together with the texts and statements of this great photographic artist, are convincing proof that the muse of photography chose him as her prophet. In our day, few people would dispute this.

By 1928, the artistic and creative tendencies in Soviet photography had formed themselves into groups, of which the 'Oktiabr' ('October') art group – whose acknowledged leader was Rodchenko – was the first to declare itself. Rodchenko's disciples and successors, including Boris and Olga Ignatovich, Eleazar Langman, Dmitry Dyebabov and others, joined battle against the 'manipulation and distortion of reality' perpetrated by photo-reportage, and against the pictorial preoccupations and techniques of the photographic art of the studio. In this public challenge to its creative adversaries, the group displayed more of the polemical ardour that characterized avant-garde art of the period than genuine dogmatic intransigence. Public stands of this kind could not seriously impress photographic circles already hardened to ultra-

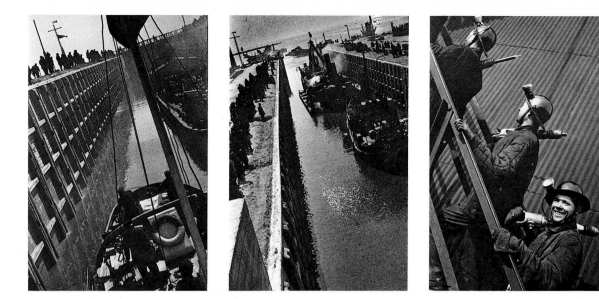

Aleksandr Rodchenko. *The White Sea Canal* 1932

Anatoly Skurikhin.
Komsomol Relief Team 1932

polemical statements announcing the imminent and inglorious demise of painting. Easel painting, proclaimed a well-known photography critic, had consistently failed the test of history. Not only could it not be the art of the future, but it was the art of an ill-fated past; only photography answered all the criteria for an art of the future.[7]

It was not long before the great pictorial news-photographers (Max Alpert, Arkady Shaikhet and others) joined the ranks of the Union of Russian Proletarian Photographers (ROPF) and engaged in a polemical exchange with the 'Oktiabr' group. Although both groups had a very short-lived existence, and accused one another of all the most unforgivable sins, in practice they accomplished the same social mission – they narrated through the medium of photography the achievements of the young Soviet state in its struggle against economic backwardness, illiteracy, juvenile delinquency, and petit-bourgeois, mercenary attitudes. They narrated in a major key, with optimism, the triumphs of industrialization, of the collectivization of agriculture, of science, of the new socialist culture.

Here it is worth correcting an error that is frequently committed by Western specialists in Soviet photography. Considering the twenties and early thirties as a period of 'photographic revolution',[8] they interpret the controversies between the 'Oktiabr' and ROPF art groups as a confrontation of principles between two irreconcilable ideological and aesthetic positions. In reality, the subsequent creative output of Soviet photographers during the thirties – which Western specialists generally consider to be a period of photographic conformism – was characterized by a complete convergence of the finest photographic talents upon a social programme which, in the preceding years, had been common to all groups. Today, rather than immersing ourselves in the rhetoric and maximalist polemics of the period, we have only to look through the photographs reproduced in this book to be convinced that such a consensus existed. Let us consider the careers of the most brilliant and talented representatives of the two groups: Boris Ignatovich ('Oktiabr') and Arkady Shaikhet (ROPF).

If Rodchenko came to photography through painting, design and photomontage, his intellectual comrade-in-arms and successor Boris Ignatovich (1899–1976) became a photographer after undergoing the discipline of journalism, as an editor of periodical magazines. For him, the politically committed nature of press photography was normal, self-evident, and presented absolutely no obstacles to his creative aspirations. Following in Rodchenko's footsteps, Ignatovich nevertheless forged his own style, seeking and discovering new modes of figurative expression. As well as employing Rodchenkoesque foreshortenings, he developed a highly expressive 'obliqueness', created by a sharp tilting of the camera at a certain angle. In Ignatovich's photographs, close-ups of faces usually occupy the whole surface of the image. Given the technical

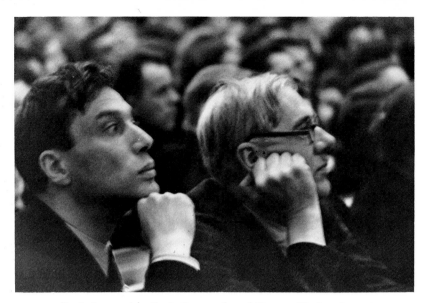

Boris Ignatovich. *Boris Pasternak and Korney Chukovsky* 1935

means available at the time, these shots would have to have been taken from a distance of no more than two or three metres, and we can only marvel at the photographer's skill, and his art of entering into relation with the subject while leaving intact the expression of a face, the human emotions.

The combination of restrained detail in close-ups and an audacious centring often dictated the choice of composition and gave a dynamism, a generalized symbolic character and a poetic quality to Ignatovich's images. As in the case of Rodchenko's most beautiful creations, Ignatovich's desire to break with traditional compositional forms was usually matched by the innovative content of his images, although in certain cases the artist was guilty of excesses in his search for unusual forms. Boris Ignatovich's conception of how to approach the subject and composition of an image was adopted by his closest colleagues and associates, especially Olga Ignatovich (born 1902), his sister and pupil, and Eleazar Langman (1895–1940).

In all photography exhibitions, and in the most authoritative illustrated publications, the photographs of Arkady Shaikhet (1898–1959) have appeared alongside those of Rodchenko and Ignatovich, regardless of the purely journalistic nature of Shaikhet's photography, which was determined by its chosen set of themes, without any attempt at formal originality. Like many other photographic reporters, Shaikhet came to journalism after holding a modest post as apprentice to a photographer and as a portrait retoucher in a photographic studio. He rapidly became a photo-journalist of the first rank. He matched his colleagues for speed, efficiency, ingenuity and professional experience, all of which made it possible to capture an event in the heat of the moment and to carry out the task entrusted to him by his editor, whatever the circumstances. Nevertheless, one can only marvel at the way in which Shaikhet, constantly pressed for time and with technically very modest equipment at his disposal, managed to produce images of exceptional visual quality.

In the history of Soviet photography, Shaikhet's name is associated primarily with the appearance of a type of journalistic photograph called 'artistic reportage'. His images seemed to erase the distinction between journalism and art photography, and testified to the existence of a phenomenon which theoreticians of photographic journalism would later refer to as the 'artistic-documentary image'. The nature of this phenomenon is twofold: the photographer obtains a specific, concrete image by seizing a moment of observed reality, and he obtains the necessary 'typification' by bringing out the universal relevance of the facts and events which he chooses to record.[9] We may note in this connection that Dostoyevsky, in his *Diary of a Writer*, had already drawn attention to the artistic basis for an awareness of the data of everyday life: 'Observe closely certain occurrences in real life which at first sight are not even particularly striking: if you are capable of doing this in the smallest degree and have

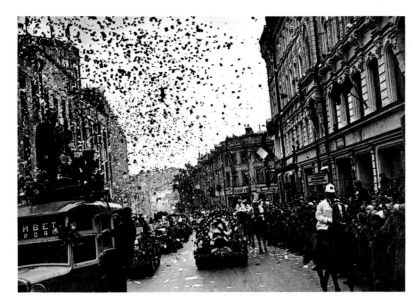

Arkady Shaikhet. *Welcoming the Inhabitants of Neliuskin* 1934

Max Alpert.
Gorky, on His Return from Italy 1928

eyes to see, you will discover a profundity such as is not to be found in Shakespeare. But there, precisely, lies the question: what eye and who is capable? Not only to create or describe a work of art, but merely to notice a fact, you have to be a kind of artist.'

When he photographed the great events of the twenties and thirties, Arkady Shaikhet always attempted to make each event live on in the film, not merely as a concrete moment of existence, but as a permanent symbol. The event served to confirm, underline and epitomize a 'typical' social phenomenon. *Ilyich's Small Lamp*, an image which has become classic, is not merely the photographic record of the installation of electricity in a peasant hut. It is an emotionally charged event, deeply moving, in which can be read the entire life of the period, when the 'Russia of darkness' (H. G. Wells) embarked on a policy of comprehensive electrification, each stage of which involved incredible difficulties, while each victory became a celebration.

The rapid succession of events, the appearance of illustrated publications with unprecedented circulations, the astonishing breakthroughs of Eisenstein, Kuleshov and Vertov in art cinema and documentary film, with their technique of superimposed shots – all this could hardly fail to open up new possibilities for photographic journalism. The beginning of the thirties saw the birth of the photographic sequence, designed to form a whole and based around a chosen sociological theme. The 'Soyuzfoto' agency's trio of photographers – Alpert, Shaikhet and Tules – were the first to produce these sequences.

At the request of the German weekly *Arbeiter Illustrierte Zeitung* (AIZ), the agency photographers were to show the German proletariat the way of life of a Soviet working-class family. Thus, over a period of four days, almost eighty photographs were taken, from which fifty-two were chosen to form the sequence *Twenty-Four Hours in the Life of the Filippov Family*. The photographers endeavoured to achieve the maximum of documentary truth for each image, deliberately resisting formal refinements. A metalworker in the 'Red Proletarian' factory in Moscow, Nikolay Filippov and members of his family were shown at work, during their leisure time, at study, in the company of friends, and so on. The photographic sequence afforded a complete picture of how Soviet workers lived, and from its first appearance in *AIZ* it had great popular success with working-class readers in many European countries and, subsequently, in the United States. Nikolay Filippov received hundreds of letters from abroad, bearing countless numbers of friendly greetings, good wishes and questions.

Max Alpert (1899–1981), when already a well-known press photographer, realized the enormous possibilities for compositions based on sequences of photographs. After serving his photographic apprenticeship in a studio, and a harsher kind of apprenticeship in the ranks of the Red Army during the civil war, in 1924 Alpert became a photographer for the *Rabochaya Gazeta* and then for *Pravda*. He photographed

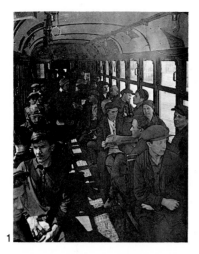

1

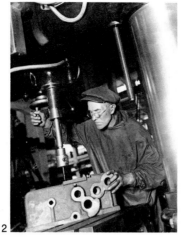

2

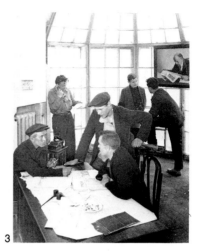

3

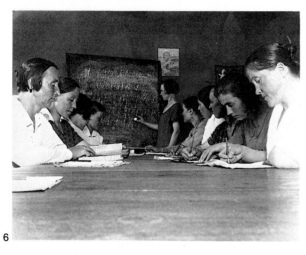

6

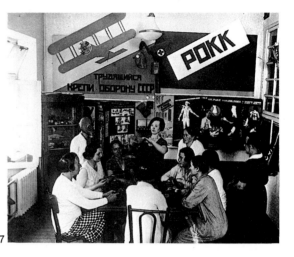

7

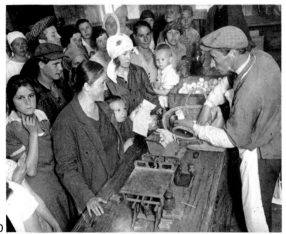

10

11

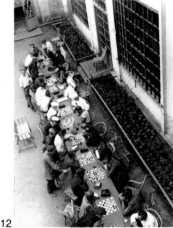

12

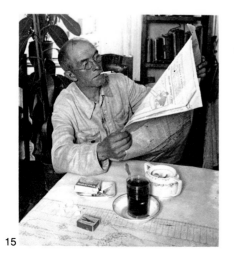

15

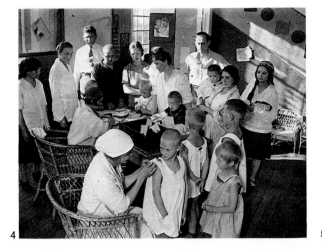
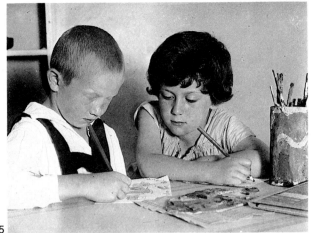
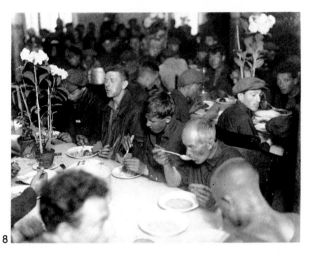

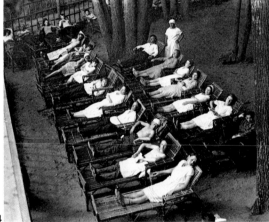

Max Alpert and Arkady Shaikhet
Twenty-Four Hours in the Life of the Filippov Family 1931

Exemplary families, like the Filippovs, were in effect very large families which were installed in collectives and which received State benefits and subsidies.

1 *Going to work on the tram*
2 *Nikolay Filippov, metalworker*
3 *The factory's little red corner*
4 *The infirmary*
5 *At school*
6 *'I am a housewife and I am conquering illiteracy'*
7 *War preparations*
8 *The midday meal in the canteen*
9 *Shopping*
10 *Shopping*
11 *Shopping*
12 *Chess, one of the most popular games in the USSR*
13 *Leisure*
14 *Leisure in the Park of Culture and Rest*
15 *After dinner: tea, cigarette and the newspaper*

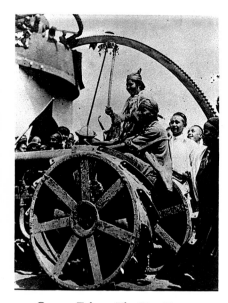

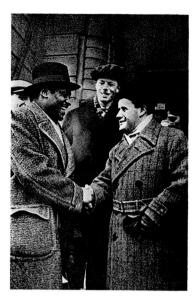

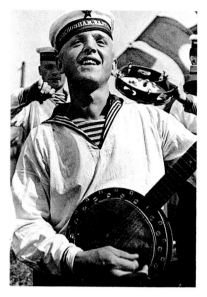

Georgy Zelma. *The First Tractor*

Dmitry Dyebabov.
Paul Robeson and Sergey Eisenstein

Yakov Khalip. *Sailor*

everything: solemn receptions for ambassadors from the first foreign countries to recognize Soviet Russia, Red Square parades, an earthquake in the Crimea, legal newsstories and the like. But gradually Alpert, like Shaikhet, began to concentrate the whole of his attention upon serious social themes with a deeper content.

Max Alpert's best-known creations are *Giant and Builder* (the story of Viktor Kolmykov, a worker in the Magnitogorsk metallurgical complex), *Lenin and Wells* (a sequence devoted to the country's electrification programme), the story of the construction of the Turkestan–Siberia railway and, finally, that of the Fergana canal. Already renowned as a master of highly expressive reportage photography, Alpert was to become, in the full sense of the term, the pioneer of monumental narrative forms, opening up new possibilities for visual expression in photographic journalism. These possibilities were widely explored in the pages of the periodical *USSR in Construction*, which was founded on the initiative of the writer Maksim Gorky and brought together the best elements of Soviet photo-reportage. The design and layout of each thematically arranged issue were entrusted to specialists as well-known and respected as Rodchenko and El Lissitzky. For the texts, the services of the best journalists were called upon. *USSR in Construction* was intended primarily for a foreign readership, and it indeed enjoyed considerable success in numerous countries, wherever people wanted to learn how the ordinary citizens of the new socialist Russia were living and working.

Irrespective of tastes, passions, or past links with one or another of the art groups, there was in each of the famous photographic reporters of the thirties a strain of Rodchenko and Ignatovich and a strain of Shaikhet and Alpert. Moreover, this did not in the least diminish their individual brilliance or prevent them – with so widespread a thematic range at their disposal – from giving precedence to personal themes.

Georgy Zelma (born 1906) gained a reputation as an expert on the peoples of Soviet Central Asia. His photographs captured facts and events which marked a crucial turning point in the ancient historical course of tsarist Russia: Moslem women throwing off the veil, poor peasants entering agricultural collectives, physical culture sessions in Tadzhik mountain villages, literacy courses, the first demonstration by women on the International Feast Day of 8th March, when they had to be protected by the police against angry husbands and fathers still fanatically loyal to Islam.

During these same years, Dmitry Dyebabov (1901–1949) started his travels through the northernmost confines of Russia. His photographs describe the immense natural riches of Siberia, the new life which had begun for the peoples of the north – formerly regarded as non-natives, oppressed and condemned by the tsarist government to gradual extinction through hunger and disease – and the development of the Northern Maritime Passage.

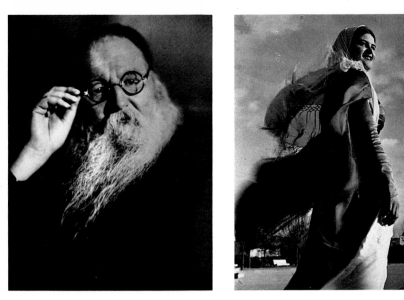

Mikhail Nappelbaum.
The Physiologist and Academician Aleksey Ukhtomsky

Georgy Petrusov.
A Young Karbardinian Girl 1936

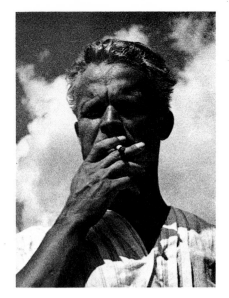

Georgy Petrusov.
The Film-Maker Aleksandr Dovzhenko

Yakov Khalip (1908–1979) took impressive photographs of the Red Army and the navy. Arkady Shishkin (born 1899) recorded in detail all aspects of the new village life and the collectivization of agriculture in Russia, with a profound insight into the special circumstances of social transformation in the countryside.

Nikolay Petrov (1892–1959) recorded characteristic features of the old Muscovite way of life which was gradually disappearing and being replaced by the new, vibrant and eventful life of Moscow the capital.

Georgy Petrusov (1903–1971), Anatoly Skurikhin (born 1900) and Ivan Shagin (1904–1982), while displaying considerable differences in theme, nevertheless all evoked – in a sober, schematic style which is at times overtly reminiscent of posters – the gigantic industrial complexes whose construction was undertaken by the first five-year plans. Many of the photographs taken by these creative prophets of the new age became, as it were, symbols of the time. But the optimistic character of these images did not in the least signify an urge on the part of the photographers to embellish facts and events, to take their desires for reality. The spirit of these years, in spite of the complex and dramatic nature of the conflicts and the difficulties and hardships which accompanied the creation of the powerful Soviet State, remained a spirit of affirmation. And this could not help but be reflected in the character of the photographic works themselves, which, moreover, were not produced solely by professionals employed in the press, but also by amateurs.

If in the early years of Soviet power there were very few amateur photographers, by the end of the twenties and throughout the thirties they constituted a significant force in photography. During this period, Soviet industry was already able to place at the disposal of amateurs some high-quality equipment, notably the 'FED', a widely used small-format camera. The photography clubs in factories, workshops, scientific establishments and in the halls and centres for pioneers and schoolchildren usually began by making landscape studies, portraits and still lifes. However, extremely rapid social developments and the increased pace of economic growth both favoured an active participation of amateur photographers in the life of the press. Many of these became independent correspondents for newspapers and magazines, with a passion for reportage. It was in this period that the tradition arose, that is still current today, stipulating that the work of amateur and professional photographers should appear on equal terms in the pages of newspapers and in the more representative Soviet and international exhibitions.

During the twenties and thirties, several large-scale photographic exhibitions were organized which had an undoubted influence upon all parties concerned in the creative process – whether art photographers or masters of photo-reportage. The most important exhibitions were those of 1928 and 1935. If, in the first of these, the artistic

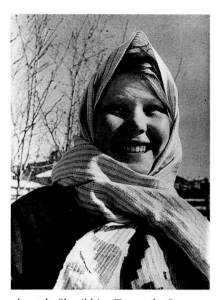
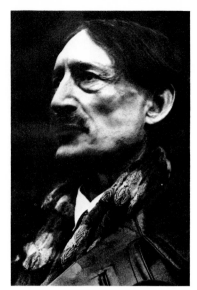

Anatoly Skurikhin. *Tanya the Peasant* Ivan Shagin. *Henri Barbusse 1936*

photography of the 'old school' (Y. Yeremin, P. Klepikov, N. Andreyev, A. Grinberg, S. Ivanov-Alliluyev and others) and journalistic photography seemed like two mutually antagonistic and incompatible tendencies, by the time of the second exhibition the situation had appreciably altered. During the intervening years, the art photographers had taken a significant step towards assimilating a new set of themes which were closer to daily life, and in many cases they had evolved from a doggedly pictorial style to a reliance upon purely photographic figurative means. At the same time, the most gifted photographic reporters had been able to move away from an over-faithful and naturalistic representation of actuality, and were approaching a kind of reportage whose scope was enlarged by its admission of figurative qualities. This fertile exchange between the two schools was clearly revealed in the 1935 exhibition, which demonstrated the unquestionable achievements of Soviet photography in each of its creative tendencies.[10]

In conclusion, it is appropriate to remark that the majority of well-known and gifted Soviet press photographers, from the first days of Russia's entry into the war with Nazi Germany, in June 1941, until the days of victory in May 1945, served as war correspondents. They produced a photographic chronicle of the war which, in terms of documentary and artistic qualities, is unique of its kind. Many of these photographers were awarded military honours and medals, not only for their exceptional journalistic services, but also for their direct involvement in fierce fighting.

The achievements of photography during the twenties and thirties, and afterwards in the Second World War, remain an invigorating source of inspiration which sustains the creativity of the present generation of photographers from all schools, tendencies and orientations within contemporary Soviet photography.

[1] Cf. A. V. Lunacharsky, *Cinema in the West and in Our Country*, 1928, pp. 63–64.
[2] A. V. Lunacharsky. Statement during a discussion on 'The foundation stones of the new culture'. Cf. V. Mayakovsky, *Literary Remains*, Vol. 1.
[3] Cf. P. Otsup, 'How I photographed V. I. Lenin', in *Fotojournalist i vremya*, Planeta, Moscow, 1975.
[4] A. Rodchenko, 'The paths of contemporary photography', in *Novyi Lef*, 1928, No. 9, pp. 31–39.
[5] *Novyi Lef*, 1928. No. 11.
[6] Archives of Varvara Rodchenko and Aleksandr Lavrentiev, daughter and grandson respectively of the artist.
[7] Cf. S. Morozov, *The Art of Seeing*, Iskusstvo, Moscow, 1963, p. 130.
[8] *Sowietische Fotografie 1928–1932*, Karl Hanser Verlag, Vienna and Munich, 1975.
[9] I. D. Baltermanz, *Specificity of Form and Content in Photographic Journalism*. Thesis summary, MGU, Moscow, 1976.
[10] Catalogue, *Ten Years of Soviet Photography*, published by the Exhibitions Committee, Moscow, 1928. Catalogue, *Exhibition of Works by Masters of Soviet Photographic Art*, Moscow, 1935.

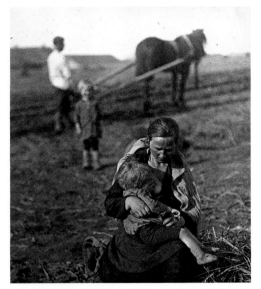

Arkady Shaikhet. *Mother, Kolomenskoye Village* 1927

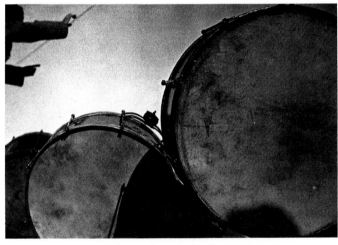

Boris Ignatovich. *Orchestra Conductor* circa 1930

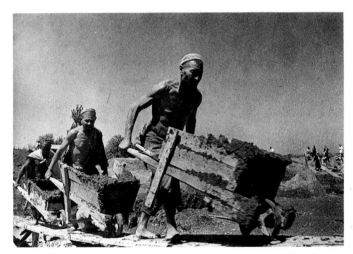

Max Alpert. *Construction Site of the Fergana Grand Canal* 1939

Boris Ignatovich. *Maternity* circa 1930

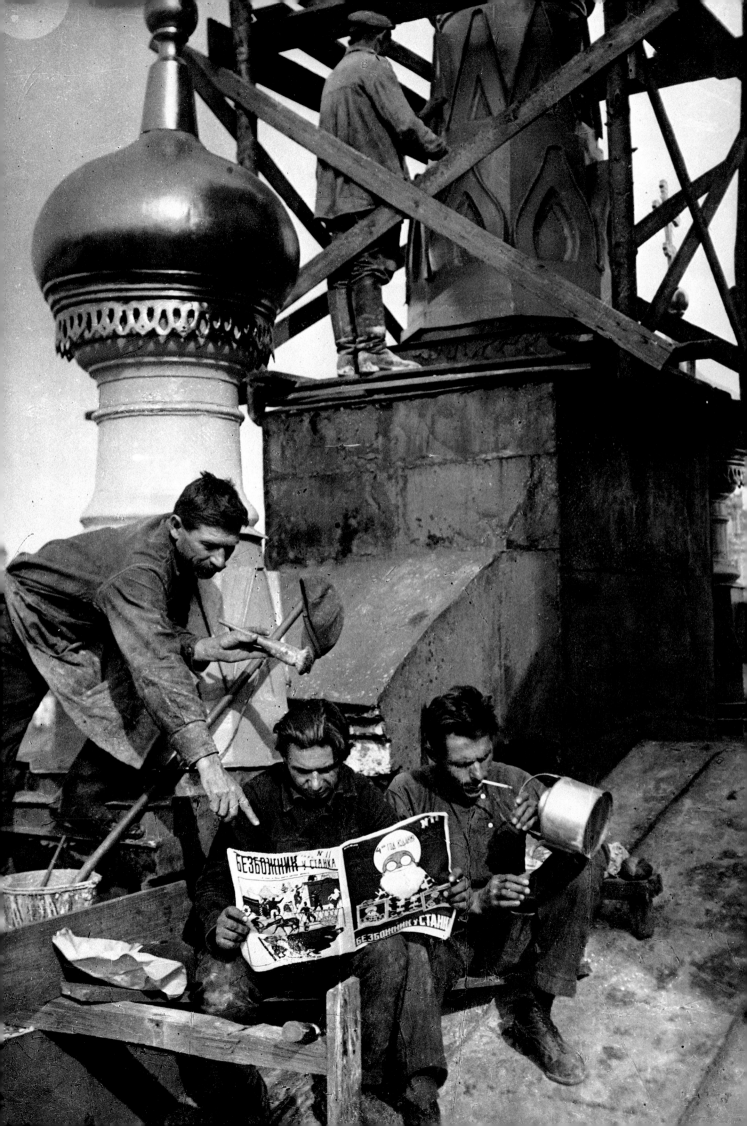

EVERYDAY LIFE

From **THE STORY OF KHRENOV
ABOUT KUZNETSKSTROY AND
THE PEOPLE OF KUZNETSK**

Across the sky
 clouds skeltering,
twilight
 by rain is hugged,
and workers there
 are sheltering
beneath a worn-out truck.
The whisper proud
 they hear repeat,
through waters
 far
 and near:
'In four years' time
 there'll be
a garden-city
 here!...
Good houses
 here
 we'll get at last,
unrationed
 bread
 and meat.
Beyond Baikal
 we'll drive out
 fast
the jungle
 in retreat.'
The workers' whisper
 rises still
above
 the dark cloud-herd,
then indistinguishably,
 till
just 'Garden-city' 's
 heard.
I know –
 a city
 here will stand,
a garden
 bloom –
 I know,
When
 in our Soviet Motherland
such
 people
 grow!

Vladimir Mayakovsky, 1929

Notes

Notes compiled by Aleksandr Lavrentiev, the grandson of Aleksandr Rodchenko, are in inverted commas and followed by the abbreviation (A.L.).

1 **Boris Ignatovich:** *Restorers* (1928). The workers are reading the magazine *Atheism in the Workshop* while restoring the roof of the church.

2 **Aleksandr Rodchenko:** *Portrait of the Artist's Mother* (1924). 'In the initial photograph the table and walls are visible. Gradually, in the course of different variations, Rodchenko arrived at this famous close-up.' (A.L.)

3 **Arkady Shaikhet:** *Kiev Station, Moscow* (1936).

4 **Arkady Shaikhet:** *Kiev Station, Moscow* (1936).

5 **Arkady Shaikhet:** *We Are Coming to Moscow to Work* (1936). Leningrad Station, Moscow.

6 **Aleksandr Rodchenko:** *Asphalt Streets* (1929). 'The Leningrad Road. This was a period when Rodchenko took many photographs of industrial subjects and changes which had transformed everyday life. In this photograph the different textures of the tarred road surface are emphasized. Another version exists, taken vertically, which includes the passers-by.' (A.L.)

7 **Ivan Shagin:** *The First Traffic-Policeman in Moscow* (1930).

8 **Arkady Shaikhet:** *Theatre Square, Moscow* (1930). In the foreground, the horses of the Bolshoi theatre; in the background, to the right, the towers of the Kremlin.

9 **Dmitry Dyebabov:** *Moscow. The Leningrad Road, Belorussia Station* (1935). The Belorussia Station in Moscow, constructed at the turn of the century in the old Russian style.

10 **Aleksandr Rodchenko:** *The Bolshoi* (1930).

11 **Nikolay Petrov:** *Pushkin Square, Moscow* (1930s).

12 **Nikolay Petrov:** *Tverskoi Boulevard in Moscow: the Book Market* (1930). At this market, books were sold and exchanged privately. The book markets were traditionally held beneath the statues of Ivan Fedorov (the first printer in Russia), Gogol, Pushkin and Griboyedov. Today, exhibitions devoted to Russian literature still take place under the trees. The statue of Pushkin dates from 1880.

13 **Nikolay Petrov:** *The Premises of the* Izvestia *Newspaper in Moscow* (1930s). Strastnaya Square. The 'Izvestia' building was constructed in 1927 to a design by Aleksandr Vesnin, on the site of the Monastery of the Passion. This Constructivist building has been recently disfigured by an architectural addition.

14 **Aleksandr Rodchenko:** *Strastnaya Square, Moscow* (1928). This square was photographed by numerous artists, including Boris Ignatovich (cf. p. 17). It is today Pushkin Square.

15 **Arkady Shaikhet:** *Strastnaya Square, Moscow* (1928).

16 **Arkady Shaikhet:** *Sverdlov Square* (1937). One of the busiest squares in Moscow, in front of the Bolshoi.

17 **Aleksandr Rodchenko:** *Streets of Moscow* (1928). 'In 1928, Rodchenko photographed many Moscow streets, as he was planning to make a film about the city which he would have liked to direct. Three themes particularly interested him:
– the various squares seen from above, in order to convey the scale of the city;
– the contrast between old and new aspects of the city (kiosks, etc.);
– the new architecture at the moment of its creation.' (A.L.)
This photograph is reminiscent of Moholy-Nagy, whose book came out in the USSR in 1929, with a preface by A. Fedorov-Davydov.

18 **Aleksandr Rodchenko:** *Miasnitzkaya Street* (now Kirov Street) (1928). 'Miasnitzkaya provided a violent and necessary contrast after the solitude of hotel bedrooms, street crowds after the silence of the provinces, the agitation and energy of buses, cars, tramways, and – like a challenge thrown in the face of the old, candle-lit villages – all around, the electrotechnics of offices.' (Mayakovsky).

19 **Boris Ignatovich:** *Monument to Ferdinand Lassalle, Leningrad* (1930). Ferdinand Lassalle (1825–1864) was a German socialist who founded and was leader of the German Workers' Union. The sculpture is by V. Sinaisky (1919).

20, 21, 22, 23 **Aleksandr Rodchenko:** *Courtyard.* 'This was the courtyard of the house next door to Rodchenko's. Today, the trees have grown and the view is no longer the same. Two of these photographs were taken with a Leica, but they are no different from the others. This is the first time that the four have been published together.' (A.L.) To see these photographs is to be reminded of Claude Monet's cathedrals, which change with the passage of the hours. Here the change takes place to the rhythm of the seasons, and the perspective is cubist, tilted, dynamic.

24 **Aleksandr Rodchenko:** *Fire Escape* (1925).

25 **Aleksandr Rodchenko:** *Balconies* (1925). 'These are the balconies of the building in which Rodchenko lived. The photographs were taken for the magazine *Sovetskoye Kino* (1926). It was the first time Rodchenko used this angle for a shot. Later on he was to deliberately look for subjects which would allow such an approach.' (A.L.) This photograph was used as a cover for *Novyi Lef* in 1927.

26 **Aleksandr Rodchenko:** *The Mosselprom Store* (1926). 'Photograph taken with a camera which Rodchenko bought in Paris.' (A.L.) Mayakovsky composed a rhyming couplet as publicity for the Mosselprom:
'The best comes from
The Mosselprom.'
The Mosselprom was a State department store.

27 **Aleksandr Rodchenko:** *Balconies* (1925). See No. 25.

28 **Aleksandr Rodchenko:** *A House on Miasnitzkaya Street* (1925). 'Rodchenko took this photograph when he returned from Paris, for *Sovetskoye Kino*. It was finally used instead by *Novyi Lef* as a cover photo.' (A.L.)

29 **Georgy Zelma:** *Parachute Jump* (1930).

30 **Aleksandr Rodchenko:** *Orchestra* (1929).

31 **Aleksandr Rodchenko:** *The Marshalling Area before the Parade* (1928). 'Photograph taken from a balcony. The sportsmen and women assemble to form into columns. The photo was taken with a Leica, which allowed greater depth – a kind of distancing effect vis-à-vis the subject.' (A.L.)

32 **Aleksandr Rodchenko:** *Streets of Moscow* (1927). 'Pushkin Square before the construction of the "Izvestia" building. From the period when Rodchenko was photographing Moscow, occasionally using a movie camera to take one shot after another in the form of separate photographs: e.g., street scenes like *The Cigarette Seller*. This photograph was taken with the Leica which Rodchenko bought in Paris which used "filmpaks". Sometimes, when he ran out of film, he would use a glass plate.' (A.L.)

33 **Aleksandr Rodchenko:** *Streets of Moscow* (1926). 'In front of the kiosk, to the far left, Stepanova is standing. Here Rodchenko has photographed the magazines to which he was a contributor, notably *AZ*, for which he made photomontages. This photograph was taken when Rodchenko was hoping to make a film about Moscow.' (A.L.) The magazines which can be seen on the kiosk racks are in German – *Die Woche*, the excellent *AIZ* (*Arbeiter Illustrierte Zeitung*), *Kölnische Zeitung* – and in French – *Monde* (cf. Barbusse No. 294) – as well as in Russian.

34 Aleksandr Rodchenko: *Street* (1929). 'Passers-by come to resemble ants; the choice of angle transforms reality, making it almost incomprehensible.' (A.L.)

35 Arkady Shaikhet: *In the Café* (1930s). Cafés were also places where one could eat.

36 Boris Ignatovich: *Tea Drinkers, Ramenskoye Village* (1928). The central figure in the photograph is reading the newspaper *Poverty*, 'the organ of the Bolshevik Communist Party'.

37 Boris Ignatovich: *Lunch in the Commune* (circa 1920). From 1918 to 1924, the USSR was ravaged by famine, and this meal at the Dom Komuna (communal house) – where the first experiments in communal work for farmers were made, prior to the creation of the kolkhozes – has a symbolic value.

38 Boris Ignatovich: *The Red Corner* (1928). In Orthodox households, the red corner ('red' and 'beautiful' were formerly the same word in Russian) was where the icons were placed, over which a small lamp would shine. The photograph shows the *little* red corners where young people gathered to give concerts and promote cultural and political issues, and where slogans, posters and books were usually on show.

39 Georgy Zelma: *We're Off!* (1932).

40 Arkady Shishkin: *Hold It! I'm Taking a Photograph!* (1928). A wedding in the Ukraine.

41 Aleksandr Rodchenko: *Steps* (1930). 'The steps of the Holy Saviour, a huge church built in the 19th century and demolished in the 1930s to make way for the construction of the Palace of the Soviets, which was never started. Although these steps were in fact decorated, Rodchenko managed to achieve a focus which is devoid of ornamentation and entirely functional. There are no verticals, no horizontals, but a rhythm which is interrupted only by the figure climbing the steps.' (A.L.)

42 Aleksandr Rodchenko: *Wild Flowers* (1937). 'A portrait of Varvara in one of the few sunlit areas of the apartment. Rodchenko always considered light to be an important element or constant in all composition, and particularly in the case of photography. Here the whole composition is constructed around light, and the flowers seem to emerge from the white shoulders of the young girl.' (A.L.)

43 Aleksandr Rodchenko: *Girl with a Leica* (1934). The Leica, a high-quality German camera, held sway throughout Europe at this time. 'Taken in the Park of Culture and Rest, in a kind of pavilion. The seated girl is Eugenia Lemberg. There are three versions of the photograph, in the first of which she is standing.' (A.L.)

44 Aleksandr Rodchenko: *Illustration to Mayakovsky's Poem* Pro Eto, *Photomontage* (the poem was published in 1926). Mayakovsky wrote *Pro Eto* ('About This') during a two-month separation from Lili Yuryevna Brik, who was at the time his mistress and the wife of Osip M. Brik, whom he had first met in 1915. She was Elsa Triolet's elder sister. 'Rodchenko only produced the photomontage for this poem, as he had not yet become a photographer. The photograph itself was taken by Shterenberg.' (A.L.)

45, 46 Aleksandr Rodchenko: *Animals*, illustrations for a children's book written by Sergey Tretyakov (1926) called *Samozveri*. 'The two photographs reproduced here form part of a series. The various figurines, made out of cardboard, were designed by Rodchenko and Varvara Stepanova. Some of them Rodchenko photographed in two takes.' (A.L.) There exists a German reprint of this work.

47, 48 Aleksandr Rodchenko: *Pro Eto.* See No. 44. No. 48 shows Lili Brik's face. See also p. 17.

49, 50 Aleksandr Rodchenko: *Glass and Light* (1928). 'Two of a series of studies which Rodchenko made for his own purposes rather than for a commission. He was experimenting with transparency, reflection and mirror-effects.' (A.L.) See also p. 17.

51 Aleksandr Rodchenko: *Intermission* (1940). 'In this year Rodchenko repeatedly photographed the circus.' (A.L.)

52 Abram Shterenberg: *Violinist.*

53 Dmitry Dyebabov: *The Animal Trainer Vladimir Durov, with a Parrot* (1935). A famous animal trainer whose speciality was birds and mice. The Durov House in Moscow is a menagerie which is very popular with children, and where the animals give concerts. Rodchenko also photographed Durov as part of his 'Circus' series.

54 Dmitry Dyebabov: *Cape 'Serdtse Kamen'. A Concert* (1936). Russian musicians on a visit to the people of Chukotsky, on the Cape Serdtse Kamen ('Stony Heart') near the Bering Straits.

55 Yakov Khalip: *Concert* (1928).

56 Boris Ignatovich: *The Conductor Dmitry Shostakovich* (1930). See No. 297.

57 Boris Ignatovich: *Wind Orchestra* (1926). The orchestra of the Dynamo factory.

58 Boris Ignatovich: *The Hermitage, Leningrad.*

59 Boris Ignatovich: *'Isaaky', Leningrad* (1930). The famous Cathedral of St Isaac in Leningrad.

60 Yakov Khalip: *Palace Square, Leningrad* (1930s). Alexander's Column, about which Pushkin wrote a famous poem entitled *The Monument*.

61 Arkady Shaikhet: *Astrakhan* (1927). A fishing village situated on the Volga.

62 Aleksandr Rodchenko: *Pine Trees* (1927). 'Taken near Mayakovsky's country house and published in *Novyi Lef*, this photograph was used in a film by Renger-Patzsch. Rodchenko was accused at the time of plagiarizing a photograph of factory chimneys by Nadar, which he had seen in a book. Rodchenko was, in fact, trying to show how such an angle could be used for natural subjects as well as industrial ones.' (A.L.)

63 Aleksandr Rodchenko: *Radio Antenna* (1929). 'Photograph taken for a specialist radio magazine, *Radiosluzhba*. Rodchenko's characteristically precise caption tells us that this was in fact an experimental radio antenna.' (A.L.)

64 Anatoly Skurikhin: *The First Radio in the Countryside* (1937). The radio gradually established itself throughout the Soviet territory. In rural areas, the radio programmes would be broadcast to the whole village through a loudspeaker.

65 Arkady Shishkin: *Old Komarov, Quality Inspector* (1935). He was responsible for quality control of the harvests.

66 Arkady Shaikhet: *The Sturdy Seven* (1931).

67 Dmitry Dyebabov: *Siberian Hunter* (1935). In the extreme north of the USSR.

68 Arkady Shaikhet: *Hikers in Moscow* (1925). They are wearing shoes made of wood and the bark from silver birch trees (*lapti*).

69 Olga Ignatovich: *Aleksandr Busygin* (1935). This blacksmith-turned-Stakhanovite had become famed throughout the USSR for his skill and speed. He established the norms for planning in the domain of mechanical construction, and was later to become a member of the Supreme Soviet.

70 Arkady Shaikhet: *Shoe Workshop* (1925).

71 Eleazar Langman: *Morning Wash in the Day Nursery* (1934).

72 Aleksandr Rodchenko: *A Student in the Workers' Faculties* (1927). 'This photo, as well as a whole sequence of similar ones, was taken in the entrance of VKHUTEMAS, which was initially housed in the same building in which the Rodchenko family lived and still live. Later on, new premises were built near the Moskva. Rodchenko used to photograph the morning gymnastics session, in which he often participated. This would take place on the roof of the building. Certain faces attracted his attention, and these he would photograph. In this case, the subject was either Russevsky (a theatre director) or Kalkain (an engraver).' (A.L.)

73 Aleksandr Rodchenko: *Sawmill. Piles of Wood* (1931). 'Part of a reportage which was carried out in Gorky, on the Volga, tracing the various stages in the processing of wood. The reportage consisted of a large number of small compositions. Here, the construction of the wood is emphasized. The shot is foreshortened.' (A.L.)

74 Boris Ignatovich: *Construction Site.*

75 Boris Ignatovich: *Transportation of Planks* (1930s).

76 Arkady Shishkin: *Now We Can Live!* (1935). Taken in Russia, probably outside Moscow or Tula. The 'Universal' tractor followed by the threshing machine symbolized the final retreat of the appalling years of famine.

77 Boris Ignatovich: *Harvests* (1920s).

78 Boris Ignatovich: *The First Tractor* (1927). An American 'Fordson' tractor.

79 Aleksandr Rodchenko: *Looking for Worms* (1933).

80 Aleksandr Rodchenko: *Winter Landscape, Karelia* (1933). This photograph is part of the Rodchenko series on the theme of the White Sea. Cf. No. 225, and p. 19.

81 Dmitry Dyebabov: *The East Siberian Sea. On the Ice Fields* (1936).

82 Max Alpert: *A Kirghiz Horsewoman* (1936). In this Asiatic republic, marriage customs required that the horseman try and touch the woman rider of his choice with his whip. If he missed, it was the woman's turn to do a round on horseback and make her own choice of a spouse. The Pamir mountains can be seen in the background.

83 Dmitry Dyebabov: *Polar Night* (1935). Polar nights affect a large part of the Soviet Union. For many years, this photograph decorated President Roosevelt's office in the White House.

84 Dmitry Dyebabov: *Kazakhistan. Hunting with a Bird of Prey* (1935). In the Kirghiz region, falcons and eagles are trained to hunt foxes and birds.

85 Boris Ignatovich: *The Wind.*
'With your green head-dress, and your virgin's breast,
O, slender birch, why do you gaze at yourself in the lake?
Tell me, O tell me the secret of your vegetable thoughts!'
(Sergey Yesenin).
Silver birches are the most widespread – and the most immortalized – trees in the Soviet Union.

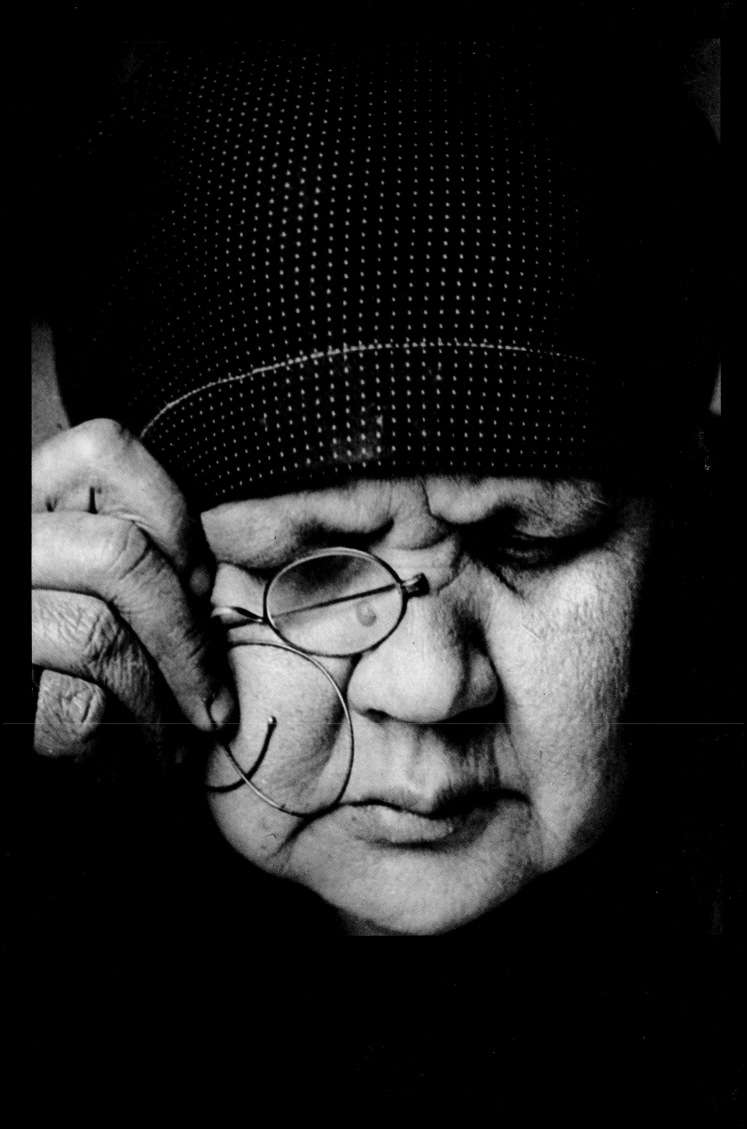

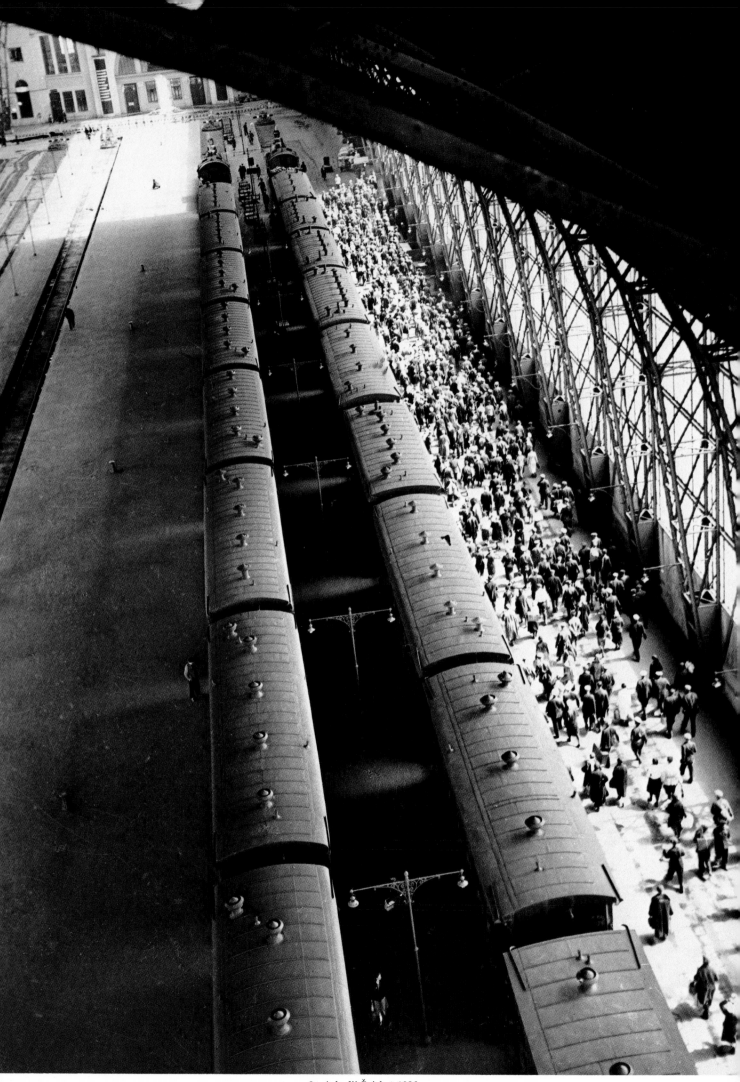

3 Arkadij Šajchet 1936

4 Arkadij Šajchet 1936

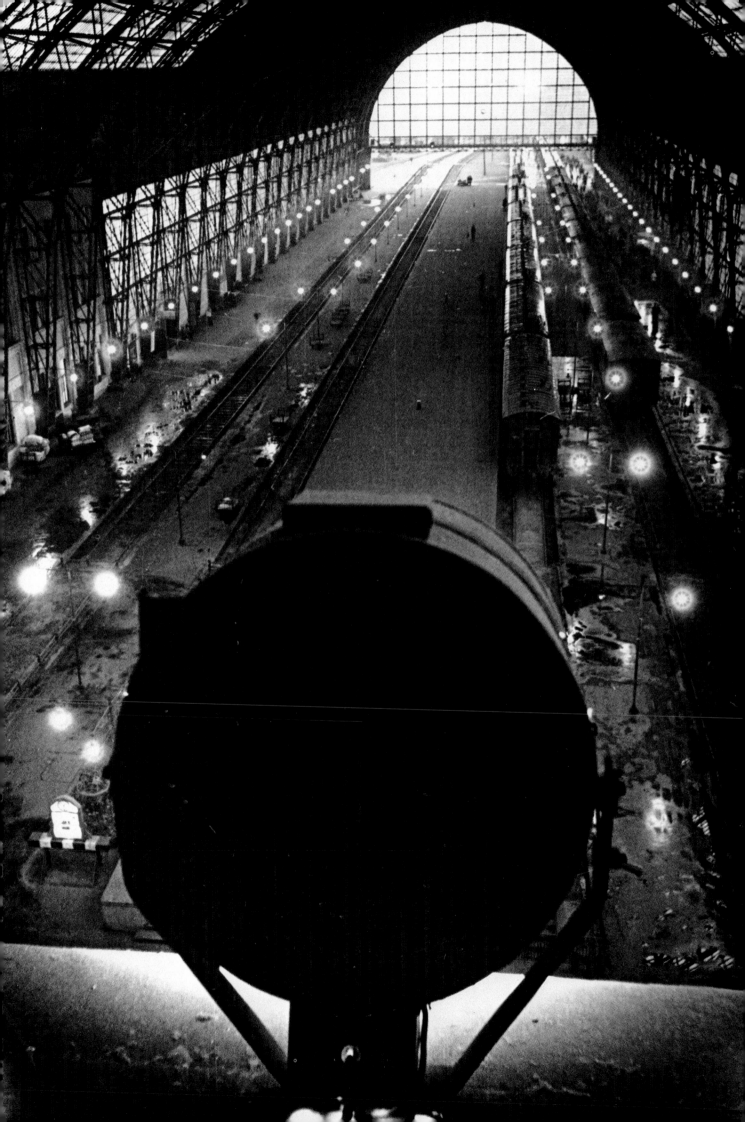

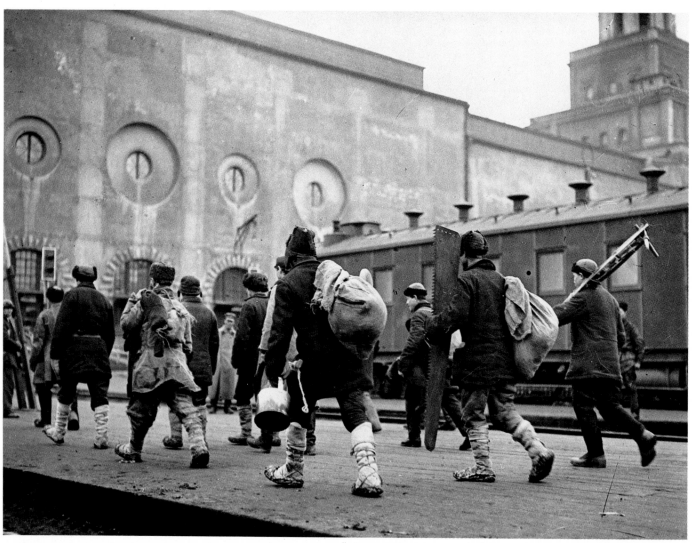

5 Arkadij Šajchet 1936

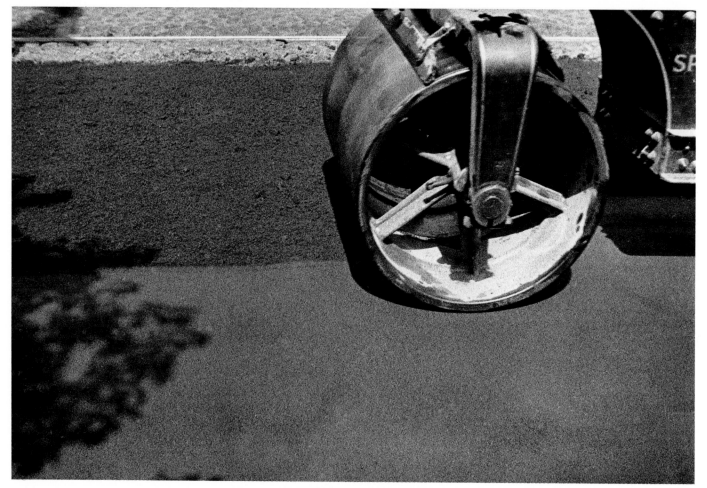

6 Aleksandr Rodčenko 1929

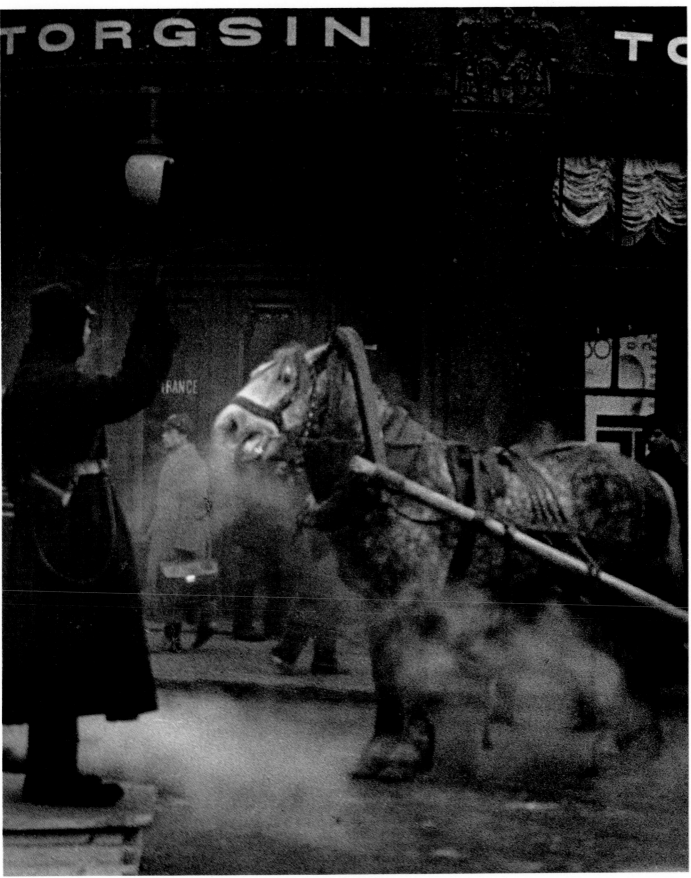

7 Ivan Šagin 1930

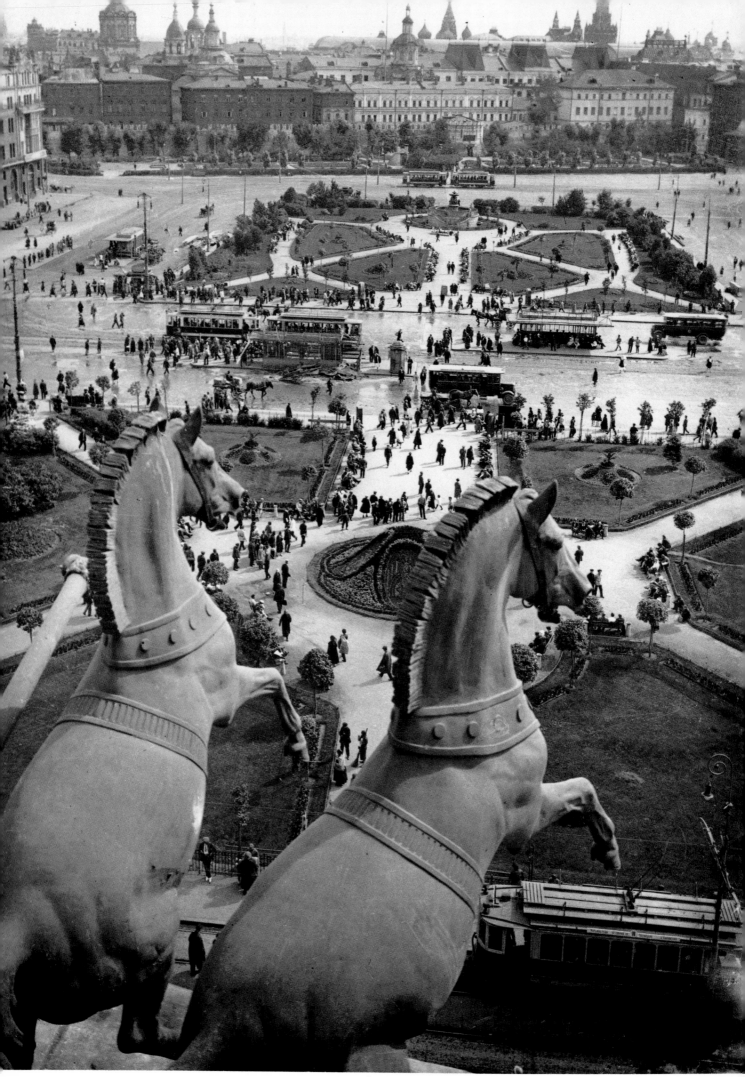

8 Arkadij Šajchet 1930

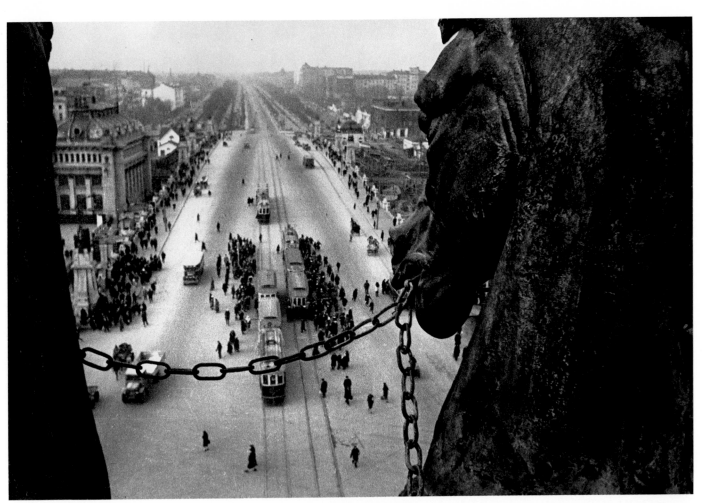

9 Dmitrij Debabov 1935

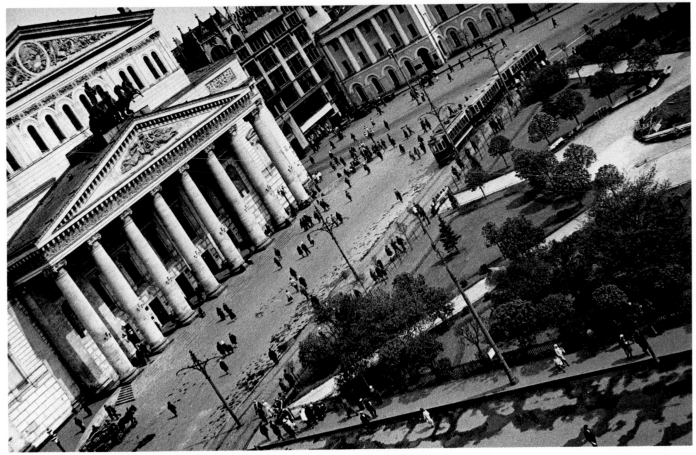

10 Aleksandr Rodčenko 1930

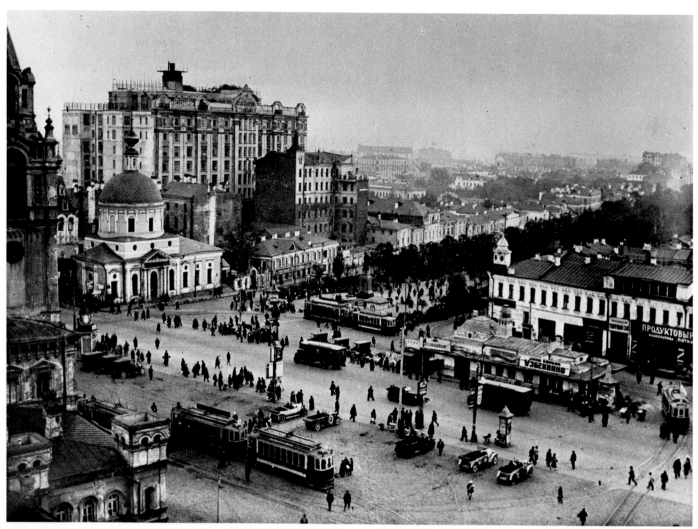

11 Nikolaj Petrov circa 1930

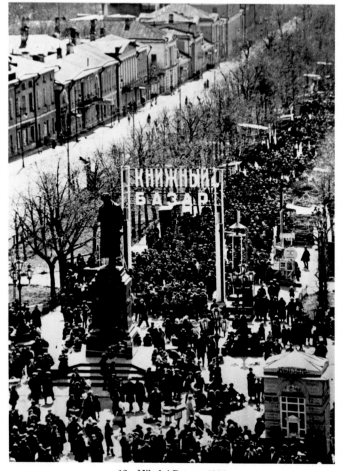

12 Nikolaj Petrov 1930

13 Nikolaj Petrov circa 1930

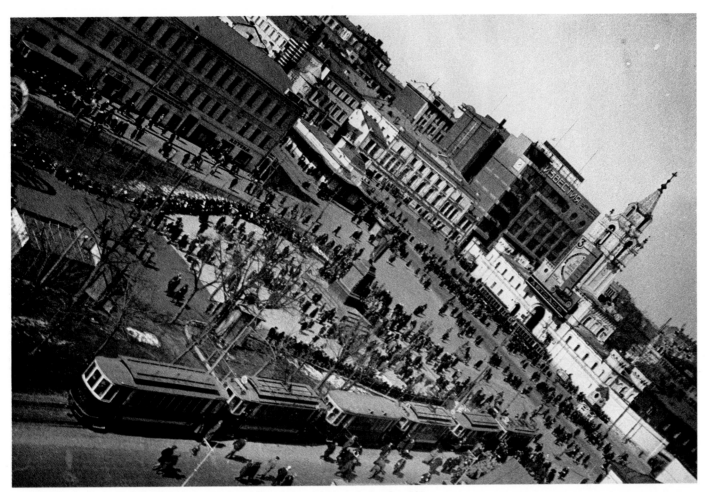

14 Aleksandr Rodčenko 1928

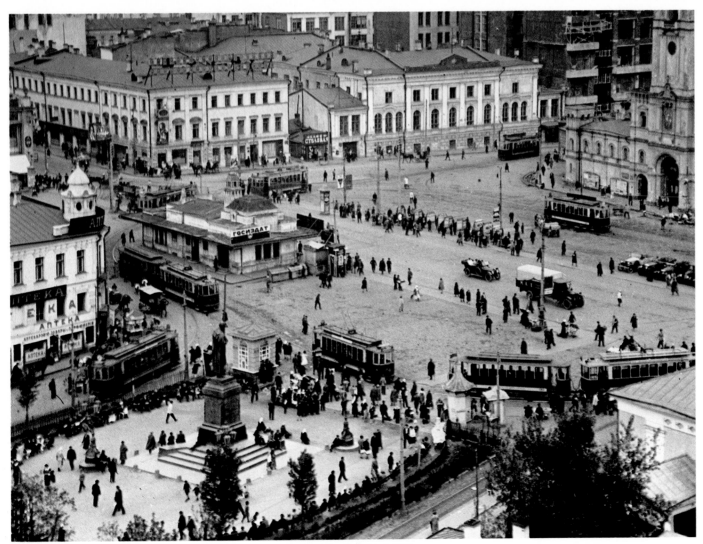

15 Arkadij Šajchet 1928

16 Arkadij Šajchet 1937

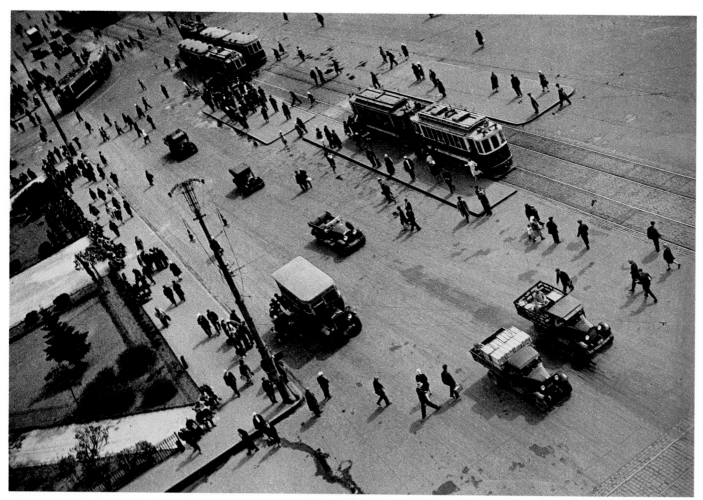

17 Aleksandr Rodčenko 1928

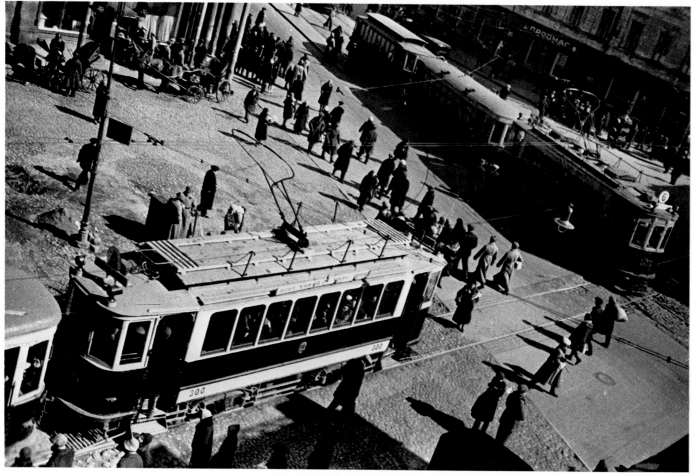

18 Aleksandr Rodčenko 1928

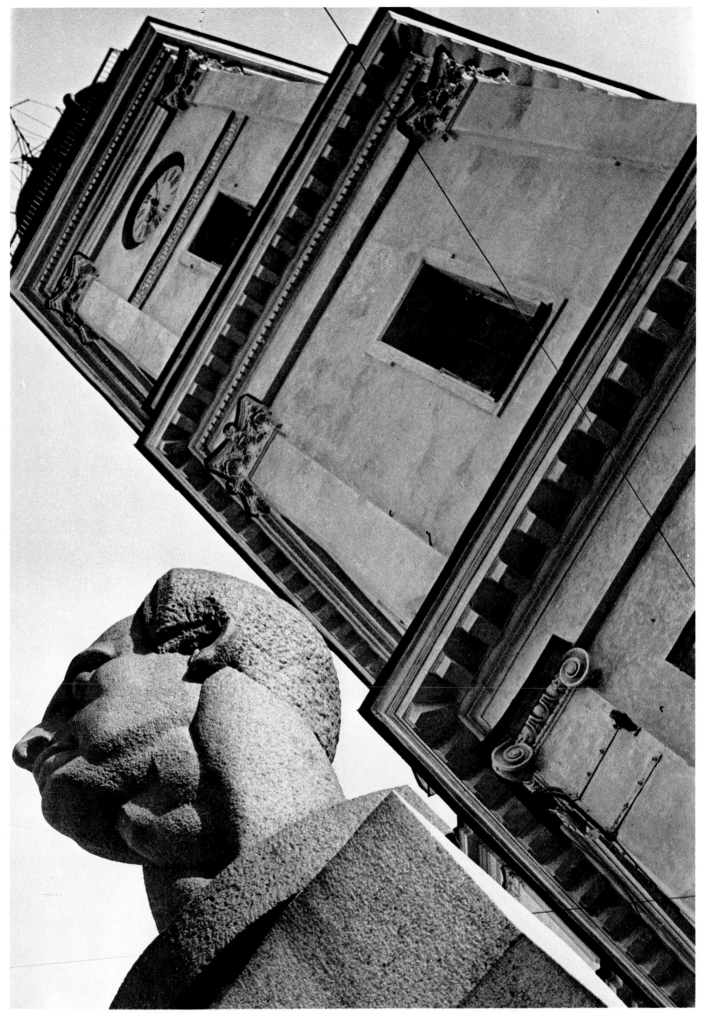

19 Boris Ignatovič 1930

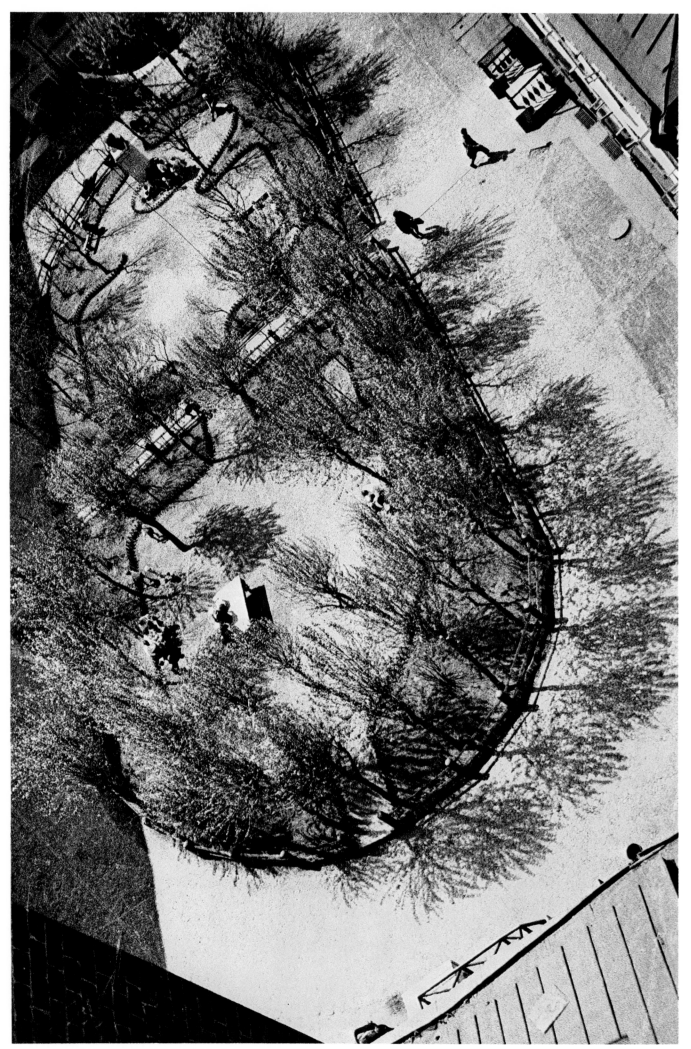

20 Aleksandr Rodčenko 1927

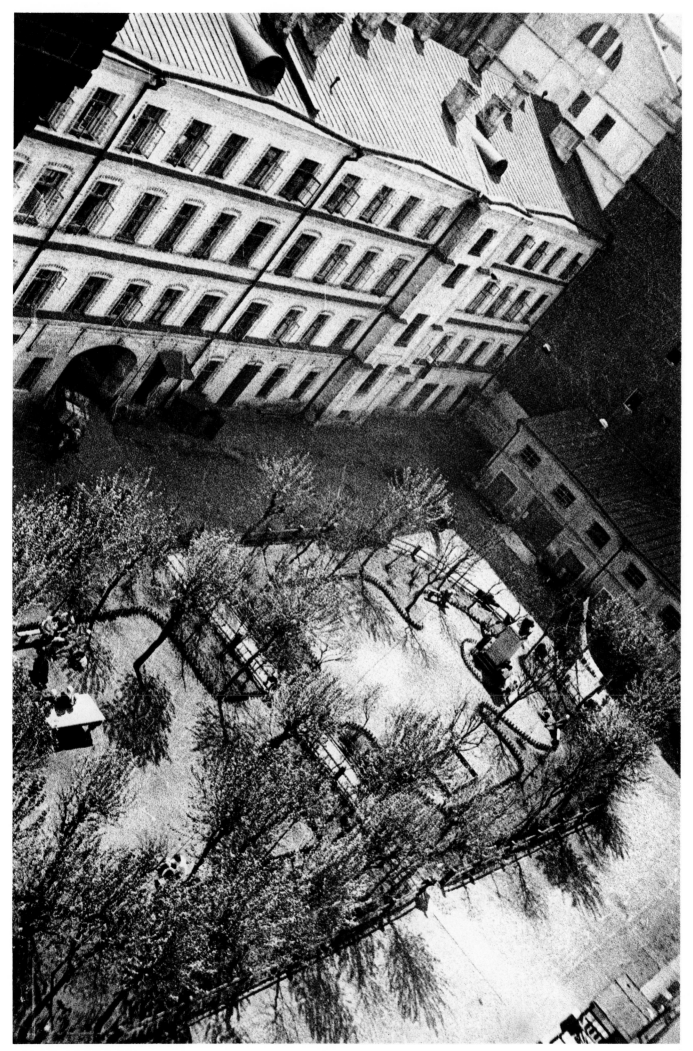

21 Aleksandr Rodčenko 1927

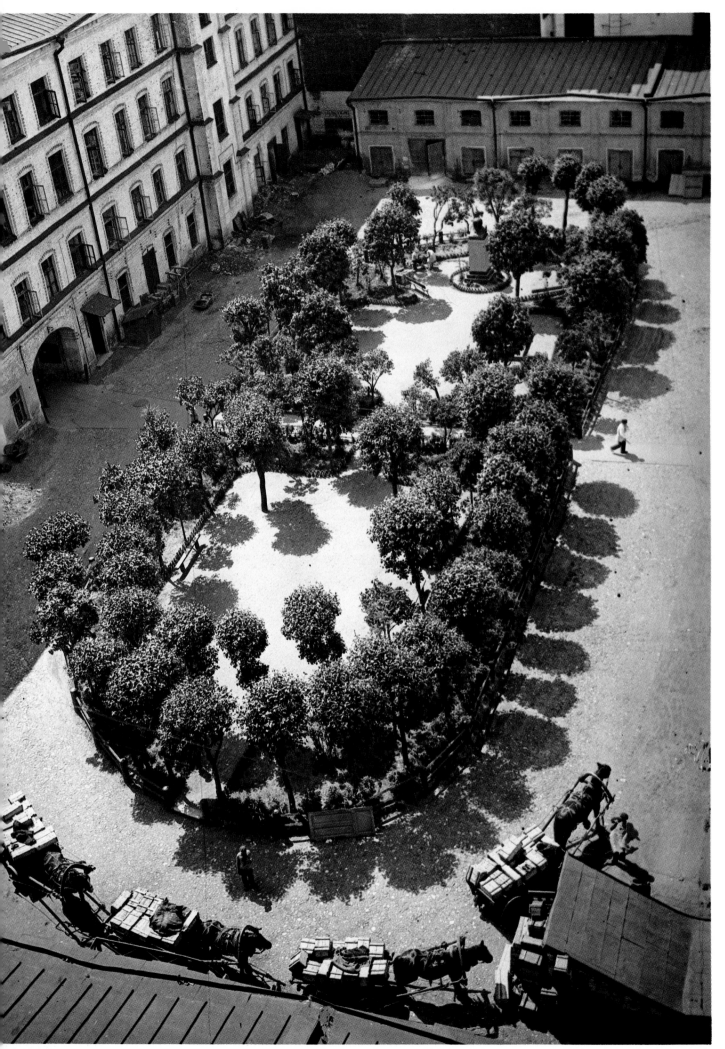

22 Aleksandr Rodčenko 1927

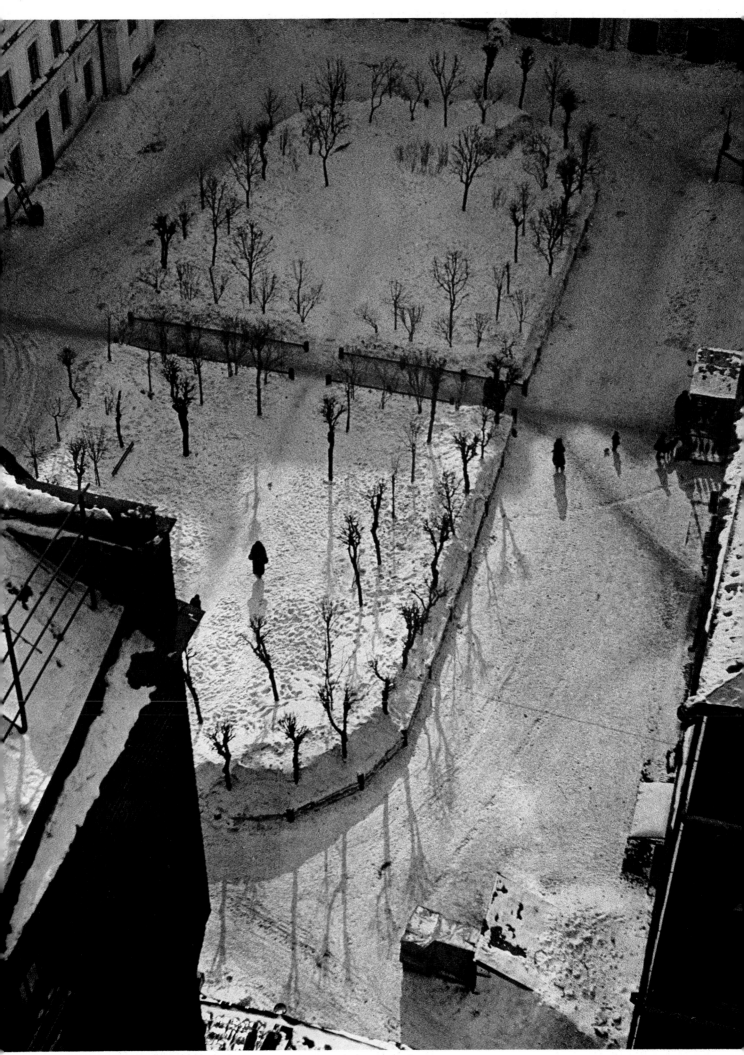

23 Aleksandr Rodčenko 1927

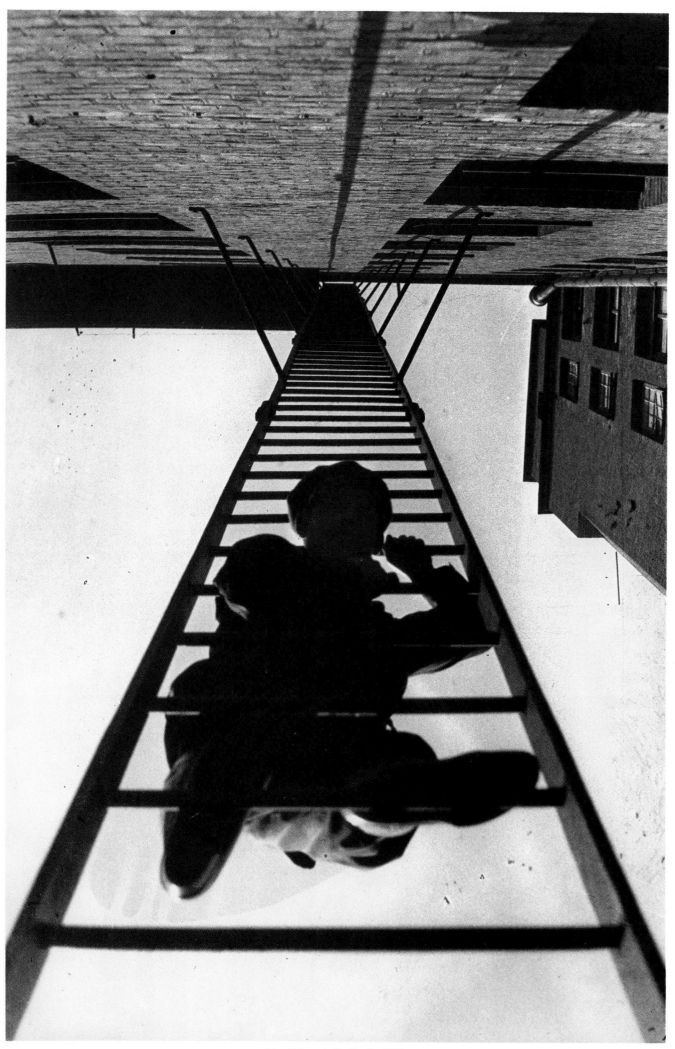

24 Aleksandr Rodčenko 1925

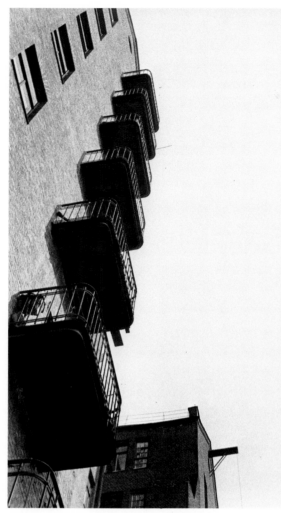

25 Aleksandr Rodčenko 1925

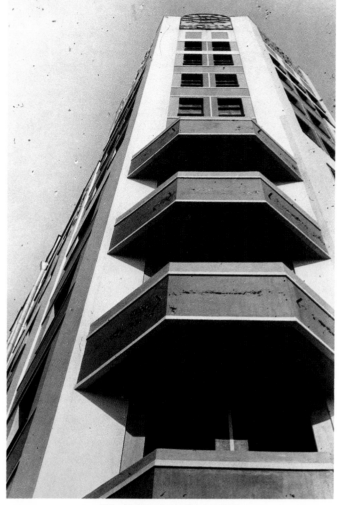

26 Aleksandr Rodčenko 1926

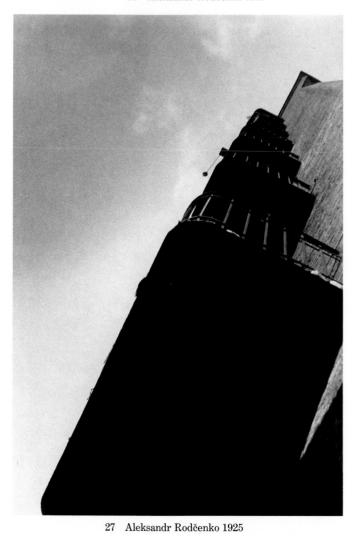

27 Aleksandr Rodčenko 1925

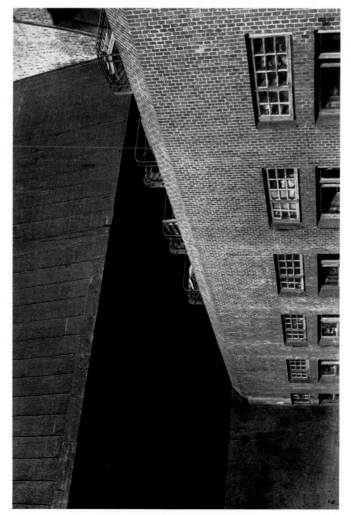

28 Aleksandr Rodčenko 1925

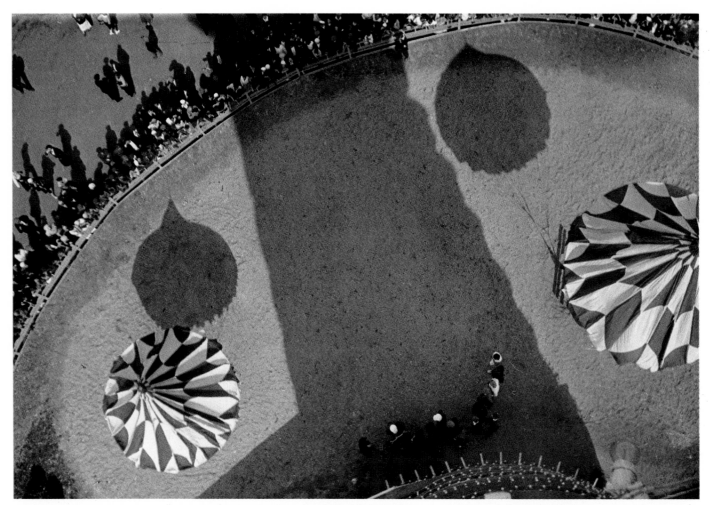

29 Georgij Zelma 1930

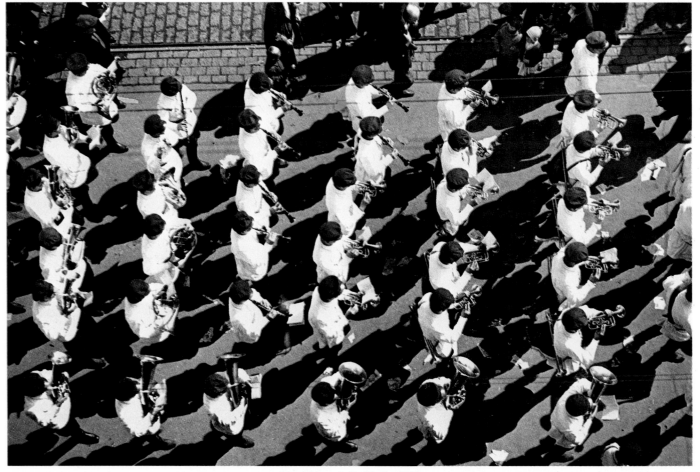

30 Aleksandr Rodčenko 1929

31 Aleksandr Rodčenko 1928

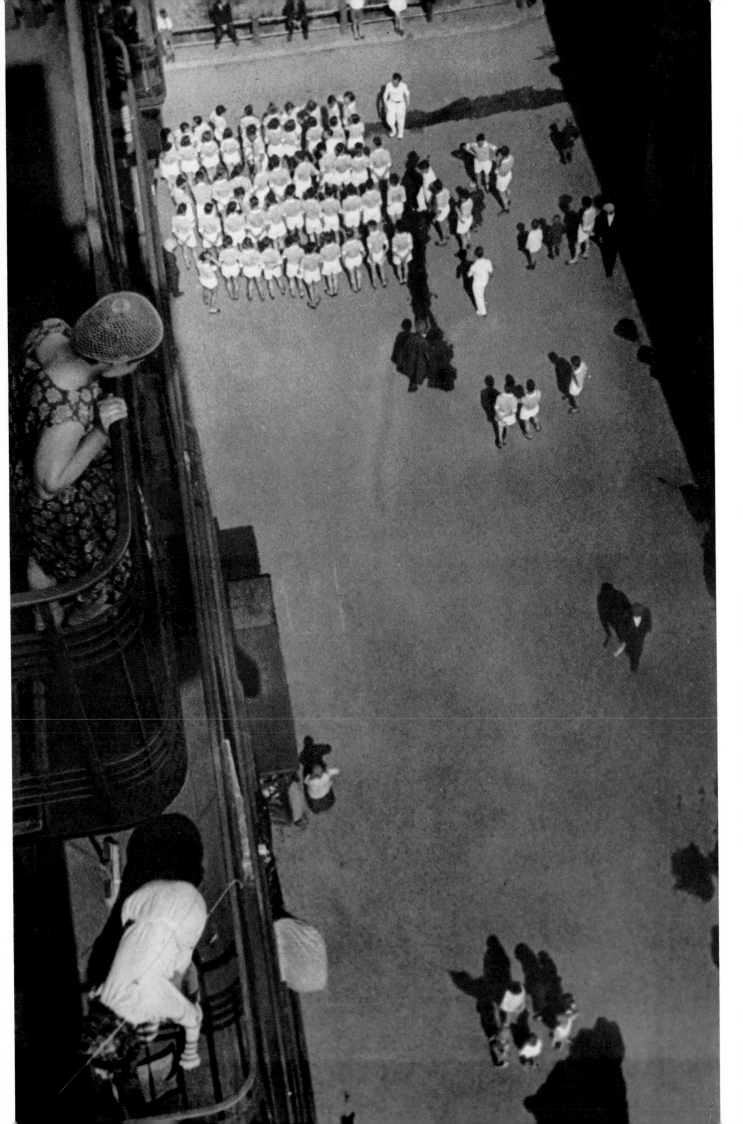

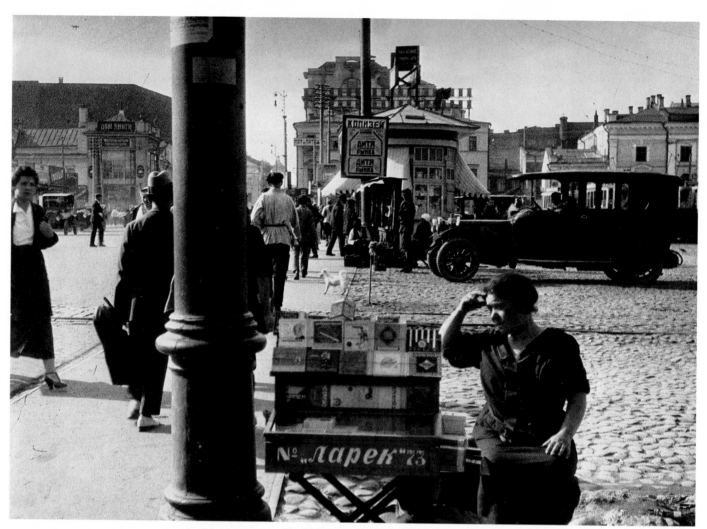

32 Aleksandr Rodčenko 1927

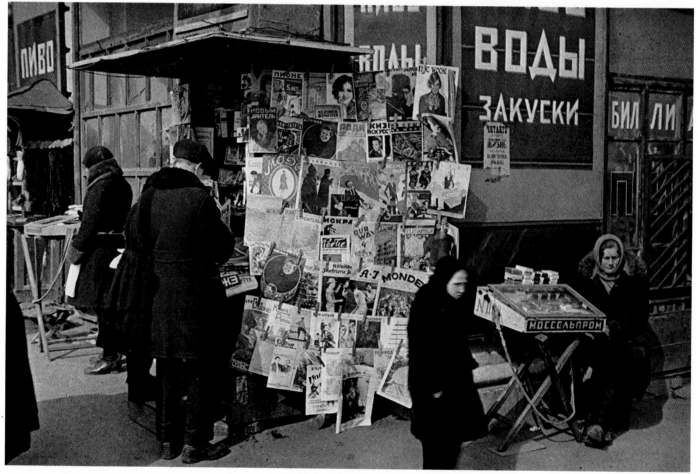

33 Aleksandr Rodčenko 1926

34 Aleksandr Rodčenko 1929

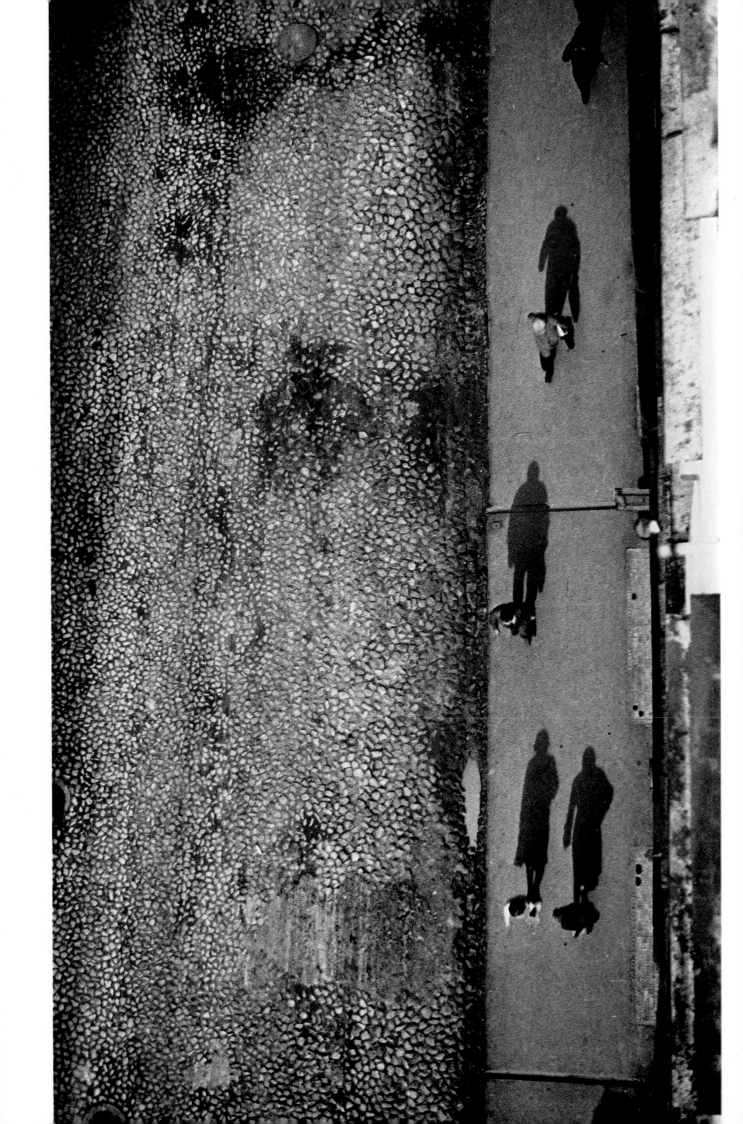

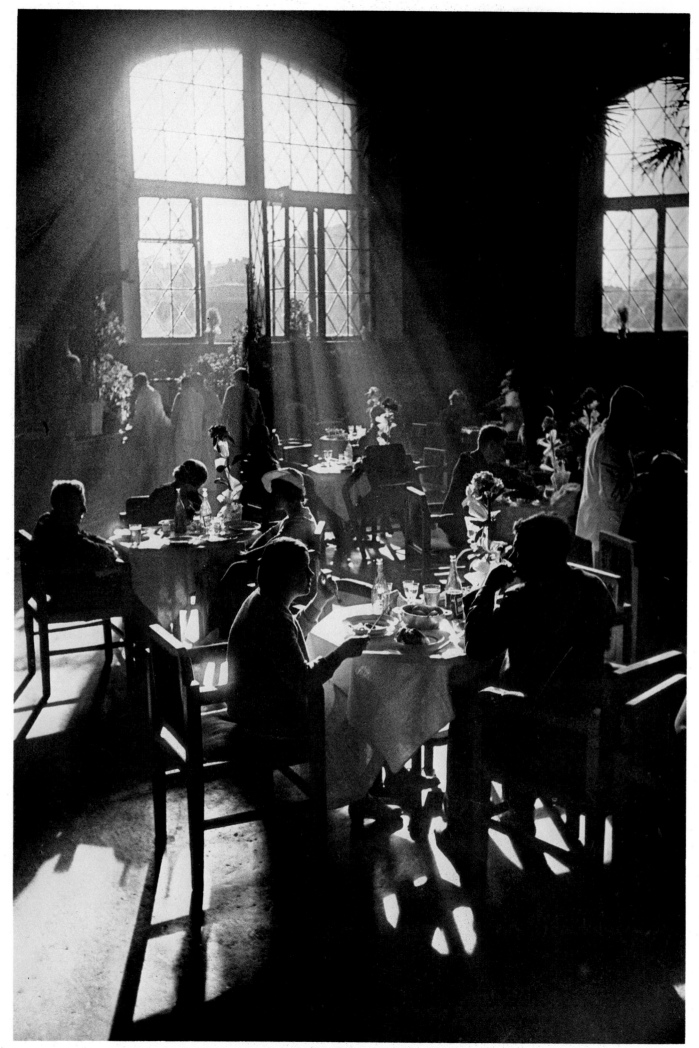

35 Arkadij Šajchet circa 1930

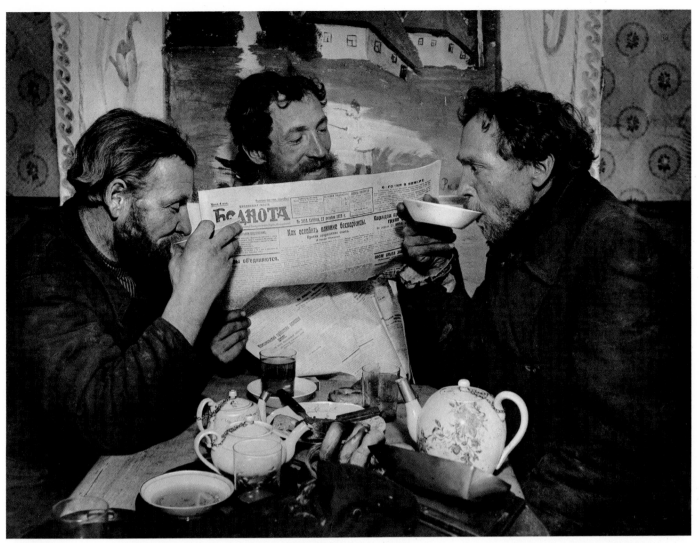

36 Boris Ignatovič 1928

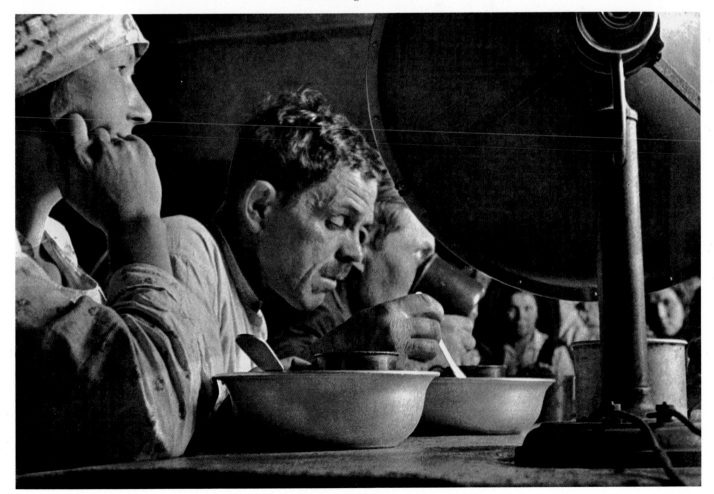

37 Boris Ignatovič circa 1920

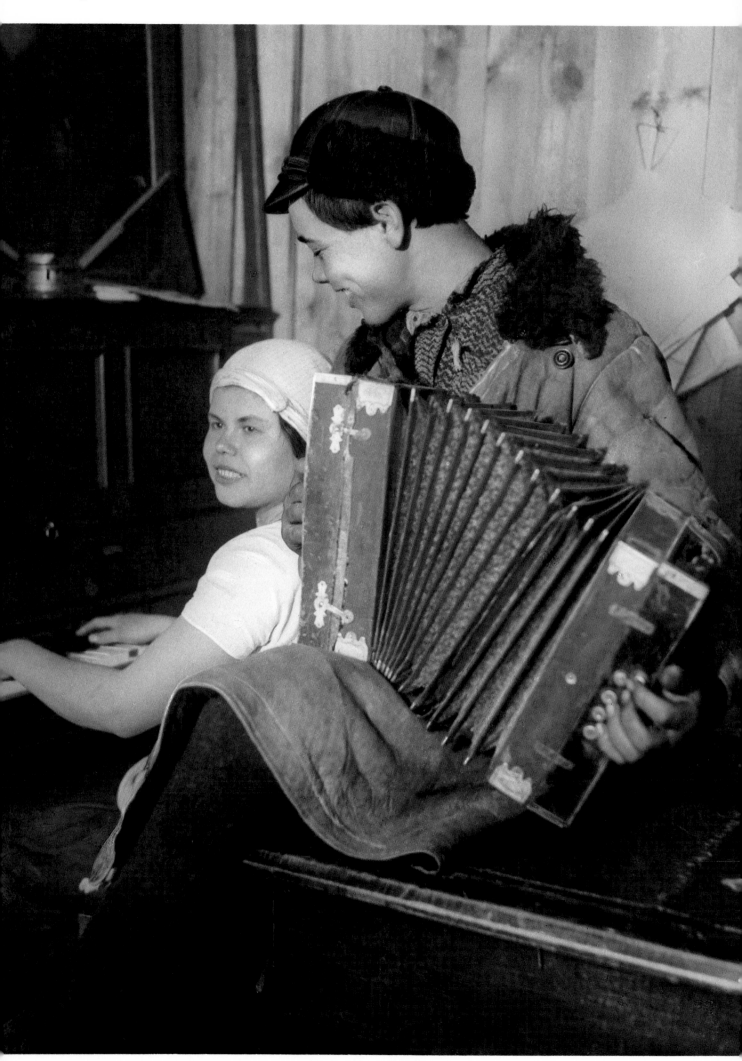

38 Boris Ignatovič 1928

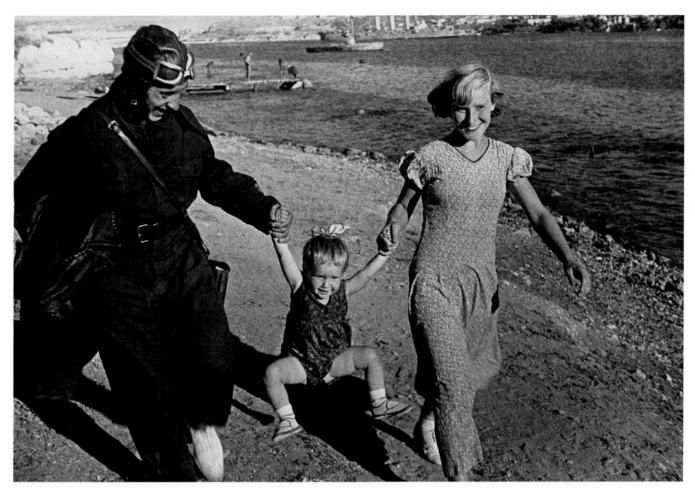

39 Georgij Zelma 1932

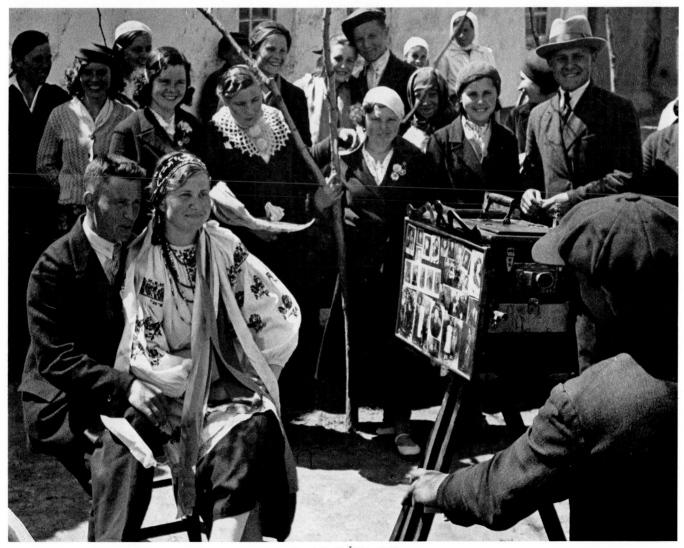

40 Arkadij Šiškin 1928

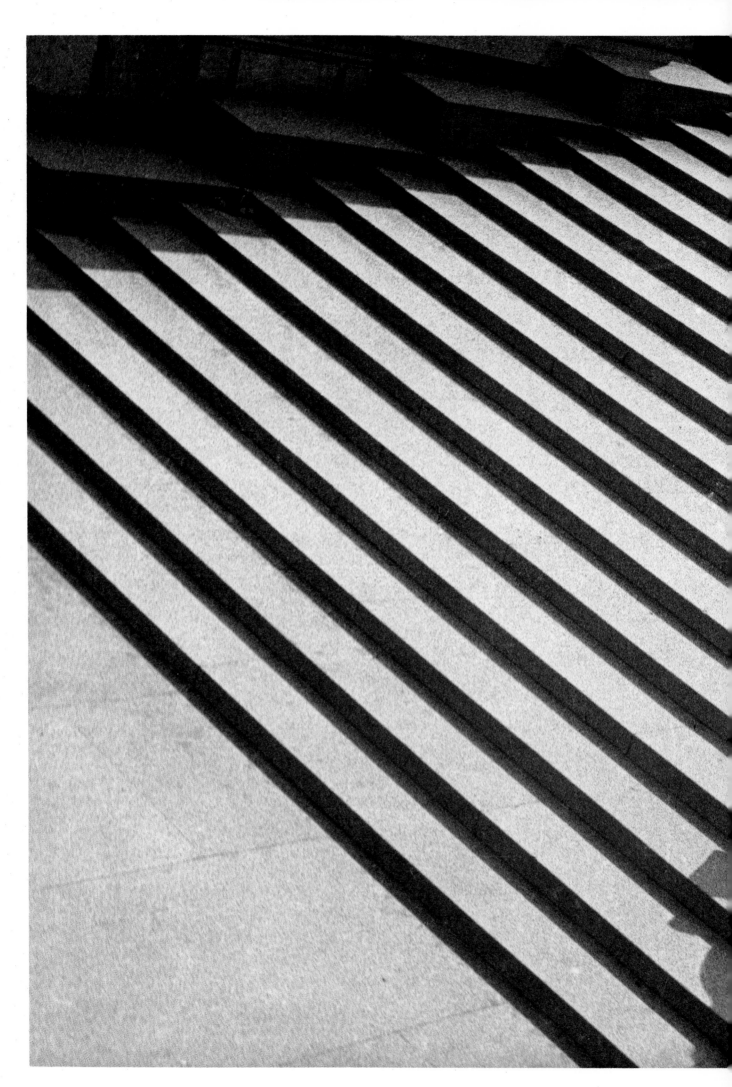

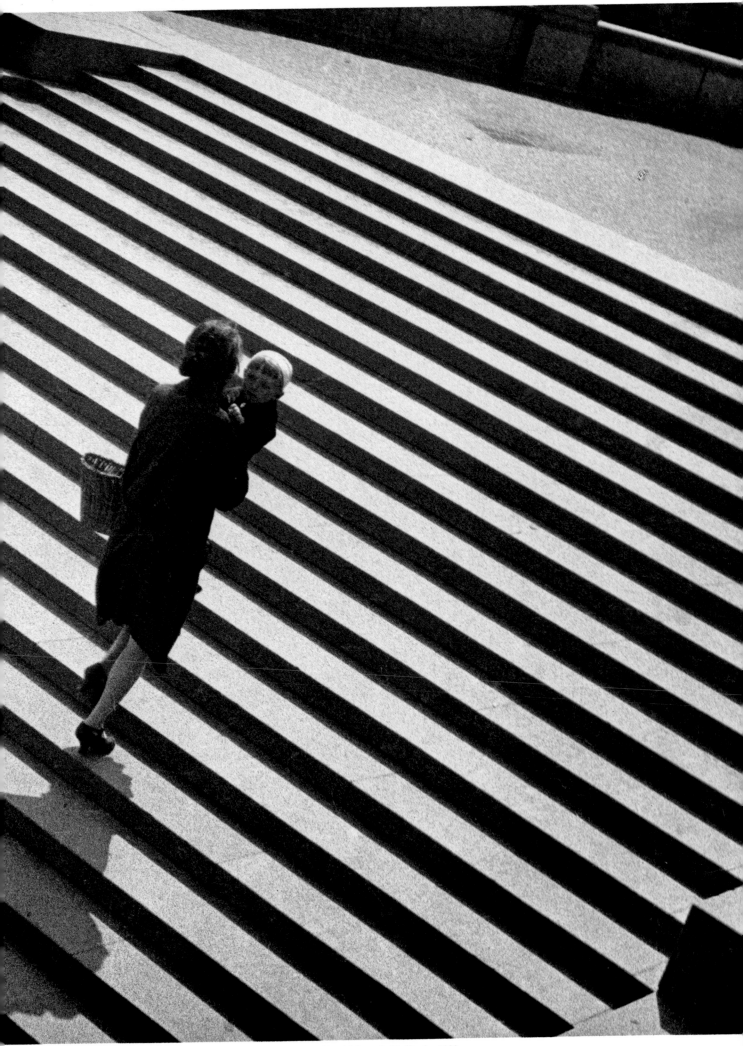

41 Aleksandr Rodčenko 1930

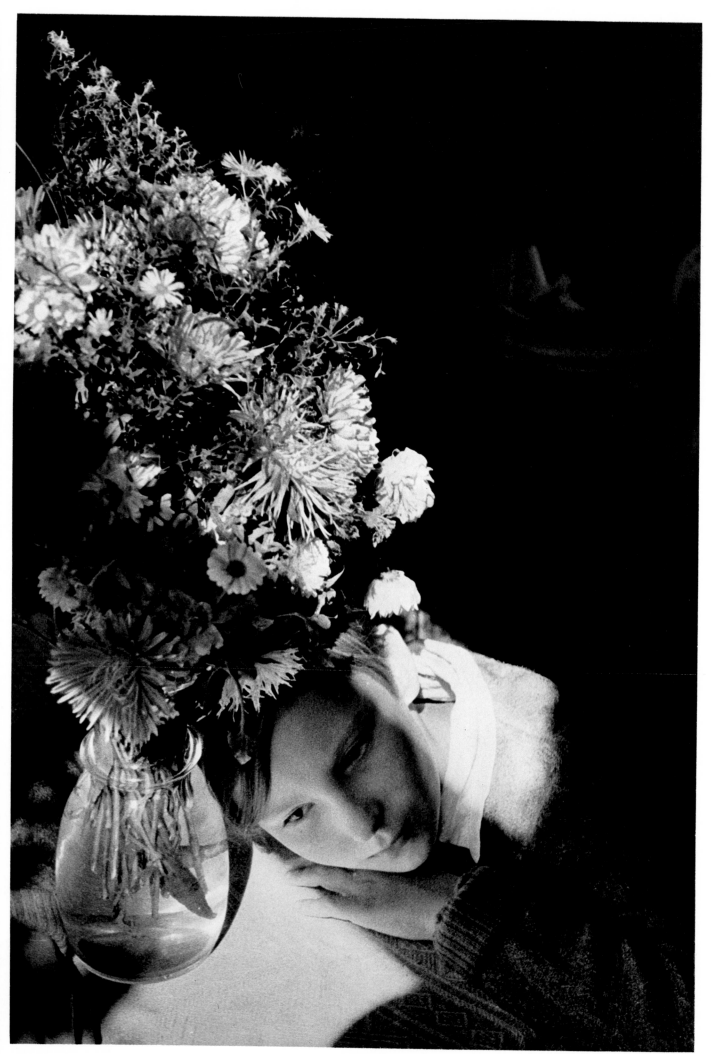

42　Aleksandr Rodčenko 1937

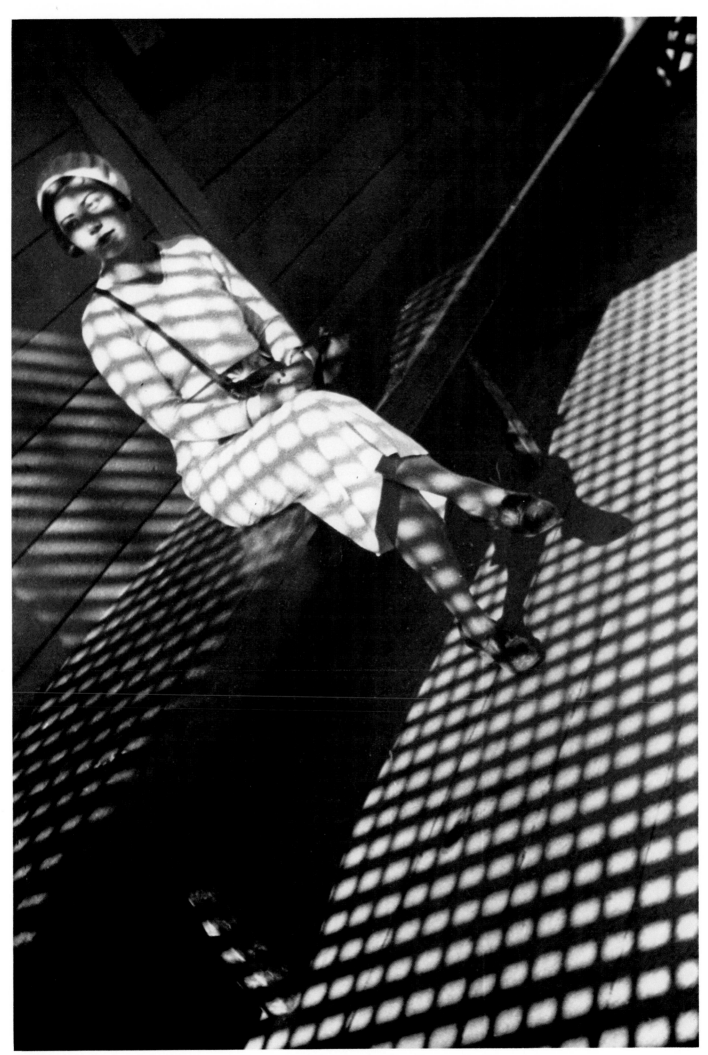

43 Aleksandr Rodčenko 1934

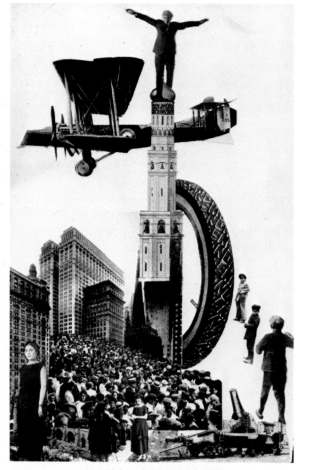

44 Aleksandr Rodčenko 1926

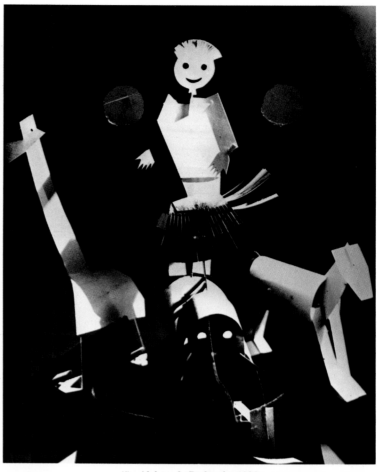

45 Aleksandr Rodčenko 1926

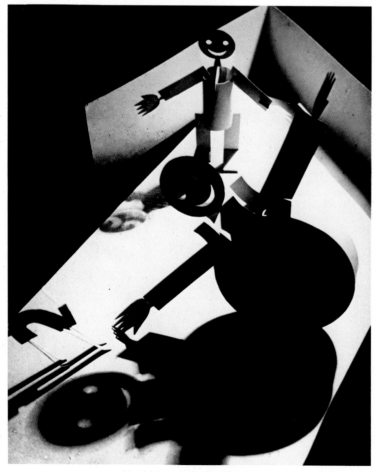

46 Aleksandr Rodčenko 1926

47 Aleksandr Rodčenko 1926

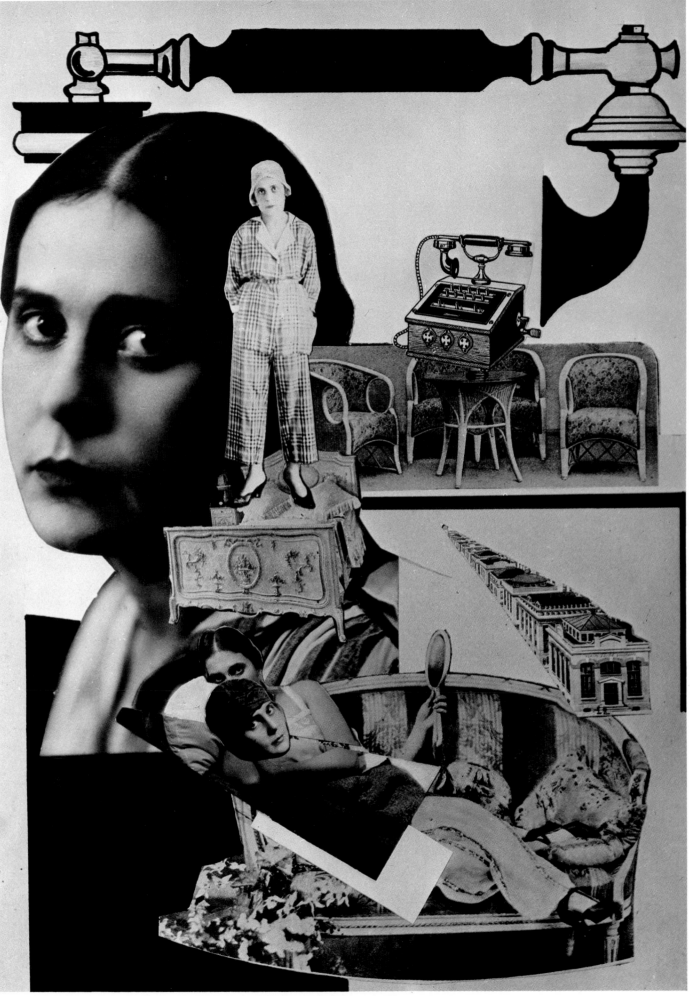

48 Aleksandr Rodčenko 1926

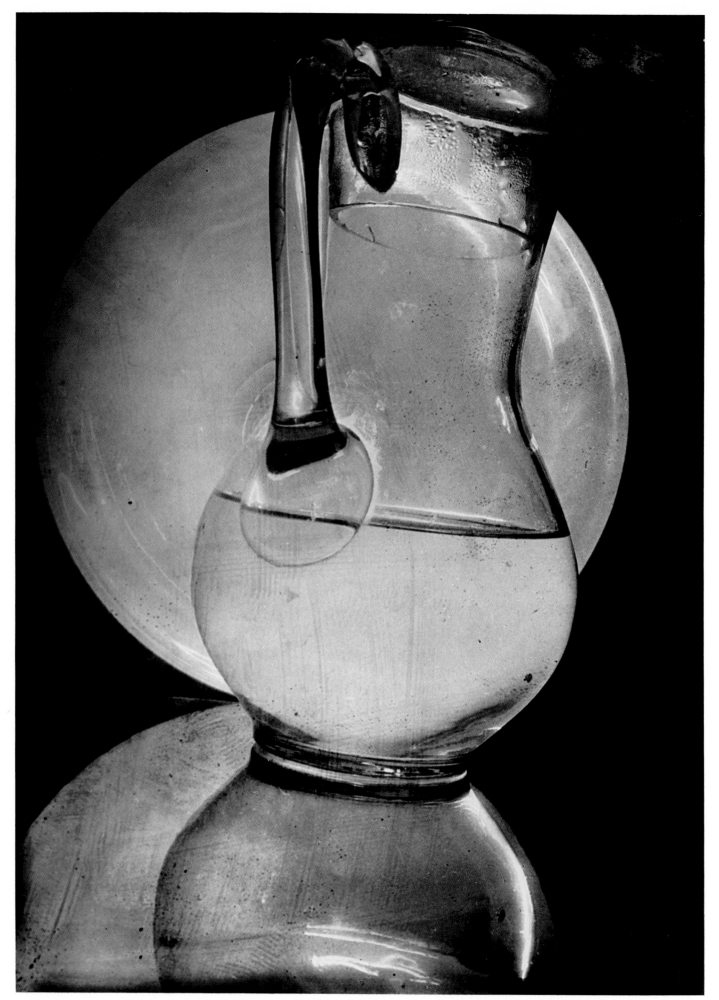

49 Aleksandr Rodčenko 1928

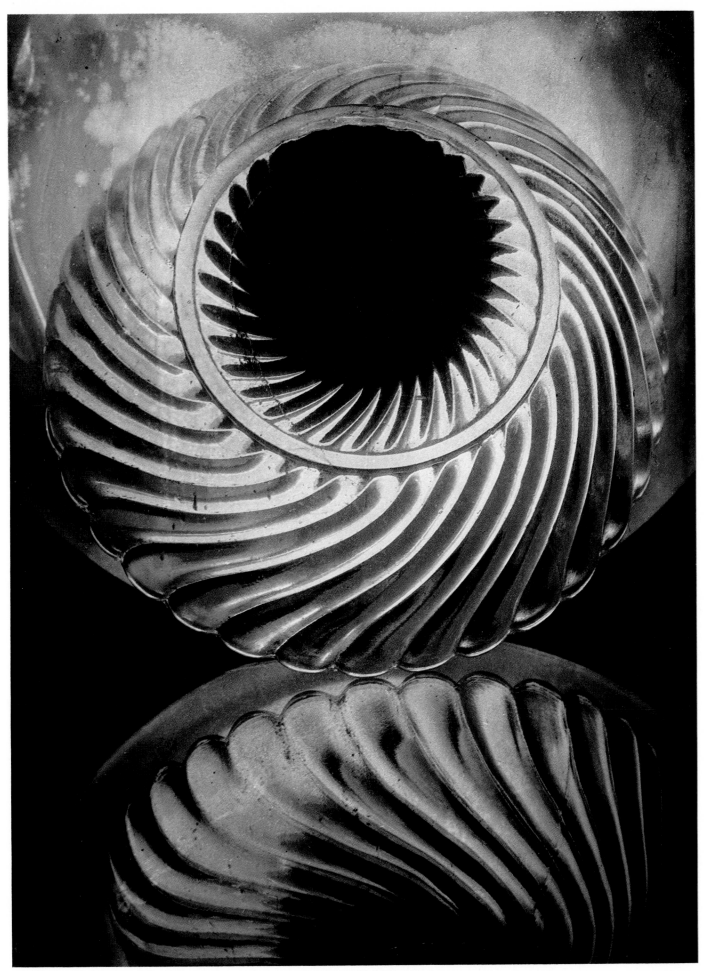

50 Aleksandr Rodčenko 1928

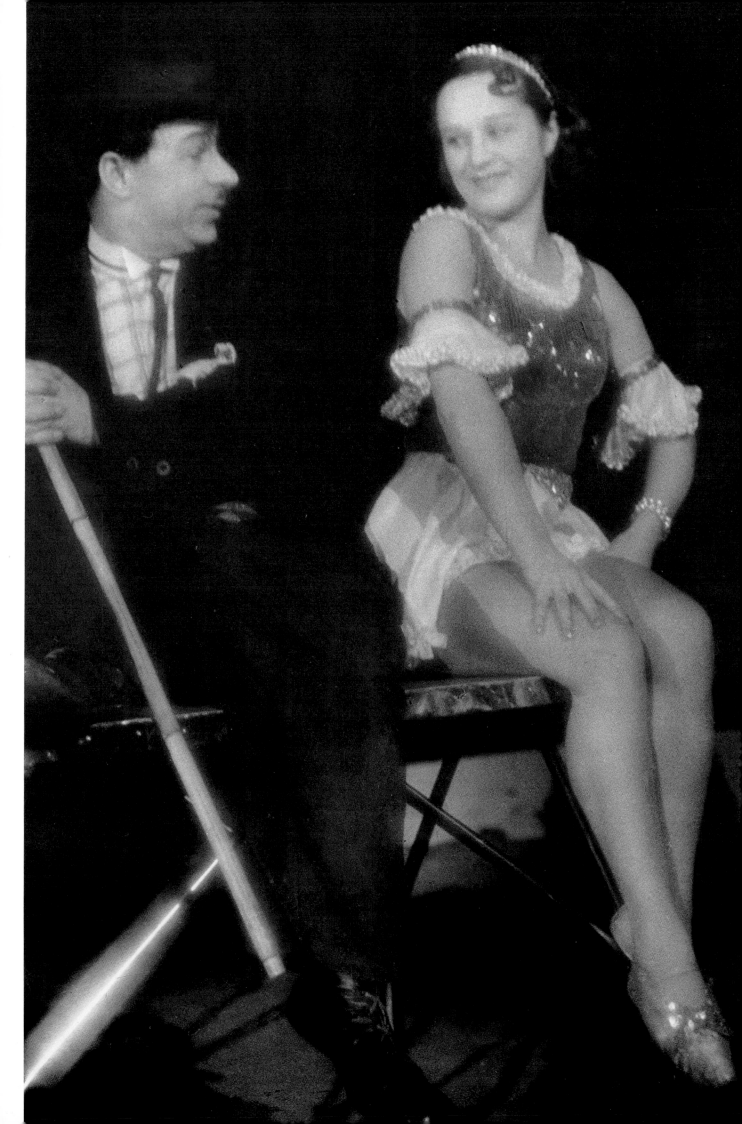

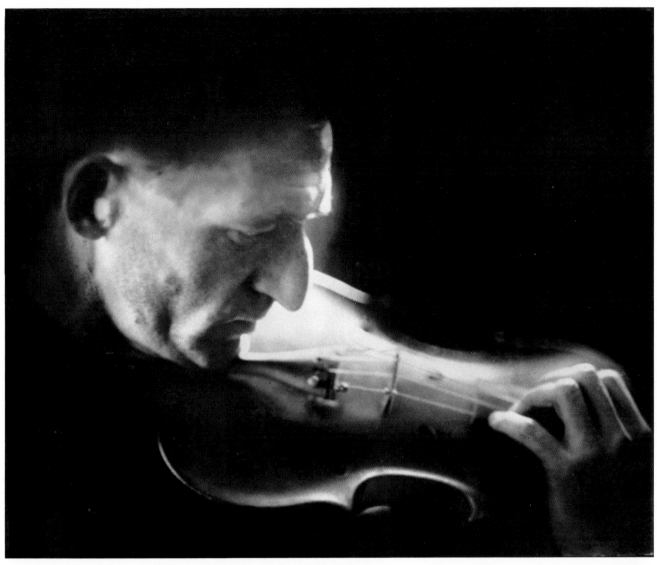

52 Abram Sterenberg

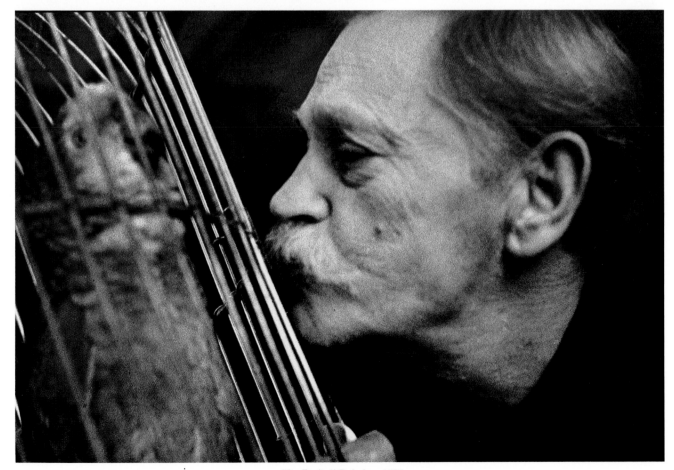

53 Dmitrij Debabov 1935

51 Aleksandr Rodčenko 1940

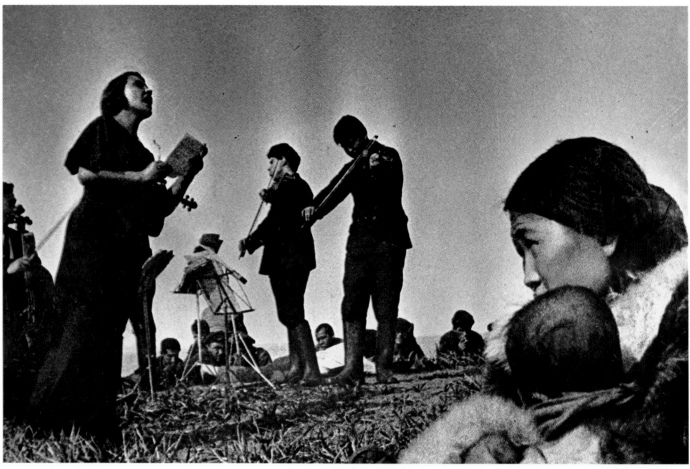

54 Dmitrij Debabov 1936

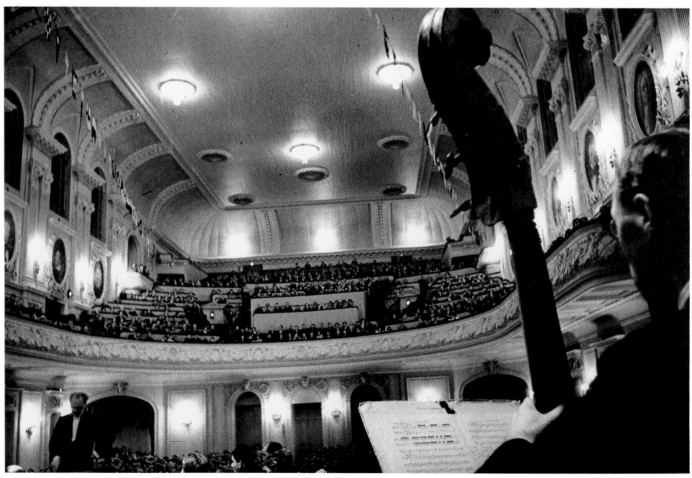

55 Jakob Halip 1928

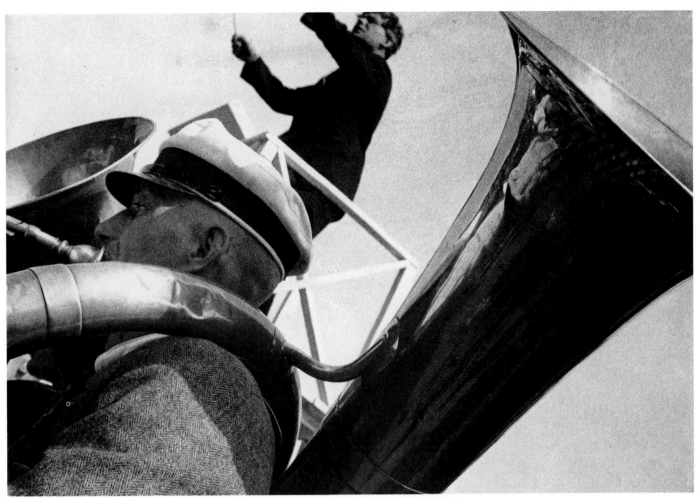

56 Boris Ignatovič. *Dmitrij Šostakovič* 1930

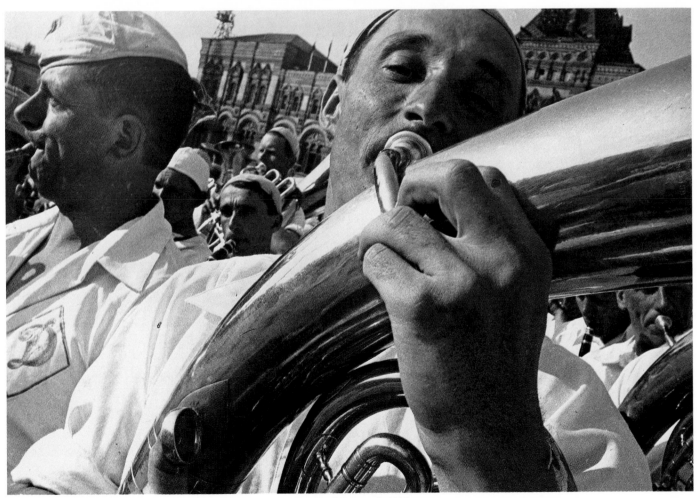

57 Boris Ignatovič 1926

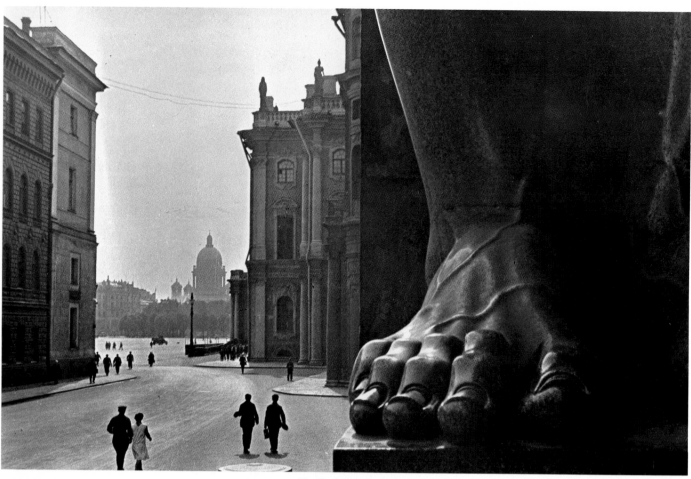

58 Boris Ignatovič

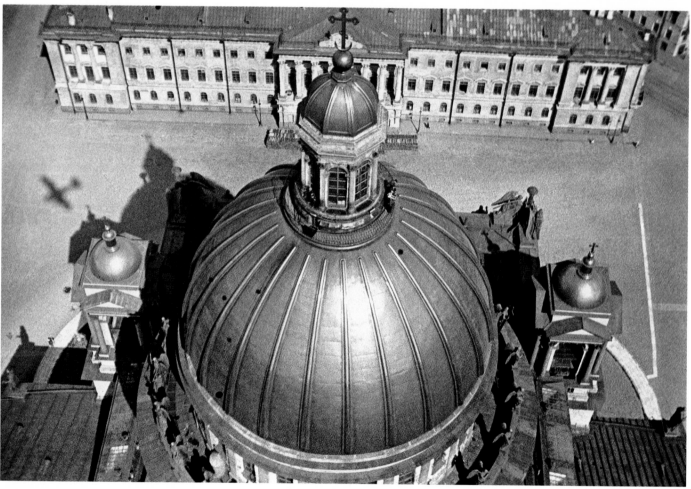

59 Boris Ignatovič 1930

60 Jakob Halip circa 1930

72

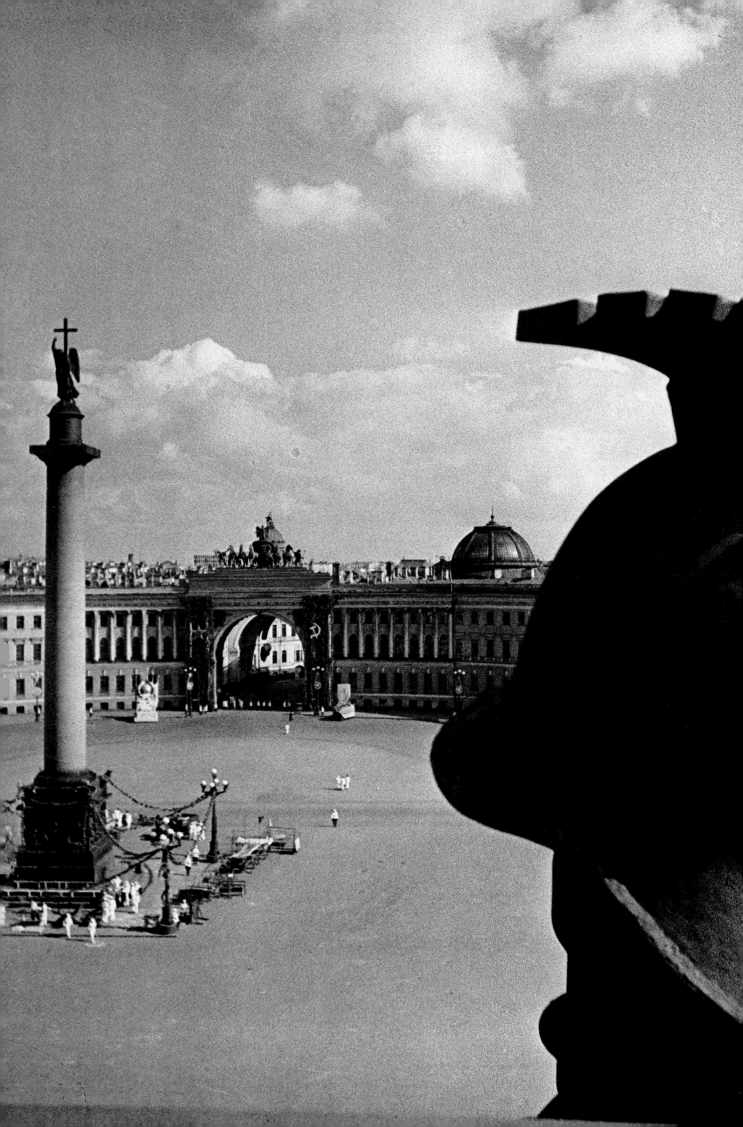

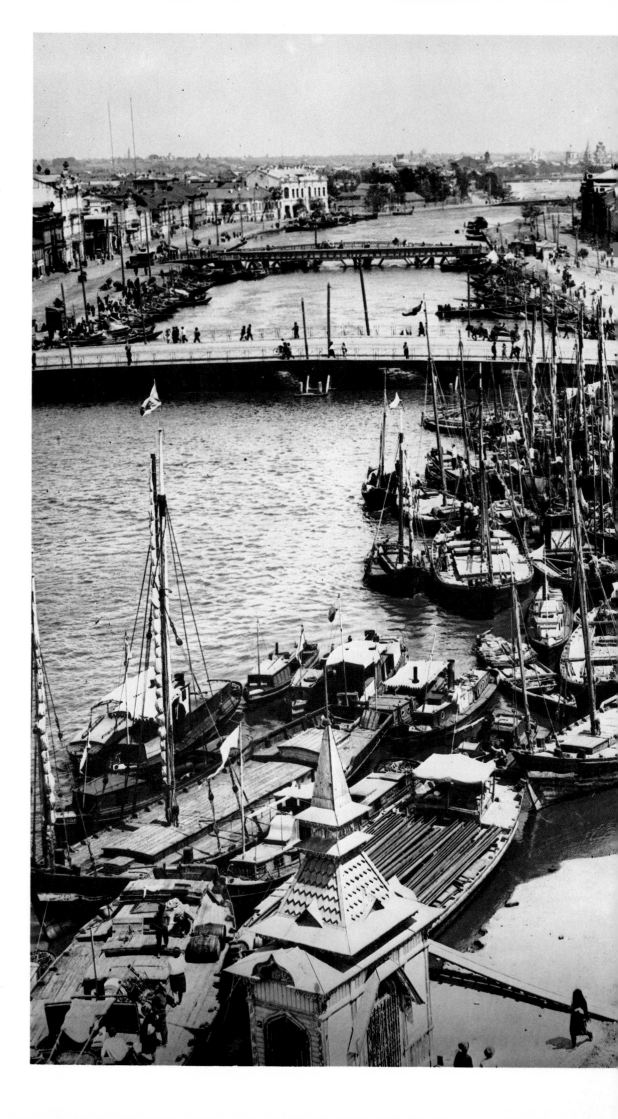

61 Arkadij Šajchet 1927

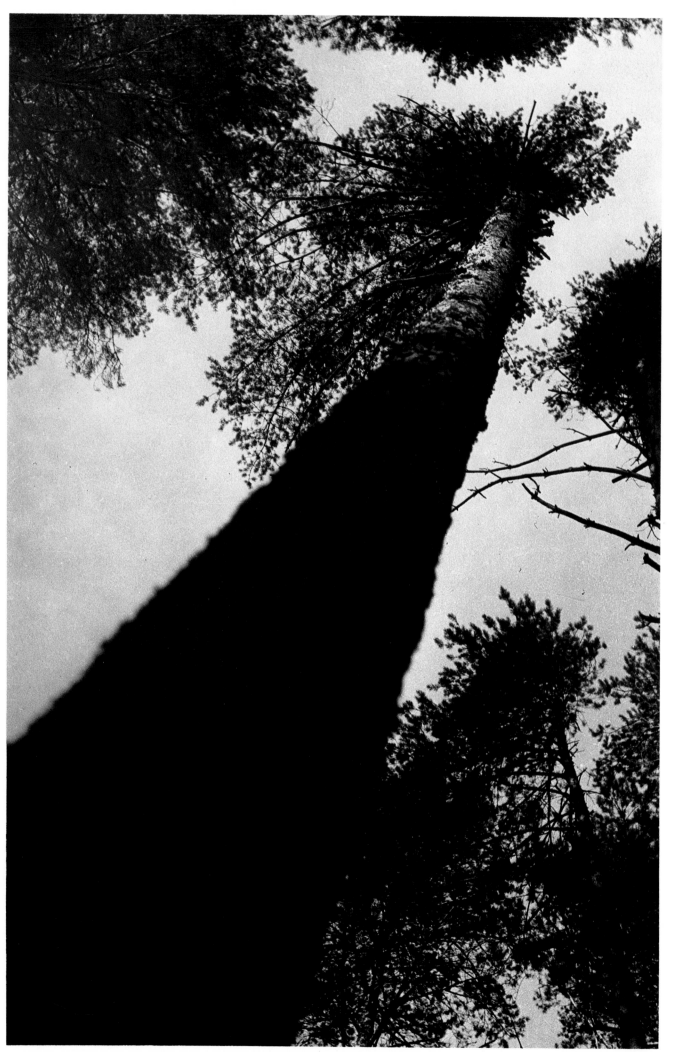

62 Aleksandr Rodčenko 1927

63 Aleksandr Rodčenko 1929

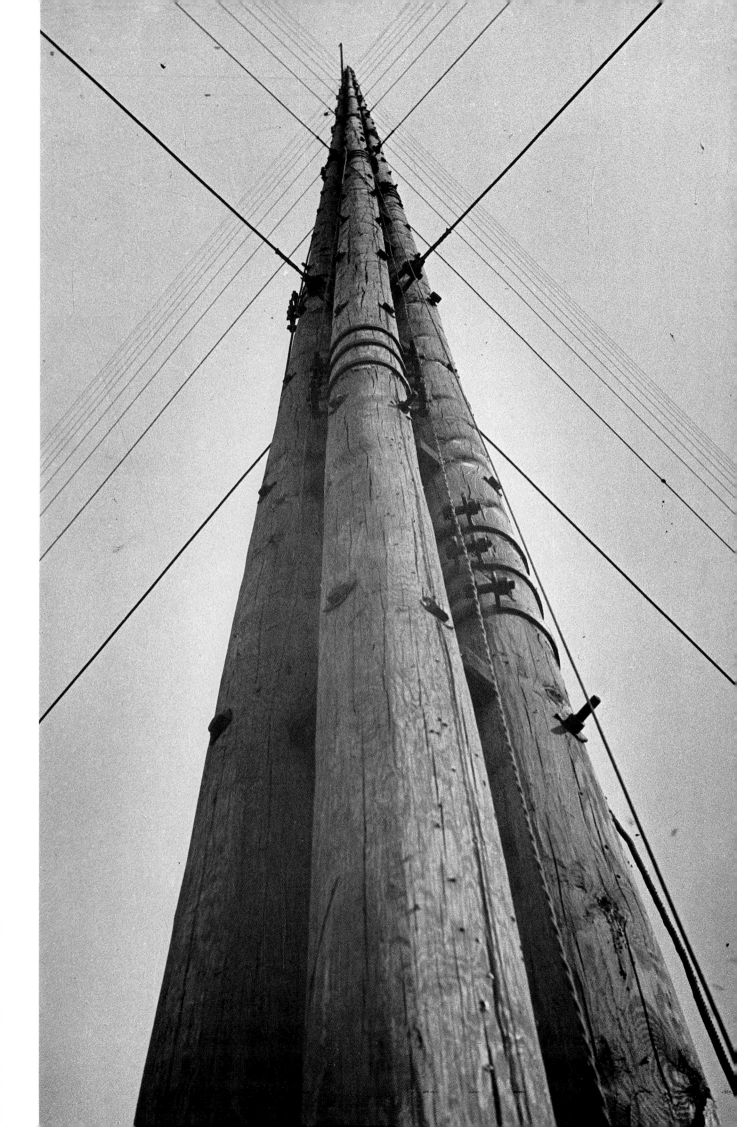

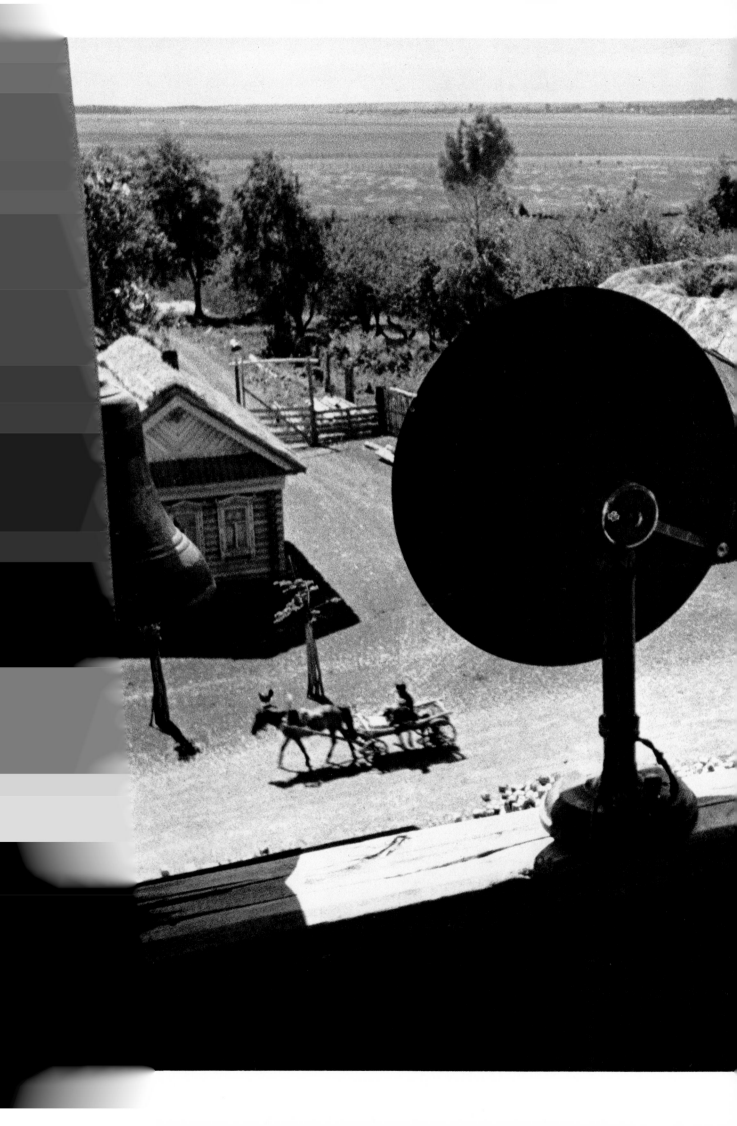

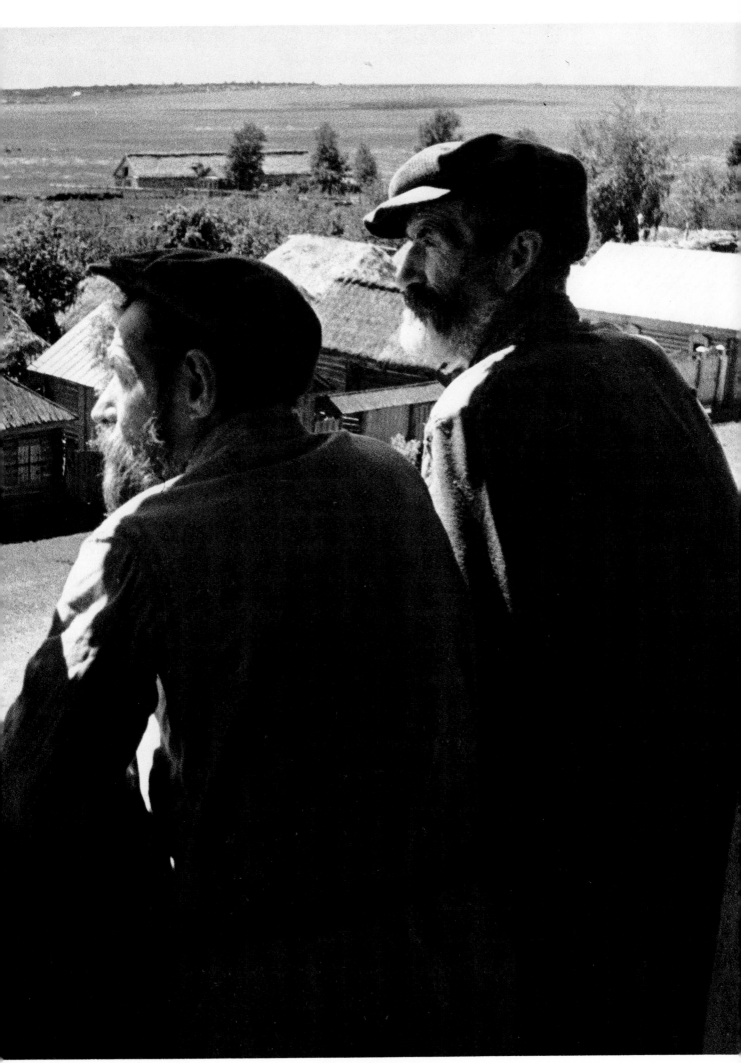

64 Anatolij Skurichin 1937

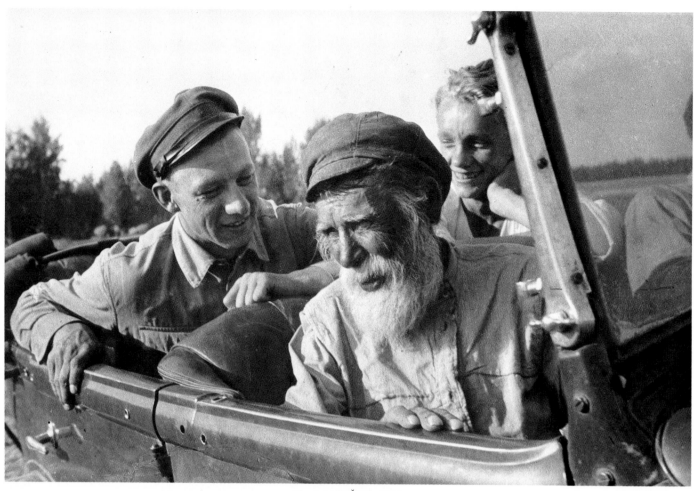

65 Arkadij Šiškin 1935

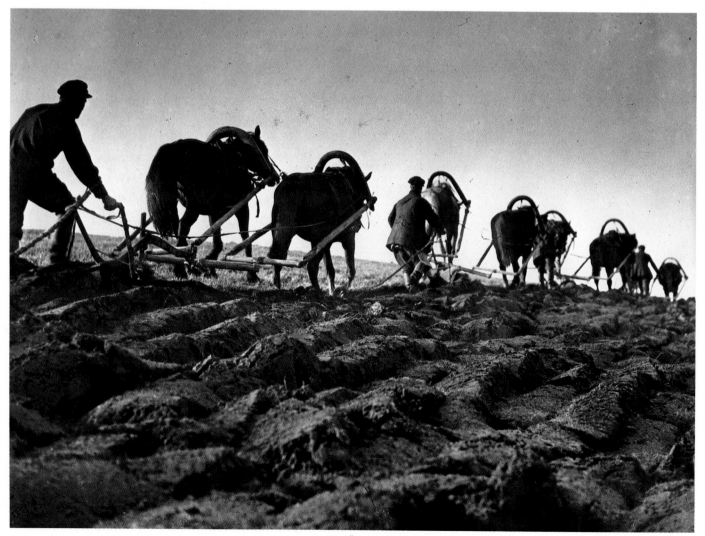

66 Arkadij Šajchet 1931

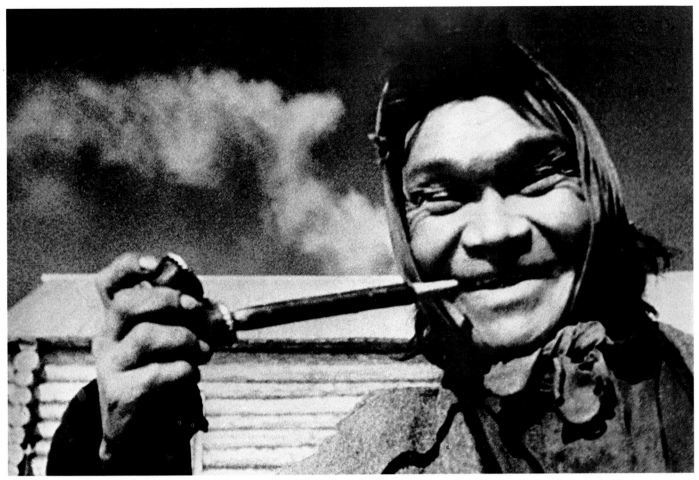

67 Dmitrij Debabov 1935

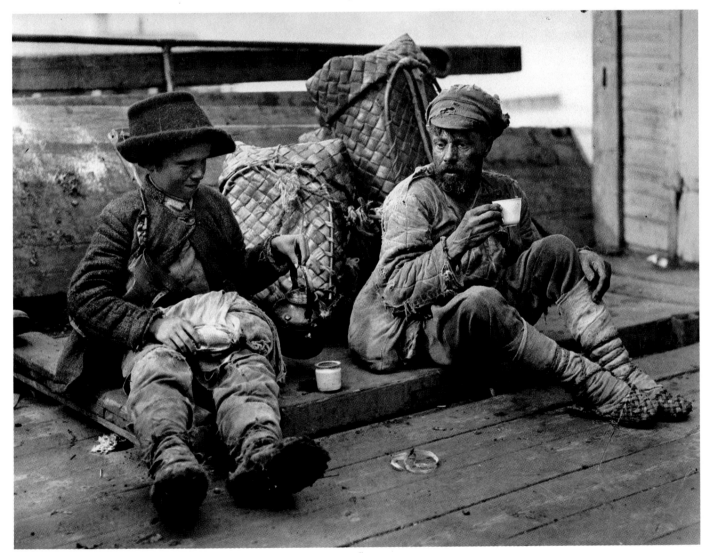

68 Arkadij Šajchet 1925

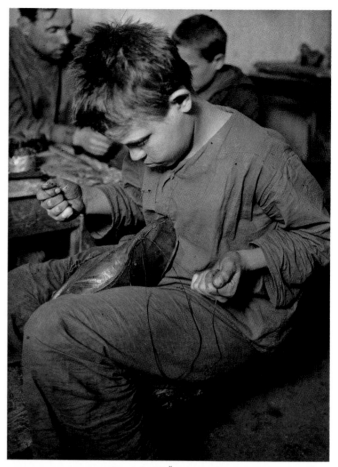

69 Olga Ignatovič. *Aleksandr Busigin* 1935

70 Arkadij Šajchet 1925

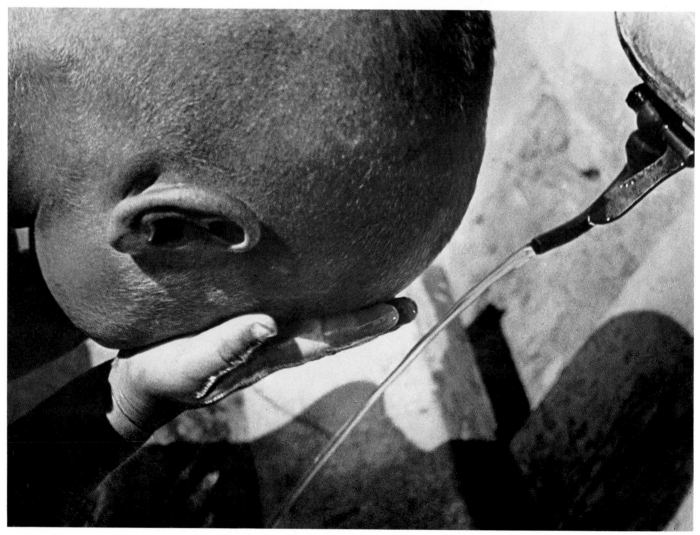

71 Eleazar Langman 1933

72 Aleksandr Rodčenko 1927

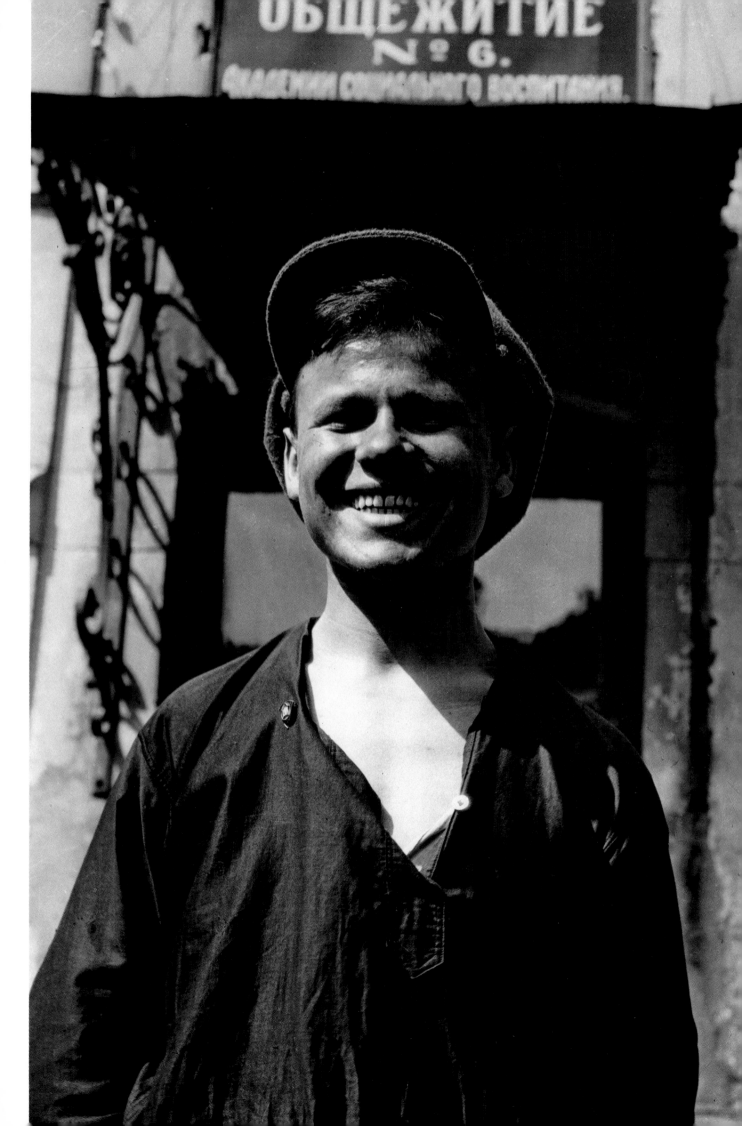

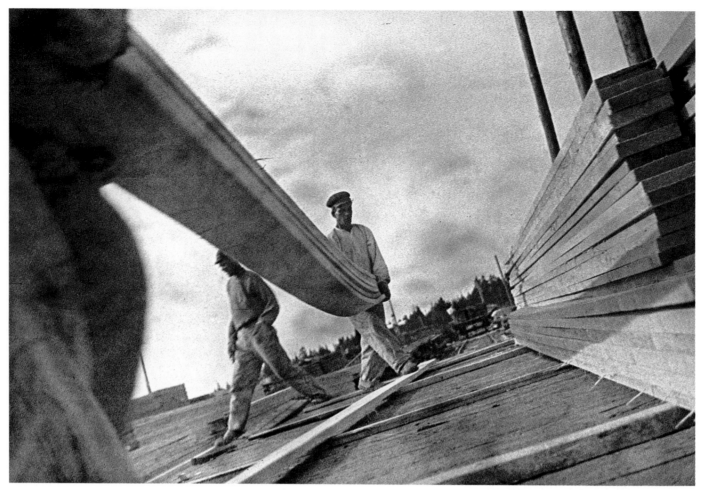

73 Aleksandr Rodčenko 1931

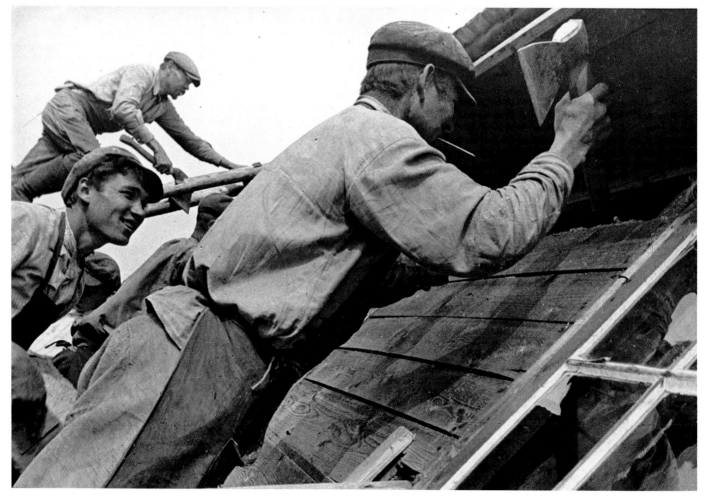

74 Boris Ignatovič

75 Boris Ignatovič circa 1930

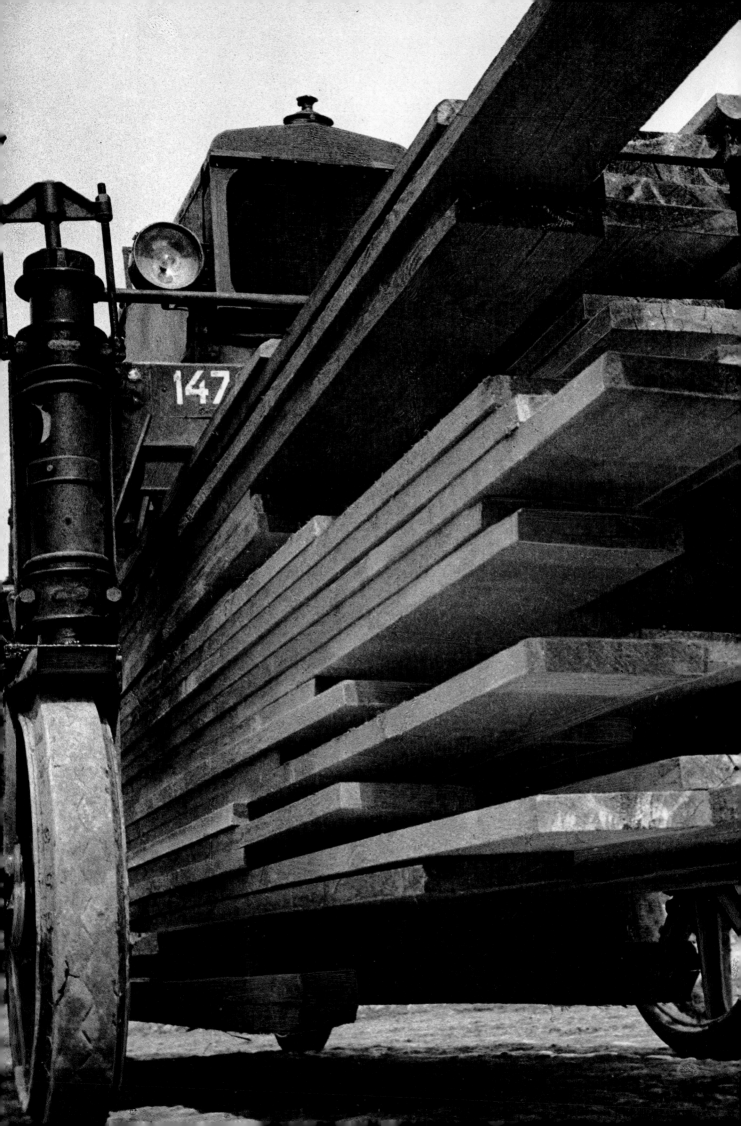

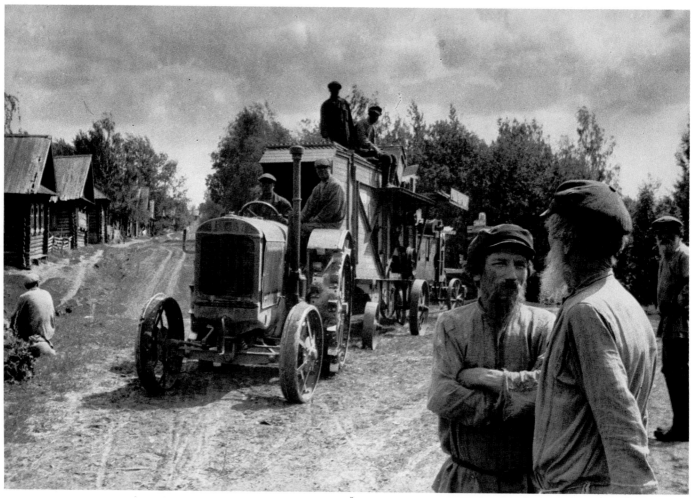

76 Arkadij Šiškin 1935

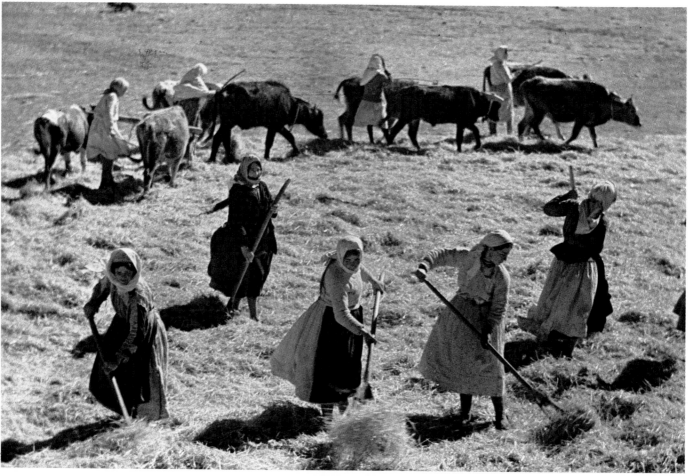

77 Boris Ignatovič circa 1920

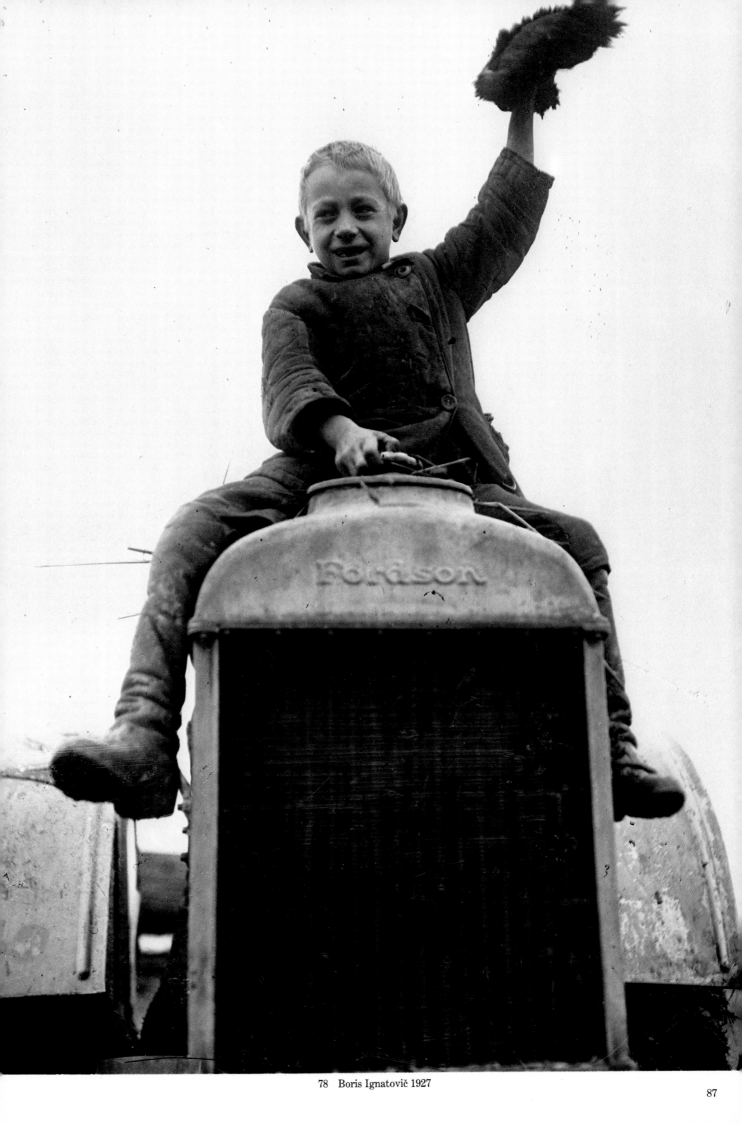

78 Boris Ignatovič 1927

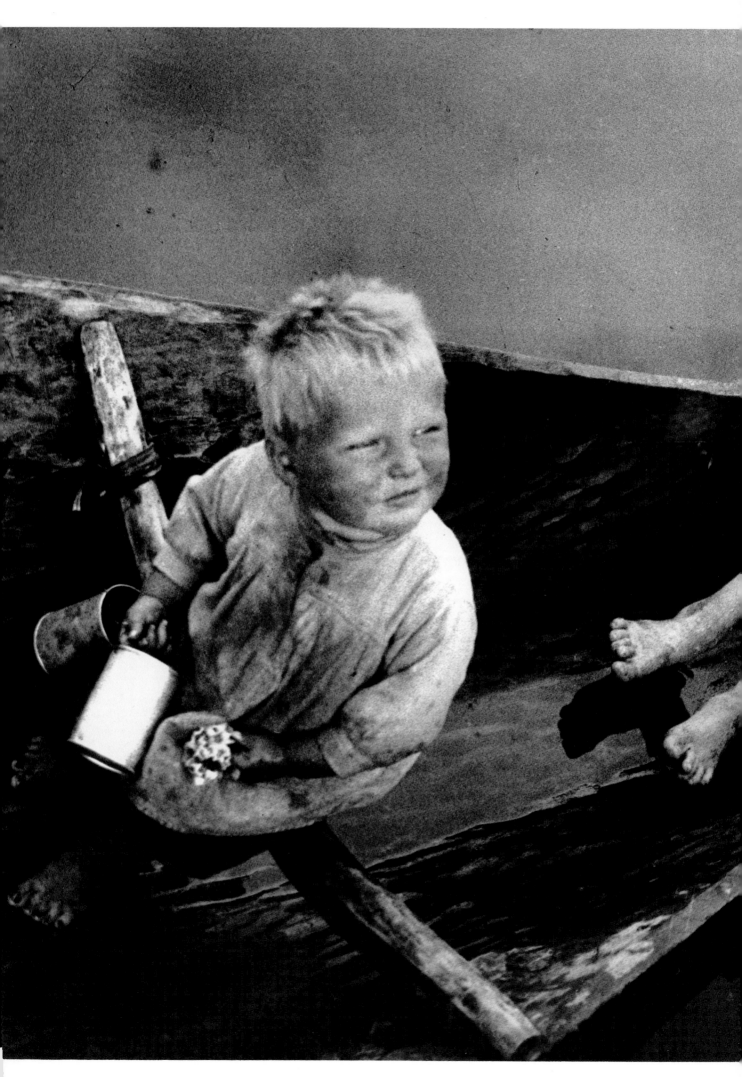

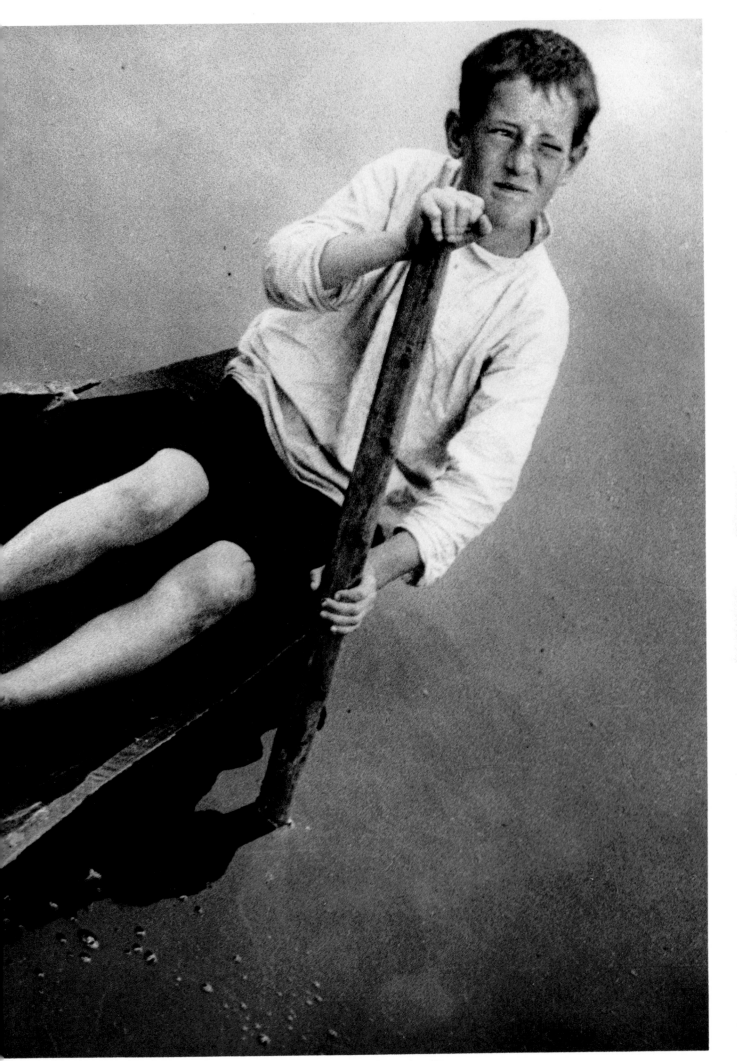

79 Aleksandr Rodčenko 1933

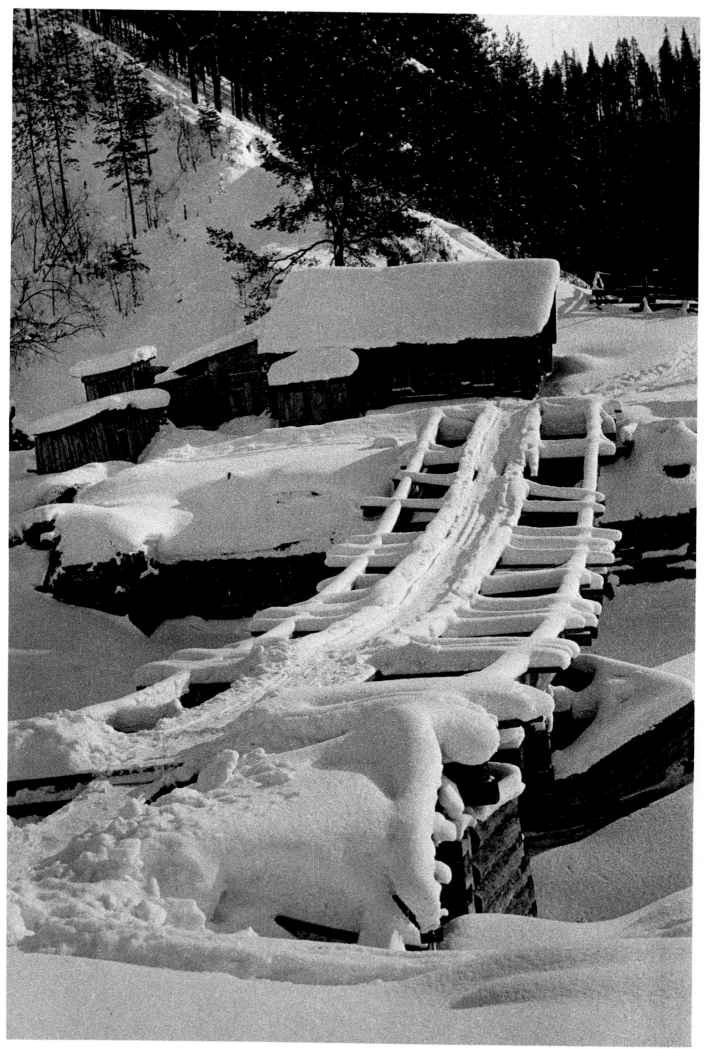

80 Aleksandr Rodčenko 1933

81 Dmitrij Debabov 1936

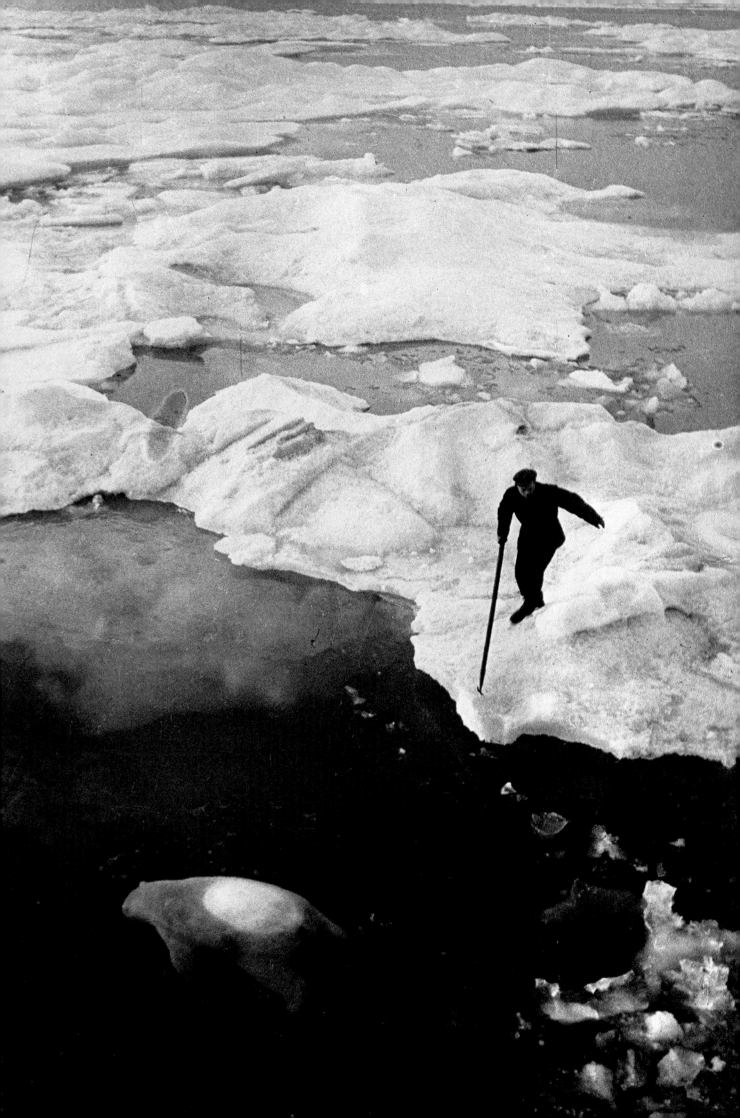

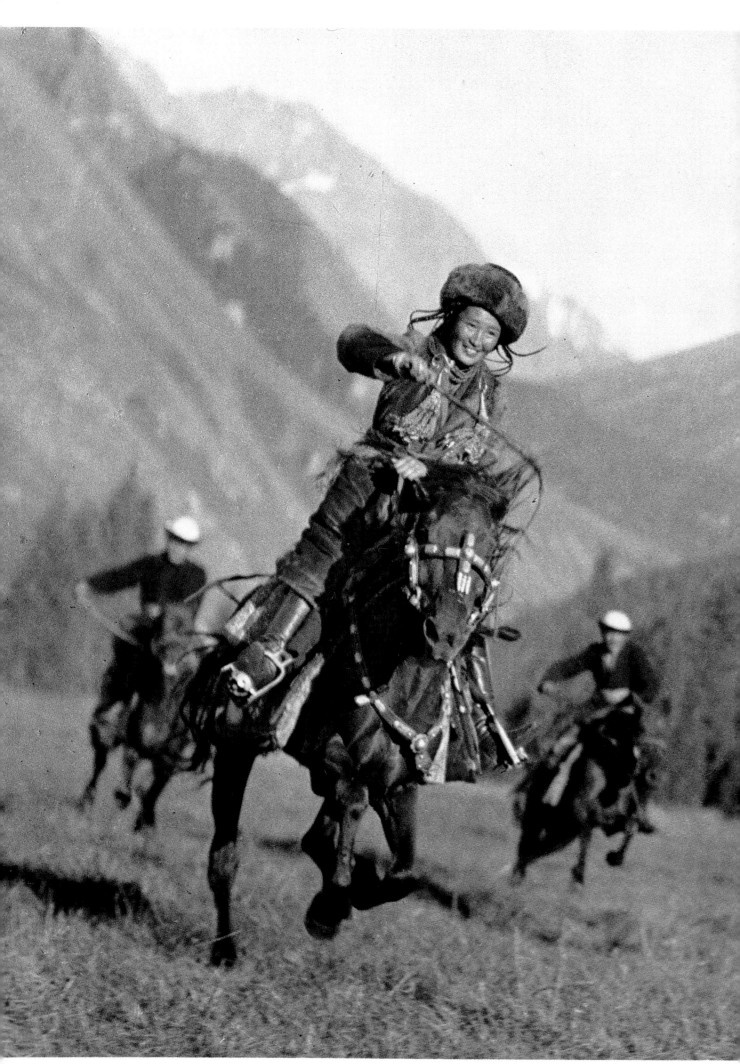

82 Max Alpert 1936

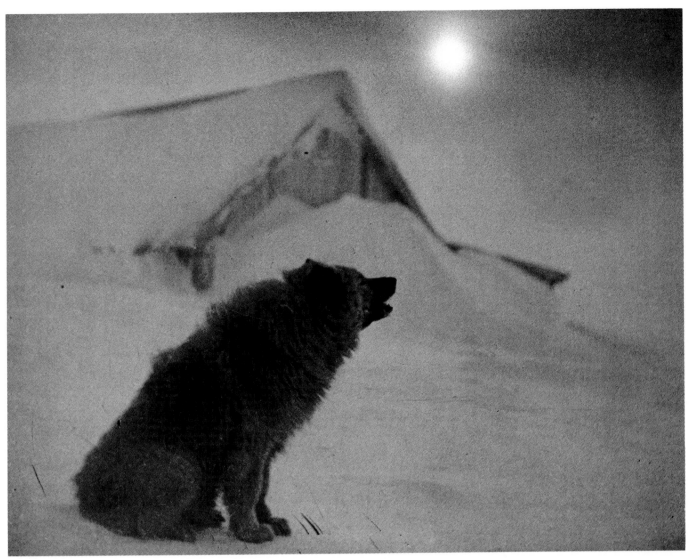

83 Dmitrij Debabov 1935

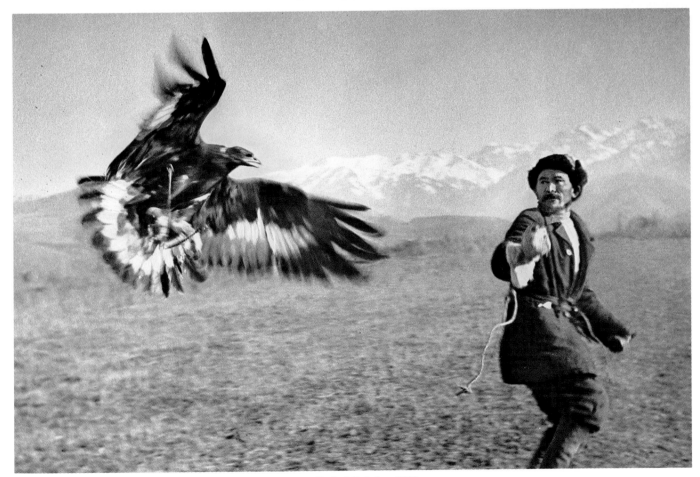

84 Dmitrij Debabov 1935

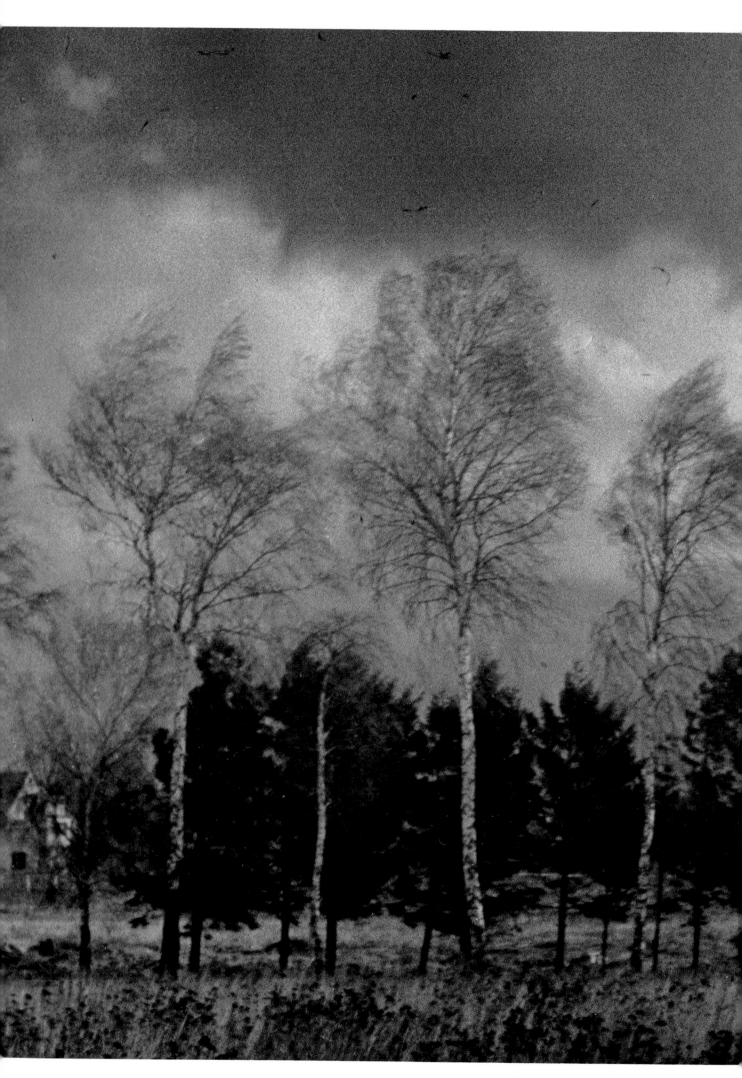

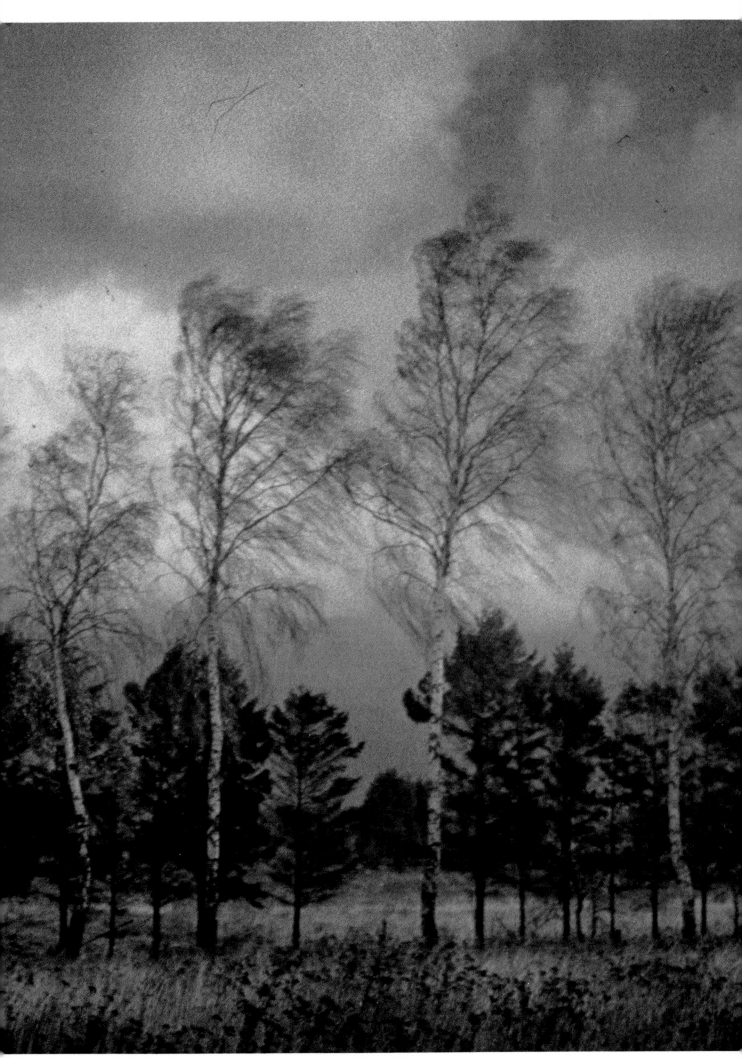

85 Boris Ignatovič

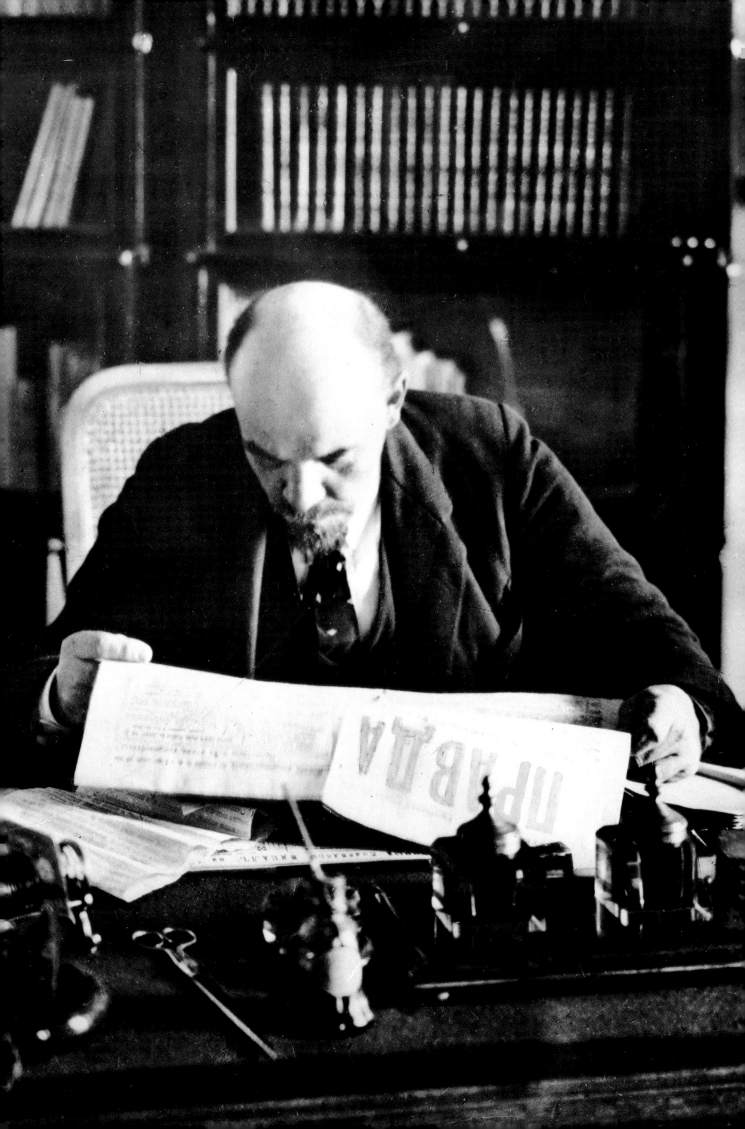

REVOLUTIONARY
FIGURES

From VLADIMIR ILYICH LENIN

It's time –
 I begin
 the story of Lenin.
But not
 because sorrow
 no longer remains,
time now,
 because
 anguish's sharp complaining
has become
 a clarified deep-pondered pain.
Time
 again
 Lenin's slogans be tempest-driven!
Shall we
 shed out tears
 in a shower?
Lenin
 is now
 the most live of all living.
Our weapon,
 our knowledge,
 our power....
I fear
 the mausoleum
 and official functions,
established statute
 servility
may clog
 with cloying unction
Lenin's
 simplicity.
I tremble for him
 as for the apple of my eye,
that none
 should slander
 with choc-box beauty.

Vladimir Mayakovsky, 1924

Notes

86 Pyotr Otsup: *Vladimir I. Lenin at the Work Table of His Office in the Kremlin* (Moscow, 16th October 1918). A famous photograph the taking of which was described by Otsup (see Grigory Shudakov's introduction).

87 Pyotr Otsup: *Yakov M. Sverdlov* (Moscow, 1918). A Soviet statesman, a member of the RSDWP (Russian Social Democratic Workers' Party), and subsequently a member of the Bolshevik Party, Sverdlov (1885–1919) took part in the 1905–1907 Revolution in the Urals. He was Director of *Pravda* and took part in the October Revolution in Petrograd. The first President of the Supreme Soviet, the executive committee of government in the USSR.

88 Pavel Zhukov: *Vladimir I. Lenin* (1920).

89 Pyotr Otsup: *Vladimir I. Lenin Delivering a Speech in Red Square, on the First Anniversary of the Great Socialist Revolution of October* (Moscow, 7th November 1918). Numerous paintings were executed from this photograph, notably Isaak I. Brodsky's portrait of Lenin. On this day, Lenin unveiled a commemorative plaque in honour of the combatants of the October Revolution.

90 Viktor Bulla: *Vladimir I. Lenin Delivering a Speech at a Meeting Concerning the Erection of the Monument to Karl Liebknecht and Rosa Luxemburg in Palace Square* (Petrograd, 19th July 1920). 'He appeared suddenly on the platform, as if impelled by the crowd of forty thousand men.... How is it possible to convey the effect which he had upon those listening? ... His words enthralled and inspired us. Fear and fatigue evaporated. It seemed as if Ilyich was not alone in speaking, but that the forty thousand had begun to speak and, standing, sitting, in mid-air, were all expressing their innermost thoughts. It seemed that everything the workers experienced was finding expression in the voice of Ilyich. Everything that each man kept to himself, everything that he felt deep down without having either the time or the words to formulate, all this suddenly took shape and found utterance....' (A worker from the Putilov factory). Delegates of the Second Congress of the Communist International took part in this meeting. Rosa Luxemburg and Karl Liebknecht were murdered in Berlin.

91 Max Alpert: *Klara Zetkin and the President of the Japanese Communist Party, Sen Katayama, in Red Square* (1925). A founder of the German Communist Party and one of the organizers of Spartakus, Klara Zetkin (1857–1933) directed the women's section of the Communist International. She is buried in Moscow's Red Square, in front of the Kremlin Wall.

92 Mikhail Nappelbaum: *Nadezhda Krupskaya* (1932). Nadezhda Konstantinova Krupskaya (1869–1939) was the colleague and devoted companion of Lenin, whom she married in 1898. From 1890 onwards, she belonged to a Marxist circle and taught workers.

93 Arkady Shaikhet: *Maria I. Ulyanova with Pioneers of the Zamoskoverchy District* (Moscow, circa 1925). The younger of Lenin's two sisters (the elder was called Anna), Maria was born in 1878 and died in 1937. She took part in the Revolutions of 1905 and 1917. From 1917 to 1929, she was on the editorial staff of *Pravda*.

94 Pyotr Otsup: *Vladimir Ilyich Lenin in Front of His Library in His Office in the Kremlin, Moscow* (1918).

95 Pyotr Otsup: *Mikhail I. Kalinin at a Meeting Concerning the Creation of a Red Air Force Fleet* (1920s). The words on the banner read as follows: 'To the workers and peasants, friends of the aerial fleet, we thank you for this present.'

96, 97, 98 Pyotr Otsup: *Mikhail I. Kalinin in His Native Village* (circa 1920). Mikhail Ivanovich Kalinin in Vershnyaya Troyka, near Tver, where he was born in 1875. Originally a peasant, he joined the Revolutionary Party while a worker in St Petersburg in 1898. He was arrested and deported to Tiflis in 1899. At the time of the 1905 Revolution, he organized the strikes in the Putilov factory (see Nos. 114–118). He was a contributor to *Pravda*, mayor of Petrograd (March 1917), and one of the leaders of the October Revolution. In 1922, he replaced Sverdlov on the Central Executive Committee of the USSR. After the December 1937 elections, Stalin left him the post of President of the Praesidium, from which he resigned in 1946 for reasons of health. He died in the same year. Here he is seen at his favourite occupations: wood-cutting and mowing.

99 Arkady Shaikhet: *Semyon M. Budyonny* (1927). Semyon Mikhaylovich Budyonny (1883–1973), marshal and civil war hero, commanded the first Red Army cavalry regiment. Chapayev (1887–1919) was one of his lieutenants.

100 Pyotr Otsup: *S. M. Budyonny, M. V. Frunze and K. E. Voroshilov in Front of a Map of the Southern Front* (1920). Mikhail Vasilyevich Frunze (1885–1925), one of the military leaders of the civil war, and Kliment Yefremovich Voroshilov (1881–1969), a future marshal of the USSR, are making final preparations with Budyonny to crush Baron Wrangel in the Crimea.

101 Pyotr Otsup: *Andrey Andreyevich Andreyev, the People's Commissar for Communication Routes* (1930s). Andreyev took part in the October Revolution in Petrograd and, as deputy prime minister, was one of the Party's high-ranking civil servants.

102 Mikhail Nappelbaum: *Vaclav Vorovsky, Publicist and Party Member* (1922). Born in 1871, Vorovsky was a statesman, a contributor to the newspapers *Uskra* and *Pravda*, and a Marxist literary critic. In 1917, he was made ambassador to Scandinavia. He was killed by the White Army in Lausanne in 1923.

103 Pavel Zhukov: *Vasily Anatonov Ovseyenko* (1923). Ovseyenko ran the political administration of the Republic's military revolutionary soviet.

104 Pyotr Otsup: *Senator Johnson in M. I. Kalinin's Office* (Moscow, 1920). The combination of the war and the bad harvests of 1920 had brought about a large-scale famine in the USSR. The Soviet State entered into negotiations with the United States and, at the end of 1921, the Americans agreed to deliver thirty million dollars' worth of provisions and seed.

105 Max Alpert: *E. Yaroslavsky in the Museum of the Revolution* (1928).

106 Max Alpert: *K. E. Voroshilov Inspecting an A.N.20 Aircraft* (1936). A marshal and people's commissar for defence, Voroshilov defended Tsaritsyn and crushed the White Army.

107 Pyotr Otsup: *Feliks E. Dzerzhinsky in a Motor Car* (1920s) Feliks Edmundovich Dzerzhinsky (1877–1926) was head of the Cheka (the 'All-Russian Extraordinary Commission' for the purpose of combating counter-revolution and sabotage) which was subsequently to become the OGPU and, finally, the KGB. He was also the minister for railways and head of the commission for the struggle of parentless children.

Arkady Shaikhet. *Kalinin Receiving Visitors*

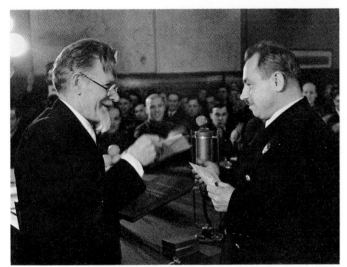

Ivan Shagin. *Kalinin Decorating the Explorer Papanin a Hero of the Soviet Union* 1937

Olga Ignatovich. *Kalinin Receiving Members of the Kolkhoz* 1934

Arkady Shaikhet. *In Kalinin's Offices*

Arkady Shaikhet. *In Kalinin's Offices*

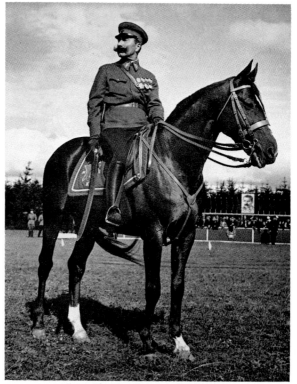

Ivan Shagin. *Semyon Budyonny*

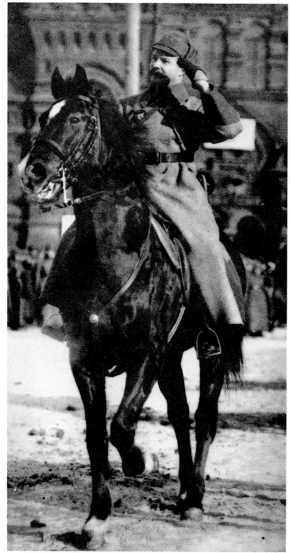

Max Alpert. *Mikhail Frunze Taking Part in
a Red Square Parade* 1925

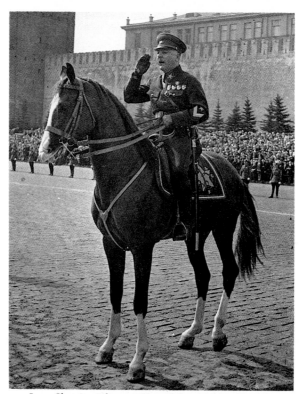

Ivan Shagin. *Kliment Voroshilov Taking Part in
a Red Square Parade* 1938

87 Piotr Ocup. *Jakov Sverdlov* 1918

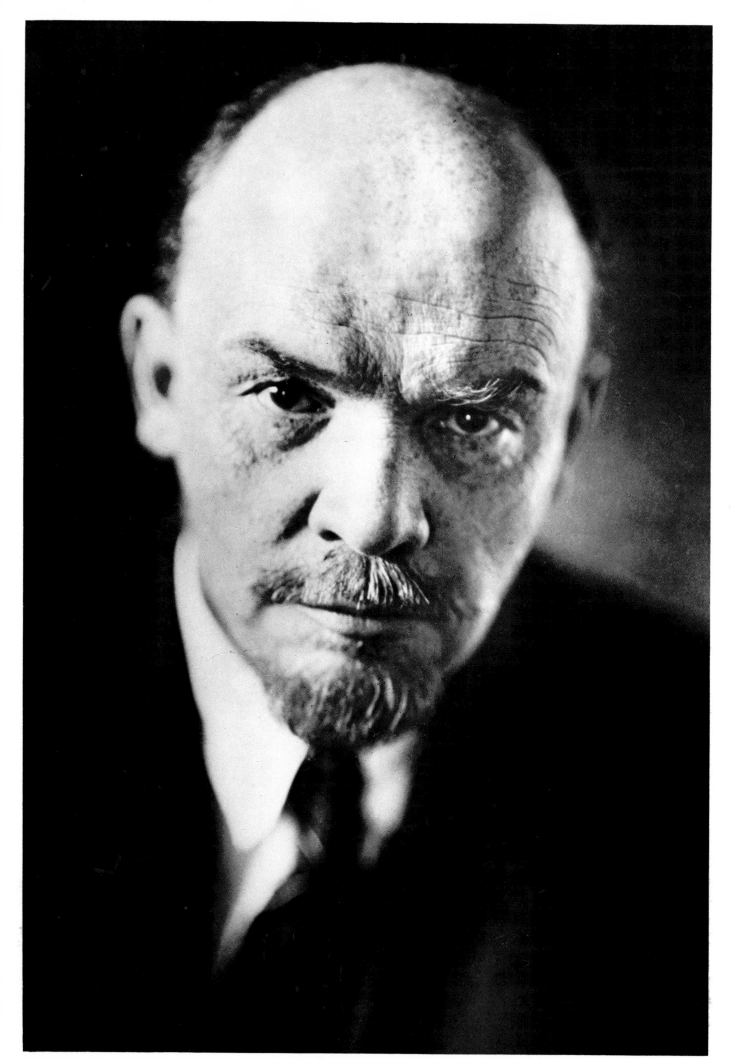

88 Pavel Žukov. *Vladimir I. Lenin* 1920

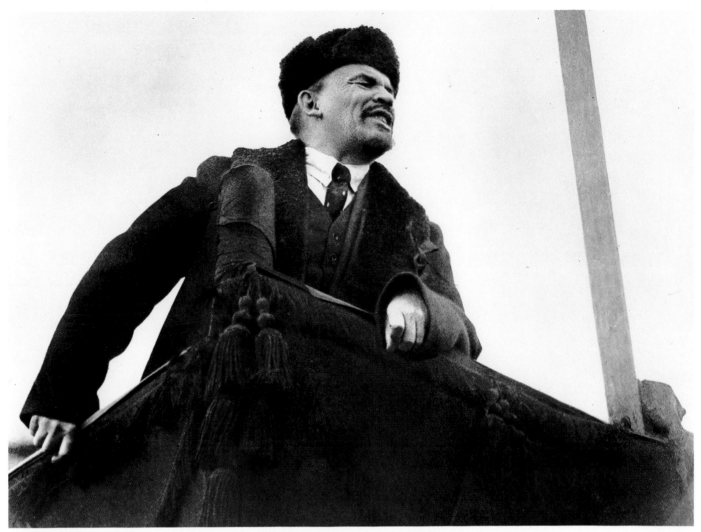

89　Piotr Ocup. *Vladimir I. Lenin* 1918

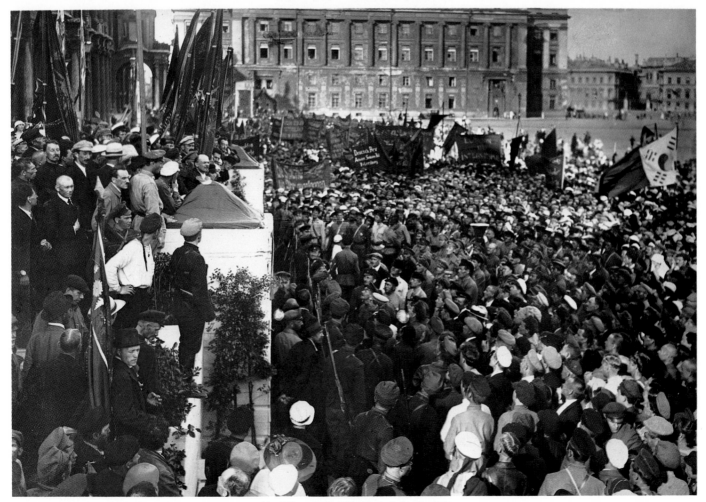

90　Viktor Bulla. *Vladimir I. Lenin* 1920

91 Max Alpert. *Clara Zetkin, Sen Katayama* 1925

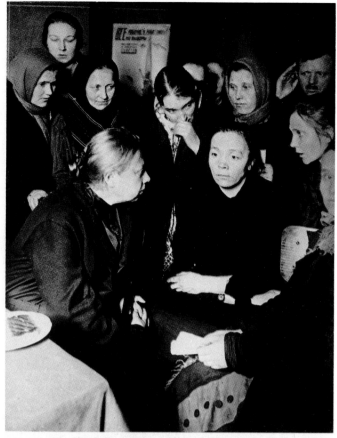

92 Mihail Nappelbaum. *Nadežda Krupskaja* 1932

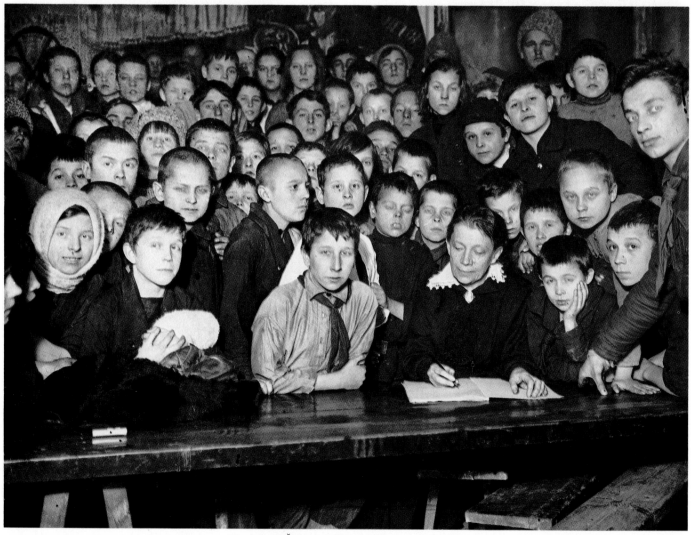

93 Arkadij Šajchet. *Maria I. Uljanova* circa 1925

94 Piotr Ocup. *Vladimir I. Lenin* 1918

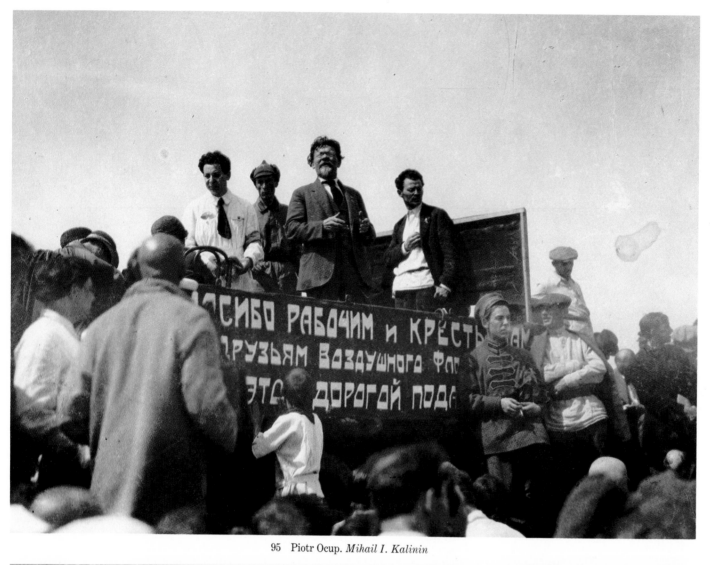

95 Piotr Ocup. *Mihail I. Kalinin*

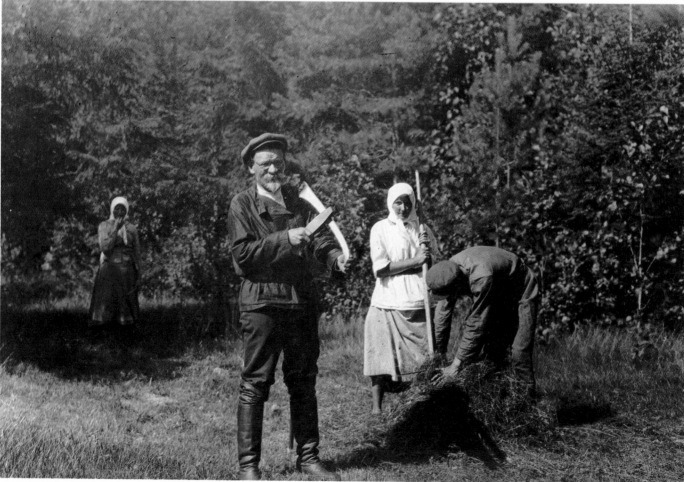

96 Piotr Ocup. *Mihail I. Kalinin* circa 1920

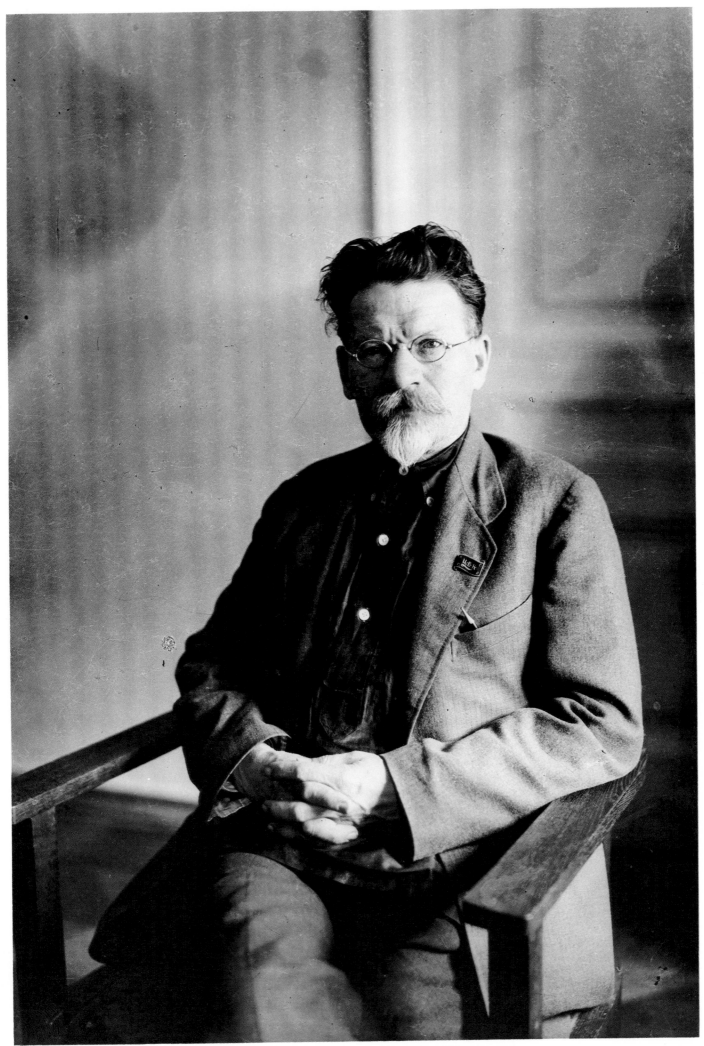

97 Piotr Ocup. *Mihail I. Kalinin* circa 1920

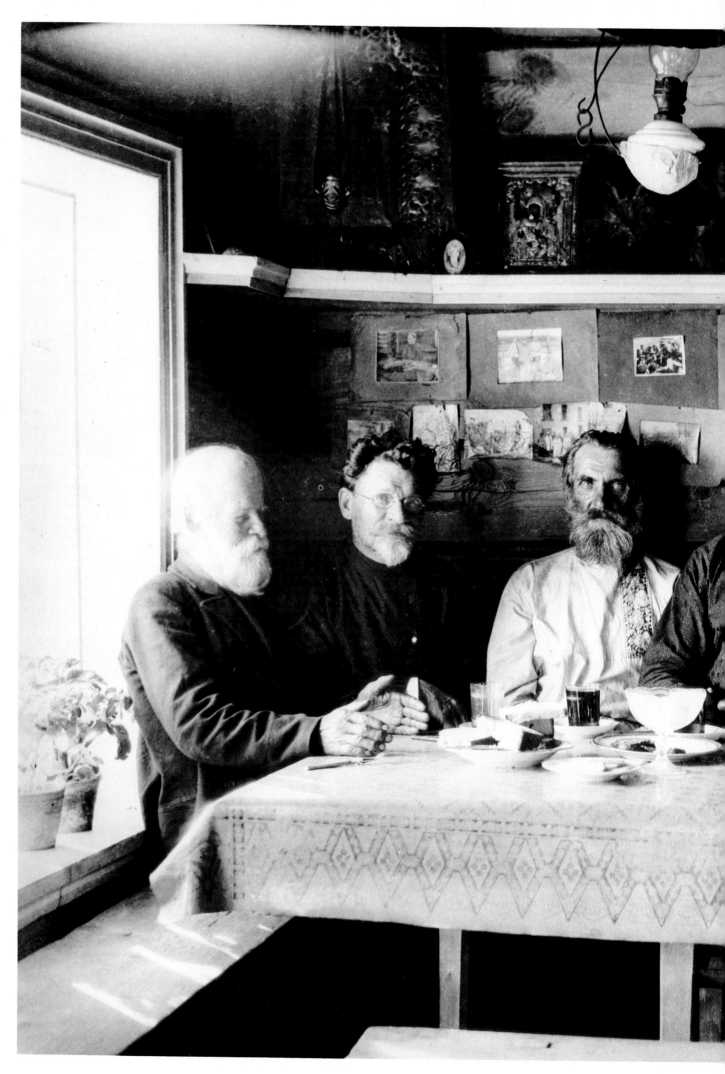

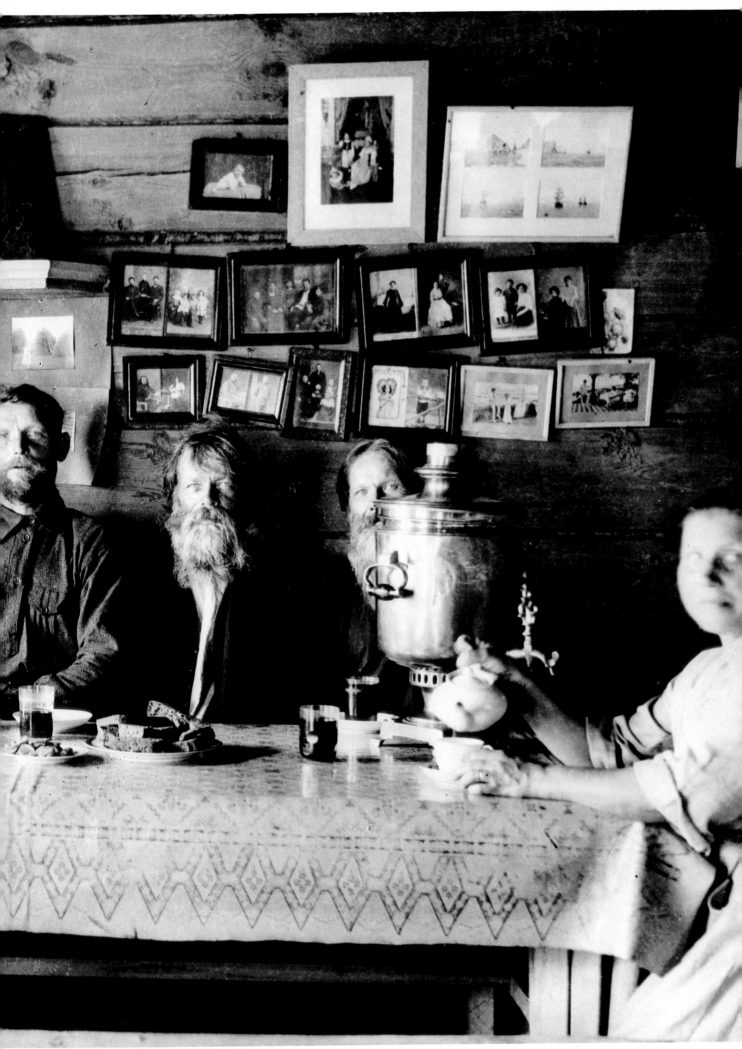

98 Piotr Ocup. *Mihail I. Kalinin* circa 1920

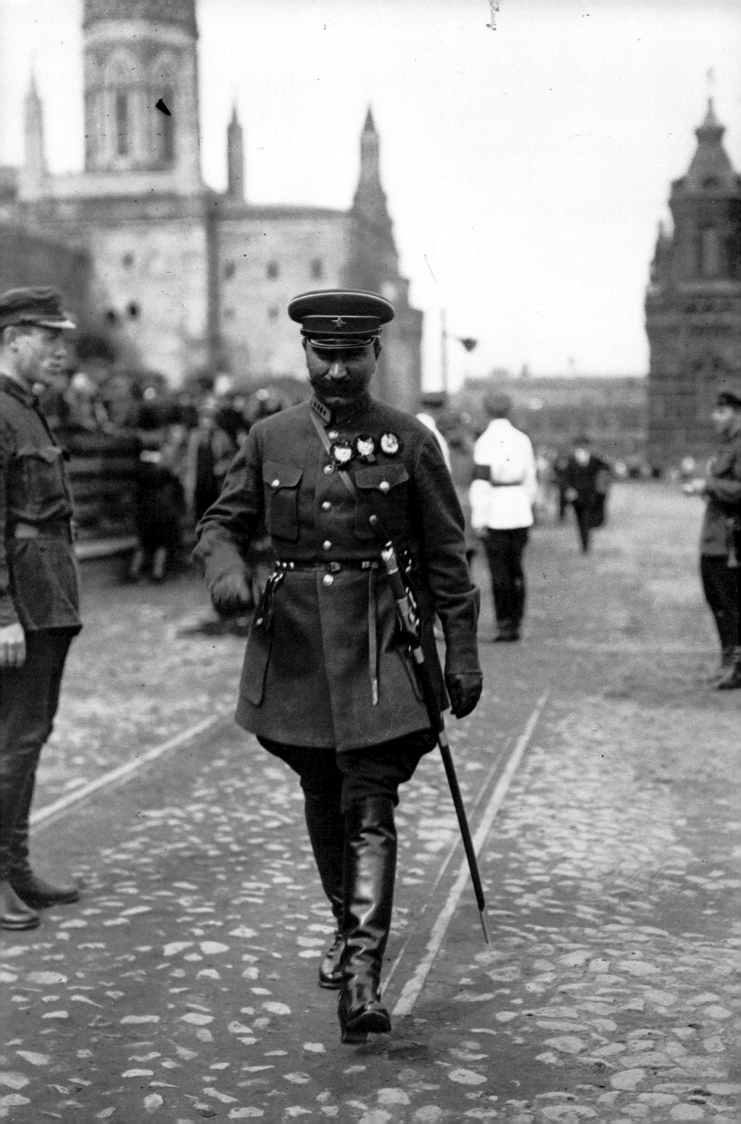

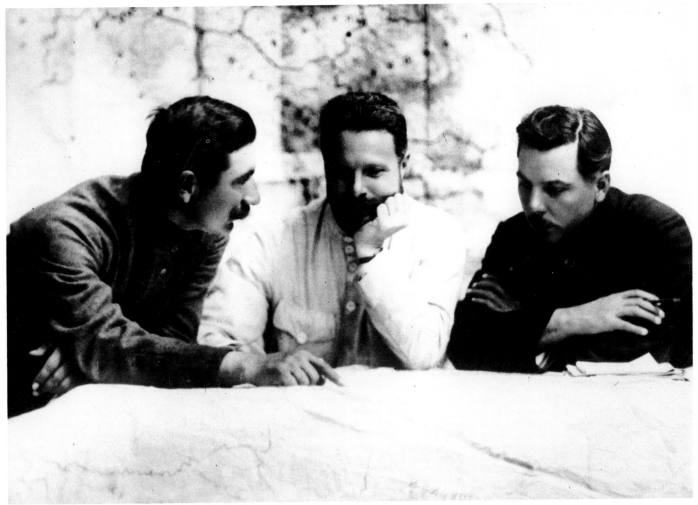

100 Piotr Ocup. *S.M. Budjonnyj, M.V. Frunze, K.E. Vorochilov* 1920

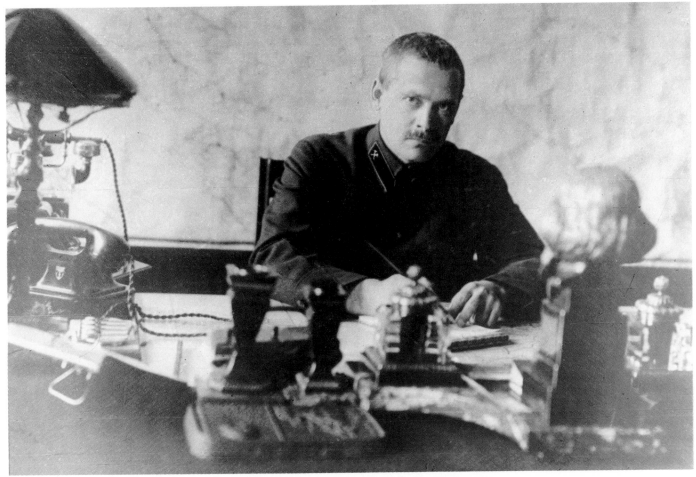

101 Piotr Ocup. *Andrej A. Andreev* circa 1930

99 Arkadij Šajchet. *Semjon M. Budjonnyj* 1927

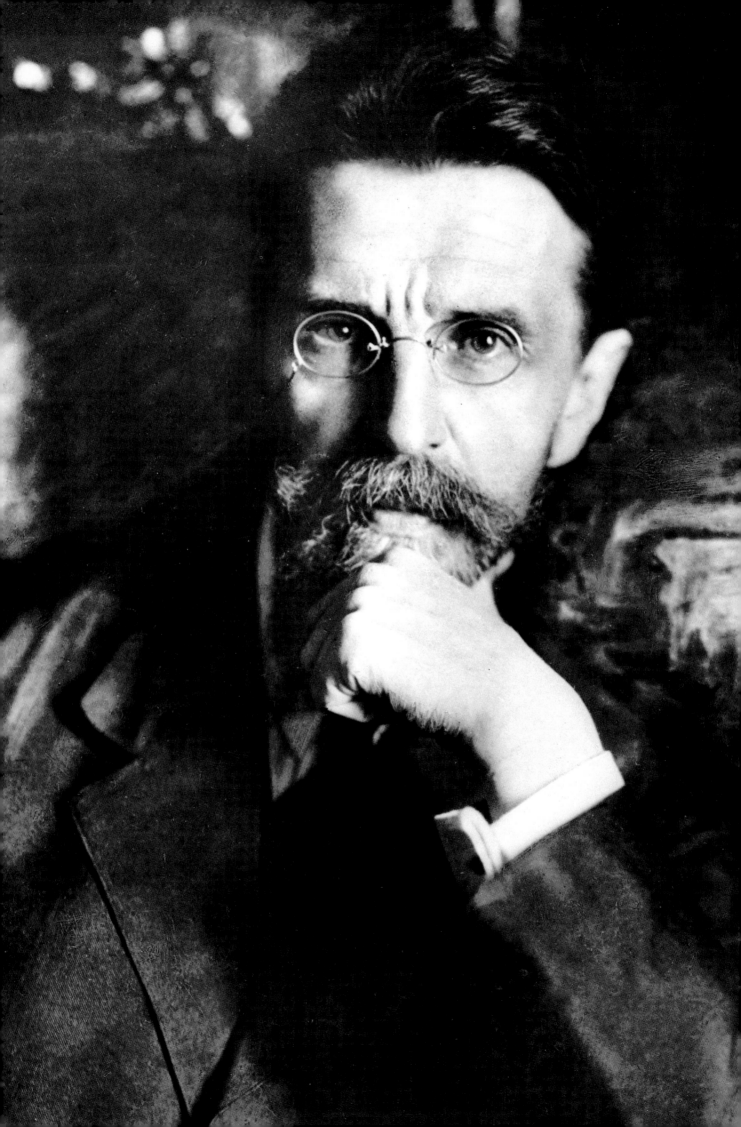

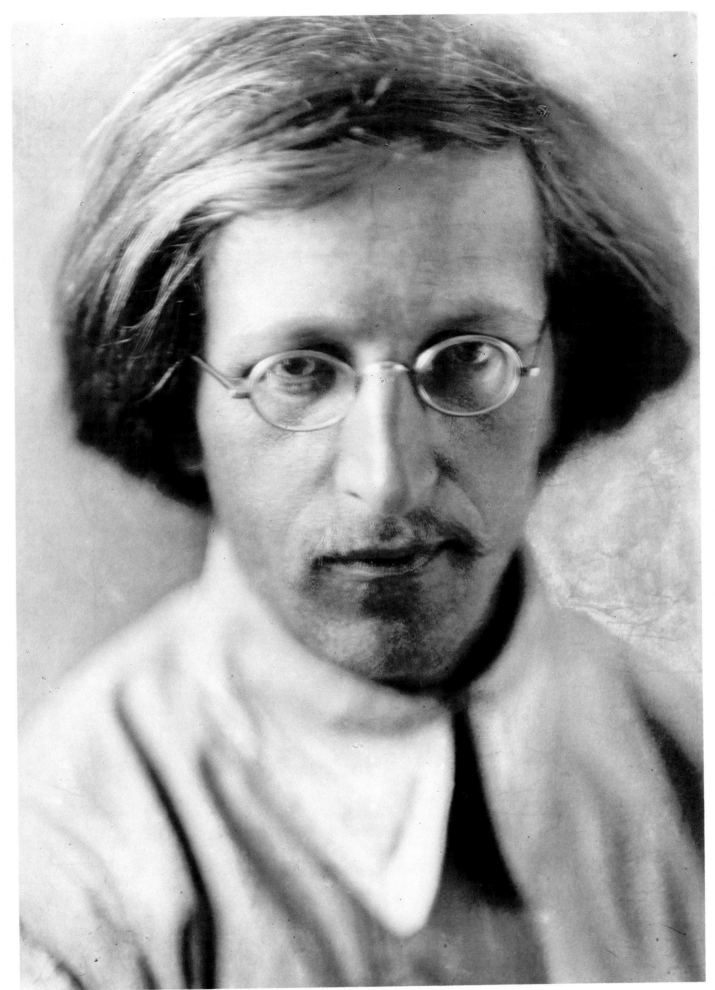

103 Pavel Žukov. *Vassilij Ovseenko* 1923

102 Mihail Nappelbaum. *Vaclav Vorovskij* 1922

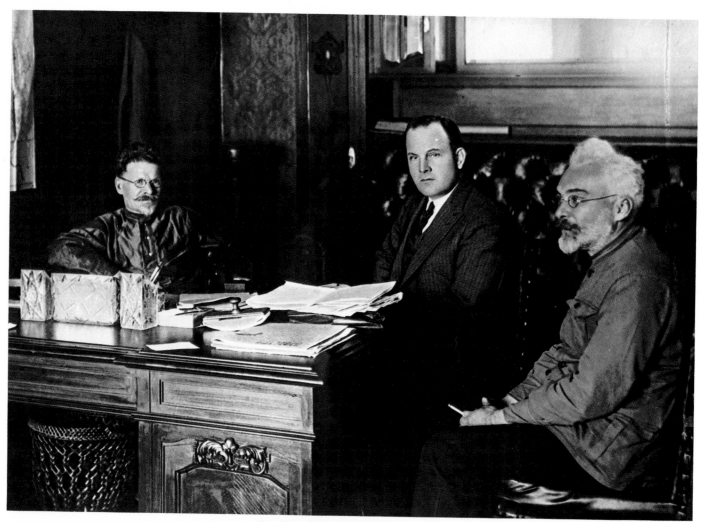

104　Piotr Ocup. *Johnson, Kalinin,* 1920

105　Max Alpert. *E. Jaroslavskij* 1928

106 Max Alpert. *K.E. Vorochilov* 1936

107 Piotr Ocup. *Felix Dzeržinskij* circa 1920

115

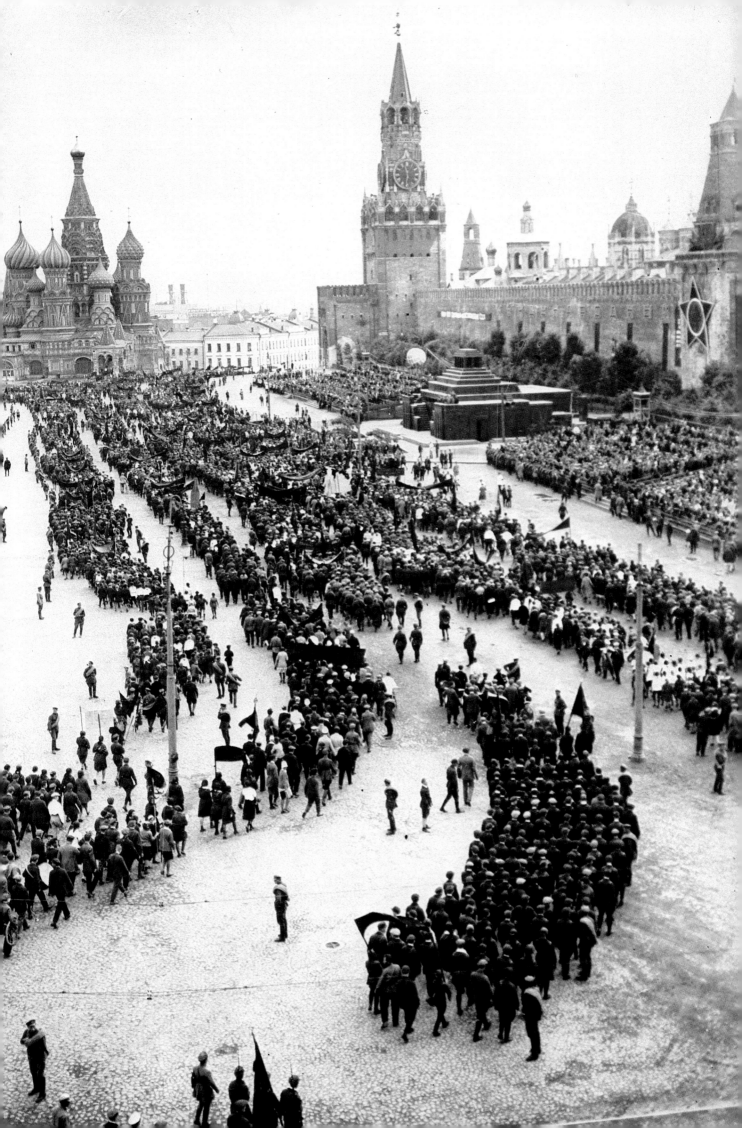

THE REVOLUTION

From THE TWELVE
(1971)

... Who goes there?

Who waves a red flag through the din?
Damn the dark. I'm blind.
Who skulks behind the houses there?
Skurrying to save his skin.

Give in. Maybe your lives we'll spare
We'll get you all the same.
Come out or a worse fate you'll find.
Come out, we're taking aim.

Rat-ta-tat. From all the houses
Come echoes, but no words we know.
Only the blizzard whoops, carouses,
In helpless merriment, on the snow.

Rat-ta-tat
Rat-ta-tat

So on they march with victorious tread.
The starveling cur trots in the rear.
Bearing the flag tempestuous red,
While blizzard blinds the world below,
Untouched by bullets whistling near,
Stepping across the storms of snow,
As snow-veils twist and veer
In white rose-gardens brightly iced
Leading the way is Jesus Christ.

Aleksandr Blok, 1918

Notes

108 **Arkady Shaikhet:** *Red Square Parade* (1927).

109 **Dmitry Dyebabov:** *Chukotsky. A Reindeer Herdsman Relaxing* (1930s). That *Pravda* should have been read in the furthermost parts of the eastern USSR, 12,000 km from Moscow, in the region facing Alaska, was a triumph over illiteracy.

110 **Pyotr Otsup:** *State Funeral for Those Who Fell in the February Revolution* (Petrograd, 1917). On the banners can be read the words: 'For Our Brothers Who Fell, Eternal Rest'. On 23rd March 1917, a procession of one million people followed the 184 victims of the February Revolution to their resting place in the Champ-de-Mars (Marsovo Pole), Petrograd.

111 **Pyotr Otsup:** *Gathering in a Moscow Street* (circa 1917). The placards say: 'Communist Party (Bolshevik) of Russia, Moscow Committee, Russian Central Executive Committee'.

112 **Pyotr Otsup:** *A File of Demonstrators Making Its Way along the Nevsky Prospect* (Petrograd, 1917). In her memoirs, Louise Bryant refers to a little man who calmly photographed all the events of the October Revolution in Petrograd, regardless of the many dangers.

113 **Pyotr Otsup:** *Red Guards and Soldiers of the Revolution Standing Guard in Front of the Smolny Institute* (1917). The Smolny, formerly an institution for the daughters of the nobility in Petrograd, was used as a military headquarters by the Bolsheviks and was the headquarters of the soviet. 'The Petrograd Soviet was meeting continuously at Smolny, a centre of storm, delegates falling down asleep on the floor and rising again to take part in the debate …' (John Reed, *Ten Days That Shook the World*).

114 **Pyotr Otsup:** *Red Guards of the Putilov Factory in Front of an Armoured Car* (Petrograd, 1917). The assault on the Winter Palace was carried out by the Red Guards, formed and trained in the factories. The Putilov factory, a steelworks bearing the name of its rich owner Putilov, played a particularly distinguished role in the revolutionary activities. The factory workers prepared the arms for the Red Guard and provided a significant contingent of men for the assault itself. During the war and the Siege of Leningrad, it was impossible to come within 20 km of the factory, whose workers acquitted themselves as valorously as during the Revolution.

115 **Jakob Steinberg:** *Sailors Checking Identity Papers during the Days of October* (1917). These are Baltic sailors, who played an important role in the revolutionary uprising. 'At the corner of the Morskaya and the Nevsky, squads of soldiers with fixed bayonets were stopping all private automobiles, turning out the occupants, and ordering them towards the Winter Palace. A large crowd had gathered to watch them. Nobody knew whether the soldiers belonged to the Government or the Military Revolutionary Committee. Up in front of the Kazan Cathedral the same thing was happening, machines being directed back up the Nevsky. Five or six sailors with rifles came along, laughing excitedly, and fell into conversation with two of the soldiers. On the sailors' hat bands were "Avrora" and "Zaria Svobody" – the names of the leading Bolshevik cruisers of the Baltic fleet. One of them said, "Kronstadt is coming!" … It was as if, in 1792, on the streets of Paris, someone had said, "The Marseillais are coming!" For at Kronstadt were twenty-five thousand sailors, convinced Bolshevi and not afraid to die….' (John Reed).

116 **Jakob Steinberg:** *A Patrol of Red Guards from the Putilov Factory* (Petrograd, 1917).

117 **Pyotr Otsup:** *A Red Army Detachment in Front of the Smolny Institute* (Petrograd, 1917).

118 **Viktor Bulla:** *Workers of the Putilov Factory at a Meeting for the Reelections of the Petrograd Soviet* (27th June 1920). The Putilov tractor factory in Leningrad. On the banners, the workers have written: 'To repair an engine is to get to the root of poverty and thus defeat capitalism once and for all. Long live the feast of the universal army of workers.'

119 **Arkady Shaikhet:** *Boycotting a Tradesman* (1924). Employees boycott the self-employed owner of a shoe factory, because they are no longer prepared to work for a private business.

120 **Aleksandr Rodchenko:** *Parade* (1920s).

121 **Arkady Shaikhet:** *A Red Square Parade* (Moscow, 1926). Lenin's mausoleum, erected by the Constructivist Aleksey Shchusev, was at first built of wood painted red, and subsequently reconstructed in porphyry.

122 **Pyotr Otsup:** *Military Parade in Red Square, 1st May 1926.*

123 **Boris Ignatovich:** *Red Square Parade* (Moscow, 1927). The tenth anniversary of the October Revolution.

124 **Arkady Shaikhet:** *Mobile Units of the RKKA, Red Square* (1928).

125 **Arkady Shaikhet:** *Military Exercises* (1930s).

126 **Aleksandr Rodchenko:** *Skirmishers* (1935).

127 **Aleksandr Rodchenko:** *Red Army Soldier in a Balloon* (1924). 'This photograph was taken during manoeuvres, although making a photo-reportage with a 9 × 12 camera was no easy matter. This was the year in which Rodchenko, having previously worked in his studio, came out into the open and took up this new kind of photography.' (A.L.)

128 **Georgy Zelma:** *Red Square* (Moscow, 1931). 'Let Us Replace Thatch with Tiles.'

129 **Boris Ignatovich:** *Holiday Decorations for 1st May* (Moscow, 1935). 'For the Technico-Economic Independence of the USSR' – a giant ball-bearing made by the workers.

130 **Boris Ignatovich:** *Elections to the Soviets* (1928).

131 **Boris Ignatovich:** *Holiday Decorations (for the Seventh Conference of the VLKSM)* (1935). The Komsomol (communist youth) conference.

132 **Pavel Zhukov:** *The Education and Enlightenment Workers Take under Their Patronage the Troops from the Military Region of Petrograd* (1923). In the autumn of 1923, a voluntary organization was founded, taking as its motto the words 'Down with Illiteracy' and directed by Mikhail Kalinin. In spite of the civil war and the ruinous state of the economy, the Soviet authorities set up an extensive network of educational establishments. Those who were illiterate would finish work two hours earlier in order to learn reading and writing, without their salaries being affected. Thousands of educated volunteers placed themselves at the service of their comrades, teaching them to read and write: students, workers, employees, scholars, schoolboys, peasants. The spread of literacy was particularly rapid within the ranks of the Red Army.

133 Arkady Shaikhet: *Pioneers in Class* (1929).

134 Arkady Shaikhet: *A Village School* (1928).

135 Boris Ignatovich: *The First Mobile Cinema* (1928). Cinema operators effectively played the role of schoolmasters, circulating in a radius of between three and ten villages with films and a projector. 'Of all the artistic genres, the one most suited to the masses is the cinema, which was created in order to educate the people.' (Lenin). The cinema was a very popular educational medium which was brought to rural areas by means of the agit-prop trains.

136 Pyotr Otsup: *Street Theatre* (1920s). The theatre played an extremely important role in the first years after the Revolution: thousands of people would gather to watch the spectacular open-air productions, which were particularly frequent in Petrograd.

137 Boris Ignatovich: *Commune Leaders in Session* (1928).

138 Arkady Shaikhet: *Maksim Gorky Addressing Workers* (1929). Gorky believed that the intellectuals should act as a locomotive for the people. He believed in the power of culture and in *My Universities* he describes how he succeeded in educating himself by dint of unflagging application.

139 Georgy Zelma: *A School in Dobrinka Village, in the Voronezh Region* (1931). In 1918, the Soviet constitution accorded the popular masses, both workers and peasants, the right to a 'complete and free general education', including all the peoples of the republic. A single-school system was introduced, which was divided into primary school, for children aged between eight and thirteen, and secondary school, for adolescents up to the age of seventeen.

140 Georgy Zelma: *Yakutsk: in Its Native Tongue* (1929). Culturally speaking, pre-Revolutionary Russia was one of the most backward countries in Europe. The rate of illiteracy was particularly high in the case of the non-Russian nationalities: 99.5% for the Tadzhiks, 99.4% for the Kirghiz, 99.3% for both the Yakuts and the Turkmens, and 98.4% for the Uzbeks. In 1906, the journal *Vestnik Vospitanya* ('Education Mail') had predicted that if the then rate of cultural development in Russia remained constant, it would take a hundred and eighty years before general literacy was attained for men, and two hundred and eighty years for women.

141 Arkady Shaikhet: *Kalmuks at School* (1930). The elimination of adult illiteracy (*Likbes*) took on the proportions of a national task.

142 Arkady Shishkin: *We Are for the Kolkhoz!* (1929).

143 Georgy Zelma: *Off With You, Chador!* (1925). In the region of Tashkent, the chador (or *chadra*) was a thick veil with which Islamic women covered their faces.

144 Pyotr Otsup: *A General View of the First All-Female Congress of Women Workers, in Session in the Kremlin* (Moscow, 1927).

145 Georgy Zelma: *Tashkent, Uzbekistan: 8th March 1926 (Women's Day)*. Women who had cast off the chador were menaced by the male population. Here, under military protection, they are celebrating their first day of equal rights with men.

146 Boris Ignatovich: *A Rural Lending-Library* (1920s).

147 Arkady Shaikhet: *Elections to the Rural Soviets* (1930s).

148 Georgy Zelma: *Uzbekistan. The Land and Water Decrees* (1924). The first Congress of the Soviets, which took place during the night of Thursday, 8th November 1917, confirmed two decrees of the new government: the decree concerning the peace settlement, and the decrees which gave the peasants control of the land and its cultivation.

149 Arkady Shaikhet: *Congress of Worker and Peasant Correspondents* (1928).

150 Arkady Shaikhet: *Waiting outside Kalinin's Office* (1924).

151 Georgy Zelma: *Uzbekistan. The Voice of Moscow Calling* (1925).

152 Arkady Shaikhet: *Reception Centre for Homeless Children* (1925). During the twenties, large numbers of orphans and abandoned children – usually victims of the civil war – roamed the streets, sometimes in gangs.

153 Arkady Shaikhet: *The First Nursery Schools for Peasant Children* (1928).

154 Arkady Shaikhet: *The First Crèche* (1920s).

155 Arkady Shaikhet: *The First Village Crèche* (1928). Two verses in the form of a nursery rhyme:
'To let our mothers labour in the fields each day,
We children in our quiet little corner play.'

156 Arkady Shaikhet: *The First Nursery Schools for Peasant Children* (1928).

157, 160 Aleksandr Rodchenko: *Girl Student* (1930). 'Rodchenko attempted to show the subject's character through the relationship between her expression and what he allows us to see of her surroundings.' (A.L.)

158 Aleksandr Rodchenko: *Sergey Urusevsky, a Student at VKHUTEMAS* (1923). 'A photo taken on the roof of the students' hostel.' (A.L.)

159 Aleksandr Rodchenko: *Student* (1930). 'Re-centred from a photograph originally taken in a students' hostel, this head became the archetypal image of the good man and was often used, notably in a poster designed by Stepanova with a text by Mayakovsky, in various collages, and as the cover of the book *The USSR in the Thirties*.' (A.L.)

161 Aleksandr Rodchenko: *Pioneer* (1930). 'A photo taken in a pioneer camp, in the early morning, at the moment of the roll call, and completely re-centred by Rodchenko. During printing, he chose to make the sky slightly whiter. The angle of the shot, taken from directly below, is rare for a portrait. Rodchenko's earliest attempt at such an angle was taken in 1925–1926, when he photographed a whole group of pioneers. Thereafter it became an occasional habit, though often he lacked sufficient depth of field, as he was using a fairly unsophisticated camera. Here, Rodchenko's technique was already improving, for the image is entirely sharp. The *Pioneer Trumpeter* (see p. 8), an extremely well-known photograph, is in reality horizontal but was re-centred vertically by Rodchenko.' (A.L.)

162 Aleksandr Rodchenko: *The Pioneer Girl* (1930).

163 Aleksandr Rodchenko: *Smile* (1930). 'A photograph of Varvara Stepanova.' (A.L.)

164 Aleksandr Rodchenko: *Fencers on Parade* (1936). 'Rodchenko watched the parade from one of the stands, and was thus able to choose his photographic moments carefully, paying attention to the double rows of diagonals or, in other photographs, to the angle of the horizon, the street, etc.' (A.L.)

165 Aleksandr Rodchenko: *Gymnastic Rhythm* (1936). 'More sport, treated with the same compositional care: the photo is centred to within a millimetre of exactness, so that the upper row of figures just enters the visual field. The idea being expressed here is that sport is a mass activity.' (A.L.)

166 Aleksandr Rodchenko: *Parade, 1st May 1930*. 'The earliest parades were rather dull: the participants simply marched past. Later on, they became more varied, and Rodchenko recorded the details. Here, the diagonal is very characteristic, used to introduce a dynamic element into the composition, but it is also a dynamic act of visual perception, for Rodchenko had to make an instant decision as to the necessary angle of the composition.' (A.L.)

167 Aleksandr Rodchenko: *Parade.*
'Rodchenko liked photographing military parades and gymnastics, the fact of movement, the structures and rhythm of people in motion. In *The Column* (p. 11), Rodchenko showed a newly formed amateur athletic club, "Dynamo". Many such clubs were founded during this period. Rodchenko was also interested in the new architecture which sprang up to accommodate these activities (sports stadiums, etc.). Here, it is amusing to notice that the athletic formation has been caught in a moment of disorder, so that it is difficult to tell who belongs to which row.' (A.L.)

168 Ivan Shagin: *Ice-Skaters* (1933).

169 Ivan Shagin: *Gymnastic Parade in Red Square* (1937).

170 Arkady Shaikhet: *Gymnastic Parade* (1930).

171 Aleksandr Rodchenko: *The Park of Culture and Rest, on a Public Holiday* (1931). 'The park was built in 1928– 1929 and, later on, some of Rodchenko's students were hired to organize attractions. Thus, Rodchenko was on particularly good terms with the park authorities. Nevertheless, it required a certain courage and a "theatrical" temperament to take this photograph: to climb on to the platform, stand behind the performers and face a large audience. Rodchenko liked taking this kind of shot: cf. the *Horse Race* (p. 18), where the photographer took up a dangerous position close to the galloping horses – again with the intention of capturing both the spectacle and the spectators.' (A.L.)

172 Aleksandr Rodchenko: *Somersault* (1936). 'Taken in the Dynamo stadium. This type of angle-shot taken "from above" or "from below" was quite rare: in general, sports photographs were taken from the side.' (A.L.)

173 Yakov Khalip: *Guard Duty. The Baltic Fleet* (1937).

174 Yakov Khalip: *V. S. Cherokov's 'Katernik'* (1937).

175 Yakov Khalip: *Large-Bore Cannon. The Baltic Fleet* (1937).

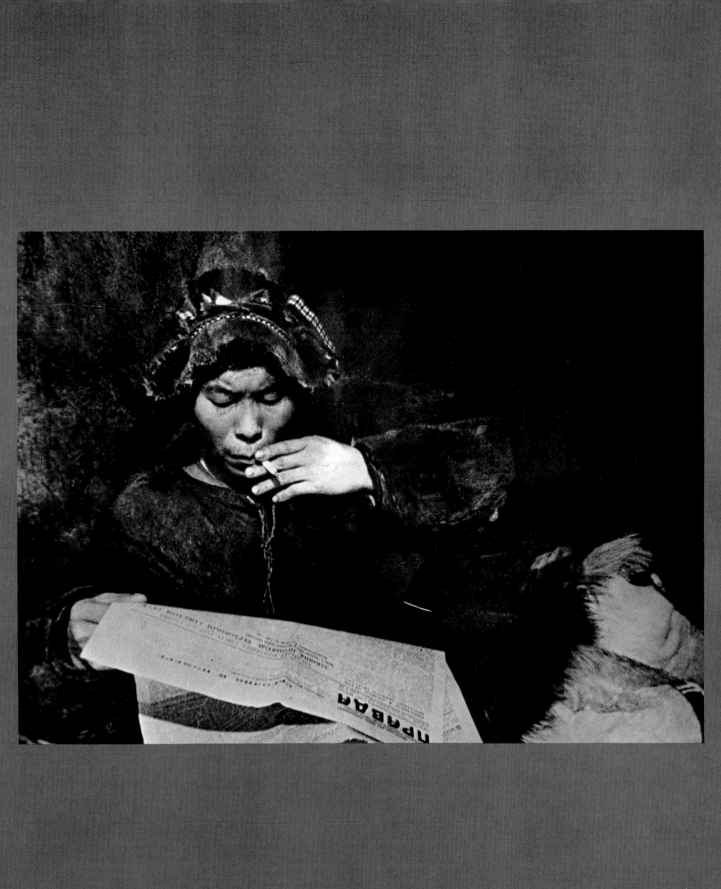

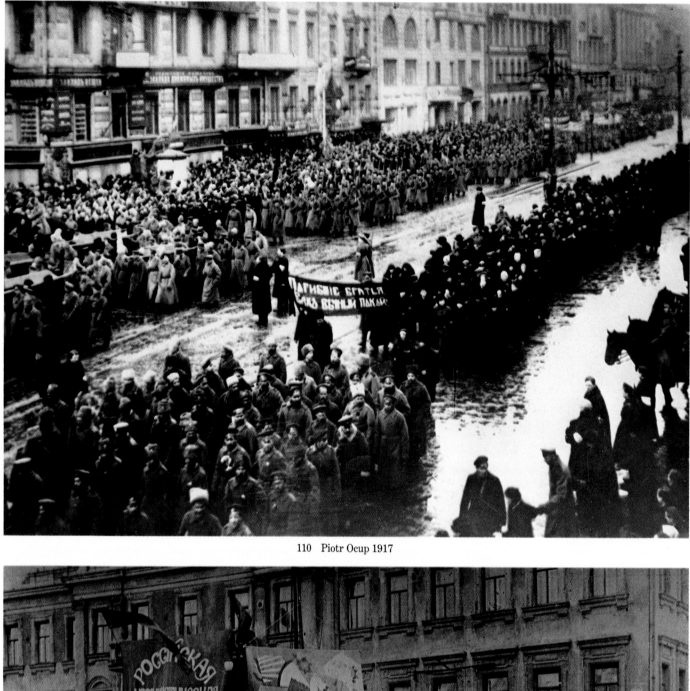

110 Piotr Ocup 1917

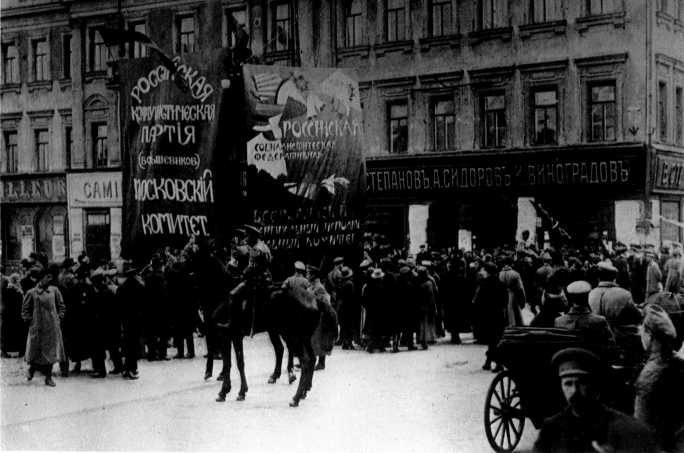

111 Piotr Ocup circa 1917

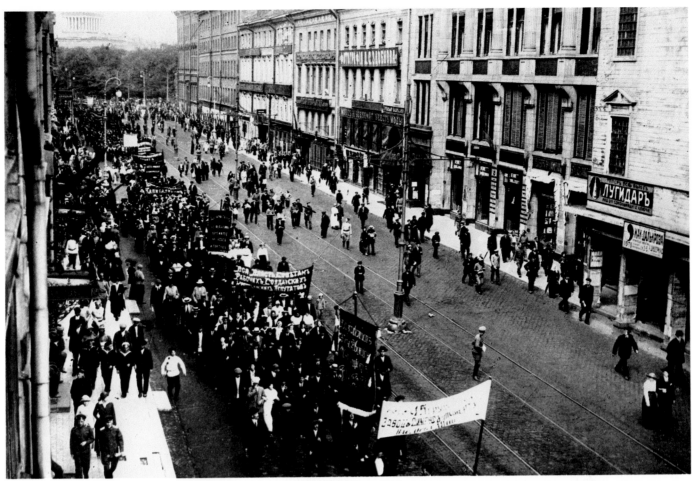

112 Piotr Ocup 1917

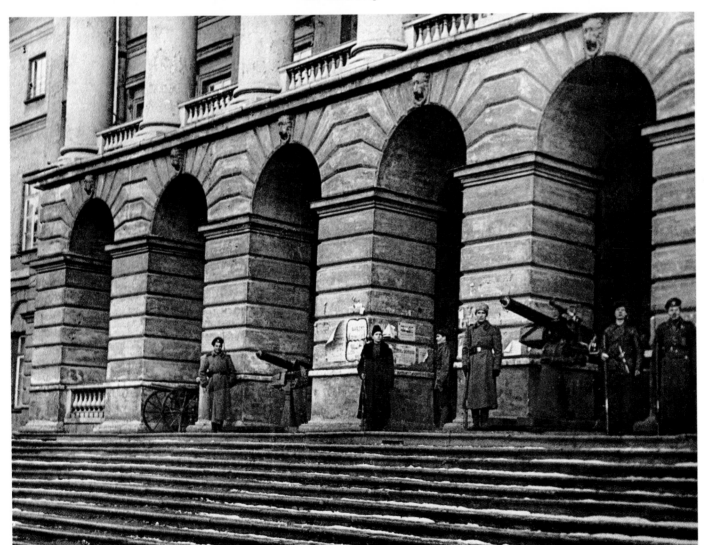

113 Piotr Ocup 1917

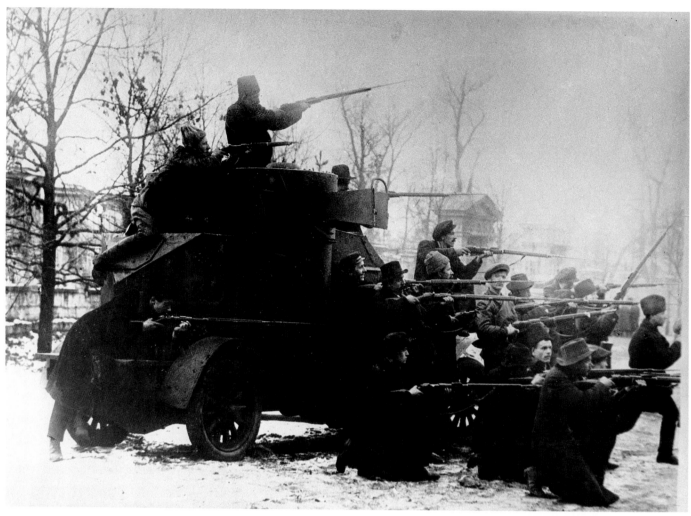

114 Piotr Ocup 1917

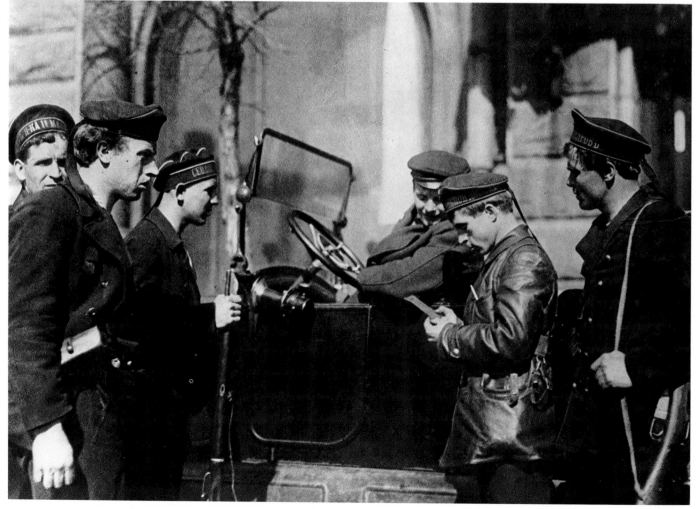

115 Piotr Ocup 1917

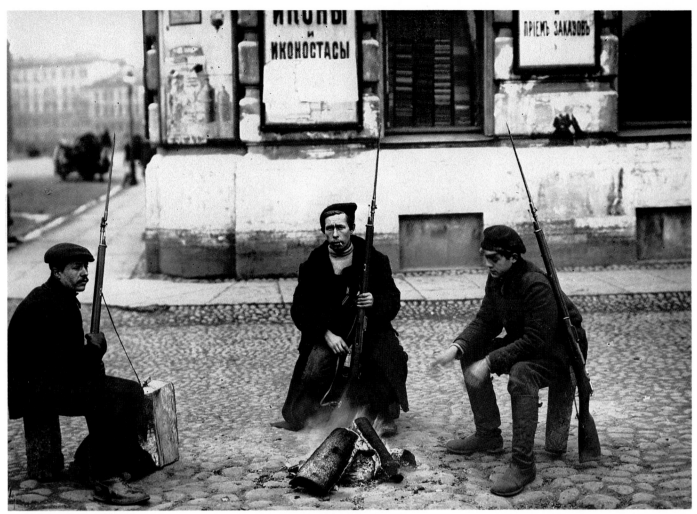

116 Jakob Steinberg 1917

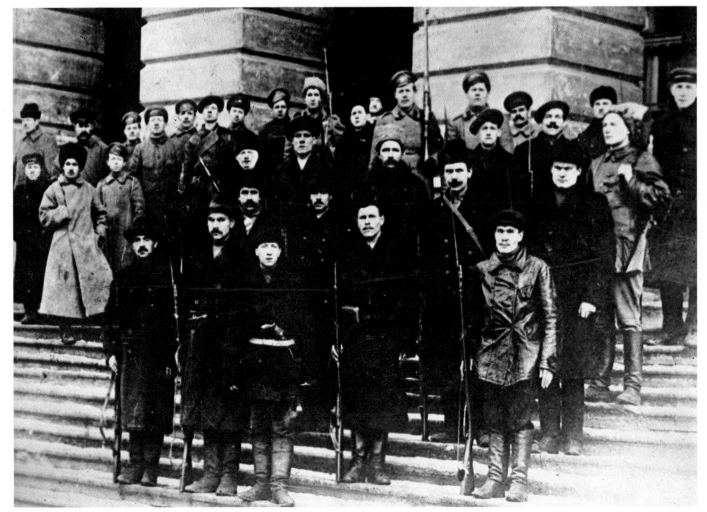

117 Piotr Ocup 1917

118 Viktor Bulla 1920 →

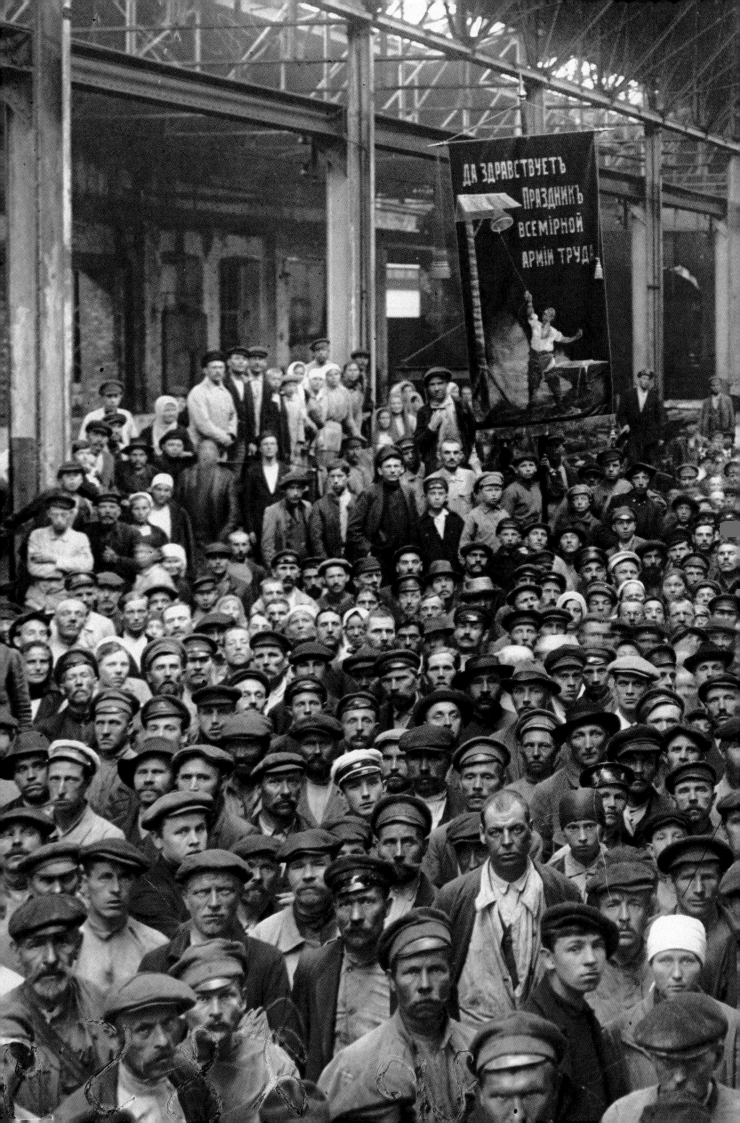

Починить один паровоз
значит приблизить конец
голода и нищеты этим
добить окончательно
капитализм

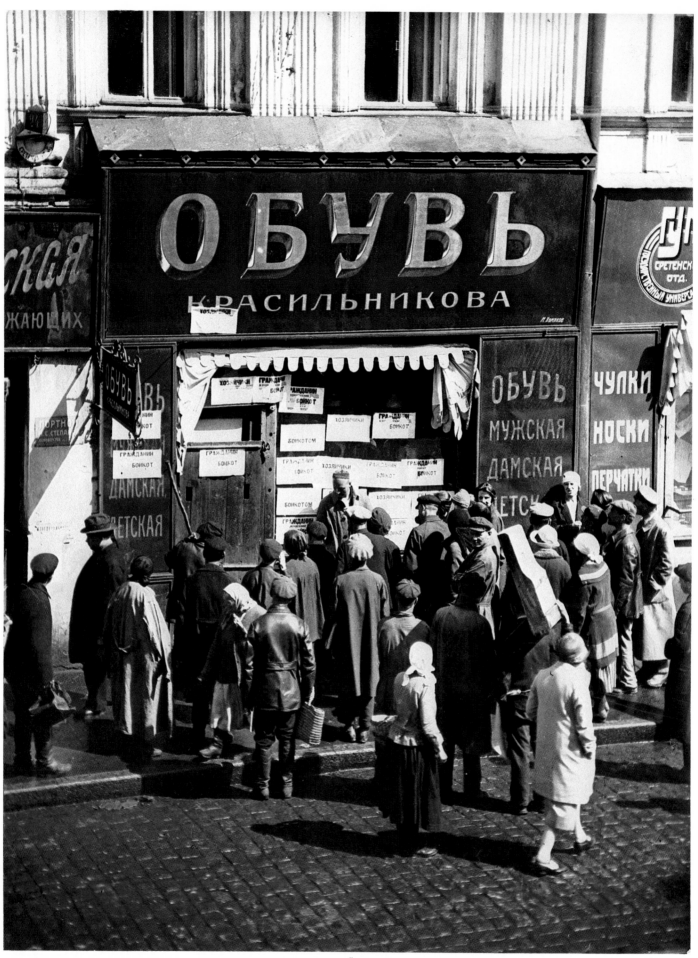

119 Arkadij Šajchet 1924

120 Aleksandr Rodčenko circa 1920

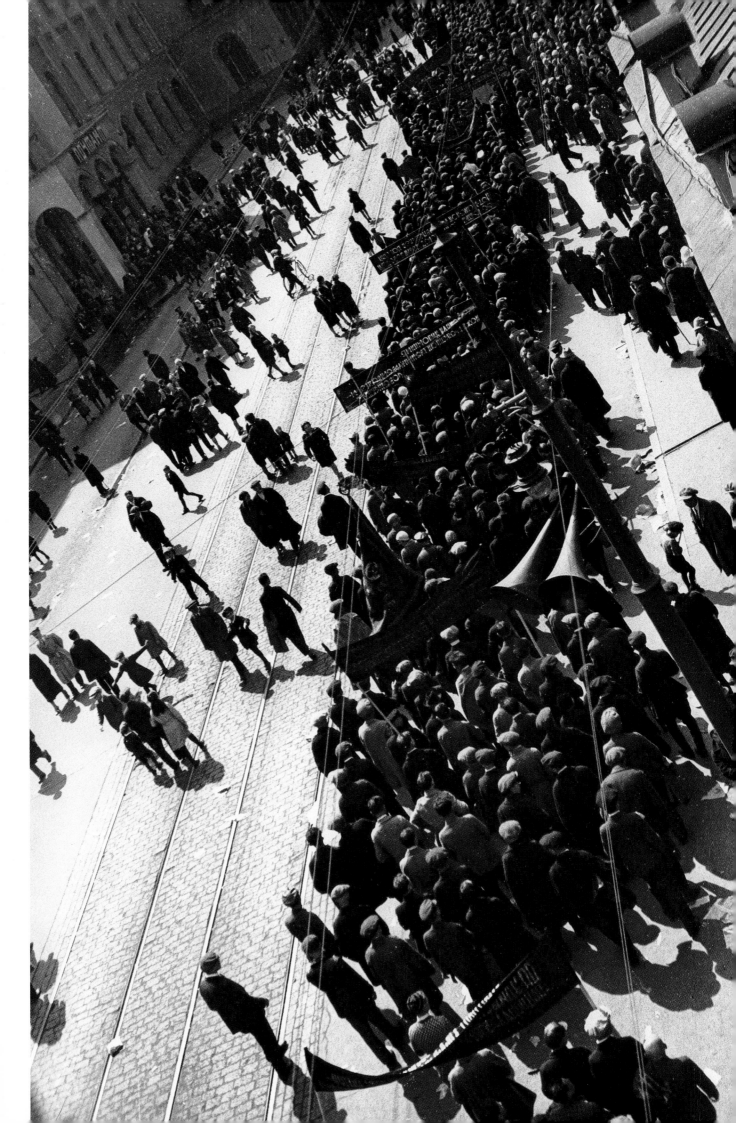

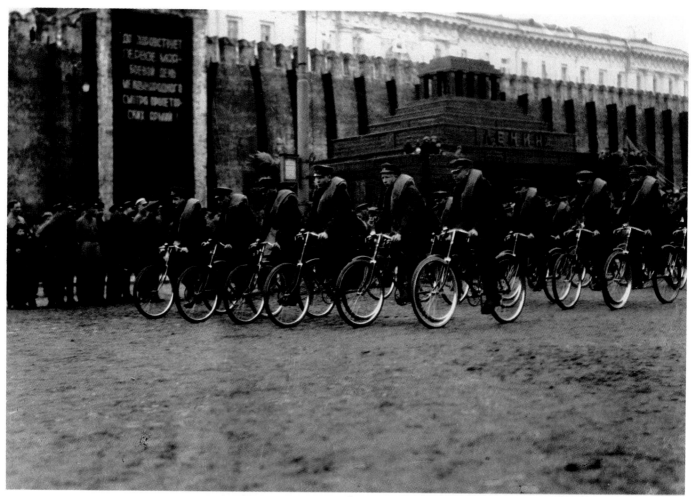

121 Arkadij Šajchet 1926

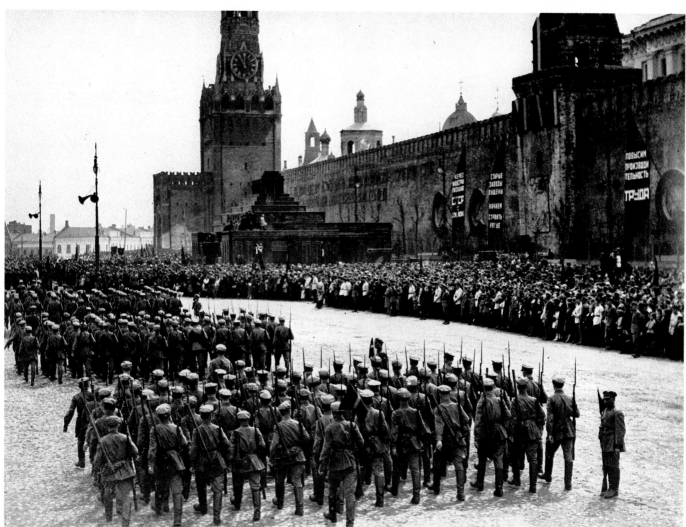

122 Piotr Ocup 1926

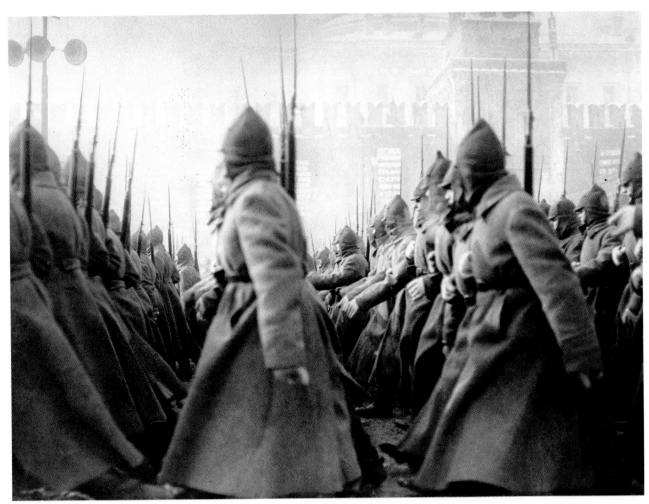

123 Boris Ignatovič 1927

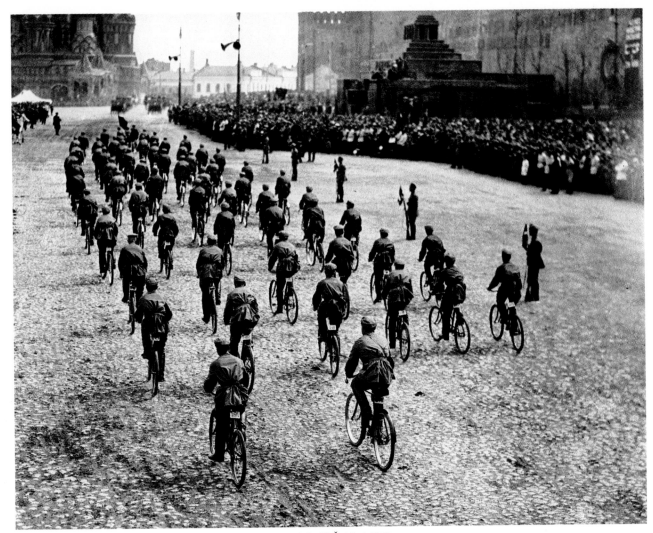

124 Arkadij Šajchet 1928

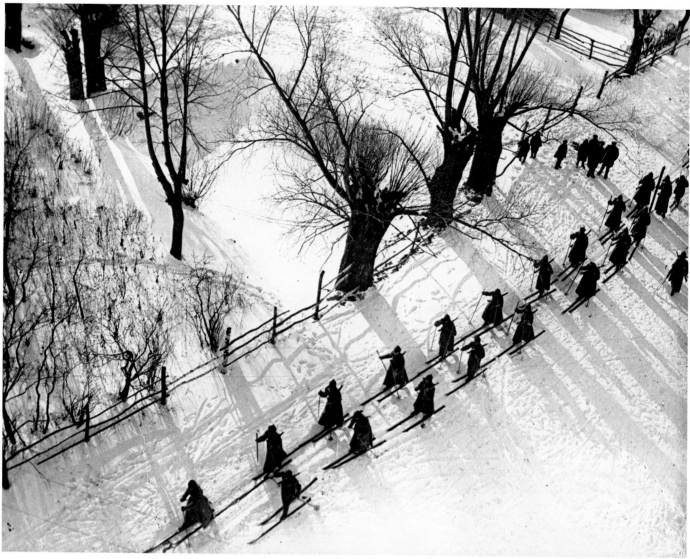

125 Arkadij Šajchet circa 1930

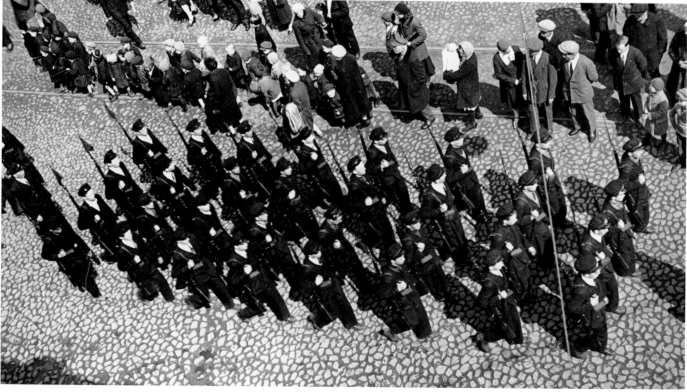

126 Aleksandr Rodčenko 1935

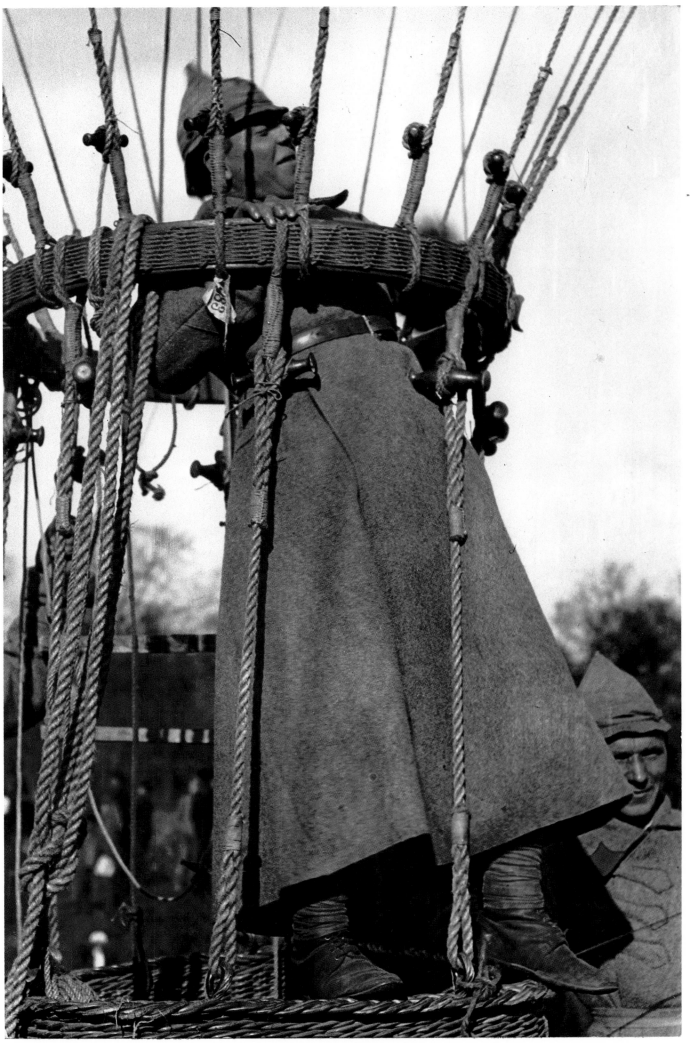

127 Aleksandr Rodčenko 1924

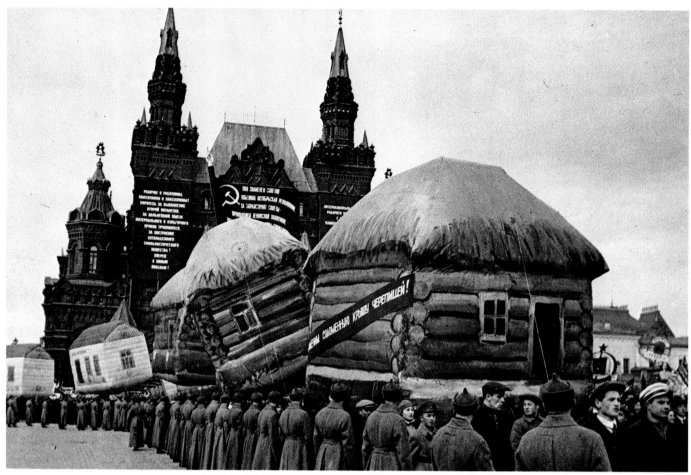

128 Georgij Zelma 1931

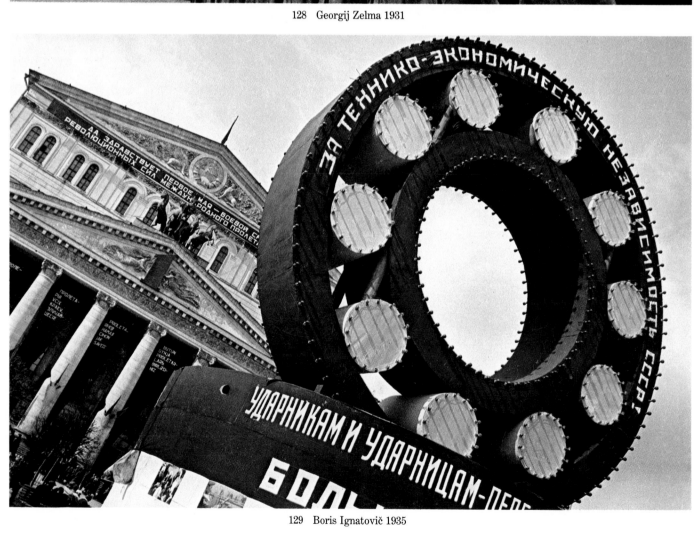

129 Boris Ignatovič 1935

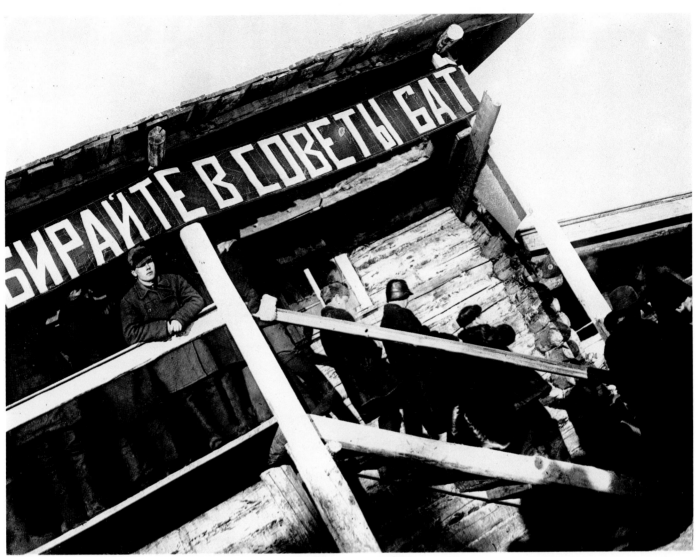

130 Boris Ignatovič 1928

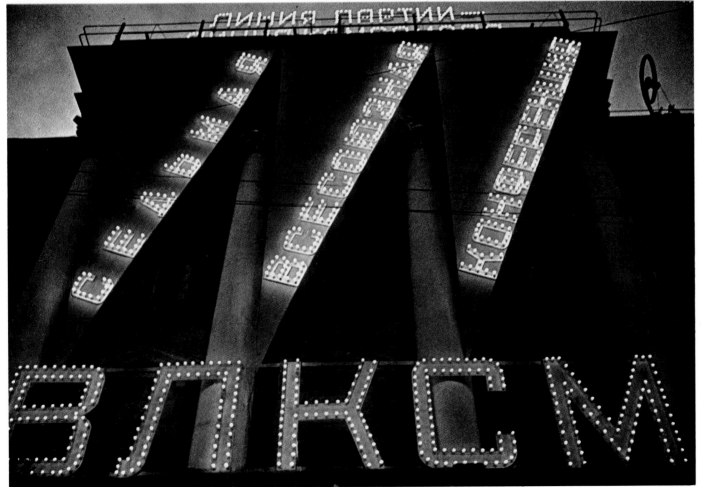

131 Boris Ignatovič 1935

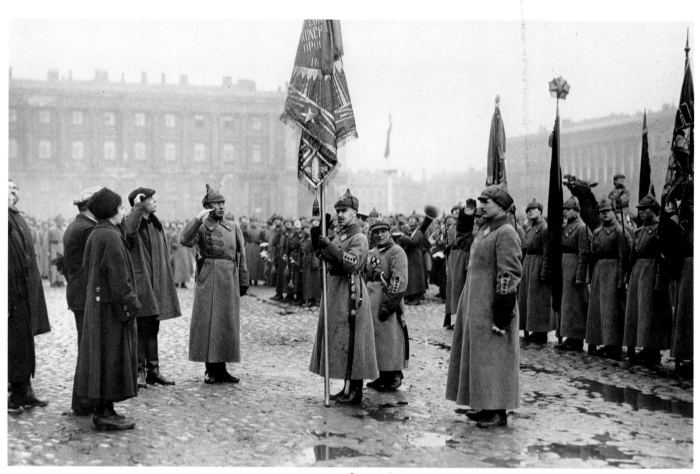

132 Pavel Žukov 1923

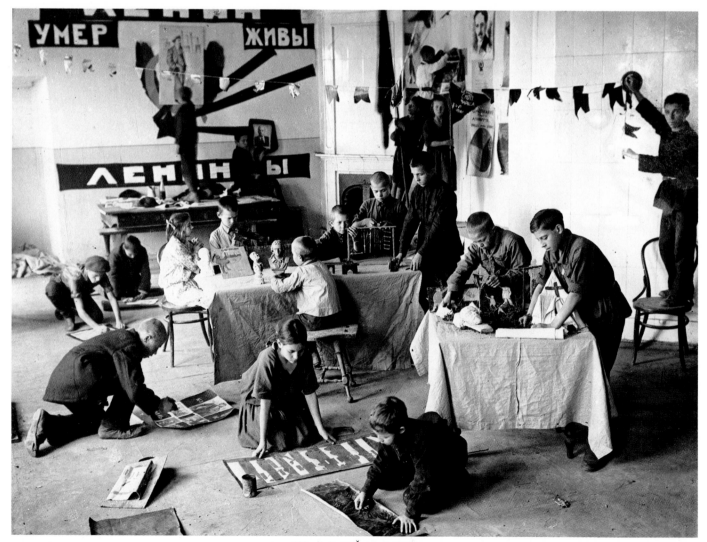

133 Arkadij Šajchet 1929

134 Arkadij Šiškin 1928

135 Boris Ignatovič 1928

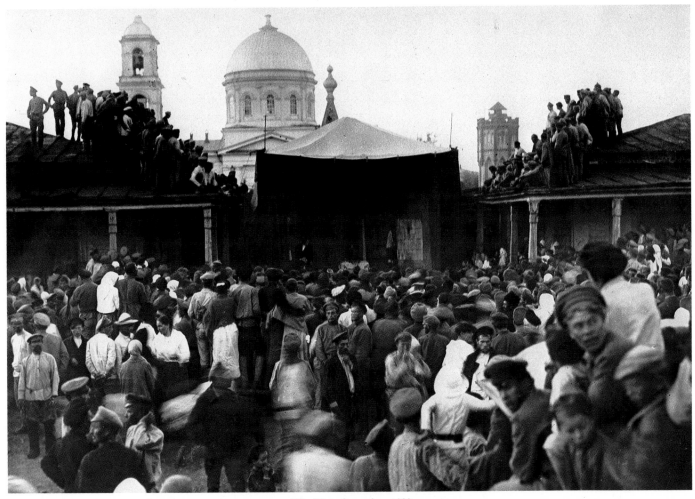

136 Piotr Ocup circa 1920

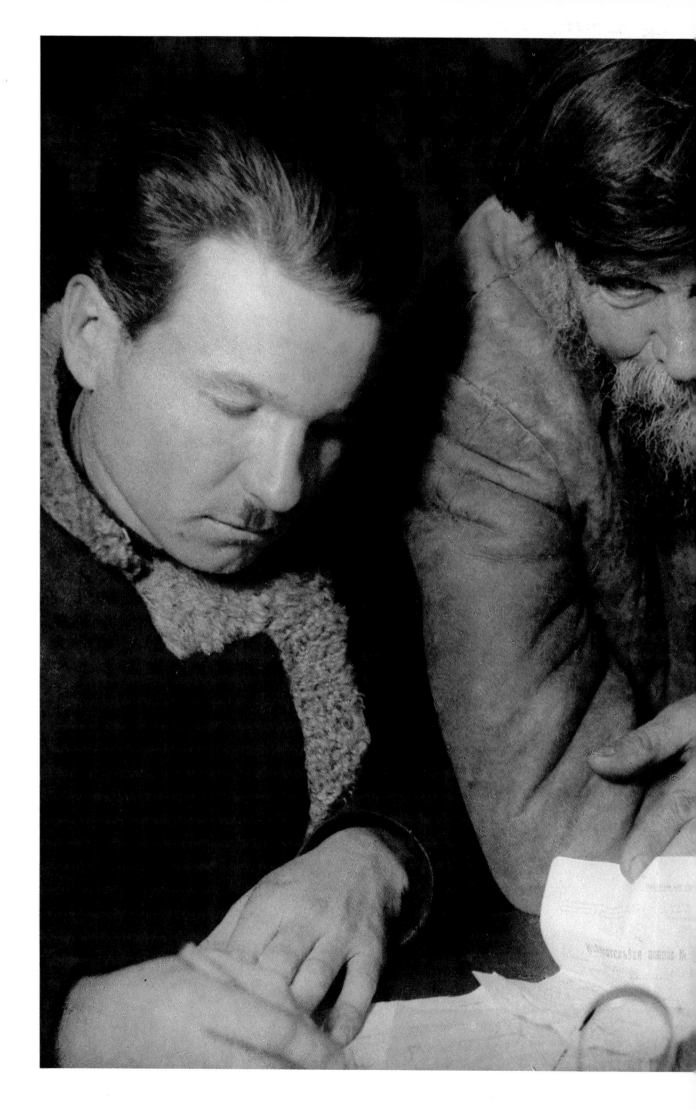

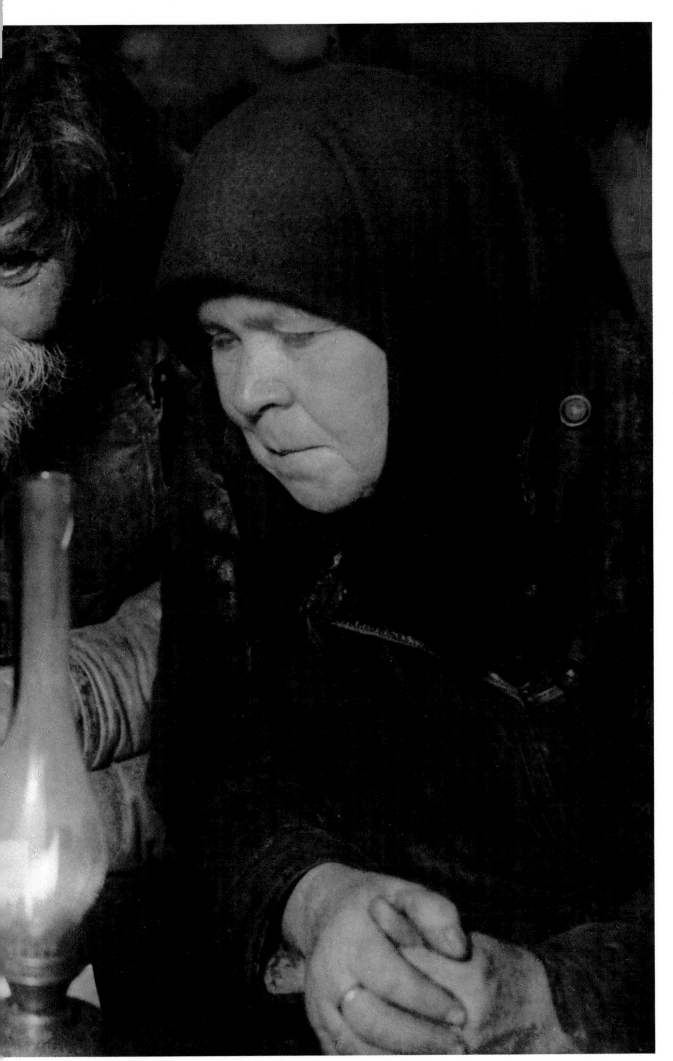

137 Boris Ignatovič 1928

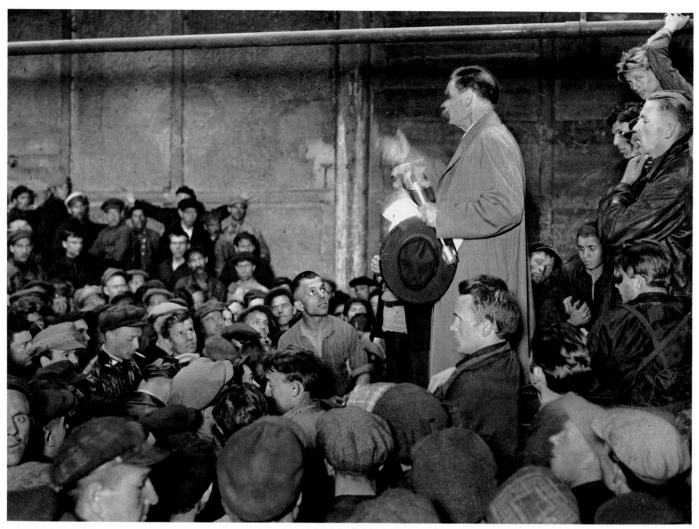

138 Arkadij Šajchet 1929

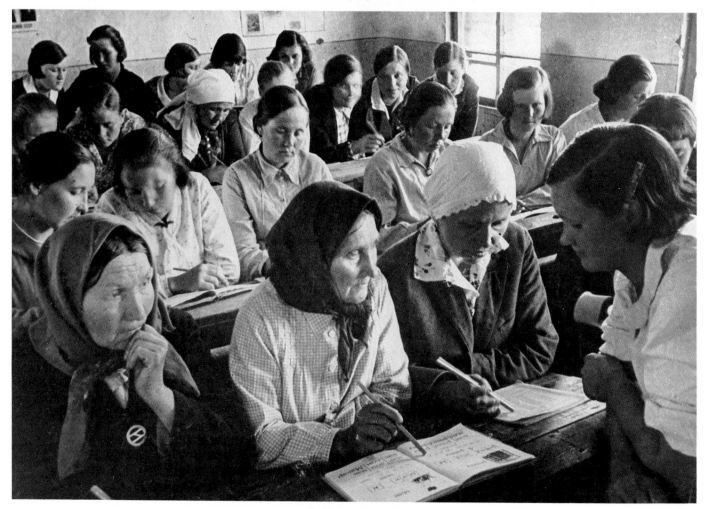

139 Georgij Zelma 1931

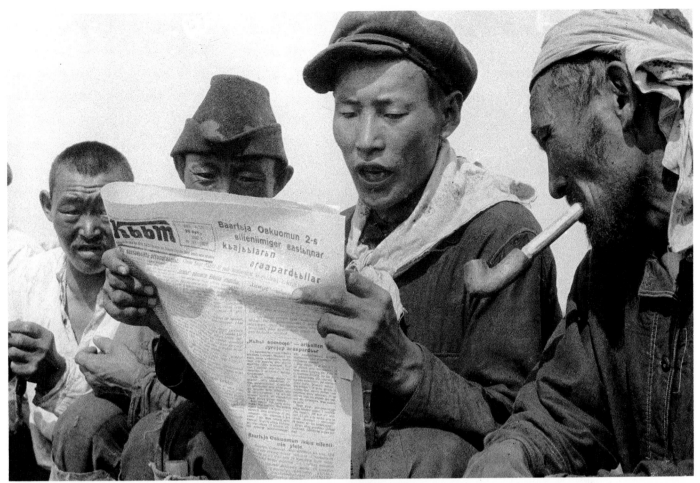

140 Georgij Zelma 1929

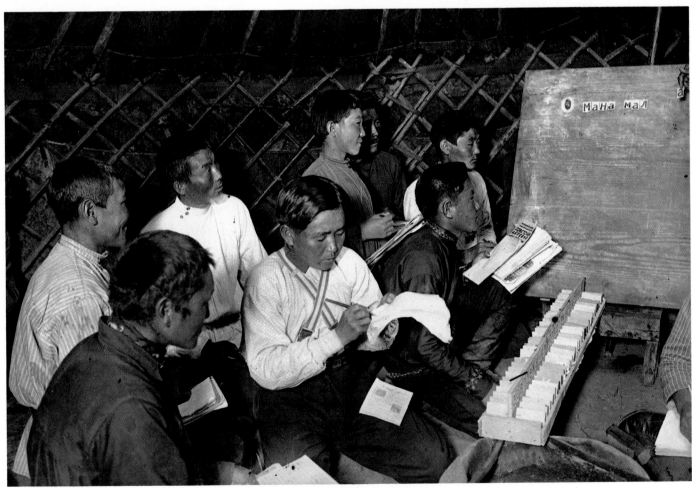

141 Arkadij Šajchet 1930

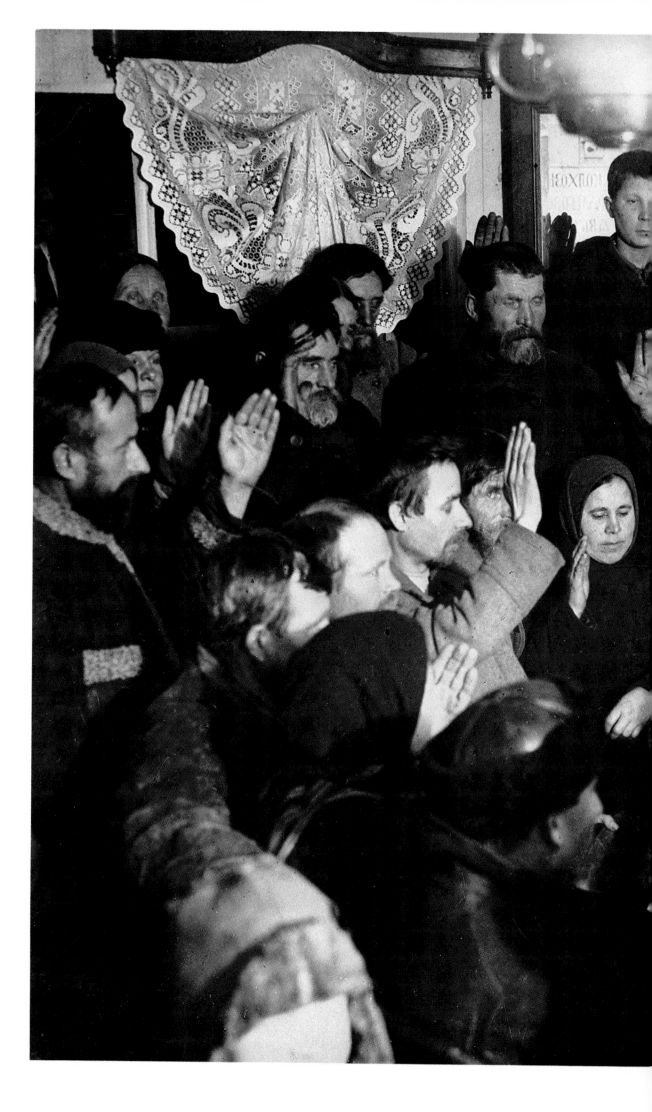

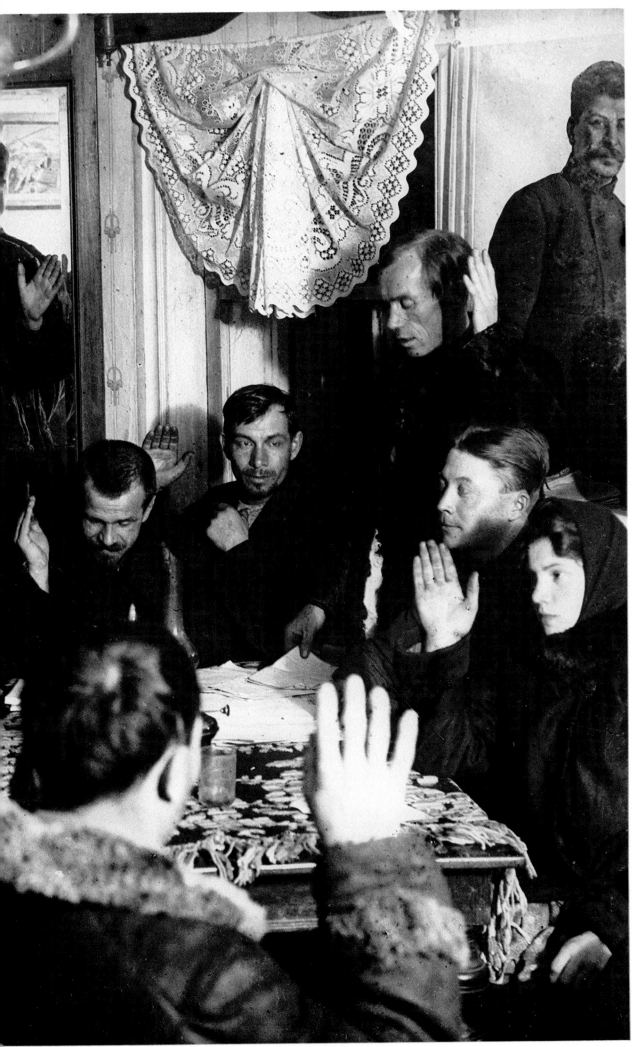

142 Arkadij Šiškin 1929

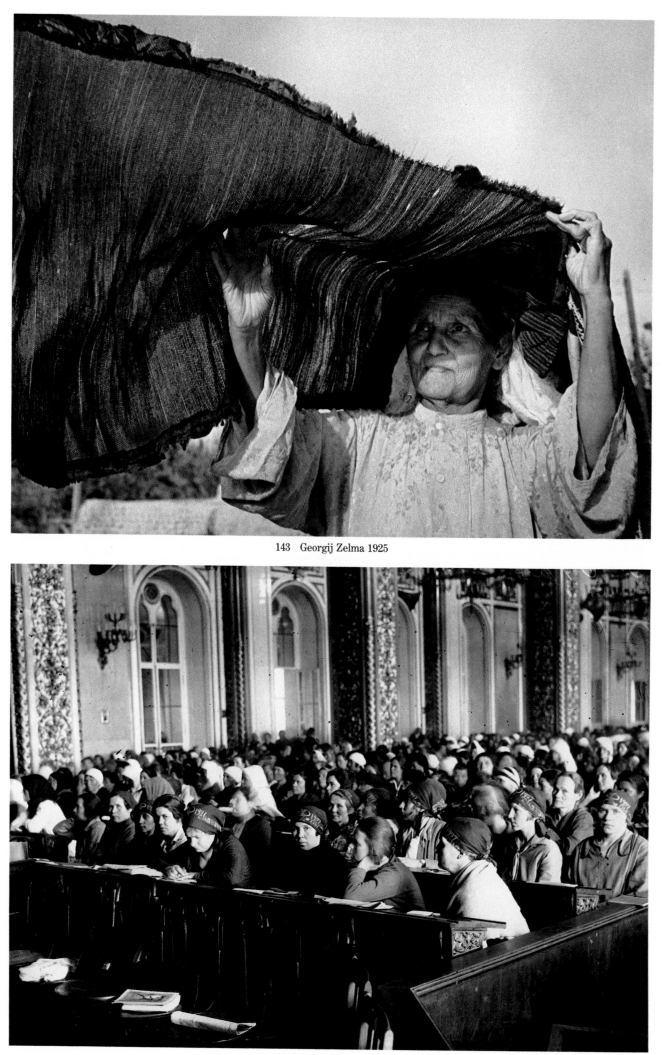

143 Georgij Zelma 1925

144 Piotr Ocup 1927

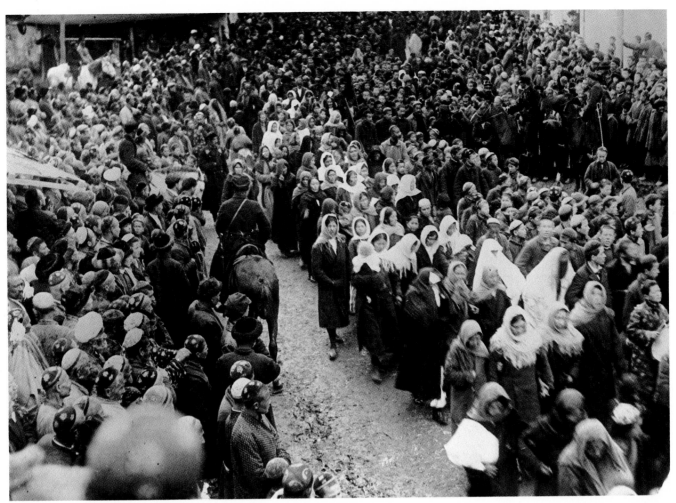

145 Georgij Zelma 1926

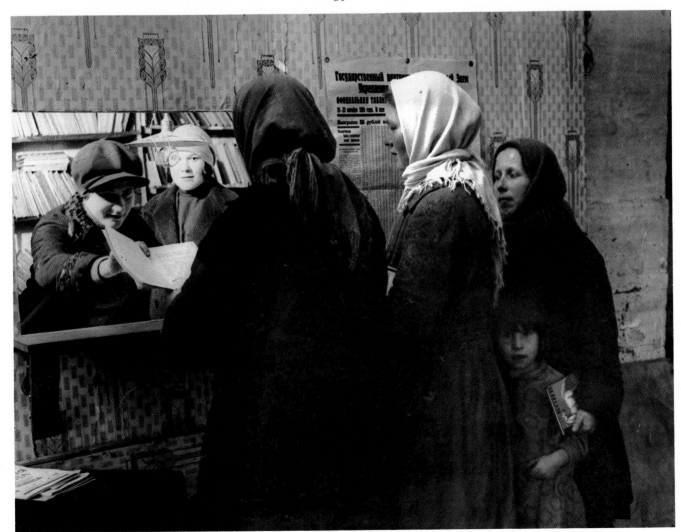

146 Boris Ignatovič circa 1920

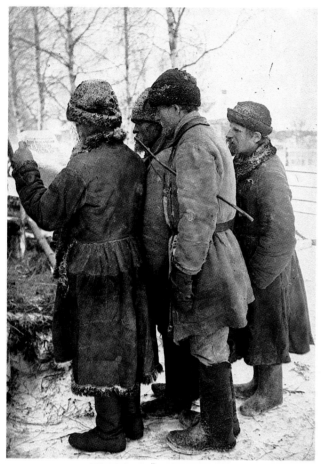

147 Arkadij Šajchet circa 1930

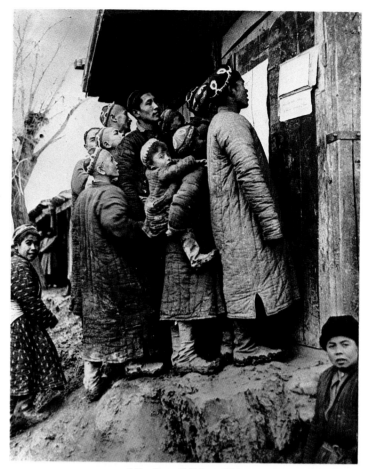

148 Georgij Zelma 1924

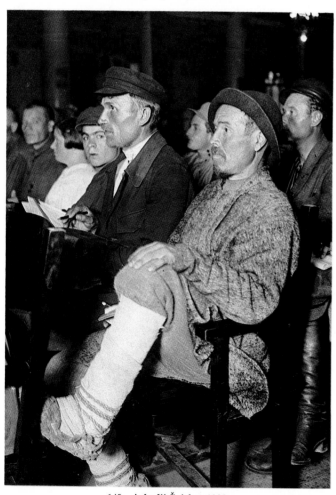

149 Arkadij Šajchet 1928

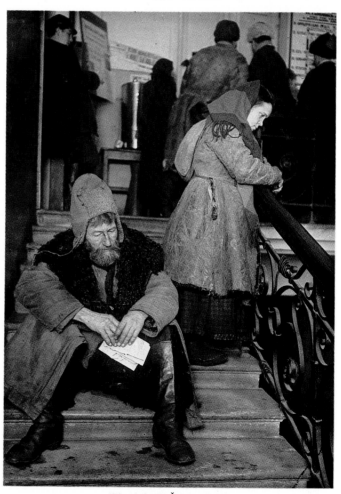

150 Arkadij Šajchet 1924

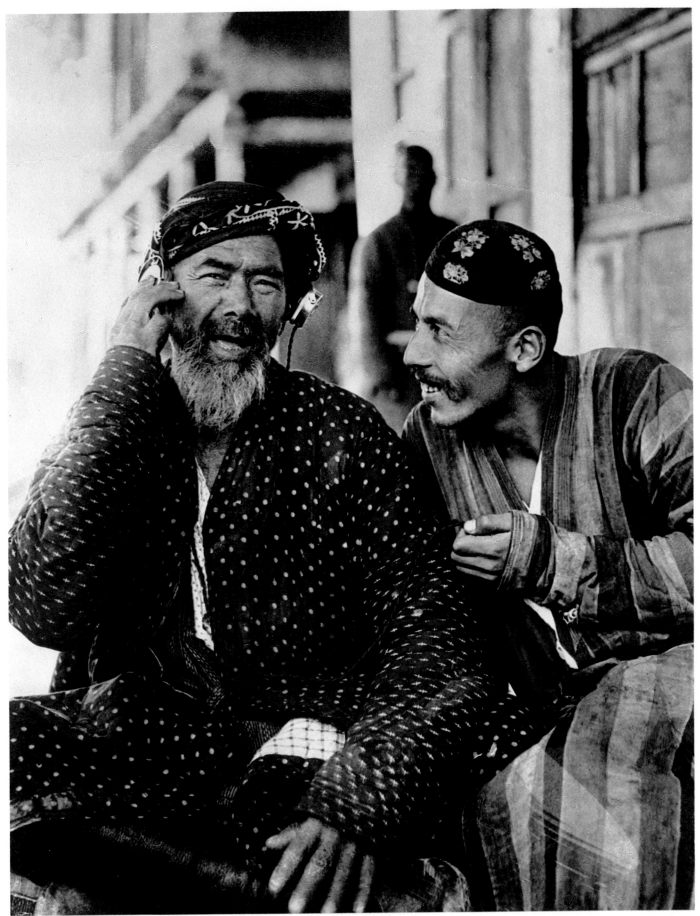

151 Georgij Zelma 1925

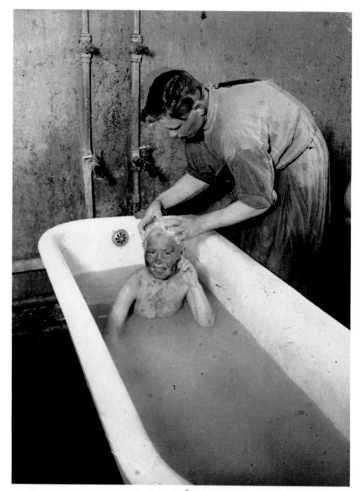

152 Arkadij Šajchet 1925

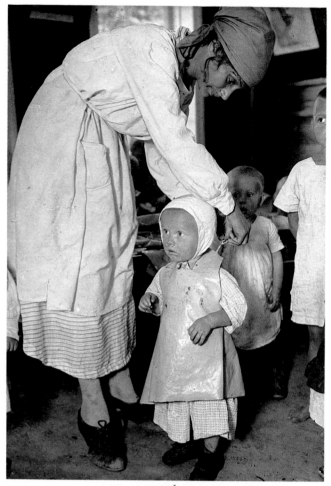

153 Arkadij Šajchet 1928

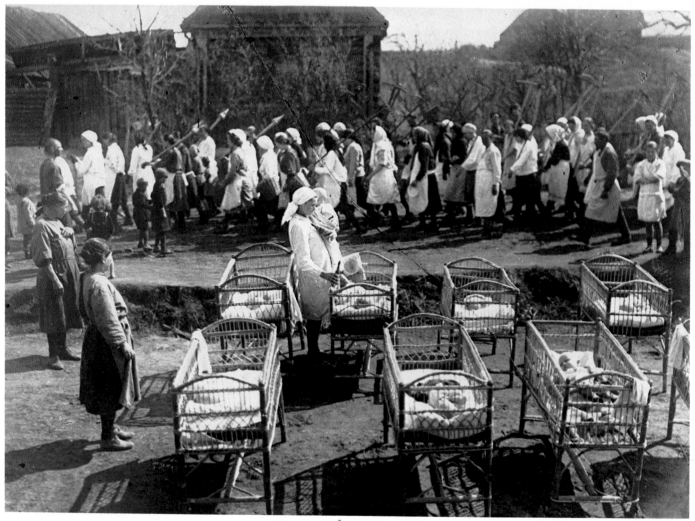

154 Arkadij Šajchet circa 1920

148

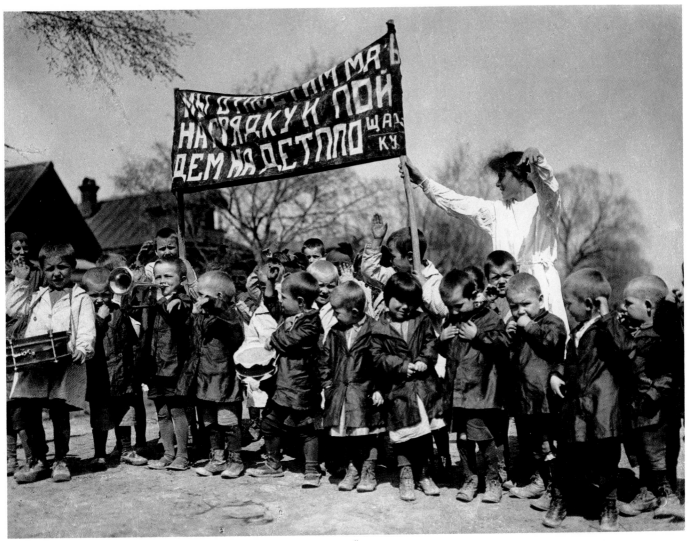

155 Arkadij Šajchet 1928

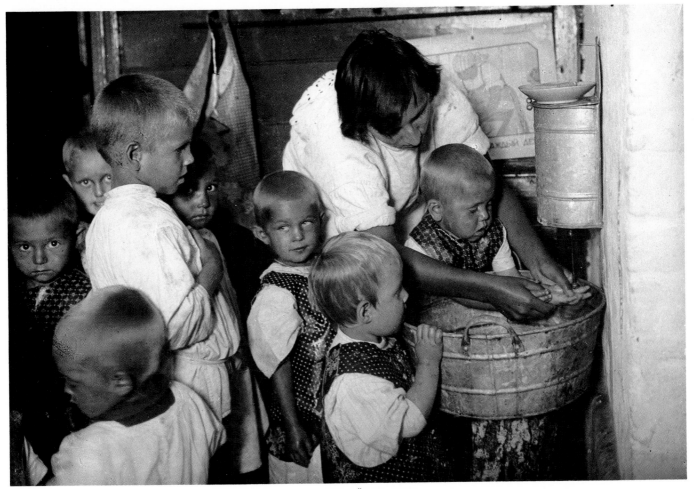

156 Arkadij Šajchet 1928

157 Aleksandr Rodčenko 1930

158 Aleksandr Rodčenko. *Sergej Urusevskij* 1923

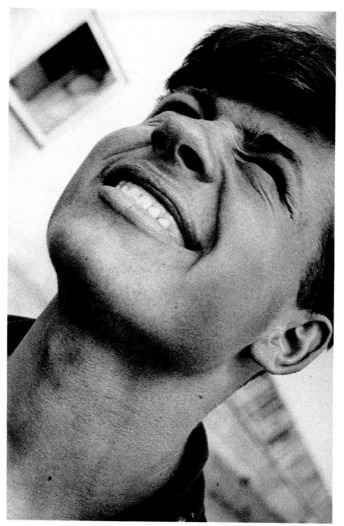

159 Aleksandr Rodčenko 1930

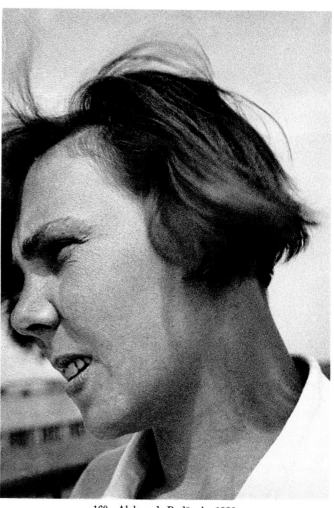

160 Aleksandr Rodčenko 1930

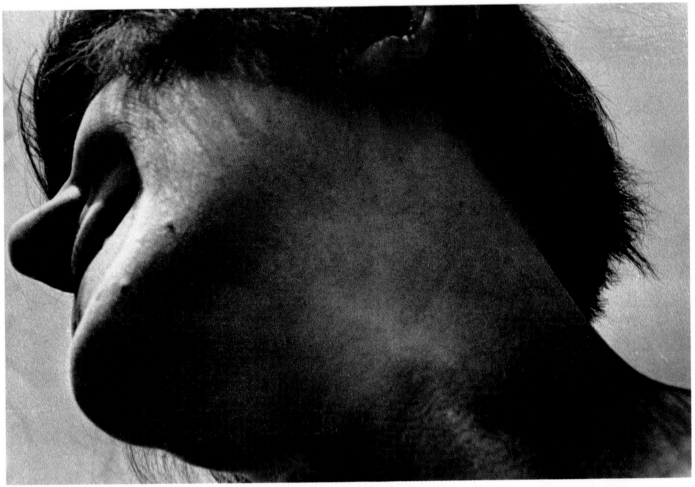

161 Aleksandr Rodčenko 1930

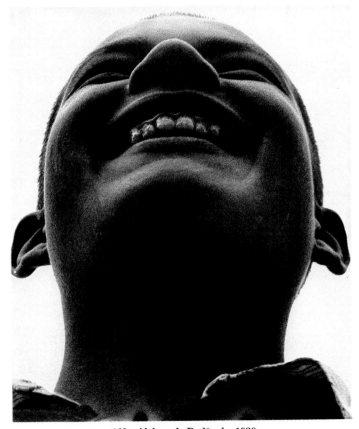

162 Aleksandr Rodčenko 1930

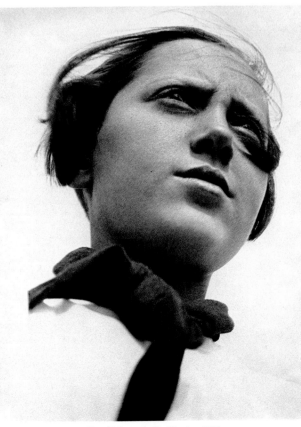

163 Aleksandr Rodčenko 1930

151

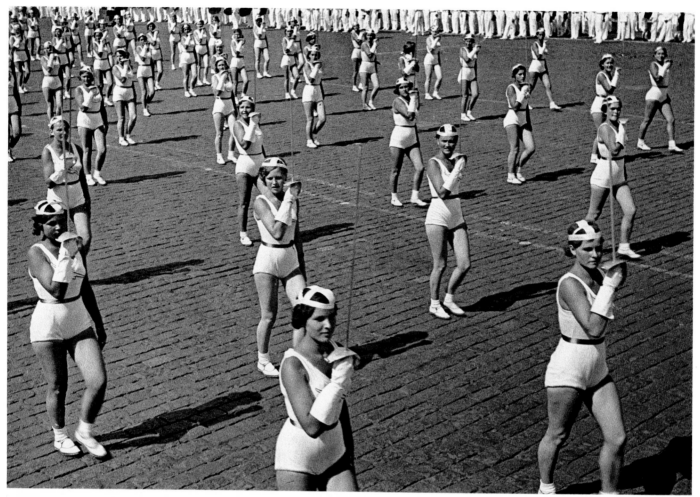

164 Aleksandr Rodčenko 1936

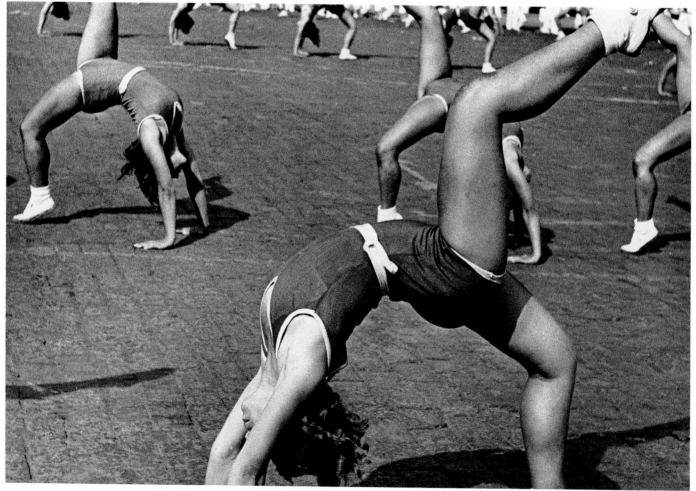

165 Aleksandr Rodčenko 1936

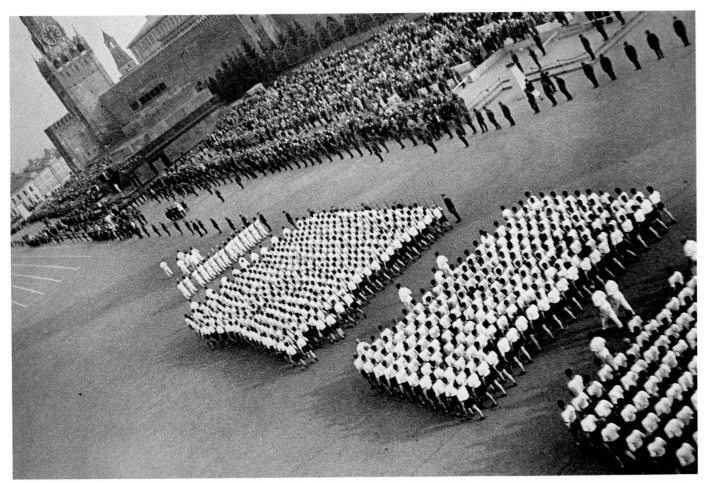

166 Aleksandr Rodčenko 1930

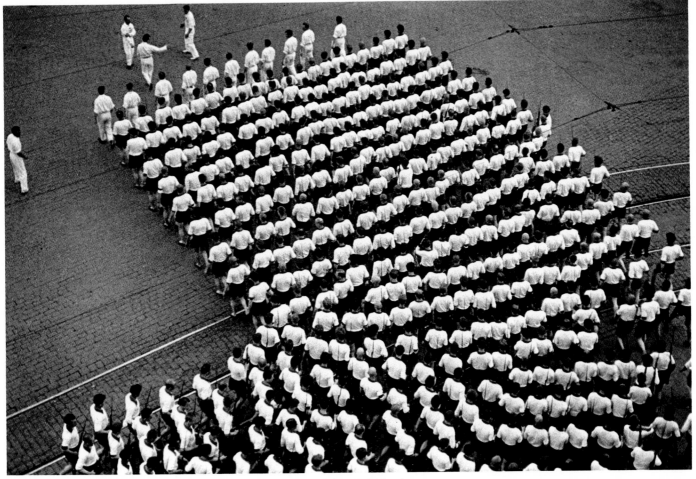

167 Aleksandr Rodčenko

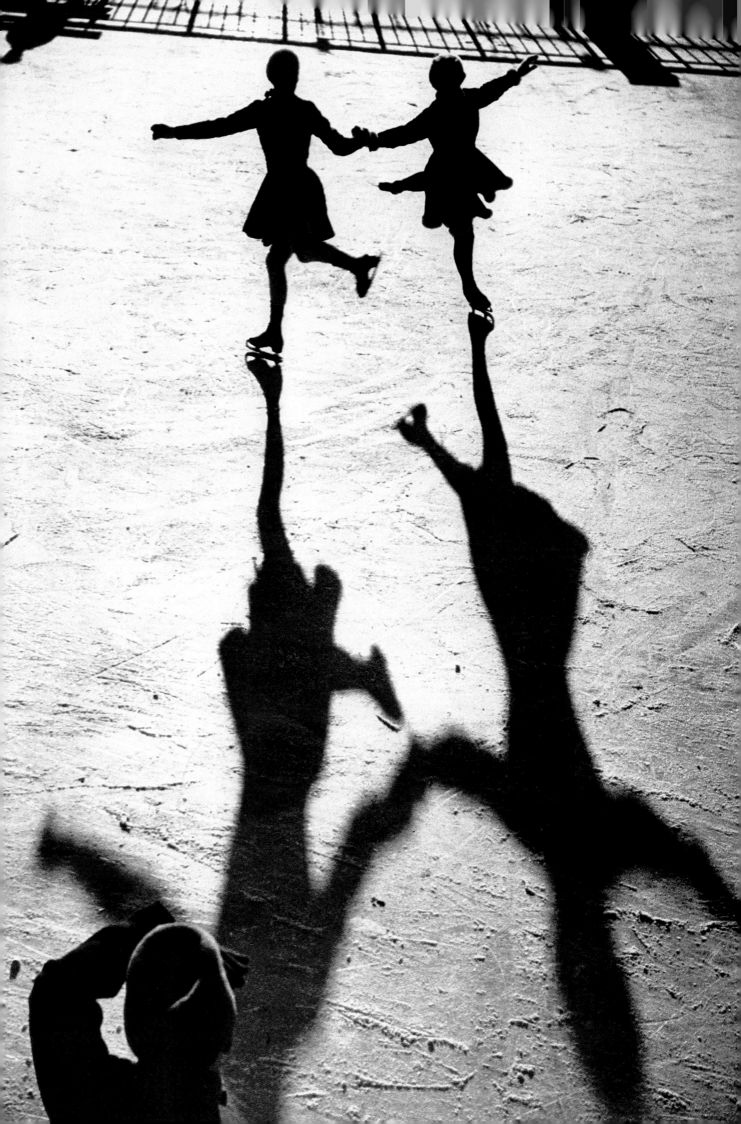

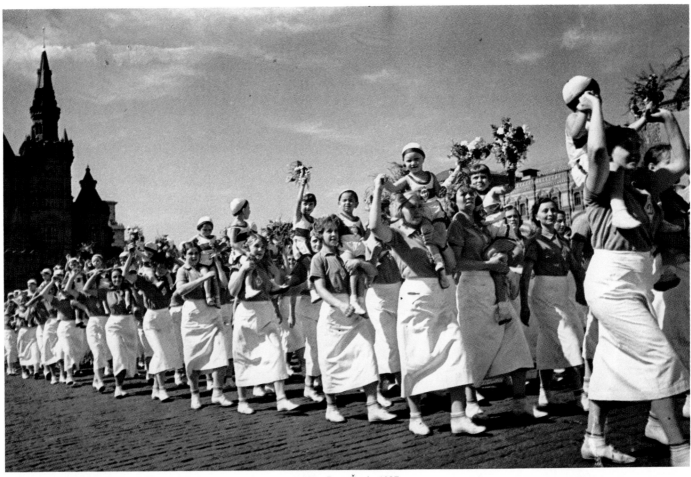

169 Ivan Šagin 1937

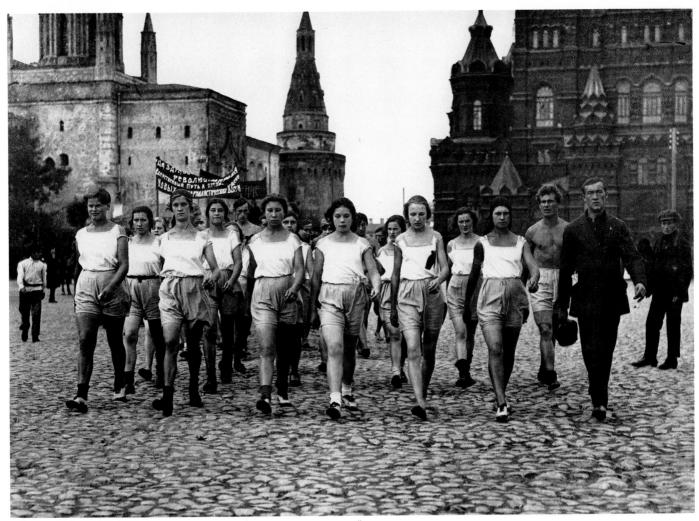

170 Arkadij Šajchet 1930

168 Ivan Šagin 1933

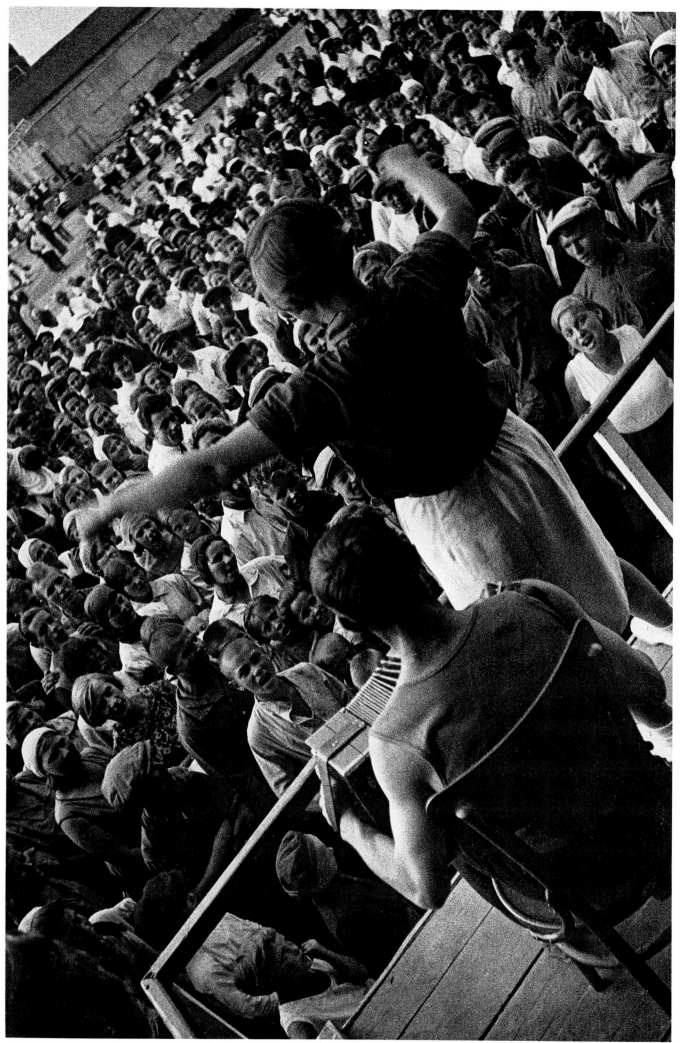

171 Aleksandr Rodčenko 1931

172 Aleksandr Rodčenko 1936

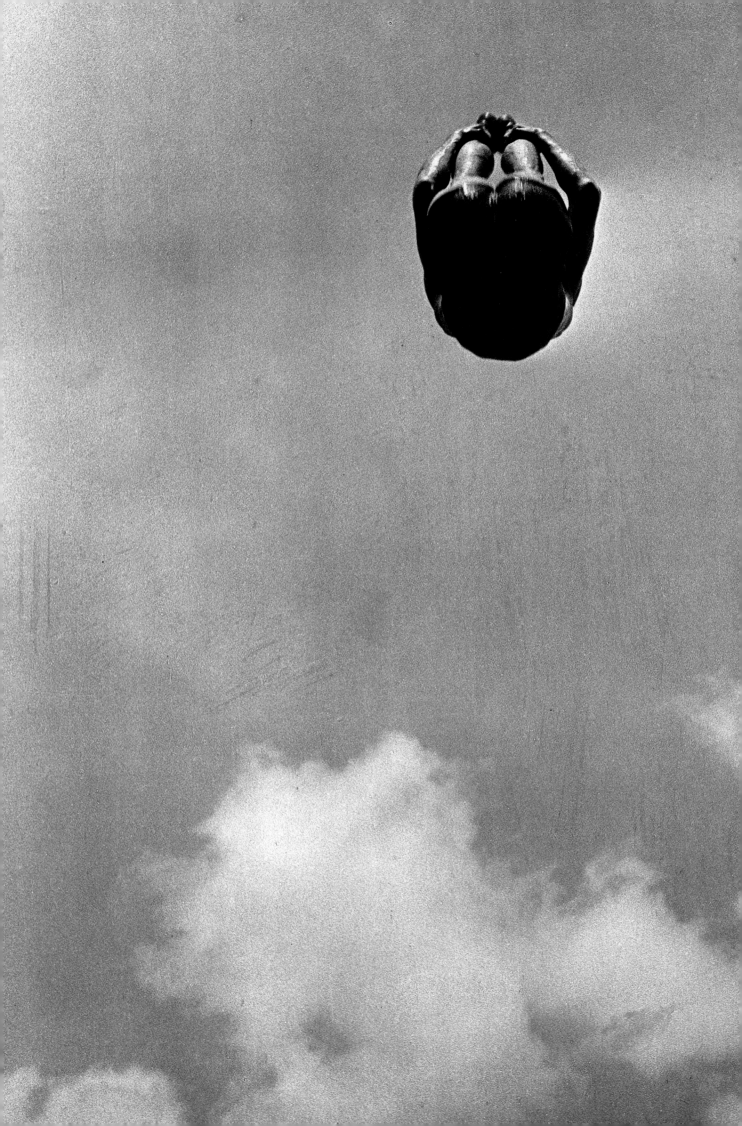

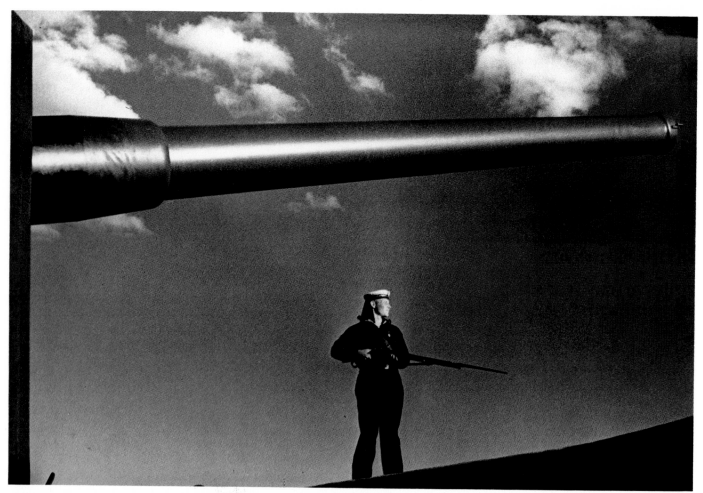

173 Jakob Halip 1937

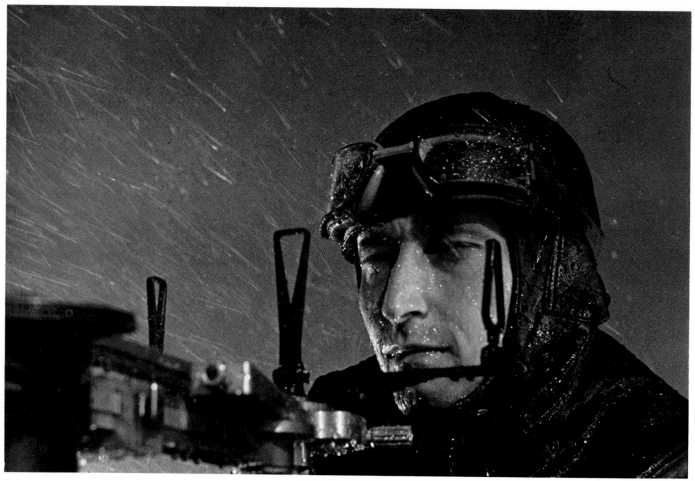

174 Jakob Halip 1935

175 Jakob Halip 1937

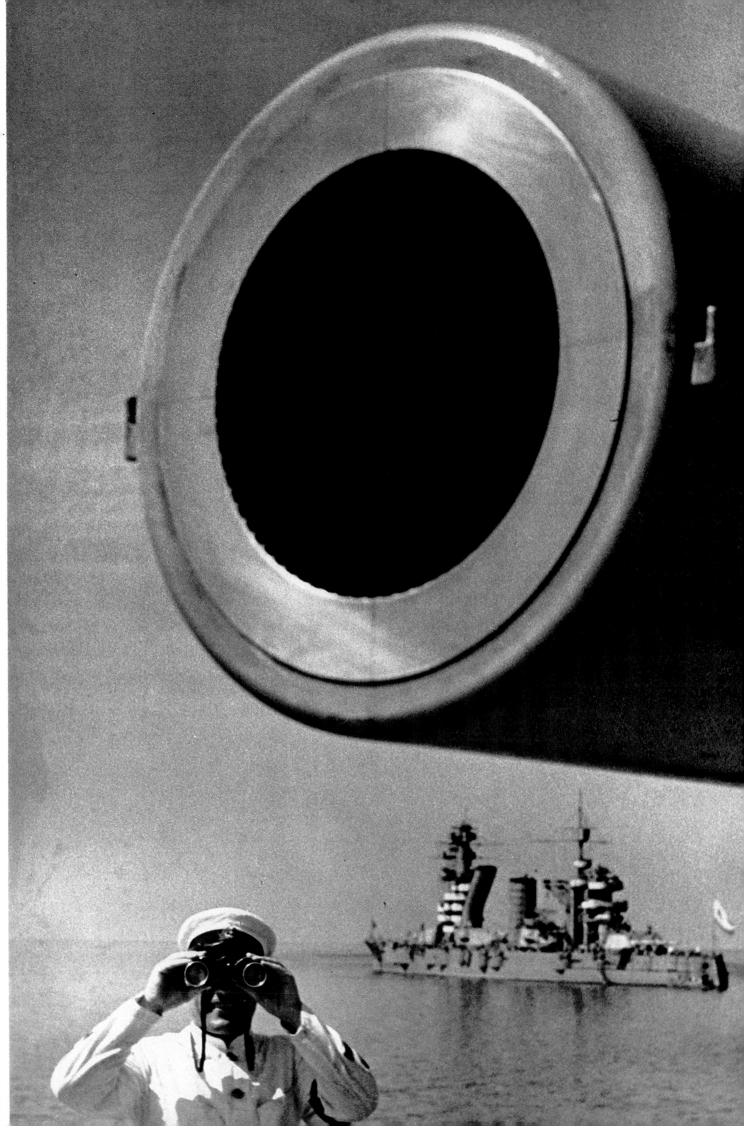

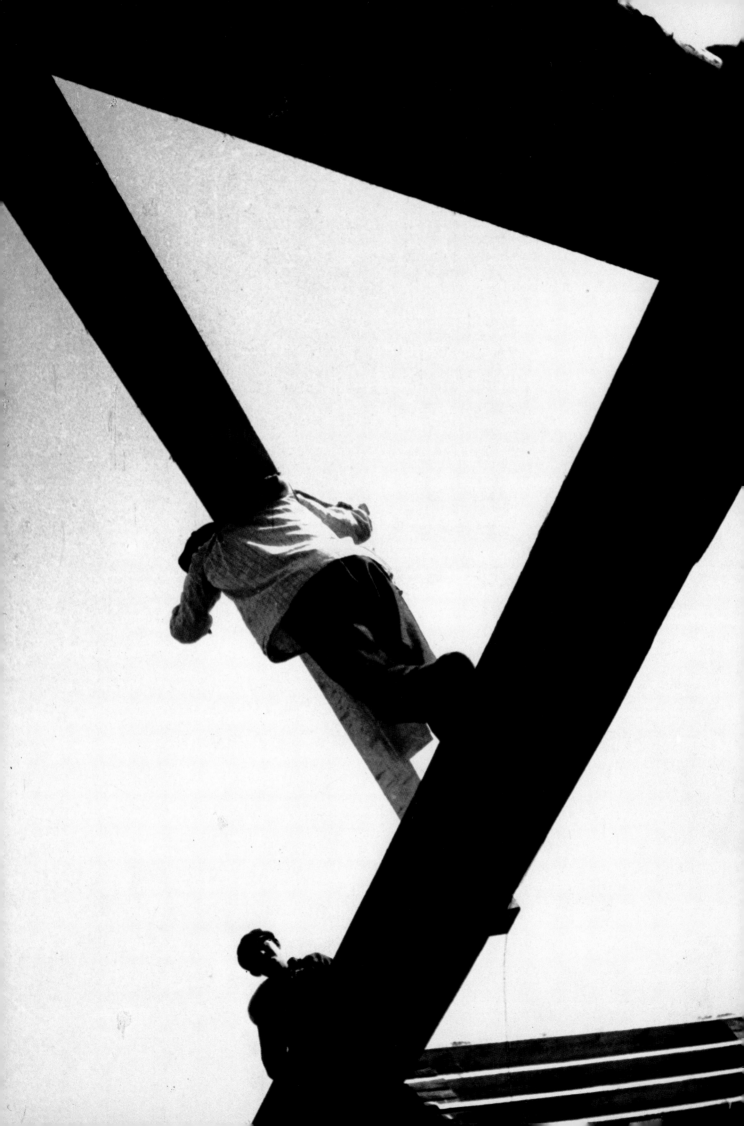

SCIENCE AND INDUSTRY

From **ABOUT THIS**

The telephone
hurls itself
at everyone.

A miracle squeezed through the tiny wire,
forcing wide the funnel of the receiver's rim,
with a pogrom of bells storming the quiet,
from the telephone a lava bursts over the brim.
That shrilling,
 that ting-a-linging,
burst against the walls,
 tried to blow them in the air.
Rings
 by the thousand
 from the walls
 came aspringing,
rolling under the bed
 and under the chair.
From the floor to the ceiling the bell-ringing soared.
Then again,
 like a ringing bell aswinging,
boomed to the ceiling, bounced from the floor,
and splattered down in a spray of ringing.
Window after window,
 damper after damper
strove to ring
 with the telephone in tone.
Shaking the house,
 like a children's rattle
 rampant,
the engulfing rings were drowning the phone.

Vladimir Mayakovsky, 1923

Notes

176 Boris Ignatovich: *On the Construction Site* (1929). This photograph was used by El Lissitzky for the cover of the book *Neues Bauen in der Welt Russland*, published in Vienna in 1929.

177 Yakov Khalip: *Portrait of the Academician Ivan Pavlov* (Leningrad, 1935). Ivan Petrovich Pavlov (1849–1936), the Russian physiologist and doctor, became famous for his theory of conditioned reflexes, as opposed to innate and unconditioned reflexes – a distinction which he proposed for the first time in 1903. He was also noted for his work on the physiology of sleep. At the instigation of Lenin, Pavlov was allowed to continue his research at the Koltushy biological research station. He was awarded the Nobel Prize for Physiology and Medicine in 1904.

178 Aleksandr Rodchenko: *On the Telephone* (1928). 'This photograph was part of a reportage executed for the magazine *Gudok*, intended to illustrate the various stages in the manufacture of a newspaper. The photograph shows Rodchenko's daughter Varvara in the family's apartment, which still exists today. Until 1932, the telephone remained in this position, hung on a wall which was covered in phone-numbers written directly on to the paint. Rodchenko subsequently redesigned the apartment, and the telephone was moved. The photograph tries to depict the moment – of great importance for a newspaper – when the news story is "filed". Rodchenko produced several variations on this theme for his reportage. This particular example is a re-centred version of the original photograph.' (A.L.) The reportage in question was entitled 'Thirty Days'.

179 Aleksandr Rodchenko: *How a Newspaper Is Made* (1928). Cf. No. 178.

180 Aleksandr Rodchenko: *At the Printer's* (1929). Cf. No. 178.

181 Aleksandr Rodchenko: *The Plates of a Rotary Press* (1928). Cf. No. 178.

182 Ivan Shagin: *The First Passengers on the Underground* (1935). The construction of the Moscow underground was started in 1932. Ten thousand Moscow komsomols (communist youth), miners from the Don region and workers from the provinces all participated in the project. The first section was inaugurated on 15th May 1935.

183 Arkady Shaikhet: *Introduction to Science* (1929).

184 Max Alpert: *Construction of the Metallurgy Plant in Magnitogorsk* (1929). The town of Magnitogorsk was built in 1929 in the Chelyabinsk region, on the banks of the Ural river and at the foot of the Magnitnaya mountain, where the subsoil is extremely rich. During the first Five-Year Plan, the Lenin metallurgical complex was built and started production of iron, steel, cast iron, sheet metal and coke. Mayakovsky wrote a poem about the creation of Magnitogorsk, which had the effect of a poetic hymn to the new age.

185 Boris Ignatovich: *The First Mechanics* (1930s).

186 Arkady Shaikhet: *A Komsomol at the Wheel, Balakhna* (1931). A paper or cotton factory.

187 Boris Ignatovich: *Steelworks. Steel Smelting* (1938).

188 Anatoly Skurikhin: *Sunlit Workshops* (1932).

189 Anatoly Skurikhin: *Dnepropetrovsk Steel* (1938). One of the most industrialized towns in the Ukraine, Dnepropetrovsk produced heavy metallurgical goods and machinery.

190 Boris Ignatovich: *Smelting Works* (1938).

191 Dmitry Dyebabov: *Magnitogorsk* (1936).

192 Boris Ignatovich: *Regulators for Trams* (1930s). These machines bear the 'Dynamo' stamp, the name of a large firm which specialized in precision instruments.

193 Aleksandr Rodchenko: *Cogwheels* (1930). 'This was a reportage commissioned by a newspaper. The photograph was taken at the "Amo" factory, where the first Soviet car, modelled on the Fiat, was produced. Rodchenko took a large number of small photographs to tell the story – in a cinematic sense – of the birth of a motor car. These photographs are often enlarged in order to emphasize details. Here Rodchenko was expressing the idea of order created out of chaos.' (A.L.)

194 Aleksandr Rodchenko: *Cogwheels* (1930).

195, 196 Aleksandr Rodchenko: *The New Mogues* (1929). 'This power station still exists today, in the centre of Moscow. It is situated on the banks of the Moskva, facing the Rossia Hotel. Today it is unremarkable, although it was an architectural classic during the twenties. It is in reality quite small, while in the photograph it is presented in an unusual manner which makes it look imposing. The photograph was part of a reportage intended for the film on Moscow and dealing with the industrial aspects of the city.' (A.L.) This photograph was used on the cover of the magazine *Dazhes* in August 1929.

197 Anatoly Skurikhin: *Magnitka under Construction* (1932). One of the vast industrial complexes of the first Five-Year Plan. On 31st January 1932, the first blast furnace in Magnitogorsk was put into action.

198 Georgy Petrusov: *The Construction of Magnitogorsk* (1928).

199 Max Alpert: *The Dneprostroy Dam under Construction* (1928).

200 Arkady Shaikhet: *The First Drilling Operation to Build the Moscow Underground* (1930).

201 Arkady Shaikhet: *The Installation of Electricity Pylons in the Countryside* (1925). In December 1920, the great plan for the electrification of the country (GOELRO) was adopted.

202 Boris Ignatovich: *The First Pylon* (1925).

203 Arkady Shaikhet: *Ilyich's Small Lamp* (1925). Beneath the portrait of Mikhail Frunze, the installation of the first electric light bulb: 'Communism is the power of the Soviets plus electricity' (Lenin).

204, 205 Max Alpert: *Construction of the Turkestan–Siberia Railway* (1929). The Turksib (abbreviation of 'Turkestan–Siberia') is a railway line which links the great Soviet networks of the Asian continent: that of Siberia in the north and Turkestan in the south. 1,140 km in length, it was constructed during the first Five-Year Plan, between 1930 and 1932, following the former mail route which linked Tashkent and Semipalatinsk. From there, a branch line connected it in those days with Novosibirsk and the Trans-Siberian express.

206 Anatoly Skurikhin: *The First Coal to Leave Kuzhbas* (1933). The first Five-Year Plan brought together, in the Ural-Kuznetsk industrial complex, the iron of Magnitogorsk and the coal and coke of the Kuzhbas field situated between the Altai mountains and the Sayan massifs.

207 Arkady Shaikhet: *The Turksib Link-up* (1930).

208 Arkady Shaikhet: *The First Turksib Locomotive Engine* (1930).

209 Arkady Shaikhet: *The First Turksib Train* (1930).

210 Max Alpert: *Construction of the Turkestan–Siberia Railway* (1929).

211 Arkady Shaikhet: *Junction on the Turksib Line* (1930).

212, 213, 214, 215, 216, 217, 218 Max Alpert: *Construction Site of the Fergana Grand Canal* (1939). The Fergana is a great inland water basin, comprising Uzbekistan, Kirgizistan, Tadzhikistan, and stretching from Tien Shan to the Pamir mountains. Between 1935 and 1950, a large canal was dug by means of picks and shovels, which was intended to link the old oases bordering the depression and form the irrigation system for a cotton-growing belt. Together with the Turksib, Magnitogorsk, Smolensk and the Dneprogues dam, the Fergana canal is one of the great constructions of the USSR as a nation. In the photographs, one can see the musical instruments which gave rhythm to these pharaonic labours: 'dutaras', flutes and drums. 'The photographic sequence provides us with an instant cross-section of the network of relations in which human beings embroil themselves.... We are constructing methodically, we must also record methodically, and sequences are a form of long-term photographic observation – there is our method.' (Sergey Tretyakov: *Proletarskoye Foto*, Moscow, 1931).

219 Arkady Shaikhet: *Construction of a Canal, Uzbekistan* (1931).

220 Arkady Shaikhet: *A Gasometer Being Lowered into Place* (1930s).

221 Arkady Shaikhet: *The Aqueduct of a Hydro-Electric Power Station* (1930). The Dneprogues dam, constructed between 1927 and 1932, was one of the great construction projects of the first Five-Year Plan. It was completely destroyed during the Second World War and rebuilt between 1944 and 1950. The power station and the dam are situated on the river Dnepr, where it runs through the city of Zakoroshyi.

222 Boris Ignatovich: *Wheels of a Threshing Machine* (1929).

223 Ivan Shagin: *The Workers of Leningrad Are for the Dneprogues* (1930s). The third turbine being installed in the Dneprogues hydro-electric power station.

224 Anatoly Skurikhin: *Birth of the Kuznetsk Mineral Field* (1932). There is a poem by Mayakovsky about the new city of Novokuznetsk in the Urals, a city built around the metallurgical industry.

225 Aleksandr Rodchenko: *The White Sea–Baltic Canal. Barges Entering the Lock* (1933). This canal, which was developed in 1933, is 277 km long. By sections, it links up the White Sea, Lake Onega, Leningrad and the Baltic Sea on one side, and joins Lake Onega to the rivers of the Volga basin on the other side. It is used for transporting wood. 'This photograph, as well as others (see p. 19), was part of a reportage on the White Sea–Baltic canal (Karelia). Rodchenko brought back between two and three thousand negatives for the magazine *Nastroyka*, which traced the construction of the canal from its beginnings to the crossings made by the first barges. He would have liked all the photographs to be published, but even given the almost entirely visual nature of the article, which had very little text, there were so many of them that it proved impossible. At the same time as photographing the canal, Rodchenko also recorded the surrounding landscapes (cf. No. 80).' (A.L.)

226 Arkady Shaikhet: *The First Motor Cars to Leave the Gorky Factory Lined up for Transportation to Moscow* (1930). Nizhny-Novgorod, renamed Gorky in 1933, is an industrial town. The first motor cars were called Emkas.

227 Arkady Shaikhet: *The First State Tractor to Leave the Stalingrad Factory* (1930). From 1926, the USSR started an enormous drive towards mechanization. By the time of the collectivization of agriculture, 34,000 tractors were in use.

228 Arkady Shaikhet: *The First Motor Cars outside the Gorky Factory* (1930).

229 Arkady Shaikhet: *The First Soviet Export Motor Cars* (1932). Probably from the Gorky factory.

230 Boris Ignatovich: *The 'Dobrolet' Aviation Club* (1930s). During the rise of civil and military aviation in the USSR, the profession of flying was promoted in the young aviator clubs: here, the 'Dobrolet' ('happy flight') club.

231 Georgy Zelma: *On the River Lena* (1929).

232 Yakov Khalip: *Landing of the SSSR-B6 Airship* (Moscow, 1937). Airships were used during the Second World War.

233 Ivan Shagin: *Soviet Airships* (1936).

234 Dmitry Dyebabov: *Action Stations on the Ice-Breaker* Krasin, *East Siberian Sea* (1936). Krasin (1870–1976) was an engineer. A close confidant of Lenin, he was a member of the Brusner group, a contributor to the newspaper *Iskra*, a diplomat, minister of trade and industry and, finally, minister of foreign trade.

235 Dmitry Dyebabov: *The Ice-Breaker* Krasin *in the Arctic Ice Fields* (1936).

236 Dmitry Dyebabov: *The Ice-Breaker* Stalin *in the Arctic Ice Fields* (1939).

237 Dmitry Dyebabov: *The Ice-Breaker* Georgy Sedov *in the Ocean* (1930s). During an expedition in the Arctic polar seas, the ice-breaker *Georgy Sedov* let itself be carried into the ice fields of the Laptevych Sea (1937) and drifted until 1940 before reaching the open seas between Greenland and Svalbard.

238 Ivan Shagin: *The First Volga Steamboats in Front of the Kremlin* (1937). Moscow was connected to the sea by the Moskva–Volga canal.

239 Ivan Shagin: *A Stratostat before Take-off into the Stratosphere* (1933). The USSR engaged in a great deal of research to perfect the stratostat.

240 Olga Ignatovich: *Pyotr Leonidovich Kapitsa* (1939). An atomic physicist, born in 1894, Kapitsa worked in England with Rutherford. He was one of the originators of low-temperature physics and high magnetic-field physics, and a founder of the Institute for Problems in Physics set up by the Soviet Academy of Sciences. 'I met Pyotr Leonidovich Kapitsa for the first time at Cambridge. . . . He was then a member of Trinity College and used to wear a black gown. He showed me his laboratory, about which I of course understood nothing, except for two things: firstly that there was an electrical machine capable of lighting something like half of London, and secondly that all this energy was focused upon a field of activity a few millimetres in size.' (Eisenstein, *Memoirs*).

177 Jakob Halip. *Ivan Pavlov* 1935

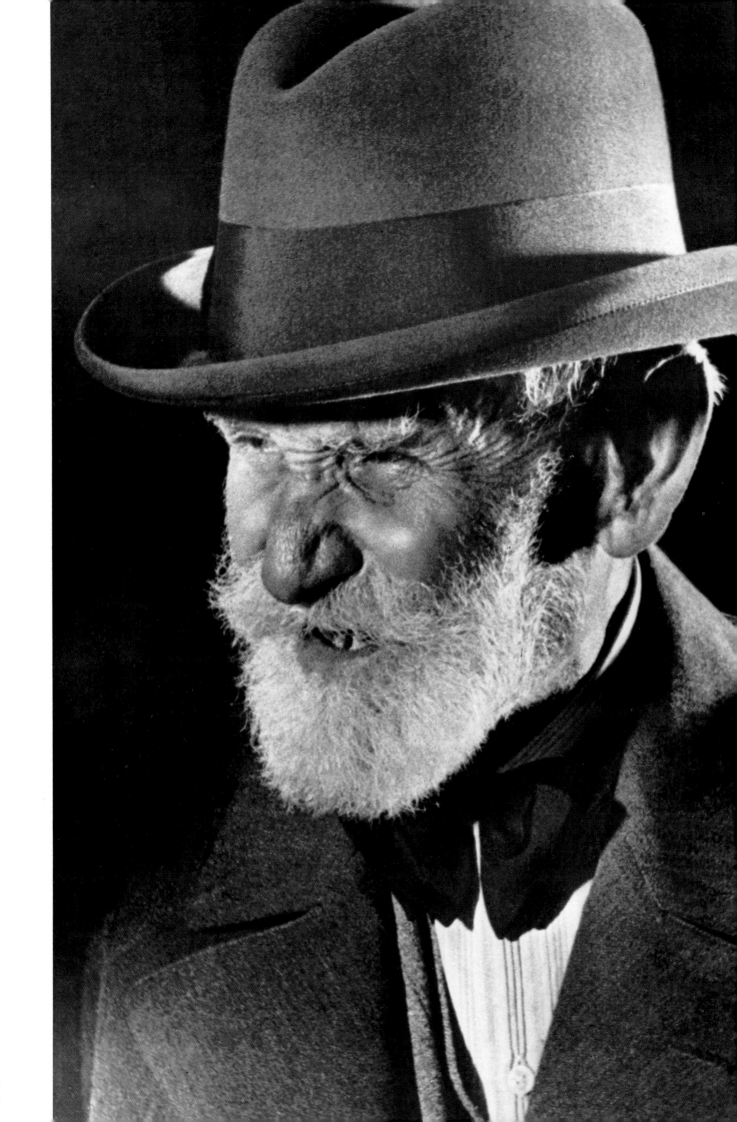

178 Aleksandr Rodčenko 1928

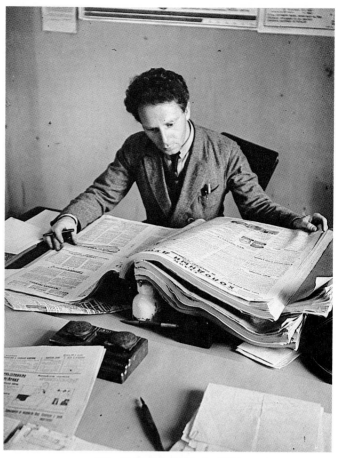

179 Aleksandr Rodčenko 1928

180 Aleksandr Rodčenko 1929

181 Aleksandr Rodčenko 1928

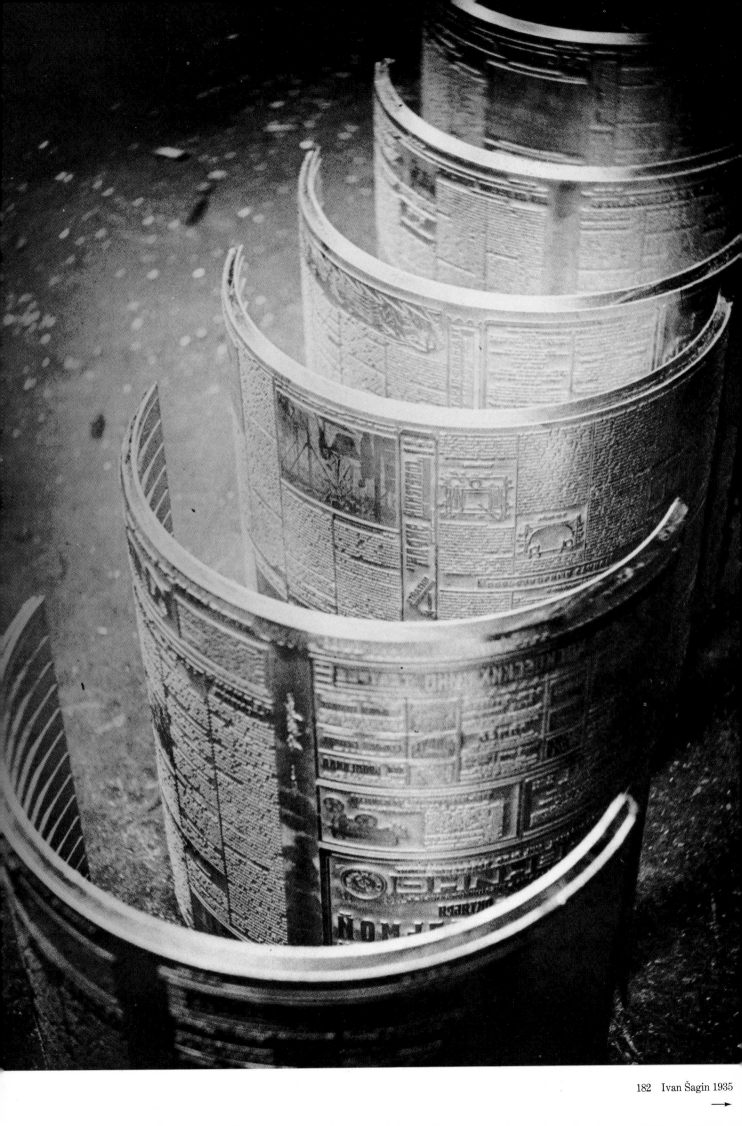

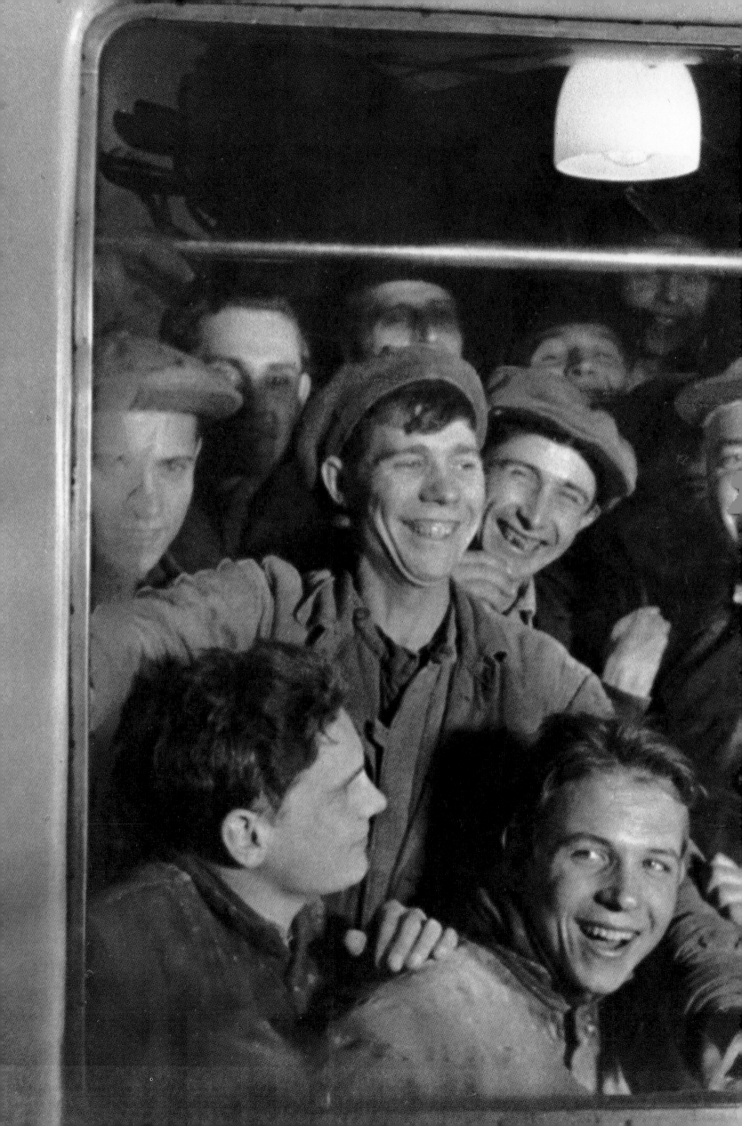

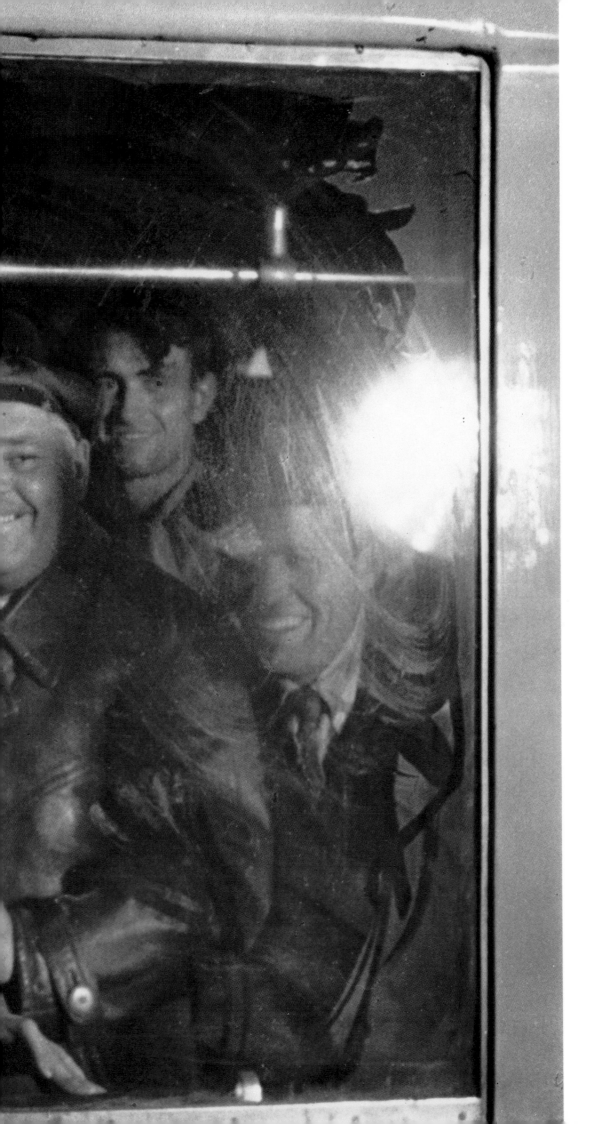

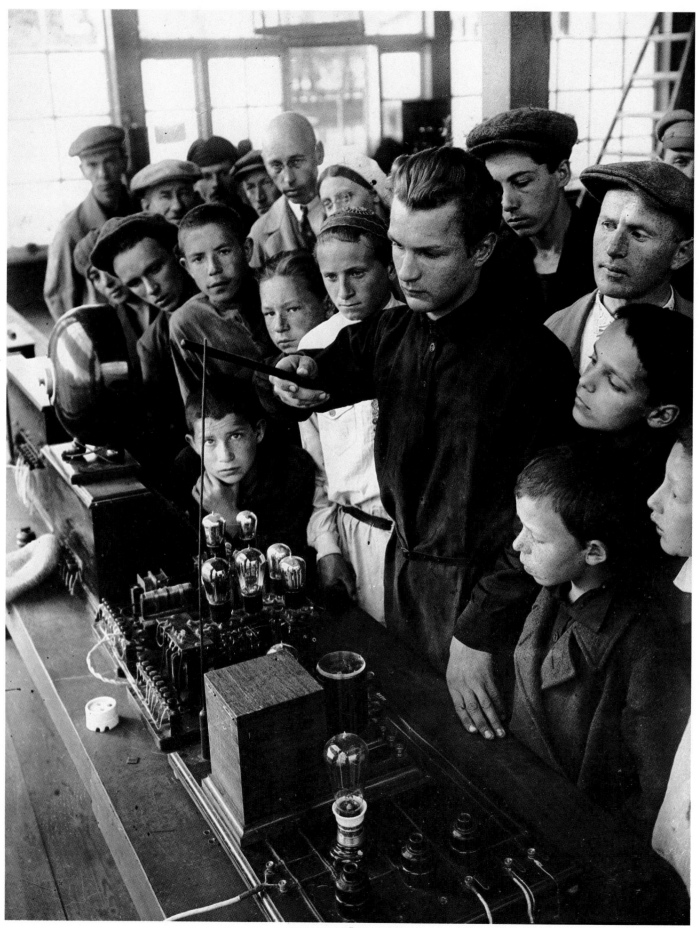

183 Arkadij Šajchet 1929

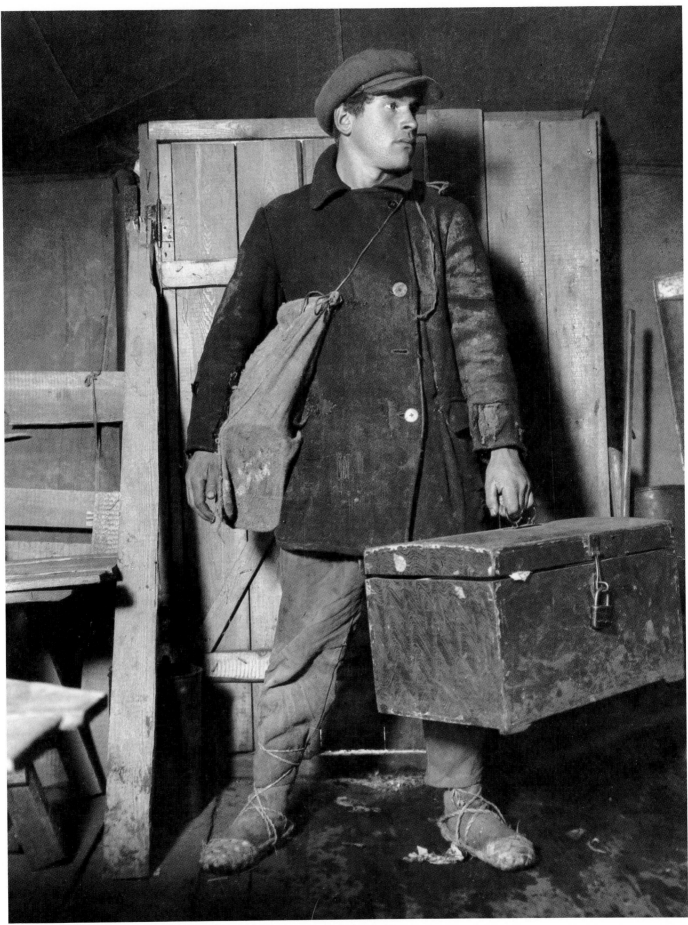

184 Max Alpert 1929

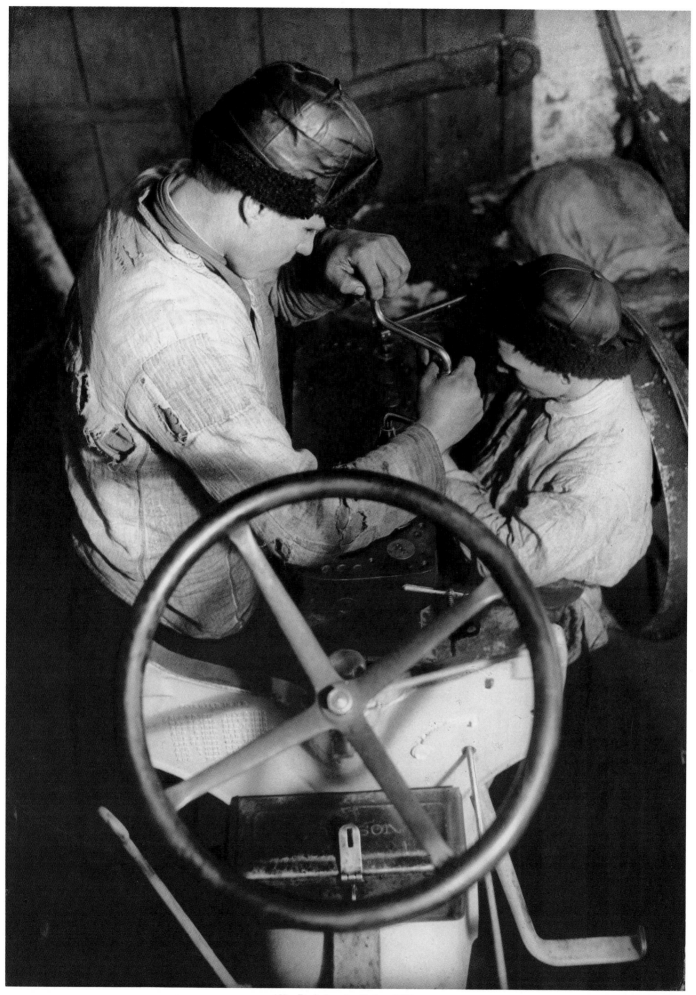

185 Boris Ignatovič circa 1930

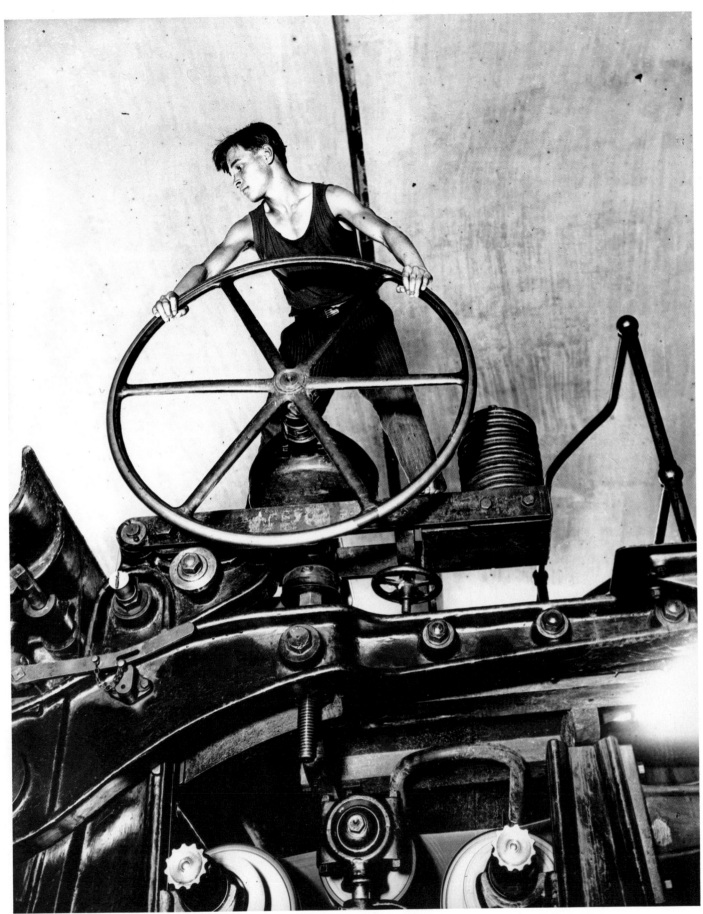

186 Arkadij Šajchet 1931

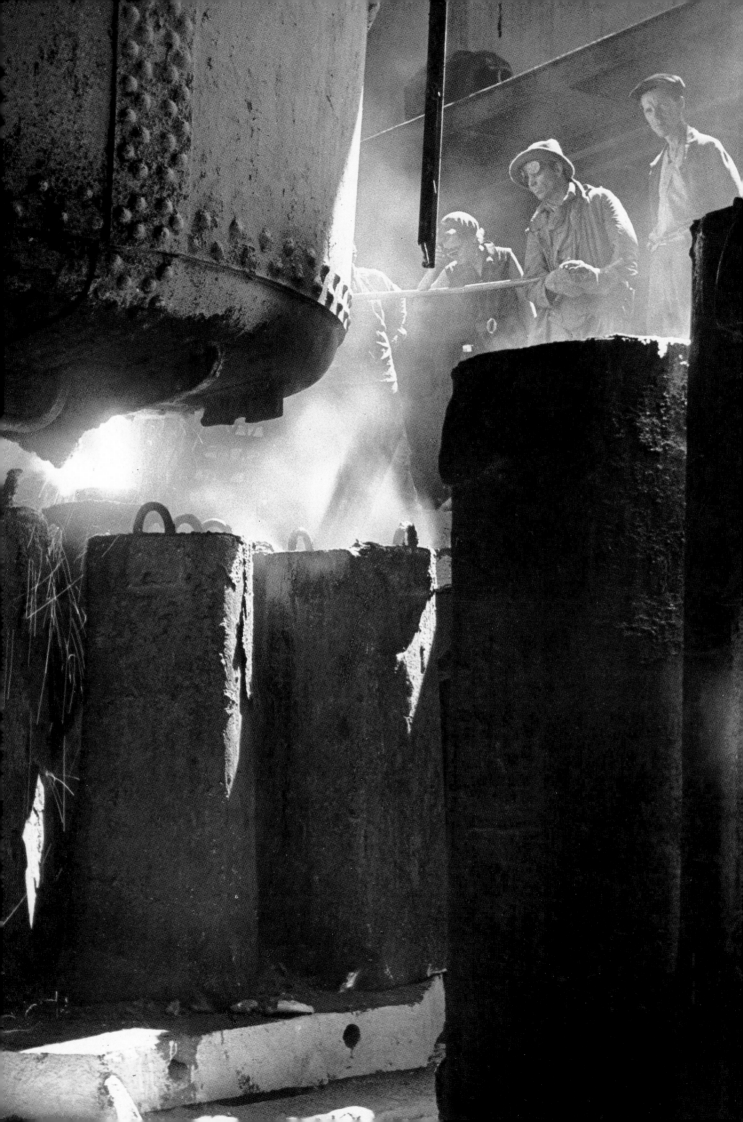

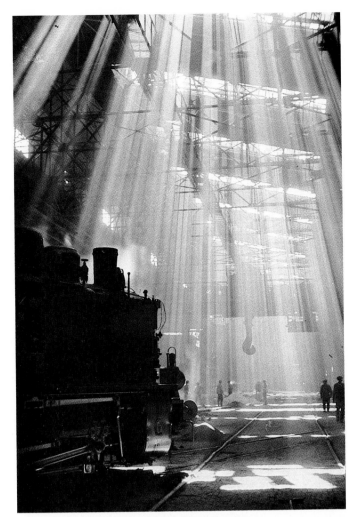

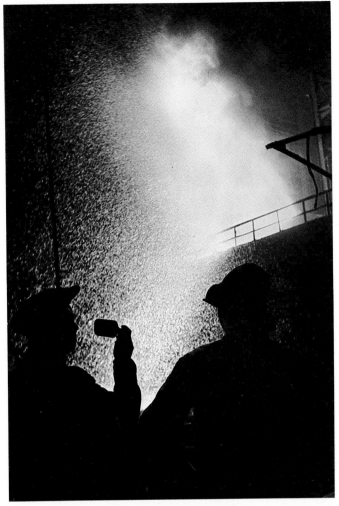

188　Anatolij Skurichin 1932

189　Anatolij Skurichin 1938

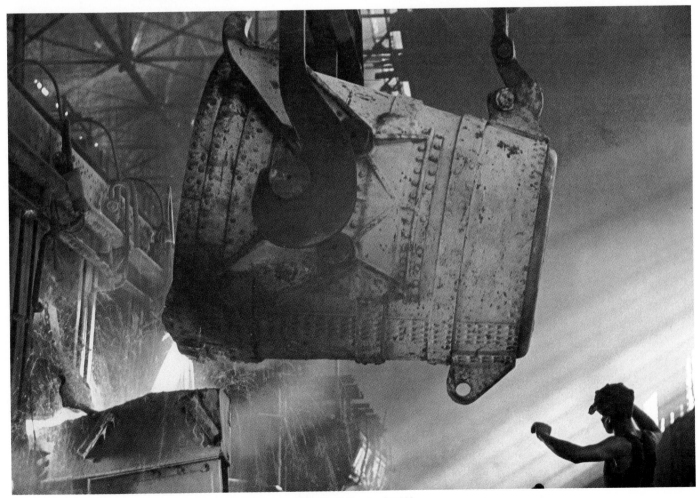

190　Boris Ignatovič 1938

187　Boris Ignatovič 1938

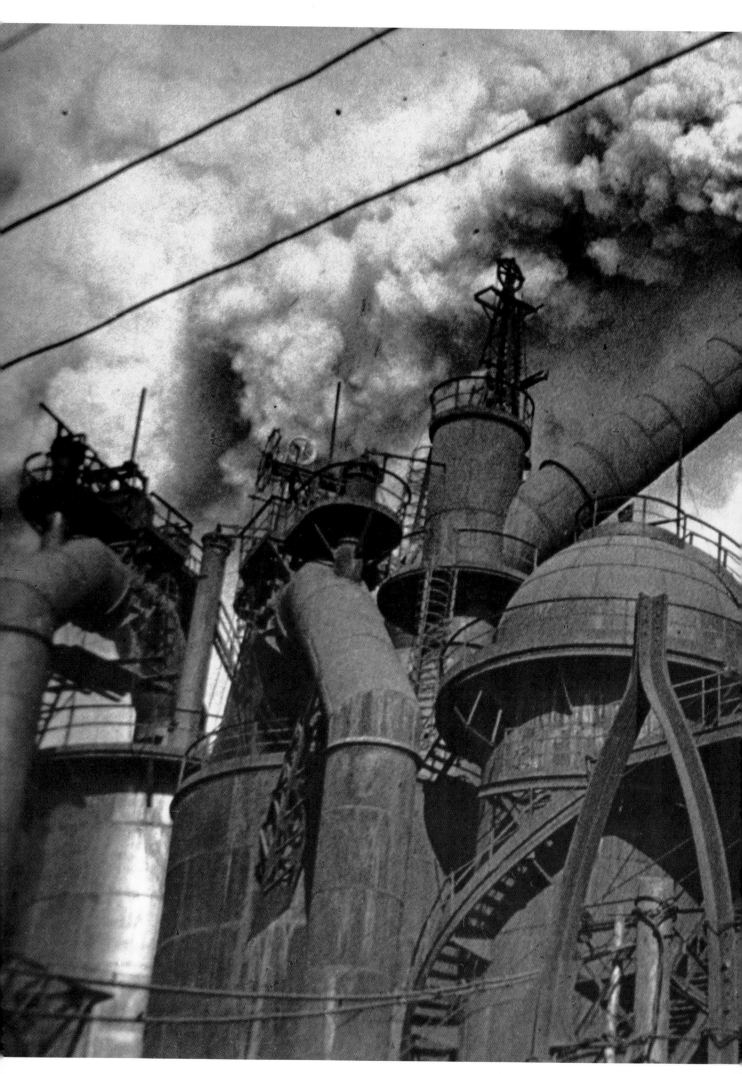

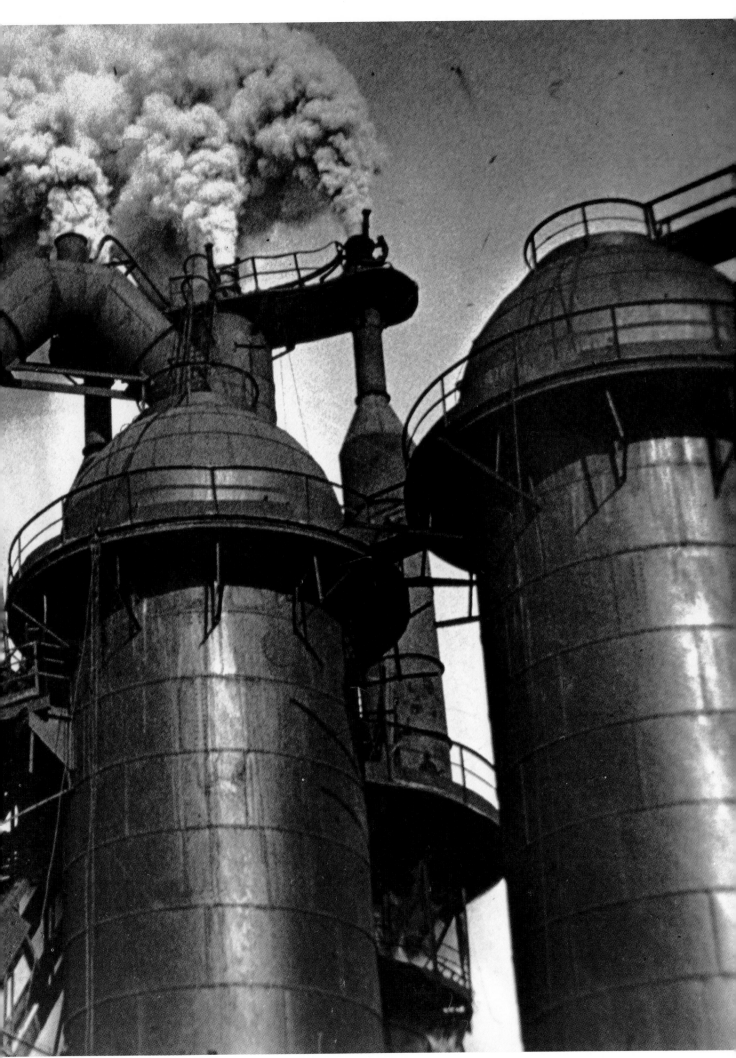

191 Dmitrij Debabov 1936

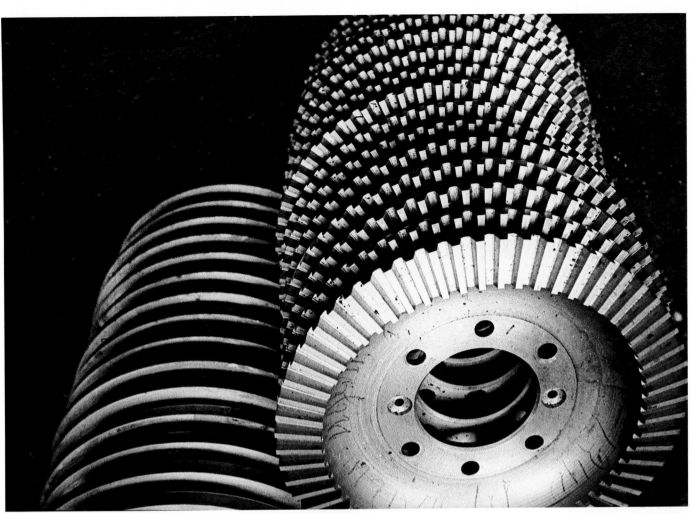

193 Aleksandr Rodčenko 1930

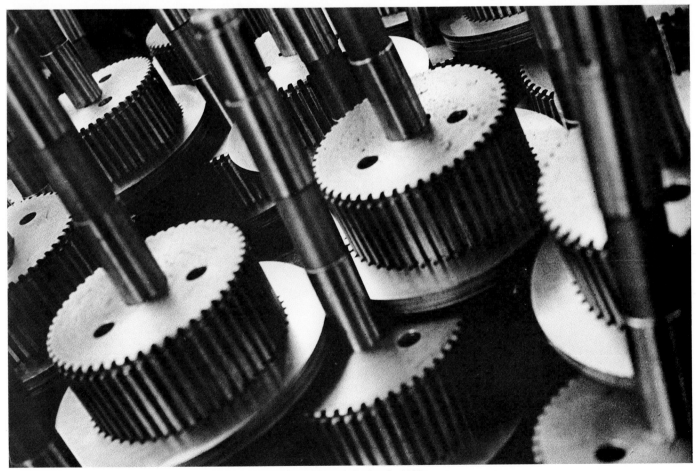

194 Aleksandr Rodčenko 1930

192 Boris Ignatovič circa 1930

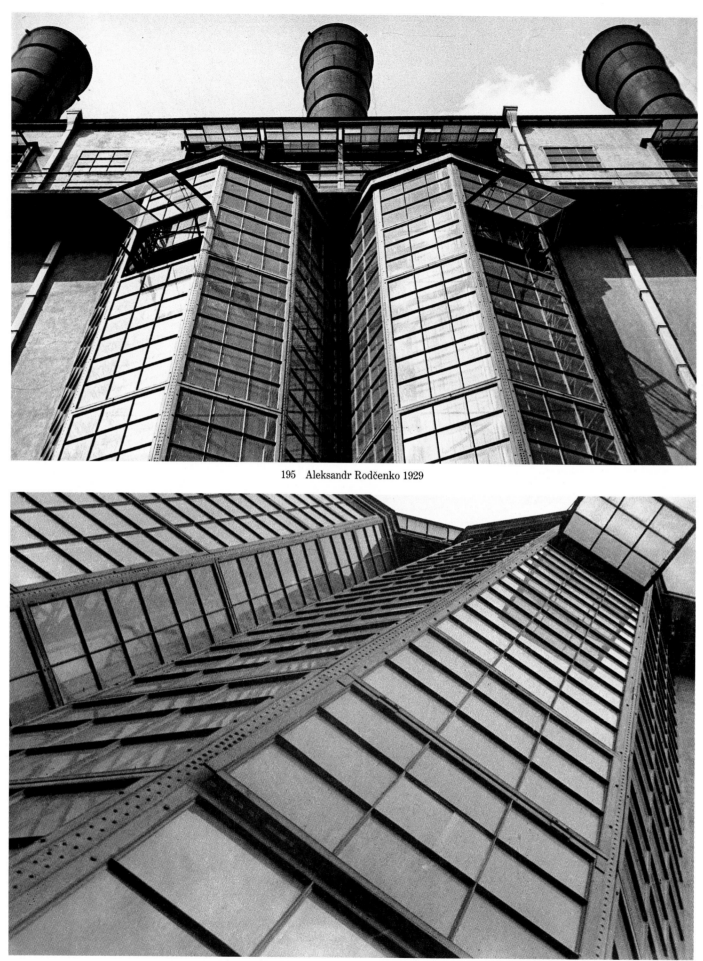

195 Aleksandr Rodčenko 1929

196 Aleksandr Rodčenko 1929

197 Anatolij Skurichin 1932

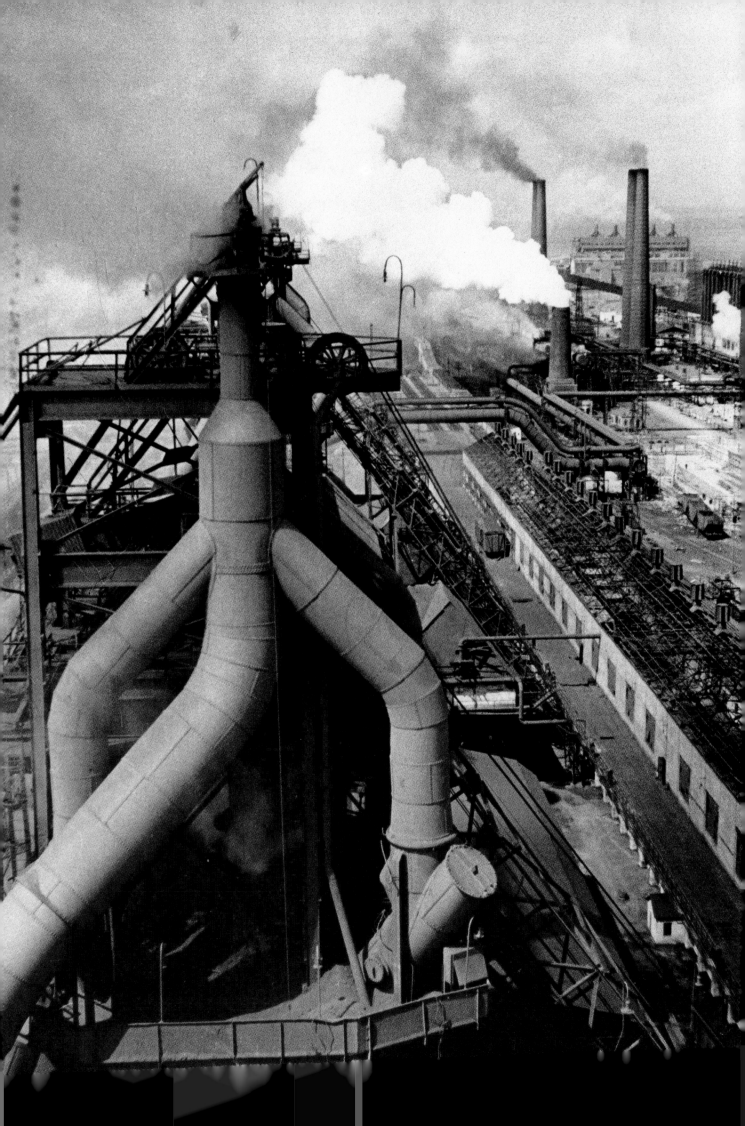

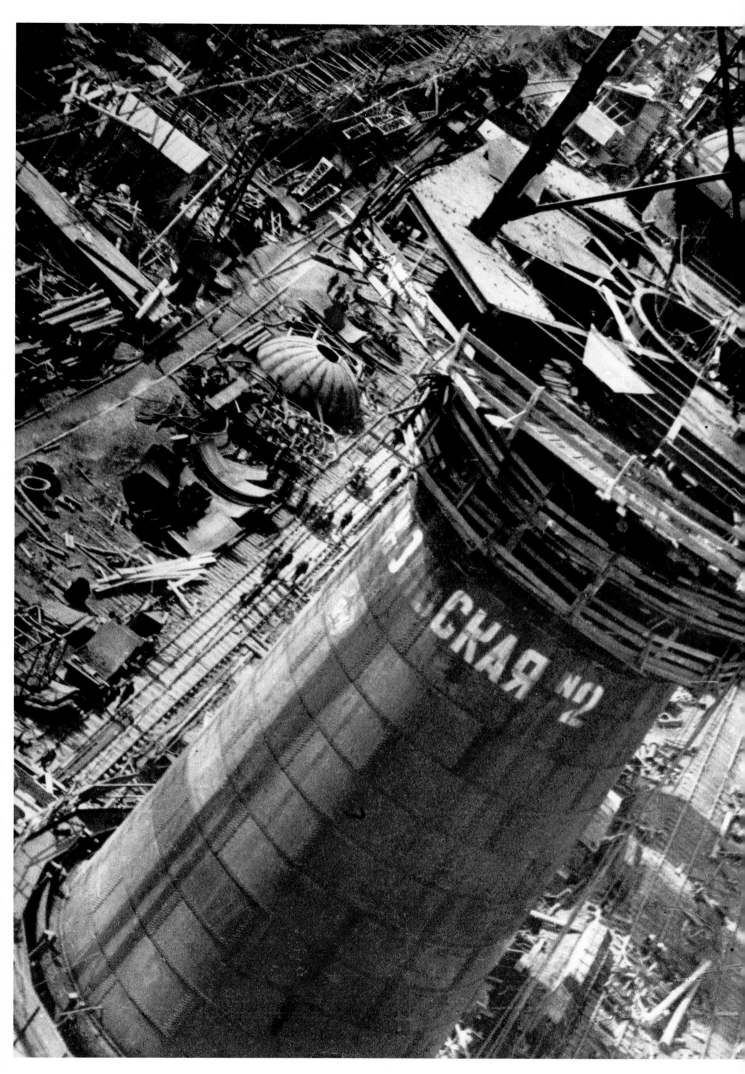

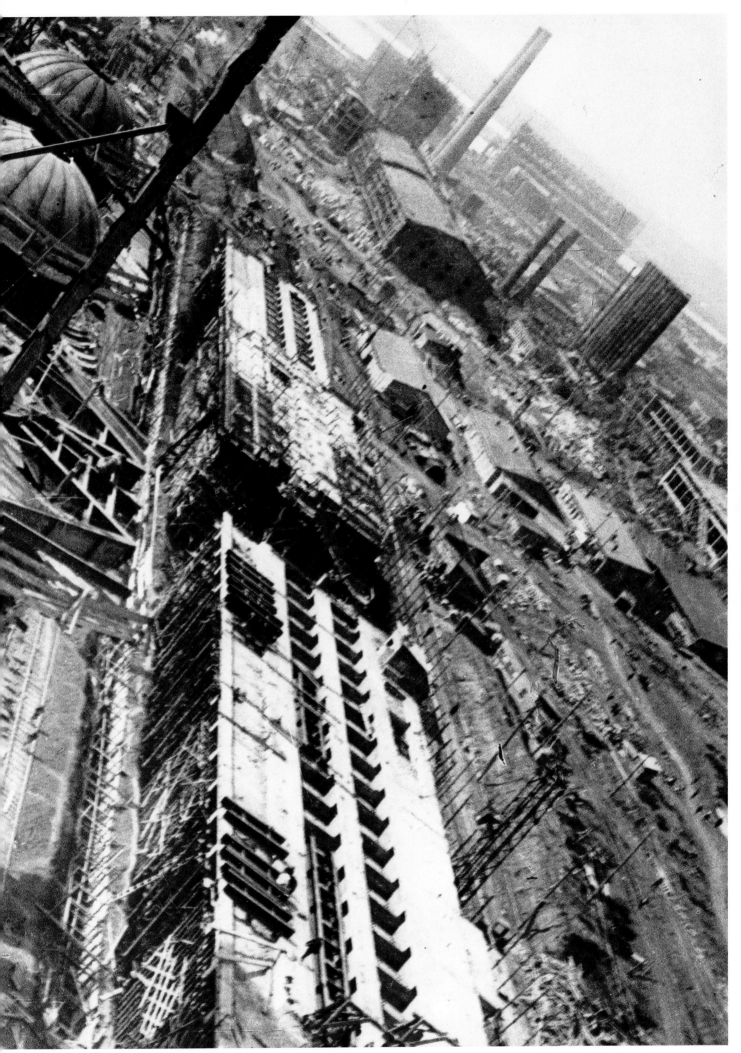

198 Georgij Petrusov 1928

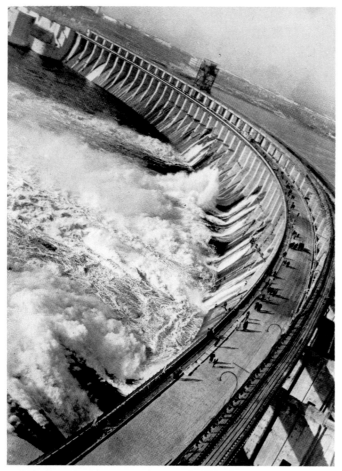

199 Max Alpert 1928

200 Arkadij Šajchet 1930

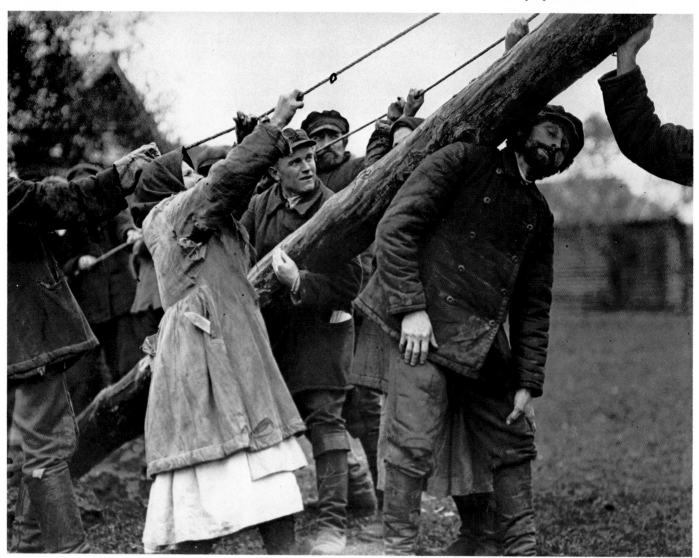

201 Arkadij Šajchet 1925

202 Boris Ignatovič 1925

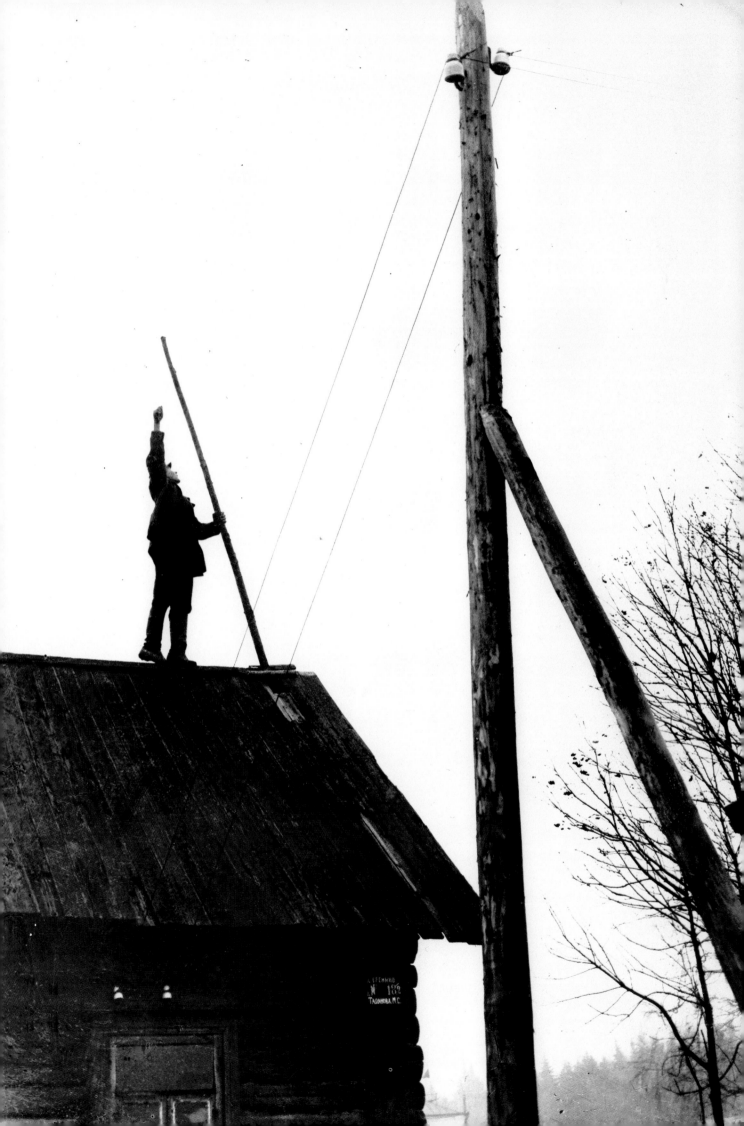

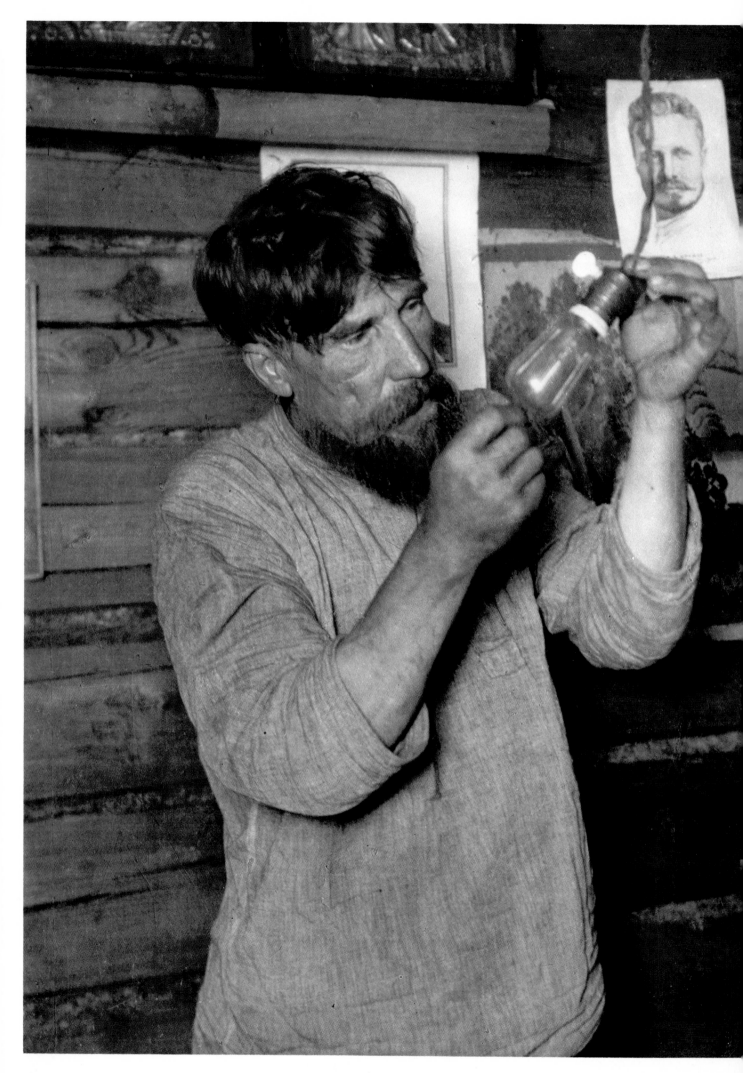

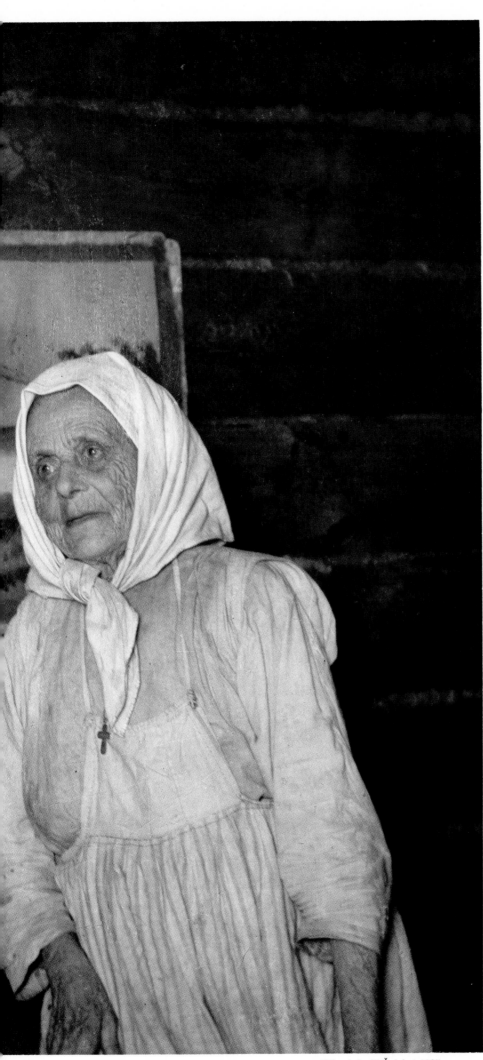

203 Arkadij Šajchet 1925

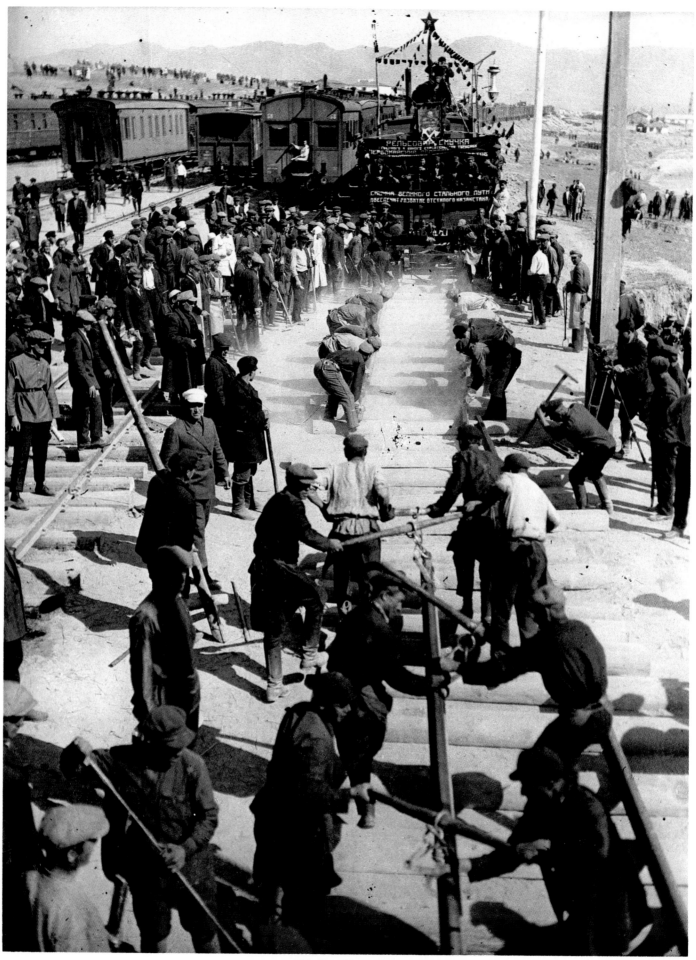

204 Max Alpert 1929

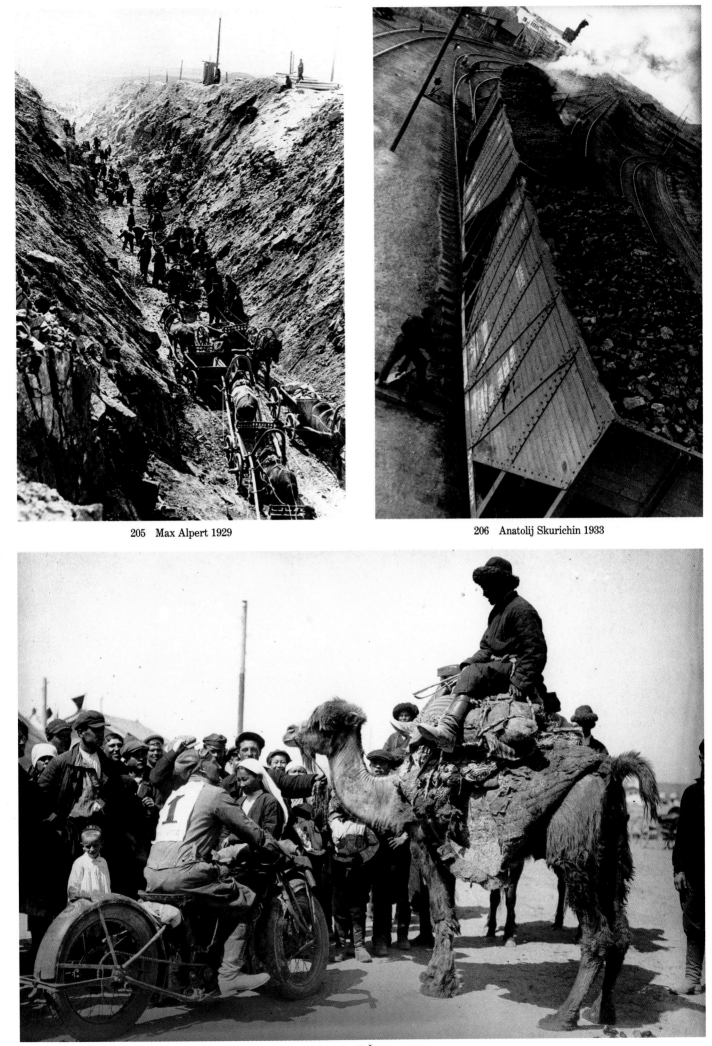

205 Max Alpert 1929

206 Anatolij Skurichin 1933

207 Arkadij Šajchet 1930

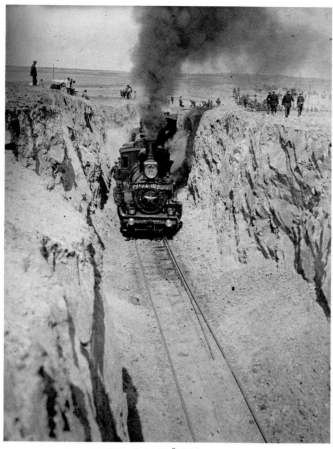

208 Arkadij Šajchet 1930

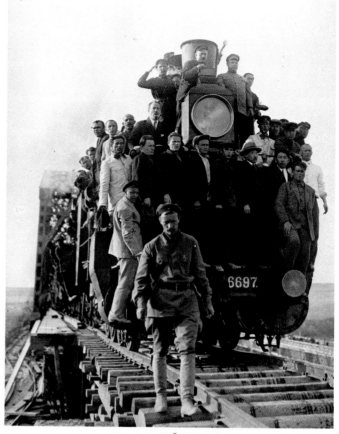

209 Arkadij Šajchet 1930

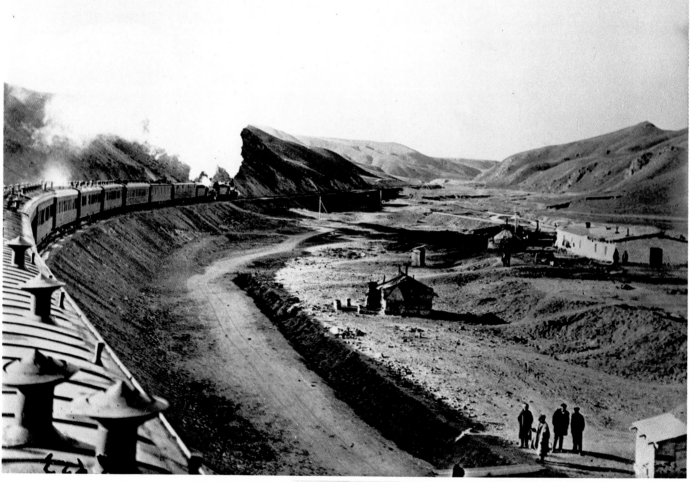

210 Max Alpert 1929

190

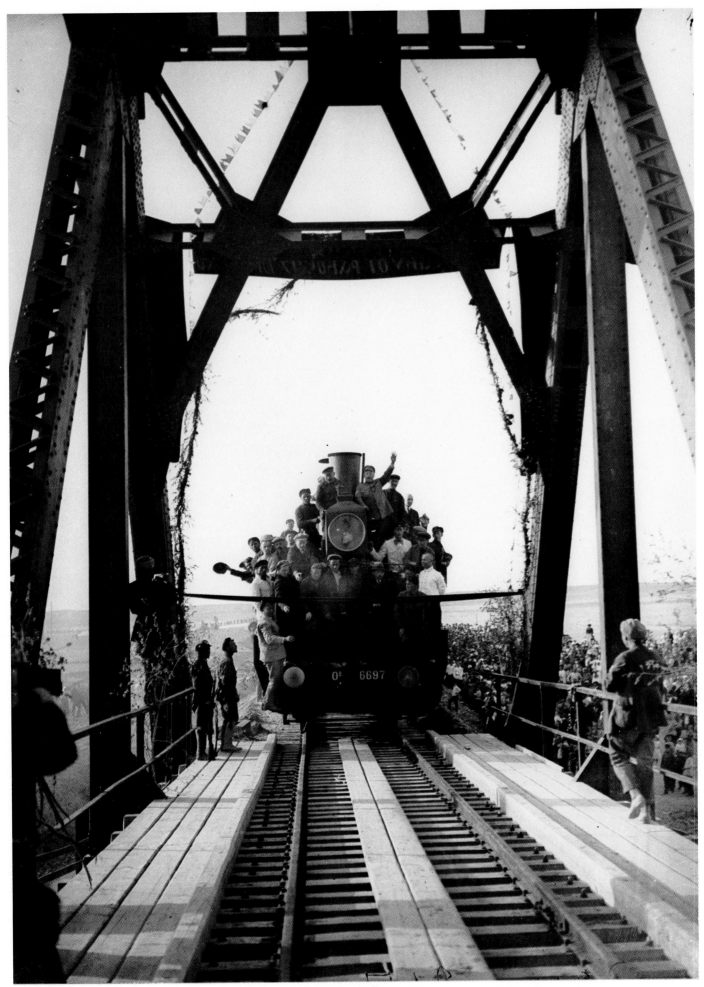

211 Arkadij Šajchet

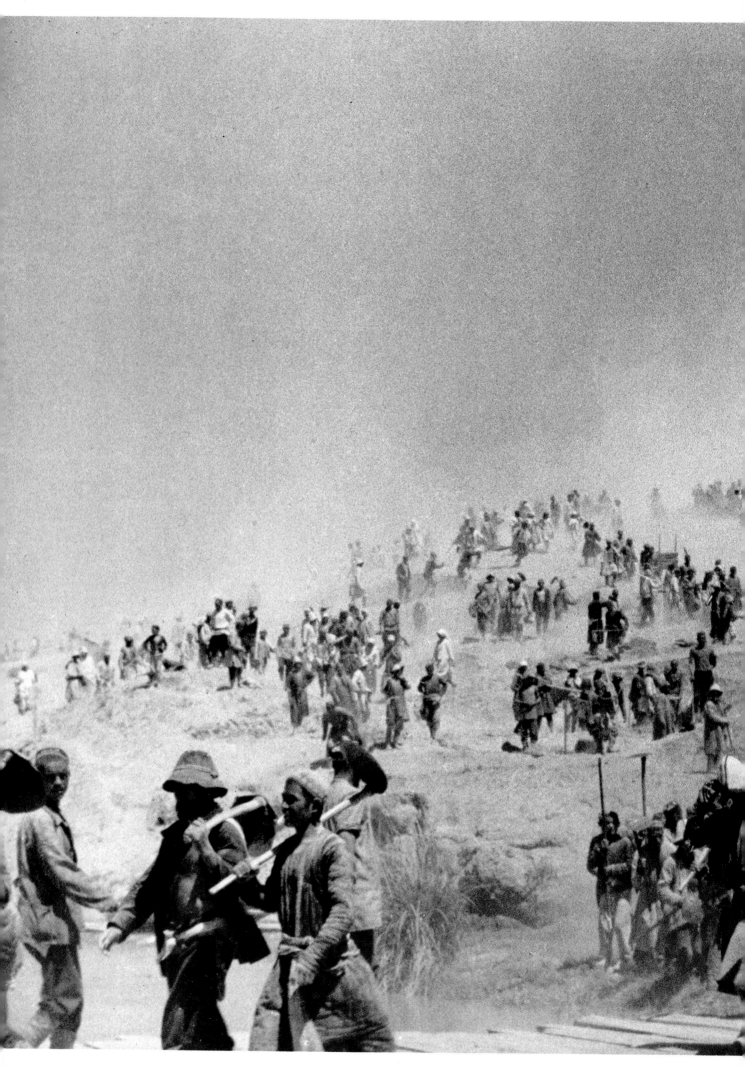

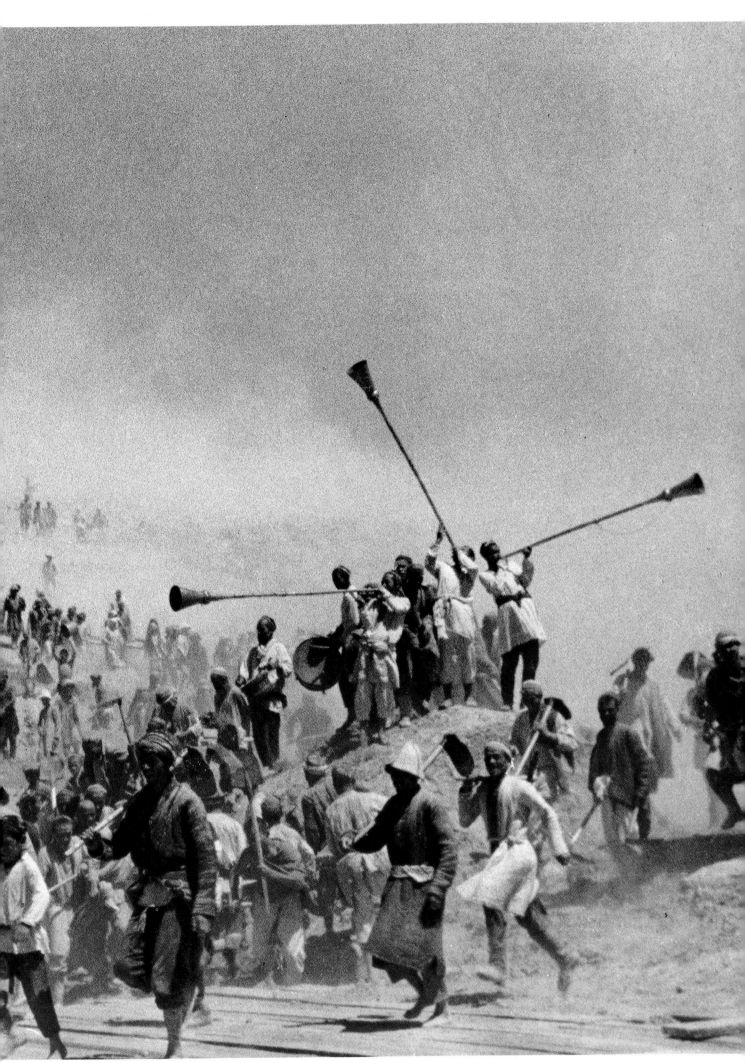

212 Max Alpert 1939

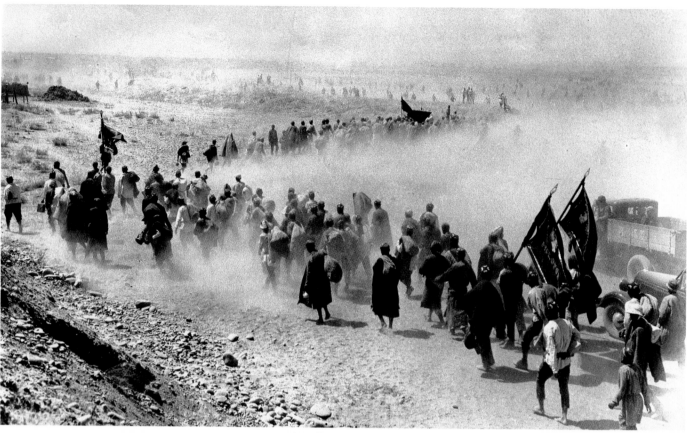

213 Max Alpert 1939

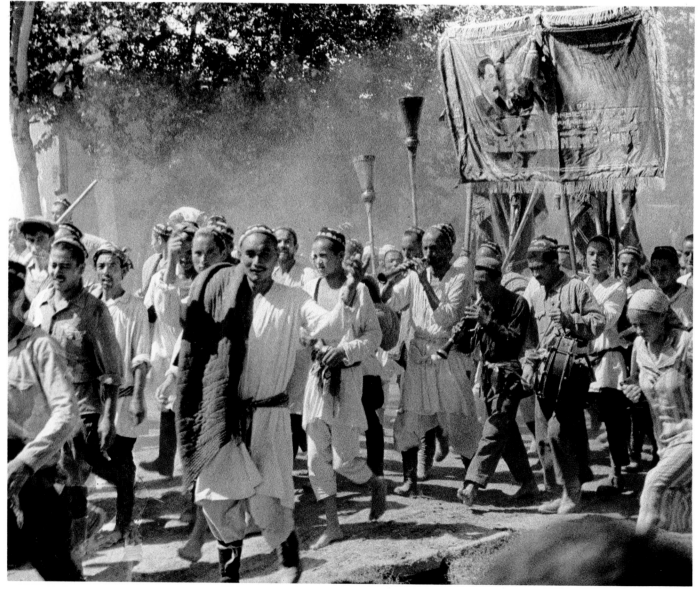

214 Max Alpert 1939

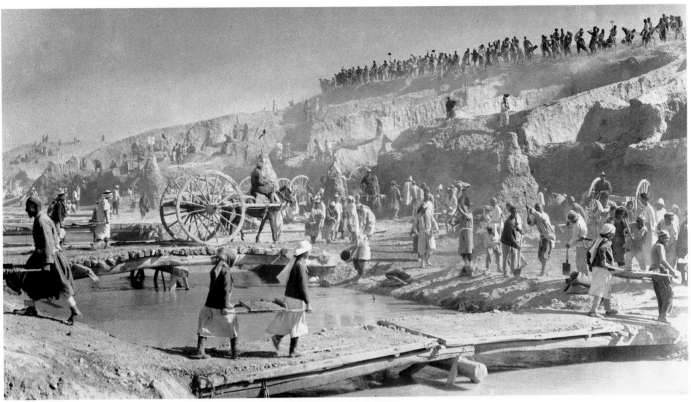

215 Max Alpert 1939

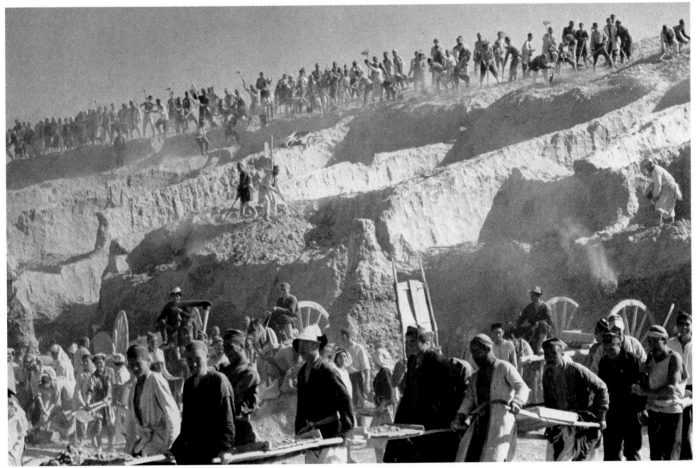

216 Max Alpert 1939

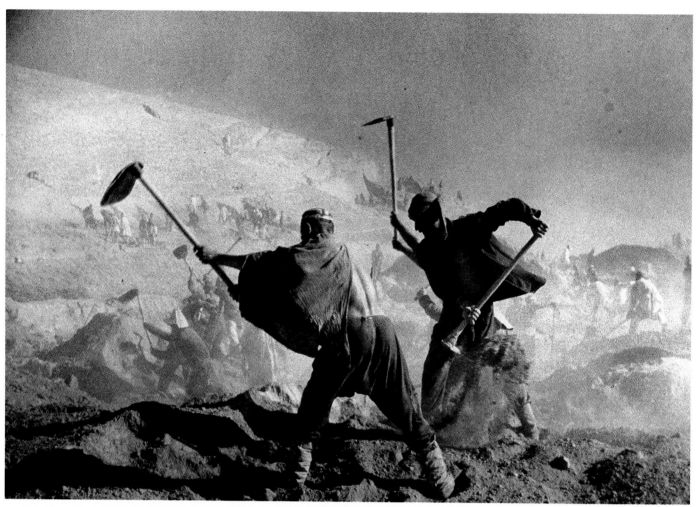

217 Max Alpert 1939

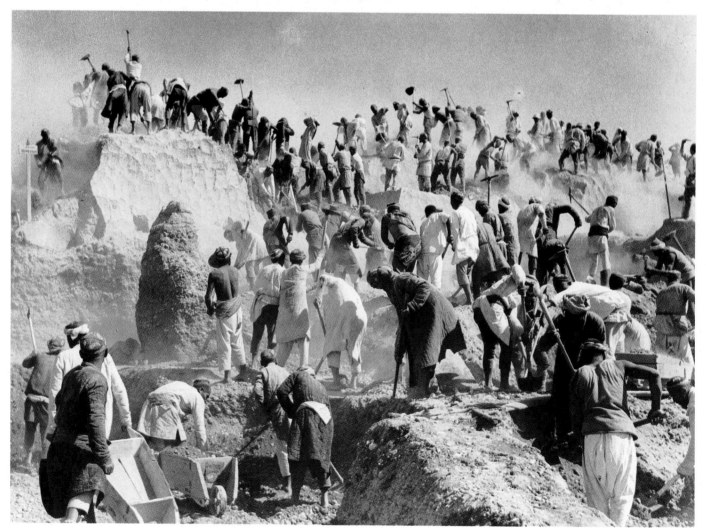

218 Max Alpert 1939

219 Arkadij Šajchet 1931

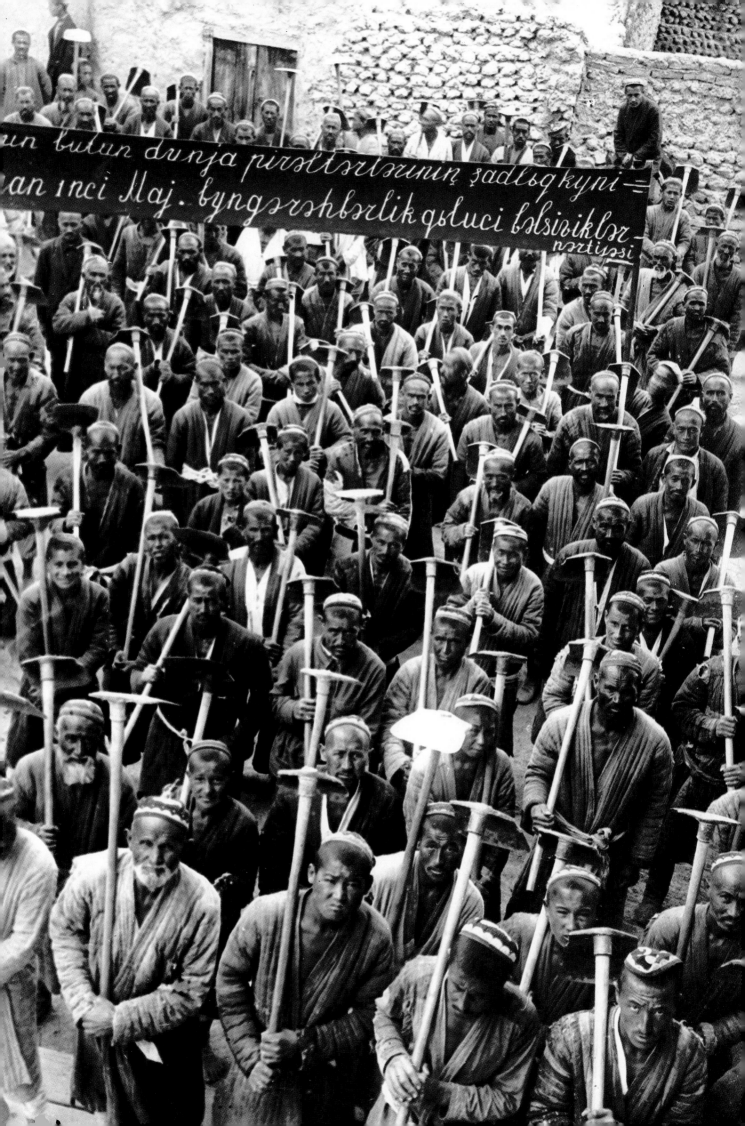

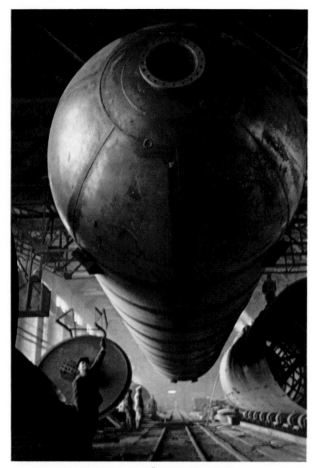

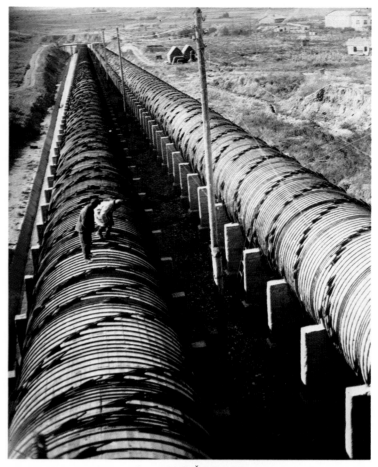

220 Arkadij Šajchet circa 1930

221 Arkadij Šajchet 1930

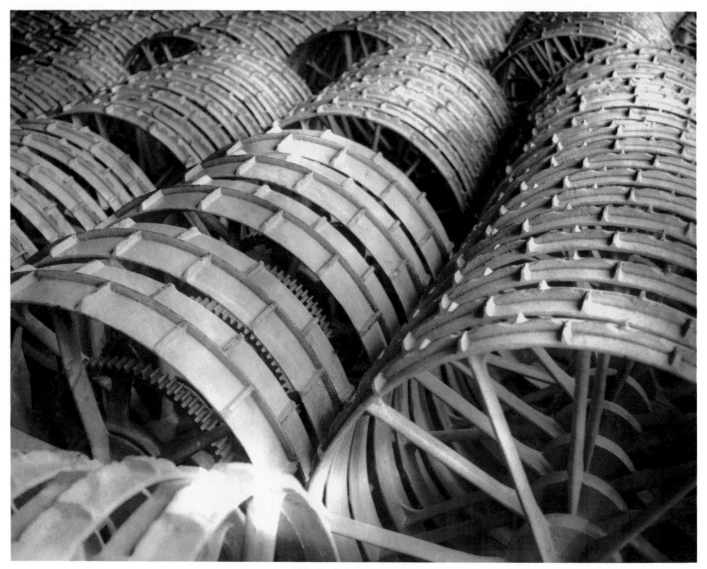

222 Boris Ignatovič 1929

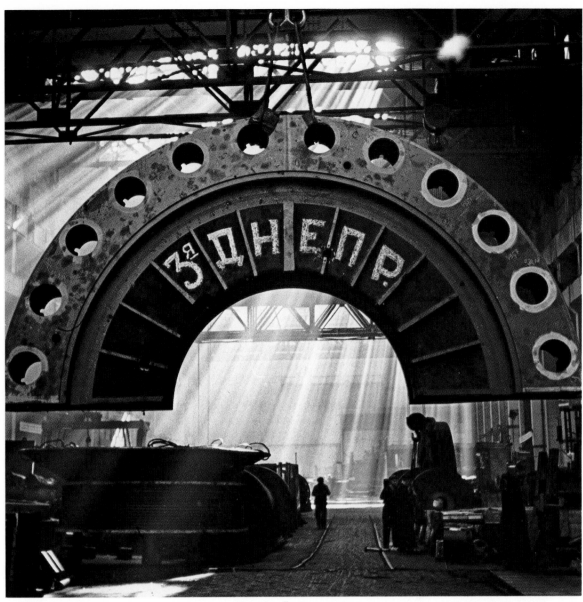

223 Ivan Šagin circa 1930

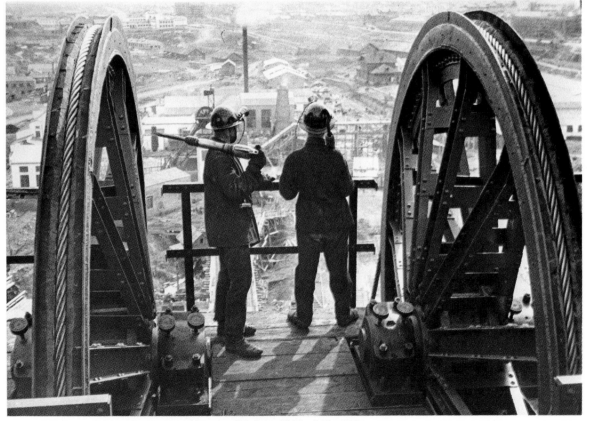

224 Anatolij Skurichin 1932

225 Aleksandr Rodčenko 1933
→

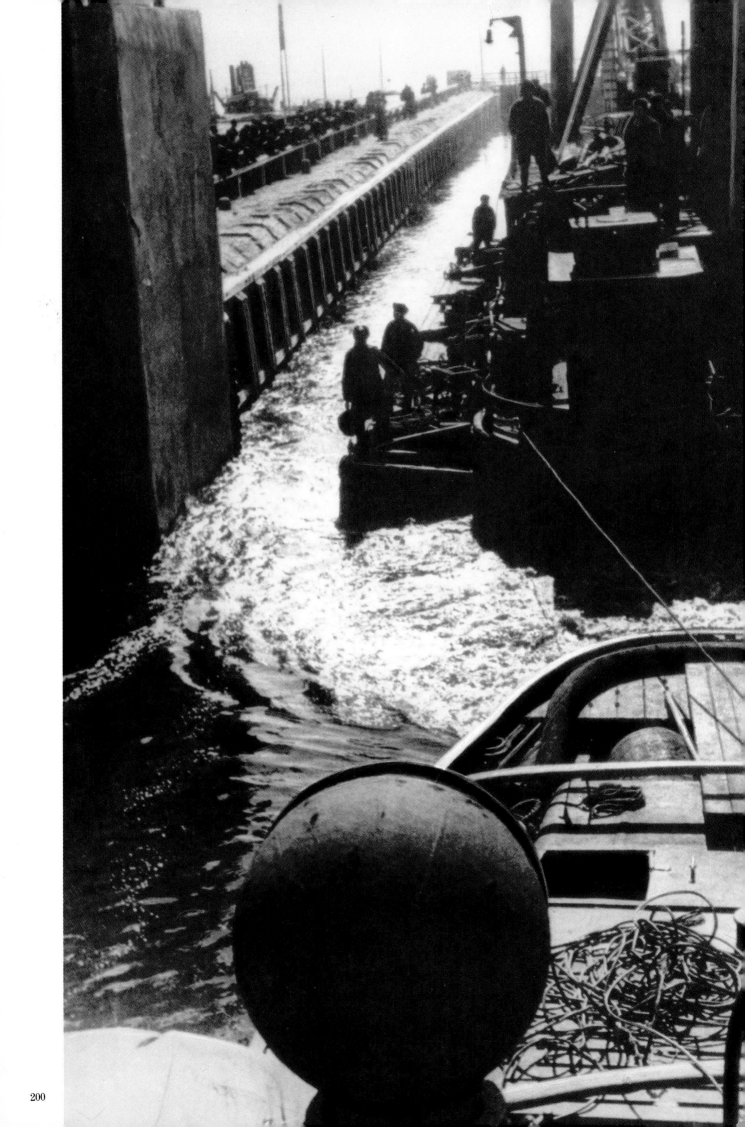

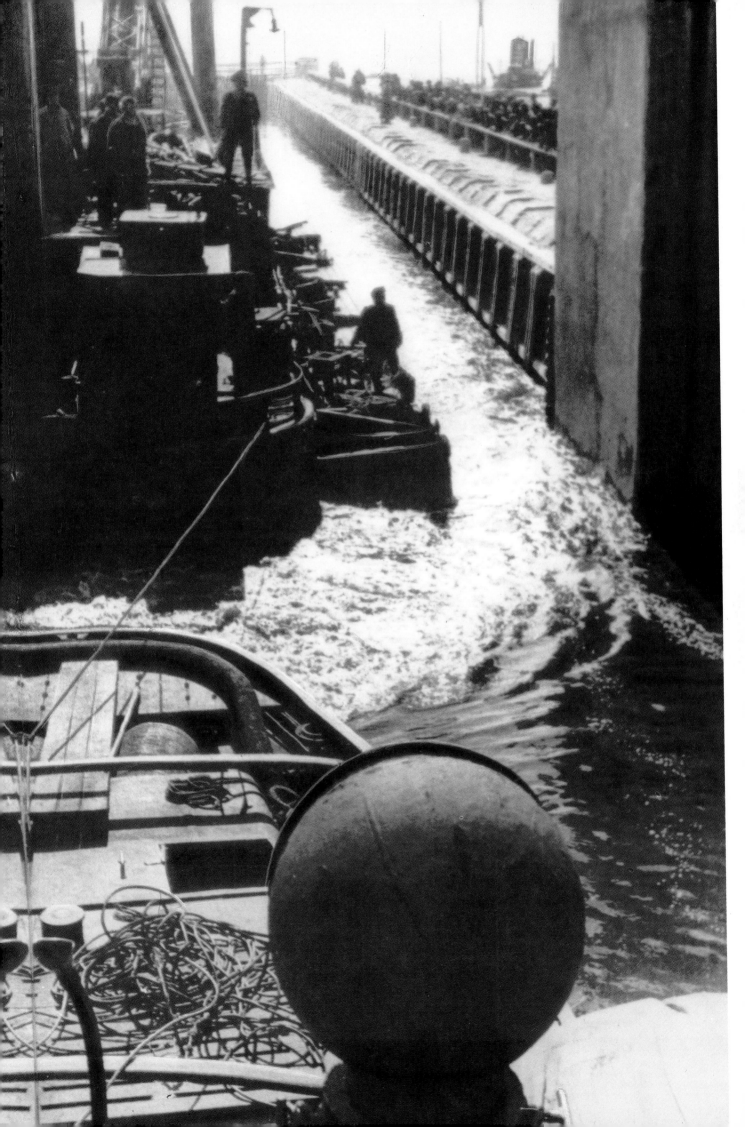

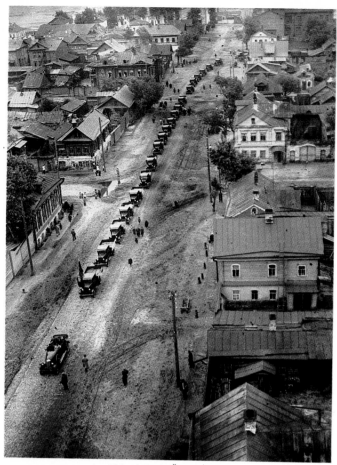

226 Arkadij Šajchet 1930

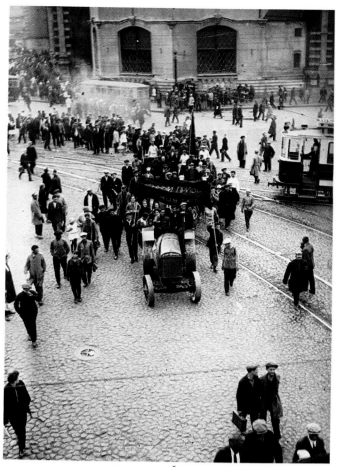

227 Arkadij Šajchet 1930

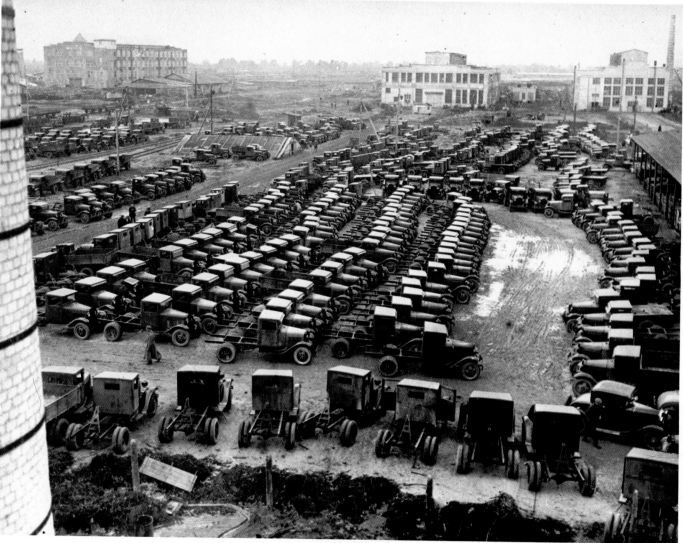

228 Arkadij Šajchet 1930

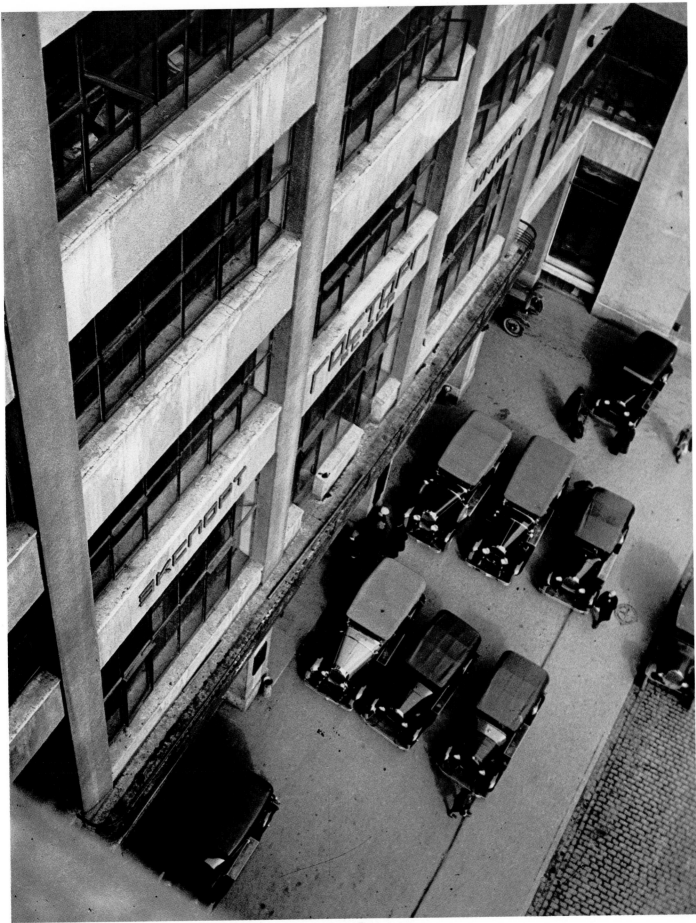

229 Arkadij Šajchet 1932

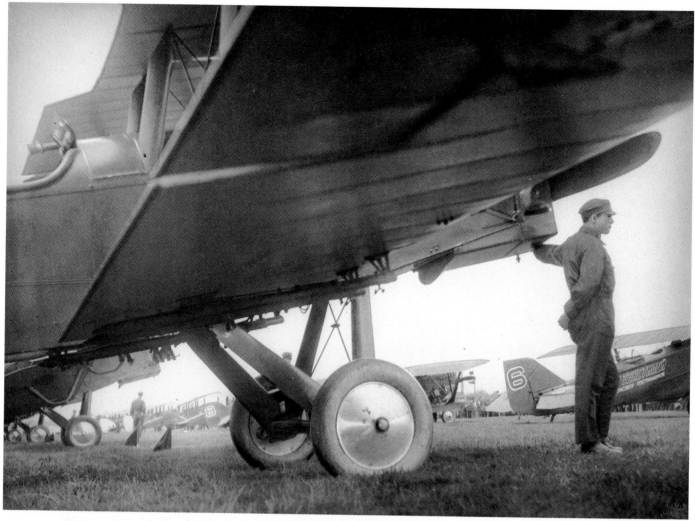

230 Boris Ignatovič circa 1930

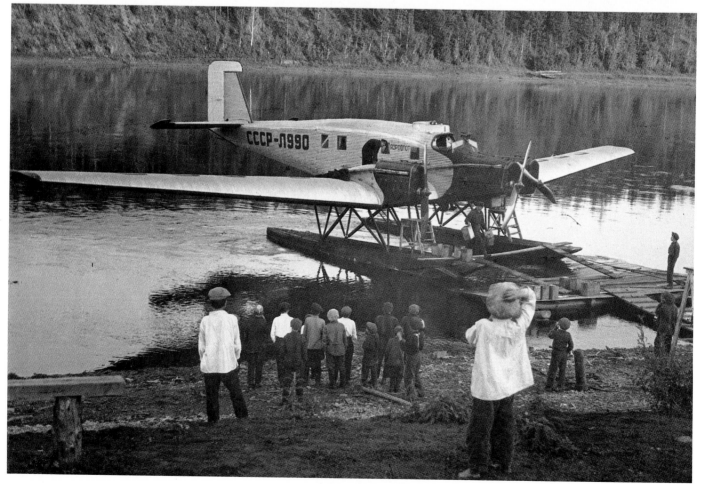

231 Georgij Zelma 1929

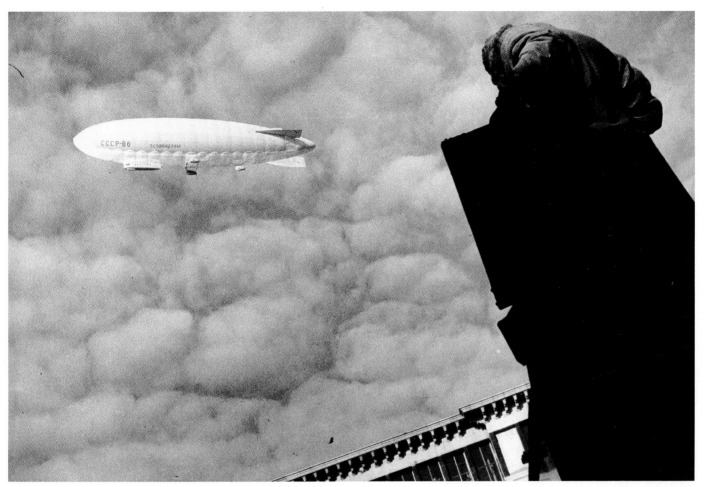

232 Jakob Halip 1937

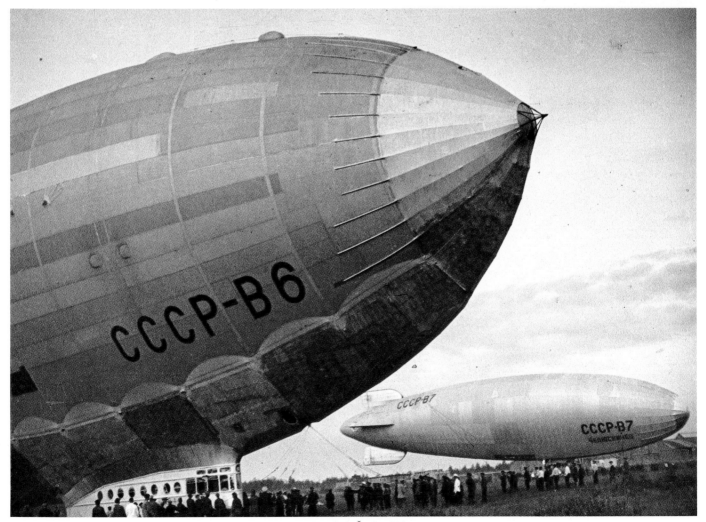

233 Ivan Šagin 1936

234 Dmitrij Debabov 1936

235 Dmitrij Debabov 1936

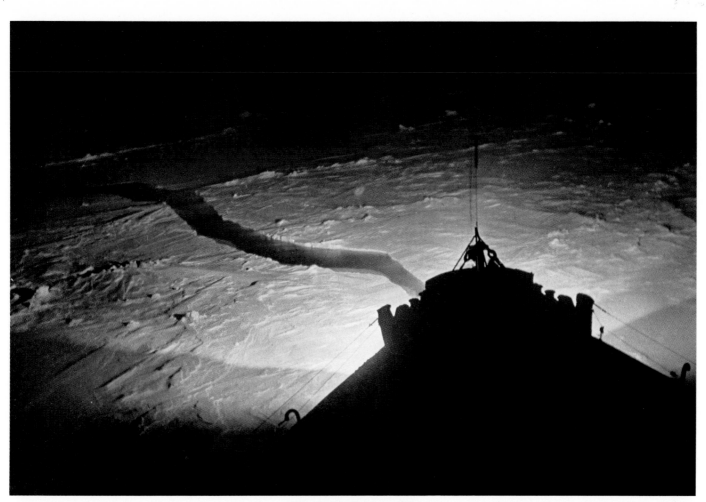

236 Dmitrij Debabov 1939

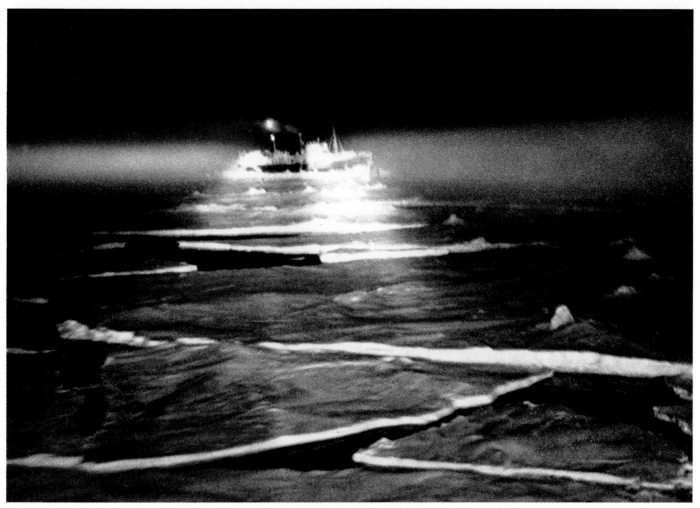

237 Dmitrij Debabov circa 1930

238 Ivan Šagin 1937
→

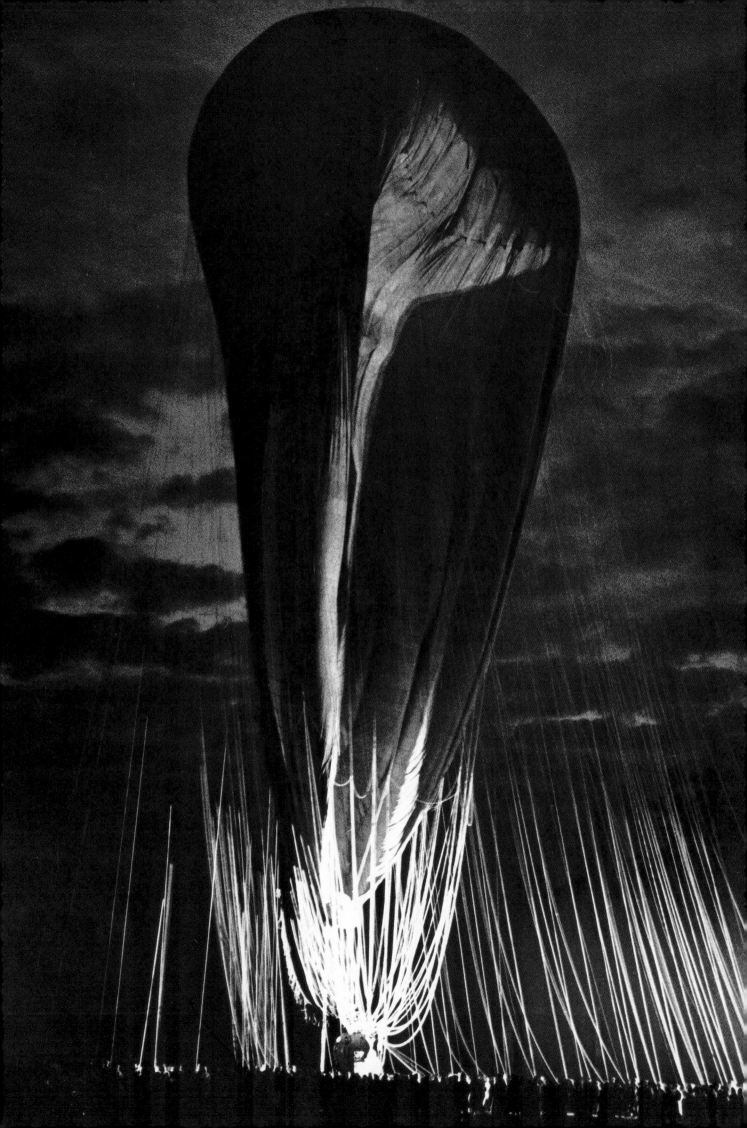

240 Olga Ignatovič 1939

239 Ivan Šagin 1933

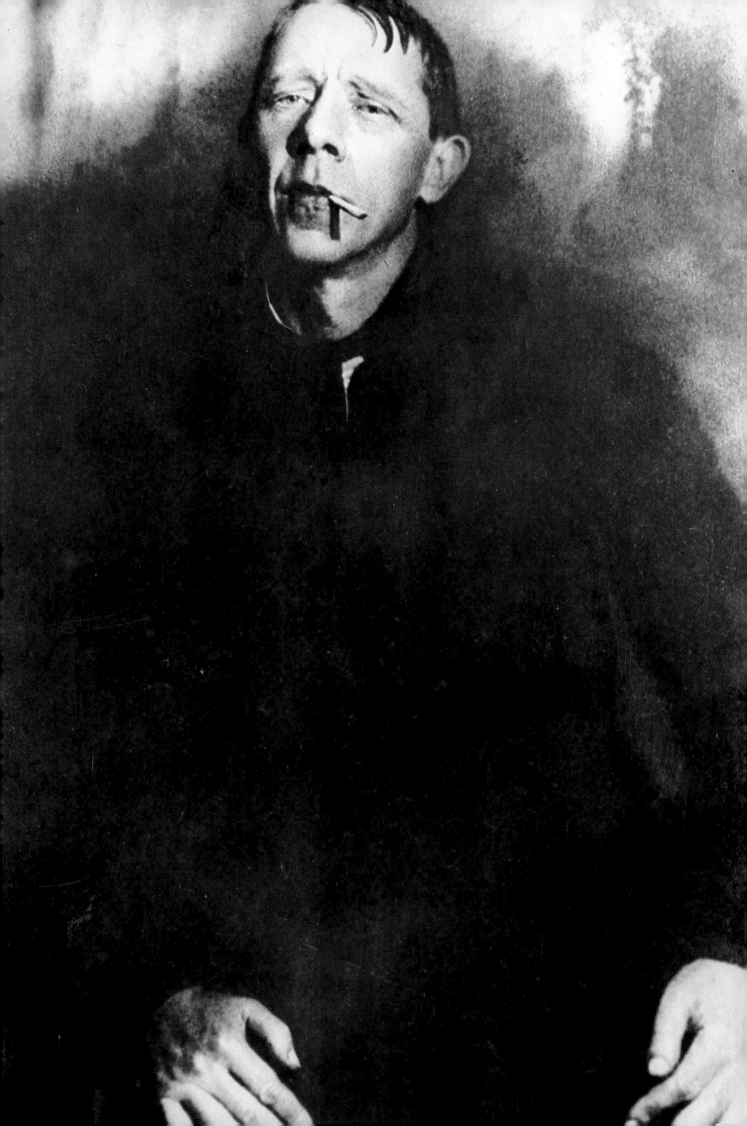

THE WORLD OF ART

From STANZAS

I know a lot
about my talent.
Poetry—there isn't much to it.
More than anything though
it was love for the place
I was born in wearied,
tortured, burned me out ...

Turn out a rhyme—
for Christ's sake anyone can do it—
girls, the stars, the moon.
But another emotion altogether
gnaws at my heart,
different dreams
oppress my skull.

I want to be citizen
and bard,
a pride and example,
a real son,
not a bastard
to the great Soviet state.

Sergey Yesenin, 1924

Notes

241 Mikhail Nappelbaum: *The Painter Vladimir Tatlin* (1928). The painter and sculptor Vladimir Yefgrafovich Tatlin (1885–1953) took part in all the major avant-garde exhibitions, together with Larionov, Goncharova and Malevich. From 1918 to 1921, he taught at the VKHUTEMAS workshops in Moscow, from 1921 to 1925 at the VKHUTEIN workshops in Leningrad, and from 1927 to 1930 at the VKHUTEIN workshops in Moscow. He was one of the founders of Constructivism.

242 Aleksandr Rodchenko: *Portrait of V. V. Mayakovsky* (1926). 'A photograph taken at Pushkino. Mayakovsky arrived in the late afternoon, when there was little light, which is why the shot was taken outdoors. Kotik the dog, who loved ice-cream, had eaten everything that Mayakovsky had bought, which is why the poet is holding him in his arms like a baby.' (A.L.) 'Mayakovsky easily identified with dogs. His nickname was "Shchen" ("little dog"), which was how he signed letters and telegrams.' (*Memoirs of Lili Brik*). Another version of this photograph is cropped to a square format and shows only Mayakovsky's face.

243, 244, 245, 246, 247 Aleksandr Rodchenko: *Portrait of V. V. Mayakovsky* (1927). 'All of these photographs were taken on the same day. The centrings are Rodchenko's own. They were intended for the cover of a collection of Mayakovsky's poems entitled *Conversation with the Tax Inspector about Poetry*. Rodchenko first photographed Mayakovsky standing, wearing the coat. There were two versions of this, but one of the negatives was lost. In the rest of the series, Mayakovsky is seen without the coat. All the photographs were taken in Rodchenko's studio, and the lack of space created difficulties.' (A.L.) An extract from Mayakovsky's diary for the year 1927: 'I am reorganizing *Lef* (after an attempt at "compression"); it is already *Novyi*.... My essential work: *Komsomolskaya Pravda*. I am writing *It's OK* in my spare time.... I will pursue this project to its conclusion. Furthermore, I have written scripts and some children's stories. I continue playing the minstrel....'

248, 249 Aleksandr Rodchenko: *The Film-Maker Yesfir (Esther) Shub* (1924). Yesfir Shub (1894–1959) was a member of the art group which formed around the magazine *Oktiabr* (Union of New Departures in Artistic Work), comprising S. M. Eisenstein, the architects A. and I. Vesnin, and V. Stepanova, as well as numerous other artists. Yesfir Shub – like Dziga Vertov – made 'unacted' cinema, a genre which had the approval of the *Novyi Lef* team: she invented the notion of the documentary film based on archive material, and made the following documentaries: *The Fall of the House of Romanov*, *The Great Path* (1927) and

The Russia of Nicholas II and Leo Tolstoy (1928). Eisenstein worked as her assistant on the re-editing of Fritz Lang's *Doctor Mabuse* in 1924. 'Shub was thinner and more photogenic seen in profile. She was the wife of Aleksey Gan, a designer and man of many talents. For this photograph, the problem was again one of lighting – Rodchenko's studio had little natural light – added to which he used a very slow film. This explains the layout on the table, which served to reflect light and so reduce the exposure time.' (A.L.)

250 Aleksandr Rodchenko: *The Poet N. N. Aseyev* (1928). 'Photographed along the diagonal, from very far away.' (A.L.) A poet and critic, Nikolay N. Aseyev was, together with Tretyakov, a member of the 'Creation' art group in Siberia, of the Futurist group 'Centrifuge' and, finally, of 'Lef'. His collections of verse were entitled: *The Steel Nightingale*, *Songs of October*, and *Poem of the Twenty-Six Commissars of Baku*. His criticism includes *Journal of a Poet* and *Working on Verse*, as well as articles on Mayakovsky.

251 Aleksandr Rodchenko: *S. Kirsanov, A. Rodchenko, N. Aseyev* (1930). 'Photograph taken in Rodchenko's studio, probably by Stepanova, who was familiar with his use of such angles for shots. While Aseyev's face was easy to photograph, Rodchenko's was not, which is why he is shown from above – an angle which suited him. Notice the composition's very interesting diagonal.' (A.L.) Semyon Isaakovich Kirsanov wrote the poem entitled *The Five-Year Plan*. He took part in the 'Lef' movement.

252 Aleksandr Rodchenko: *Double Portrait of Aleksandr Shevchenko* (1924). 'This is one of Rodchenko's earliest attempts, for it was during the winter of 1924 that he began taking photographs. This was also the moment when the first issues of the magazine *Lef* were appearing, and an occasion – as well as an excuse – to record on film all his friends and fellow-contributors to the magazine: Brik, Aseyev and others. Amongst these was Shevchenko, then a painter at VKHUTEMAS, whose workshops were housed in the building in which Rodchenko's daughter Varvara and her son Aleksandr Lavrentiev still live today. It is a double exposure because, although a beginner, Rodchenko was already attracted to experimentation. A similar photograph of his wife Stepanova, in which three shots are superimposed in one frame, was taken during the same period. This, however, was an unsuccessful attempt.' (A.L.) Aleksandr Vasilyevich Shevchenko (1883–1948) was a painter in the tradition of Cézanne.

253, 254 Aleksandr Rodchenko: *The Painter Varvara F. Stepanova* (1924). Varvara Fedorovna Stepanova (1894–1958) worked as a designer for the first State textile factory, and made posters, theatre sets and typography. She took part in the '5 × 5 = 25' exhibition. In 1920, she became a member of INKHUK, and later was made a teacher at VKHUTEMAS (in the textile faculty). She was also a member of 'Lef' and 'Novyi Lef', and worked on the magazine *USSR in Construction*. She met Rodchenko in 1911. 'The first photograph, in which she

is wearing a hat designed by Rodchenko, dates from 1924. Here, Rodchenko was attempting to portray a "woman of the twenties". The other photograph, dating from 1928, was taken at a table. The unusual reflection is made by a glass – which Rodchenko also used in various still lifes – and by an optical mirror, which served both to reflect the image and to magnify it.' (A.L.)

255 Aleksandr Rodchenko: *Osip Maksimovich Brik. Photomontage for the Magazine* Lef (1924). The magazine *Lef* ('Left Front of Art', which became *Novyi Lef* from 1927 to 1929) brought together Dziga Vertov, Sergey Eisenstein, Boris Pasternak, Stepanova, Rodchenko, Osip Brik, Mayakovsky and Tretyakov. 'The fundamental position of *Lef*: against illusion, against aesthetics and psychologizing in art; for the propaganda piece, for skilled journalism and news reporting.... One of the watchwords, one of the great achievements of *Lef*, is the de-aestheticizing of the applied arts – Constructivism. Its poetical adjunct is the poem of economic agitation – the advertisement.' Osip Maksimovich Brik (1888–1945), the husband of Lili Brik, with whom Mayakovsky was in love, published the latter's poems. He was also one of the founding theoreticians of the poetical language theory, together with Jakobson and Shklovsky. 'Here, at the very inception of his career as a photographer, Rodchenko resorts to experimentation and makes a photomontage. In order to represent the various members of *Lef*, he uses a metaphor: Brik only knew how to deal with one thing at a time, for which he would abandon everything else: at this moment, it was the magazine *Lef*.' (A.L.)

256 Aleksandr Rodchenko: *Valentin Katayev* (1929). 'A famous photograph. Note the beauty of the profile and the originality of the angle used for the shot (along the diagonal), which succeeds in spite of the restricted location.' (A.L.) Valentin Petrovich Katayev, born in Odessa in 1897, was the author of *The Ehrendorf Island* (1921), an adventure story, and *The Embezzlers* (1927), a satirical novel. He also wrote a book about the Five-Year Plan project to build Magnitogorsk, entitled *On with Time* (1932). The author of *Grass of Oblivion* and *The Sacred Well*, he is also known for his plays *Squaring the Circle* (1929) and *I Want to See Myusov*.

257 Aleksandr Rodchenko: *Sergey Tretyakov* (1927). 'Man of the theatre, poet, translator and journalist, literary theoretician and avant-garde militant, Tretyakov believed himself to be the ideologist of the cultural revolution and teacher of the new socialist man. He attempted to weld into a single fighting force the political culture of the USSR, Marxist-Leninist ideology and the beliefs of the artistic avant-garde.' (Henri Deluy). Sergey Tretyakov (1892–1939), a contributor to *Lef* and *Novyi Lef*, was a mentor and friend to Bertolt Brecht. He was probably the earliest theoretician of 'alienation' in the theatre, an idea that was further developed by Brecht. Tretyakov was also a poet (*The Iron Pause*, 1919, and *The Octobrists*, 1923) and a dramatist (*Roar, O China*, directed by Meyerhold). 'One of Rodchenko's

friends and collaborators on *Lef*, whom he photographed several times. Here, the camera which was used required a long exposure time. Several versions of this photograph exist, but with only small variations in the angle of the profile.' (A.L.)

258 Mikhail Nappelbaum: *The Poetess Anna Akhmatova* (1924). Anna Andreyevna Gorenko (1899–1966) chose as a pseudonym the name of her maternal grandmother, a Tartar princess. She was a member of 'The Stray Dog', a poetry circle in St Petersburg and a meeting place for Aleksandr Blok, Mayakovsky, Osip Mandelstam, Sergey Yesenin and Nikolay Gumilyov her husband. Gumilyov, Akhmatova and Mandelstam were the founders of a new school of poetry, 'Acmeism'. Their manifestos, which were published in the magazine *Apollo*, proclaimed a break with the languorous symbolism current at the time, in an effort to push language to its 'acme' or limits of clarity and precision.
'Rosary beads around my neck
Hands hidden in a large muff
I watch vaguely.
Never again shall my eyes weep.

The silk's mauve shadows
Make my face even paler,
My straight fringe
Almost touching my eyebrows.'

259 Mikhail Nappelbaum: *The Poet Eduard Bagritzsky* (1928). Eduard Georgyevich Bagritzsky (1896–1934), a poet who was won over to the Constructivist movement but managed to retain a style of his own which influenced a number of other poets. His most famous poems are *Duma for Opanas* (1925), *Victors* (1932) and *The Last Night* (1933).

260 Mikhail Nappelbaum: *The Poet Aleksandr Blok* (1921). Aleksandr Aleksandrovich Blok (1880–1921) is generally considered to be the greatest of the Russian Symbolist poets. His style became increasingly 'Scythian'. He was the son-in-law of Mendeleyev, the great chemist.

261 Mikhail Nappelbaum: *The Poetress Anna Akhmatova* (1924). See No. 258.

262 Mikhail Nappelbaum: *The Poet Sergey Yesenin* (1924). Sergey Aleksandrovich Yesenin (1895–1926), a very popular poet to whom Mayakovsky dedicated a famous poem, is here photographed two years before his suicide.

263 Mikhail Nappelbaum: *The Writer and Academician Anatoly Lunacharsky* (1924). Anatoly Vasilyevich Lunacharsky (1875–1933) was a politician and writer. Arrested and deported after the defeat of the 1905 Revolution, he returned to the USSR after the October Revolution and was People's Commissar for Education and Enlightenment until 1929. He reorganized the State education system and was responsible for the fine arts, during which time he encouraged avant-garde artists. He was himself an author of historical dramas (*Oliver Cromwell*, 1920, and *Campanella*, 1922), an art and literary historian and a publicist. In these capacities, he launched an appeal on 16th November 1917 for the protection of works of art: 'Comrades!... You are the young rulers of this country, and although

at present you have many other things to worry and preoccupy you, you must also think of protecting your artistic and scientific heritage. I implore you, comrades, to support me and help preserve the beauties of our country, for yourselves and your descendants. Let us be the guardians of our nation's wealth....'

264 Mikhail Nappelbaum: *The Poet Mikhail Kuzmin* (1928). Mikhail Alekseyevich Kuzmin (1875–1953) was one of the first strenuous opponents of Symbolism and the founder of 'Clartéism', a poetical style whose ideal was clarity of expression. He was also a musician, a collaborator of Diaghilev, and a creator of pantomimes and operettas. Certain aspects of his work are reminiscent of the Russian traditions of the Old Believers.

265 Mikhail Nappelbaum: *The Writer Valentin Katayev* (1944). See No. 256.

266 Mikhail Nappelbaum: *The Composer Aleksandr Glazunov* (1918). Generally considered to be the last representative of the great 19th-century school of Russian music, Aleksandr Konstantinovich Glazunov (1865–1936) was primarily a symphonic composer. Among his most important works are eight symphonies, three ballets and seven symphonic poems.

267 Mikhail Nappelbaum: *The ballerina Galina Ulanova* (1933). Born in 1910, Galina Ulanova is generally considered to be the greatest Soviet ballerina of our time. She was a member of the Kirov ballet and subsequently of the Bolshoi, and her career as a dancer only ended in 1960, when she became a teacher in the tradition of classical Russian choreography.

268 Mikhail Nappelbaum: *The Theatre Director Vsevolod Meyerhold* (1932). 'Meyerhold! The genius of a creator allied to the treachery of an individual. Those who loved him without reserve, like myself, suffered innumerable torments, but also innumerable moments of elation when witnessing the creative magic of this inimitable theatre magician.... What hell I suffered – though only temporarily, thank God – before being lifted up to paradise in the ranks of his theatre when I "dared" present my own collective – in the Proletkult.' (Sergey Eisenstein, *Memoirs*). Vsevolod Meyerhold (1873–1938) was, together with Stanislavsky and Danchenko, one of the founders of the Moscow Arts Theatre. He invented Constructivist scenography and biomechanistic acting techniques, and directed Mayakovsky's plays.

269 Mikhail Nappelbaum: *The Theatre Director Konstantin Stanislavsky* (1942). Konstantin Sergeyevich Alekseyev, known as Stanislavsky (1863–1938), founded the Moscow Arts Theatre, together with Nemirovich-Danchenko. He was one of the great theatre directors of our time, author of an *Ethics of Theatre*, and creator of a revolutionary system of teaching and acting. His 'psychotechnical' method, which he taught until 1936, induced in the actor an inward awareness of the character he was to play, so that he would abandon completely his own identity while on stage. The Russian Revolution, together with advances in the

human sciences, led Stanislavsky to evolve a new system, the 'physical actions' method. This theory was close in spirit to those of Brecht and Jouvet, according to which the character is no longer the hero of 19th-century fiction, but rather a witness or critic of the times in which he lives. Stanislavsky became known for his productions of Chekhov (*The Seagull*, *The Cherry Orchard*, *Uncle Vanya*) as well as of Gorky (*The Underworld*), of Maeterlinck (*The Blue Bird*), of Strindberg and of Andreyev.

270 Mikhail Nappelbaum: *The Actress Fayna Ranevskaya* (1928). Born in 1896, this theatre actress made her stage début in 1915. She was a member of the Mossoviet company. Among other parts, she played the title-role in Gorky's play *Vasa Zheleznova*. She also appeared in a number of films.

271 Mikhail Nappelbaum: *The Actress Vera Pashennaya* (1932). A theatre actress (1887–1962). Attached to the Maly theatre, she was a representative of the realist school of Russian acting. From 1941 onwards, she taught acting.

272 Mikhail Nappelbaum: *The Actor Igor Ilyinsky* (1934). A pupil of Meyerhold, he acted in Zheliabuzhsky's film *The Cigarette Salesgirl from the Mosselprom* (1924) and in Protazanov's *The Trial of the Three Million* (1926).

273 Mikhail Nappelbaum: *The Writer Romain Rolland* (1935). A fervent pacifist, Romain Rolland (1866–1944) was a friend of Rabindranath Tagore, of Gandhi and of the Czechoslovak President Masaryk. His friendship with Maksim Gorky became legendary: following in the footsteps of numerous French intellectuals like Barbusse, Gide and Aragon, Rolland visited the Soviet Union in 1935 to meet the Russian writer.

274 Mikhail Nappelbaum: *Maksim Gorky* (1931). Aleksey Maksimovich Peshkov, known as Gorky (1868–1936), chose the pseudonym of Gorky ('bitter') as a result of his hardships in youth, which are described at length in his books. He lived in Italy on two separate occasions (1905–1913 and 1921–1928) and, on his return to the USSR after his second stay abroad, formulated the basic tenets of 'socialist realism' in its application to literature.

275 Mikhail Nappelbaum: *The Writer Marietta Shaginyan* (1923). Born in 1888 in Armenia, Shaginyan is the author of a long serial novel, *Mess-Mend* (1923–1925), one episode of which had as a cover a photomontage by Rodchenko (*Black Hand*, 1924). She has also written a tetralogy about Lenin, *The Ulyanov Family*, and two biographies, *Goethe* and *Chevchenko*.

276 Mikhail Nappelbaum: *The Writer Vikenty Veresayev* (1926). Pseudonym of V. V. Smidowicz (1867–1945), author of *Jottings of a Doctor* (1901) and, later, of literary biographies.

277 Mikhail Nappelbaum: *The Writer Mikhail Zoshchenko* (1924). A writer and poet, Zoshchenko (1895–1958) was the author of numerous short satirical stories, *Mikhail Sinyagin* (1930), and *Blue Book* (1934).

278 Mikhail Nappelbaum: *Ilya Ehrenburg* (1945). Ilya Grigoryevich

Ehrenburg (1891–1967) was an eclectic and prolific writer, as well as a poet. His first novel, *The Extraordinary Adventures of Zhurenito and His Disciples* (1921), written in Belgium, was very successful. He wrote reportages and stories about his travels in Europe, and a series of memoirs (*Years and Men, A Writer in the Revolution, The Two Poles, Night Falls*).

279 Mikhail Nappelbaum: *The Writer Leo Luntz* (1921). He was one of the 'Brothers Serapion', a free grouping of poets and writers from all camps.

280 Mikhail Nappelbaum: *The Writer Aleksandr Tvardovsky* (1942). Director of the literary review *Novyi Mir*, Aleksandr Tvardovsky (1910–1971) was also one of the best-loved poets in the Soviet Union. His most widely known collections are *Vasily Tyorkin* and *Moravia the Country*.

281 Mikhail Nappelbaum: *The Poet Maksimilian Voloshin* (1928). Maksimilian Aleksandrovich Voloshin (1877–1932) wrote an indictment of the civil war and a plea for peace in his *Poems of Terror* (1924). He was also the author of *The Deaf and Dumb Devils* (1919) and *Iverny* (1918), which were marked by their literary preciosity. He translated numerous French writers, including Barbey d'Aurevilly, Henri de Régnier and Paul Claudel.

282 Mikhail Nappelbaum: *The Painter Aleksandr Tyshler* (1934). From 1922 to 1923, Aleksandr Tyshler (born in 1898) painted non-figurative works. He then began working on traditional themes of Russian or gypsy inspiration. He also made theatre sets (in particular for Shakespearean plays) and wooden sculptures.

283 Mikhail Nappelbaum: *The Painter Aleksey Favorsky* (1924).

284 Mikhail Nappelbaum: *The Writer Boris Pasternak* (1926). Boris Leonidovich Pasternak (1890–1960), a poet of great gifts (*My Sister Life*, 1922; *Themes and Variations*, 1923), was awarded the Nobel Prize in 1958 for his novel *Doctor Zhivago*.
'He, who compares himself to the eye of a horse,
Peers, looks, sees, recognizes,
And instantly the puddles shine, ice withers
Before this liquid diamond.
... He has received the gift of eternal childhood,
And this munificence, this sharpness of stars,
The whole earth, has been handed down to him,
And all this he has shared with everyone.' (Anna Akhmatova, *Boris Pasternak*).

285 Dmitry Dyebabov: *The Camera Crew of the Film* The Old and the New: *Edward C. Tissé (Cameraman), Grigory Aleksandrov and Sergey Komarov* (1926). '*The General Line* was originally intended to be the first of a series of films about the Revolution and the Bolshevik line. Eisenstein worked on the scenario of these various episodes before undertaking to direct one of the films, concerning the first experiments in rural collectivization, which he made in 1926.' (George Sadoul).

286 Dmitry Dyebabov: *The Film Director Sergey Eisenstein* (1926). Sergey Mikhaylovich Eisenstein (1898–1948) was without question the greatest Soviet cinema director of our time. He was also one of the great theoreticians of the cinema, particularly in the realm of photomontage and the relationship between image and sound.

287, 288 Olga Ignatovich: *Hands* and *Portrait of Sergey Obraztov* (1930s). 'V. G. Lidin always used to make us laugh with his funny stories. On one occasion, he invited us to dinner with a young and very enthusiastic puppeteer: his Carmen was an emaciated old hag; two balls declared undying love for each other.... This was S. V. Obraztov.' (Ilya Ehrenburg, *Night Falls*).

289 Abram Shterenberg: *Portrait of the Photographer Yuri Yeremin*. One of the traditionalist photographers.

290 Abram Shterenberg: *The Poet Vladimir Mayakovsky*.

291 Abram Shterenberg: *The Sculptor Sergey Konenkov*. Konenkov is noted for his sculpture which decorates the Red Square in Moscow: *To Those Who Perished in the Cause of Peace and Friendship between Nations* (1918), and for his portrait of Lenin, which hangs in the Tretyakov Gallery.

292 Abram Shterenberg: *The Painter Martiros Sarian*. Martiros Sergeyevich Sarian (1880–1972) was an Armenian painter who took part in 'The Blue Rose' exhibition of 1907 and the 'World of Art' exhibitions from 1910 to 1916.

293 Abram Shterenberg: *The Poet Dzhambul Dzhabayev*. A Kazakh bardic poet (1846–1945). Before the October Revolution, he performed satirical songs. He also wrote patriotic songs. Ilya Ehrenburg portrayed him thus: 'Dzhambul invited me to his room. He was accompanied by a disciple who served as an interpreter. Dzhambul described how, forty years earlier, at the wedding of a bey (provincial governor) he had won against all the other bards. Boiling water was brought in, tea was made. Dzhambul took up his dombra and began humming a monotone air. His face was like old parchment, but his eyes were lively, both shrewd and melancholic by turns. He was then ninety-two years old.'

294 Abram Shterenberg: *Henri Barbusse*. Henri Barbusse (1893–1935) became famous with the publication of *Under Fire* (1916). A fervent pacifist writer of the twenties, he founded the magazines *Clarté* and *Monde*. He played a very important role in the pacifist and anti-fascist movement known as the Pleyel Amsterdam, and organized the large international congresses for the defence of culture which took place in Paris in 1935. He died in Moscow during a visit to the Soviet Union.

295 Abram Shterenberg: *Paul Robeson*. Born in 1898, Robeson is widely known and appreciated in the USSR. The son of a former slave, he became successively an actor, a lawyer and a singer. He made several visits to the Soviet Union from 1934 onwards.

296 Georgy Petrusov: *Rabindranath Tagore in the Hall of Pillars at Union House* (1927). Photographed here during one of the many lectures which he gave throughout the world, Rabindranath Tagore is known in the USSR as a 'Hindu humanist whose lyrics, written in Bengali, are characterized by a romantic spirit', as the author of 'novels, stories, novellas, plays and articles which are aimed against survivals of feudal and religious reaction, the absence of women's rights, racial discrimination, the caste system', and finally as 'the anti-imperialist author of *The Crisis of Civilization*.'

297 Arkady Shaikhet: *The Composer Dmitry D. Shostakovich* (1930s). Dmitry Dmitryevich Shostakovich (1906–1975) was one of the great Russian composers of the 20th century. Between 1925 and 1935, he resolutely forged a modern style: two symphonies, two operas (*The Nose*, adapted from Gogol; *Lady Macbeth of the Mtzensk District*, adapted from Leskov) and two ballets (*The Golden Age* and *The Bolt*, which sealed his membership of the avant-garde). He subsequently opted for a social and heroic style, in his 5th to 9th Symphonies and in *The Song of the Forests*. In all, he composed thirteen symphonies.

298 Georgy Petrusov: *Isaak Babel* (1933). 'He did not like sitting for photographs – here Petrusov caught him unawares.' (A.L.) Babel was the author of *Red Cavalry* (1923–1926) and *Tales of Odessa* (1927), and wrote the second scenario for *Bezhin Lea* by Eisenstein (1936–1937), based on a story by Turgenev), who portrayed him thus: 'But of course the most astonishing stories are those by Babel.... Who else then, except Babel, would encounter one evening on the road leading from the Nemchinov post station to the dacha – A wood fire...
Beside the fire – a Jew...
Next to the Jew – a cello...
A solitary Jew playing the cello... beside a wood fire... in a copse, near to the Nemchinov post station....' (Eisenstein, *Memoirs*).

299 Georgy Petrusov: *Aleksey Tolstoy in a Children's Village near Leningrad* (1940). A poet and writer, Aleksey Nikolayevich Tolstoy (1883–1945) was also 'an astonishing story-teller: thousands of people still recall today the stories he told them and which they remember for the rest of their lives. For example, the stories from his childhood, of the cook who once served the soup in a chamber pot, or of the deacon who used to put billiard balls in his mouth, etc. Tolstoy wrote from morning till night without respite and with an art whose perfection of phrase took your breath away.' (Ilya Ehrenburg). He wrote an autobiography (*The Childhood of Nikita*, 1922) and a series of historical novels (*Bread*, 1935; *Peter the First*, 1925–1945; *Ivan the Terrible*, 1943).

300 Olga Ignatovich: *The Painter V. Favorsky* (1935). Vladimir Favorsky (1886–1964) was a wood-engraver of great skill and refinement. He taught at VKHUTEMAS and VKHUTEIN.

301 Dmitry Dyebabov: *Anatoly Lunacharsky Addressing a Meeting in the 'Young Pioneers' Stadium* (Moscow, 1930).

302 Ivan Shagin: *Maksim Gorky* (1935). See No. 274.

303 Georgy Petrusov: *Worker Reading a Newspaper* (1933).

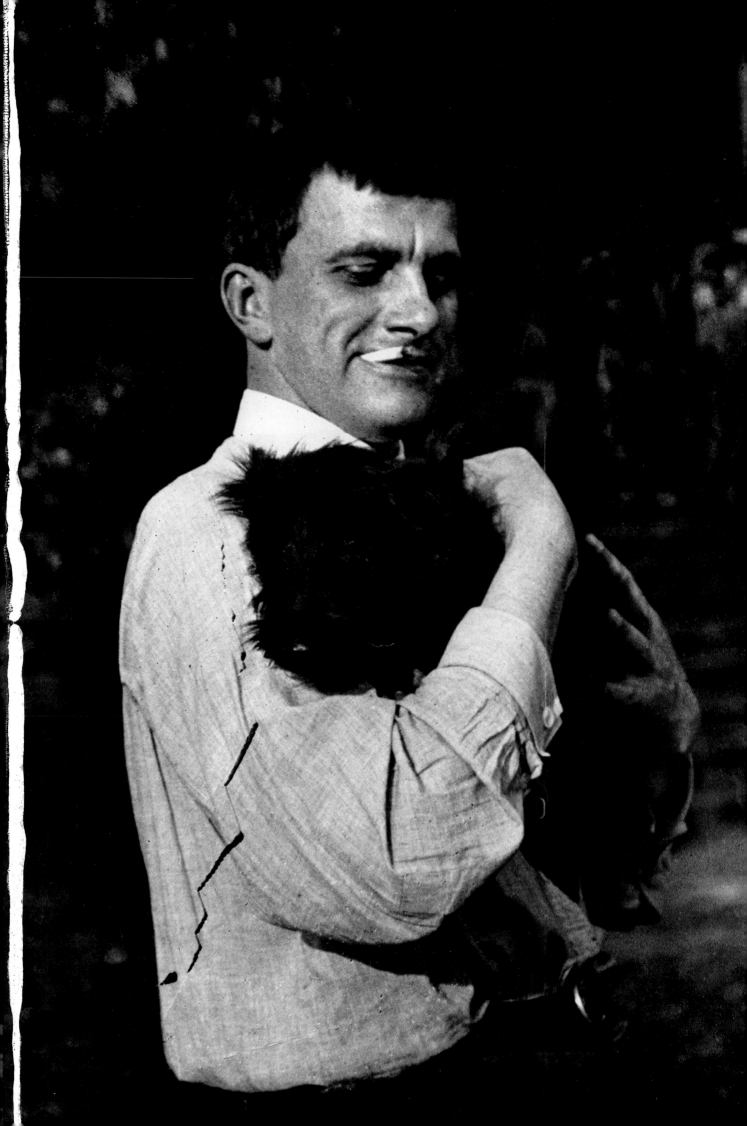

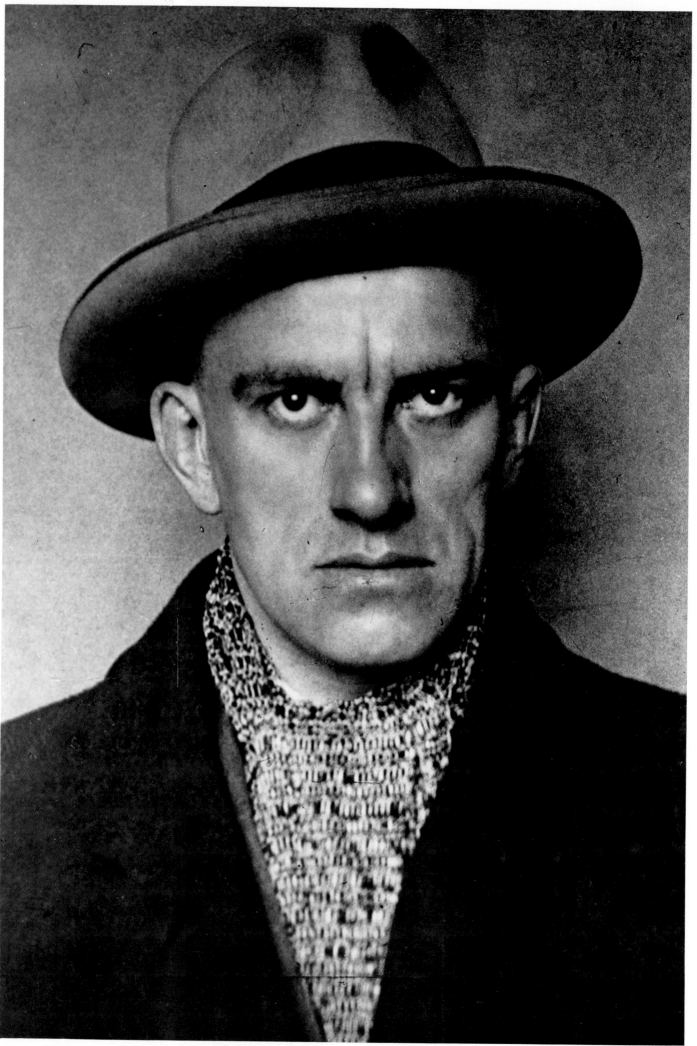

243 Aleksandr Rodčenko. *Vladimir Majakovskij* 1927

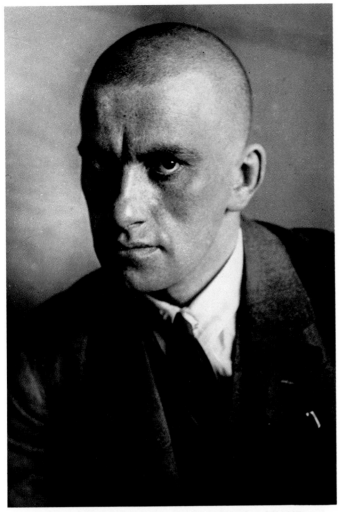

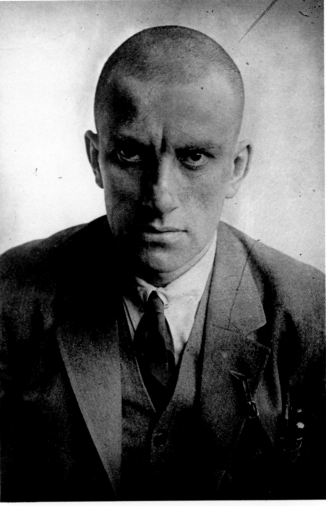

244 Aleksandr Rodčenko. *Vladimir Majakovskij* 1927

245 Aleksandr Rodčenko. *Vladimir Majakovskij* 1927

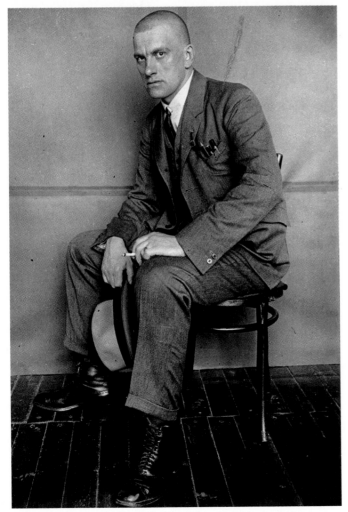

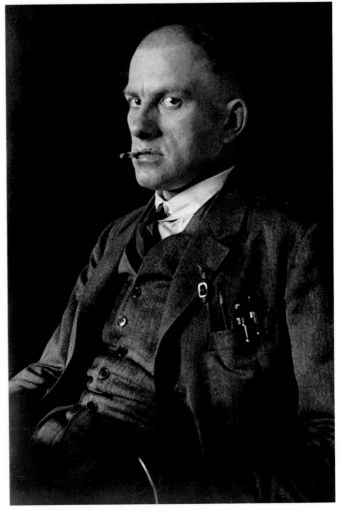

246 Aleksandr Rodčenko. *Vladimir Majakovskij* 1927

247 Aleksandr Rodčenko. *Vladimir Majakovskij* 1927

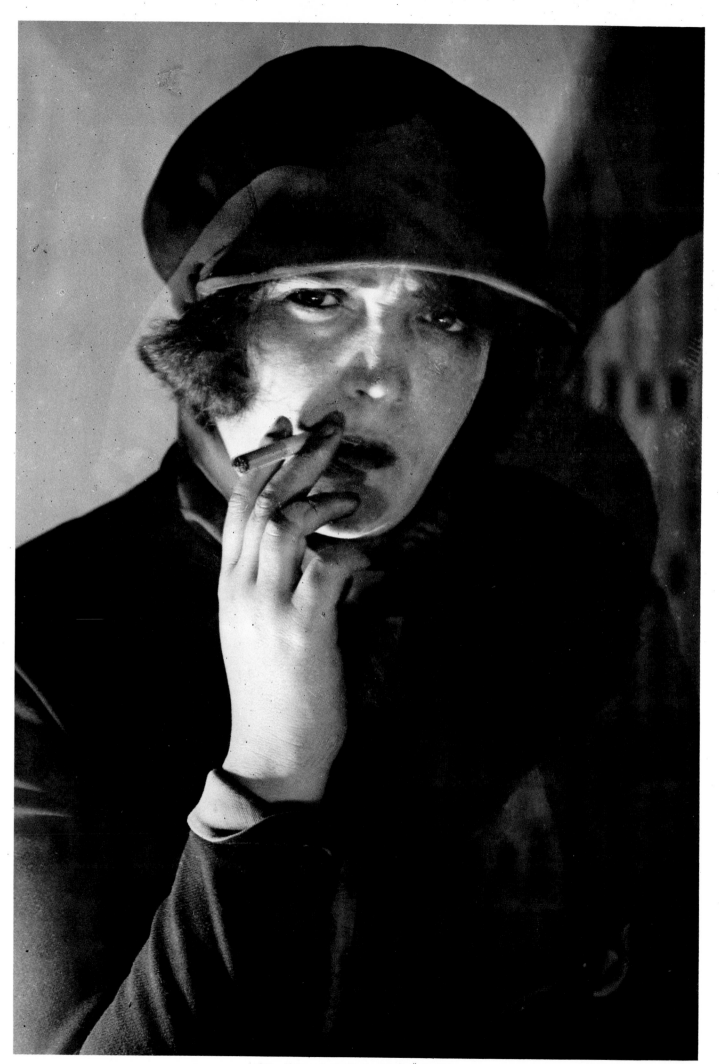

248 Aleksandr Rodčenko. *Esfir Šub* 1924

249 Aleksandr Rodčenko. *Esfir Šub* 1924

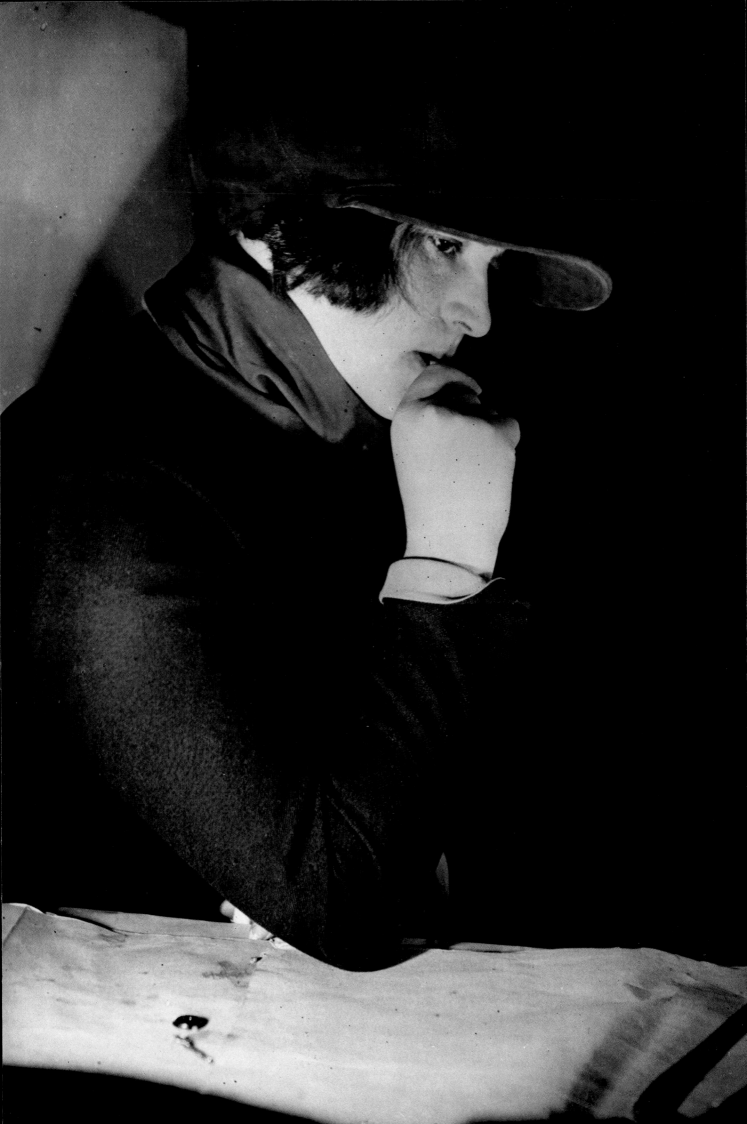

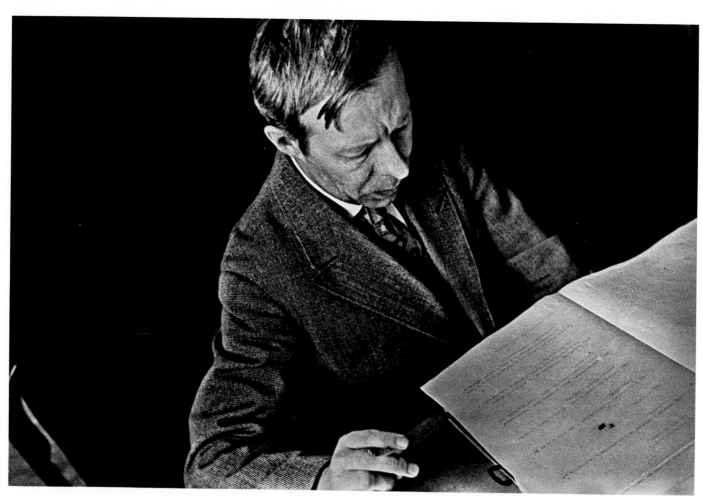

250 Aleksandr Rodčenko. *Nikolaj Aseev* 1928

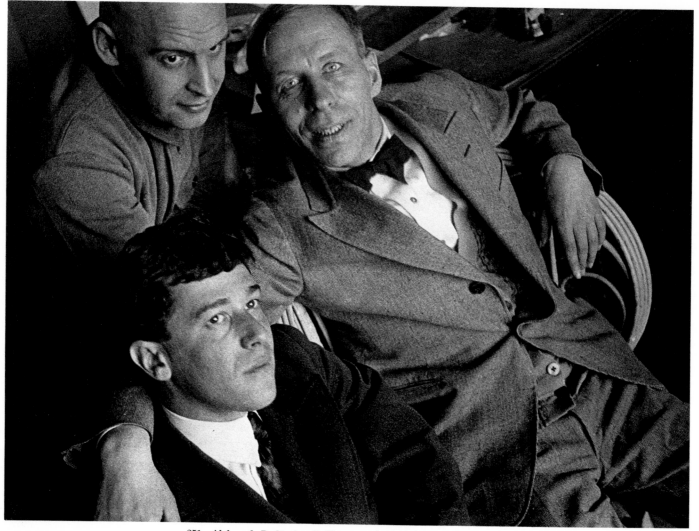

251 Aleksandr Rodčenko. *S. Kirsanov, A. Rodčenko, N. Aseev* 1930

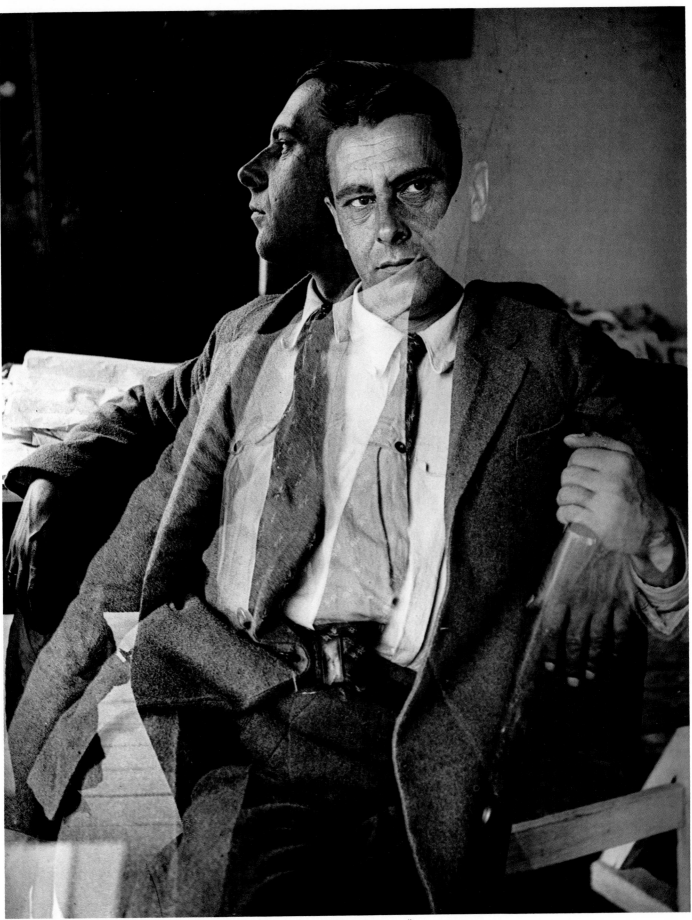

252 Aleksandr Rodčenko. *Aleksandr Ševčenko* 1924

253 Aleksandr Rodčenko. *Varvara Stepanova* 1924

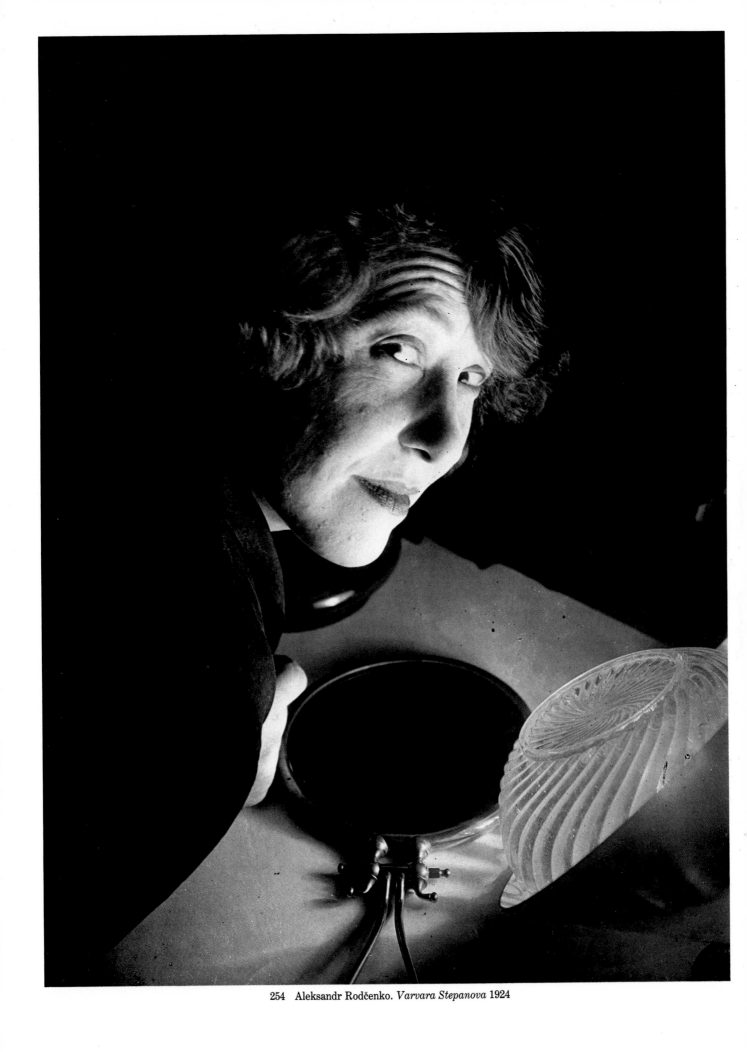

254 Aleksandr Rodčenko. *Varvara Stepanova* 1924

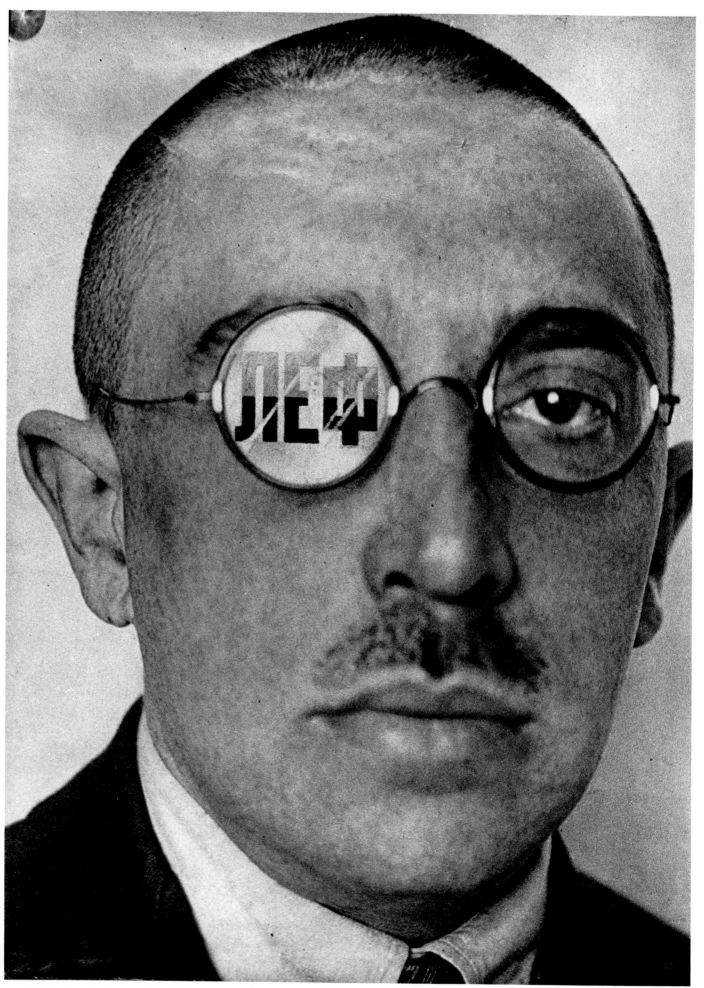

255 Aleksandr Rodčenko. *Osip Brik* 1924

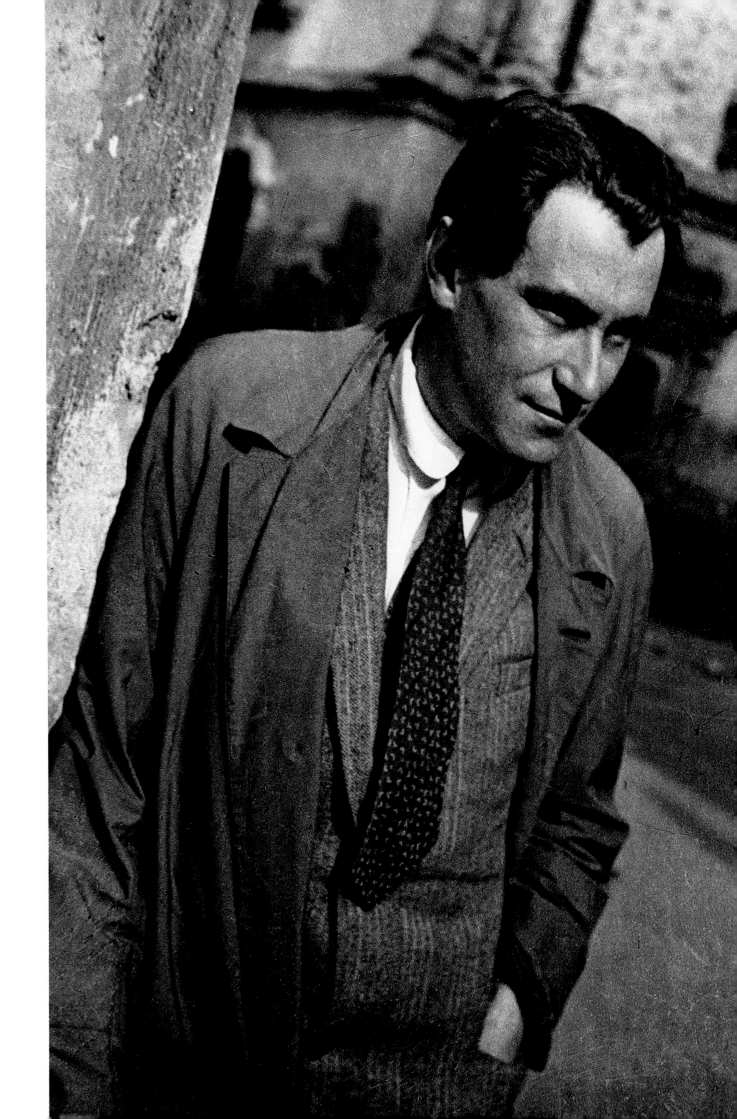

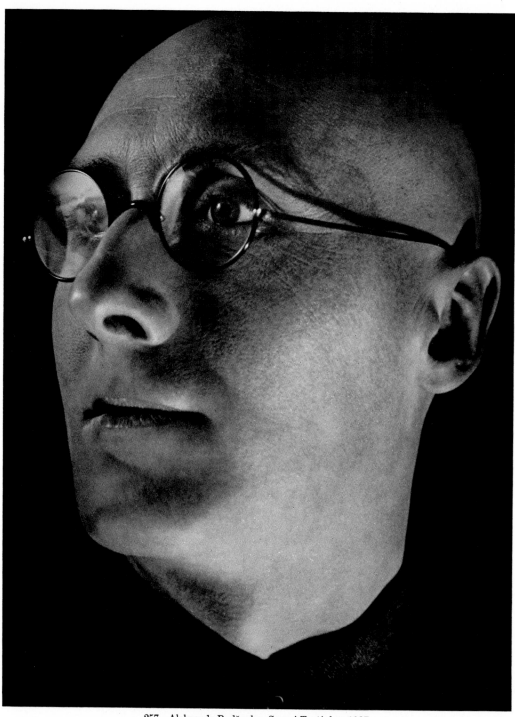

257 Aleksandr Rodčenko. *Sergej Tretjakov* 1927

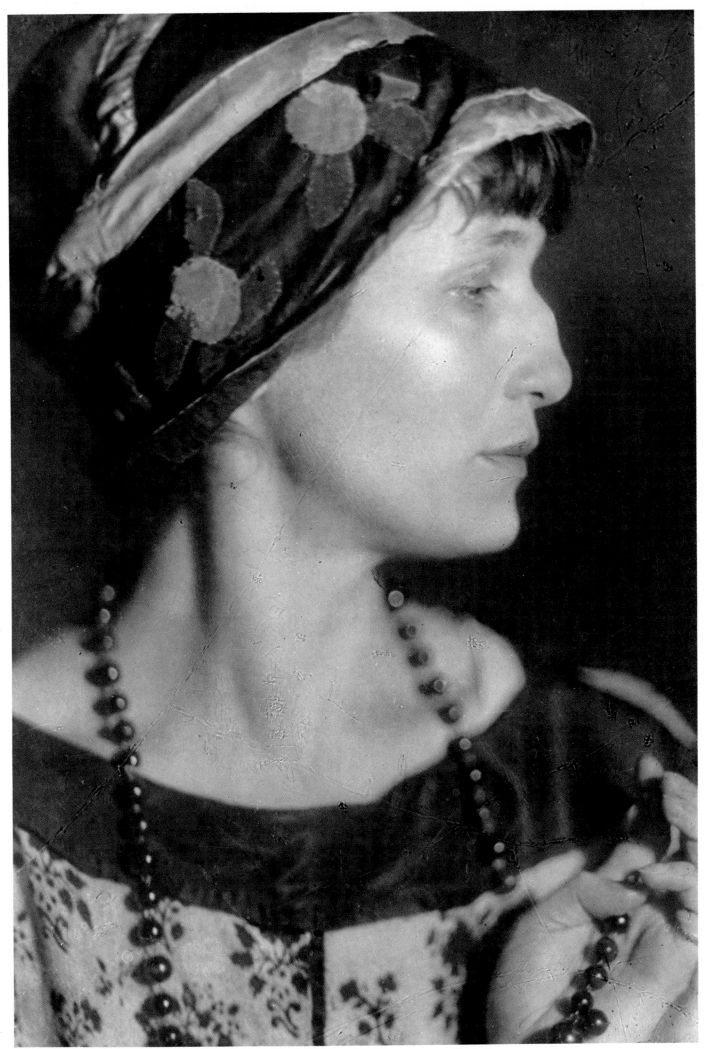

258 Mihail Nappelbaum. *Anna Ahmatova* 1924

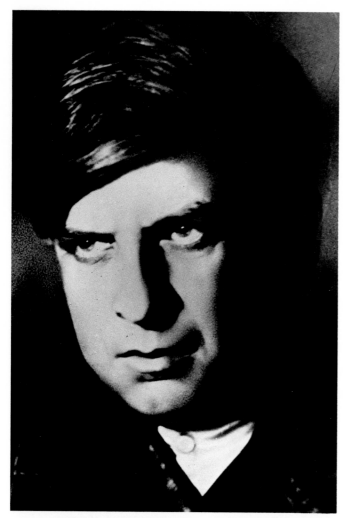

259　Mihail Nappelbaum. *Eduard Bagrickij* 1928

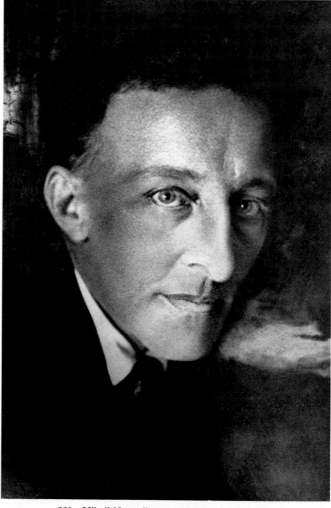

260　Mihail Nappelbaum. *Aleksandr Blok* 1921

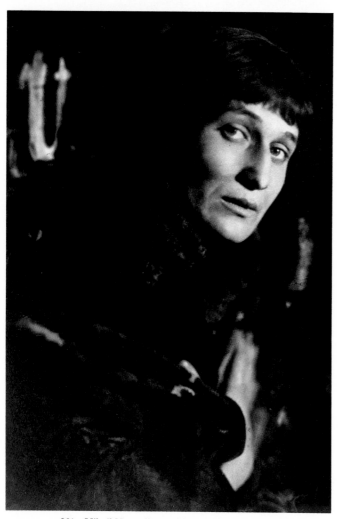

261　Mihail Nappelbaum. *Anna Ahmatova* 1924

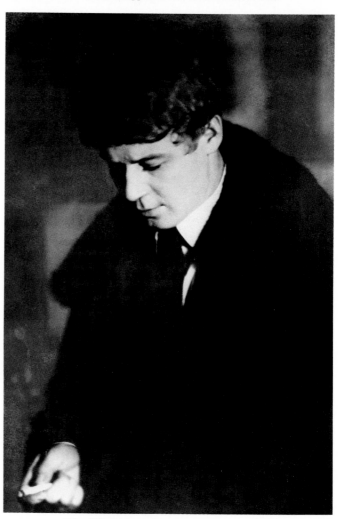

262　Mihail Nappelbaum. *Sergej Esenin* 1924

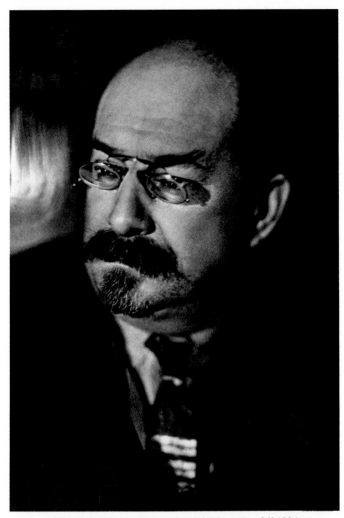

263 Mihail Nappelbaum. *Anatolij Lunačarskij* 1924

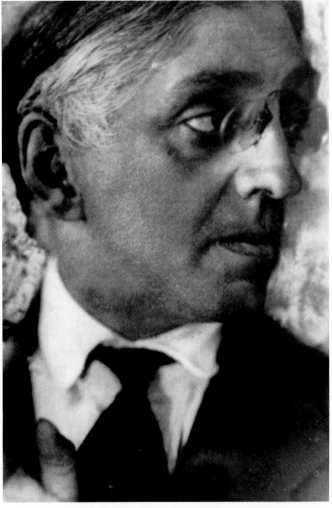

264 Mihail Nappelbaum. *Mihail Kuzmin* 1928

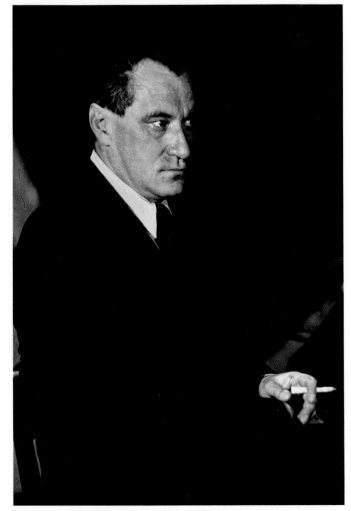

265 Mihail Nappelbaum. *Valentin Kataev* 1944

266 Mihail Nappelbaum. *Aleksandr Glazunov* 1918

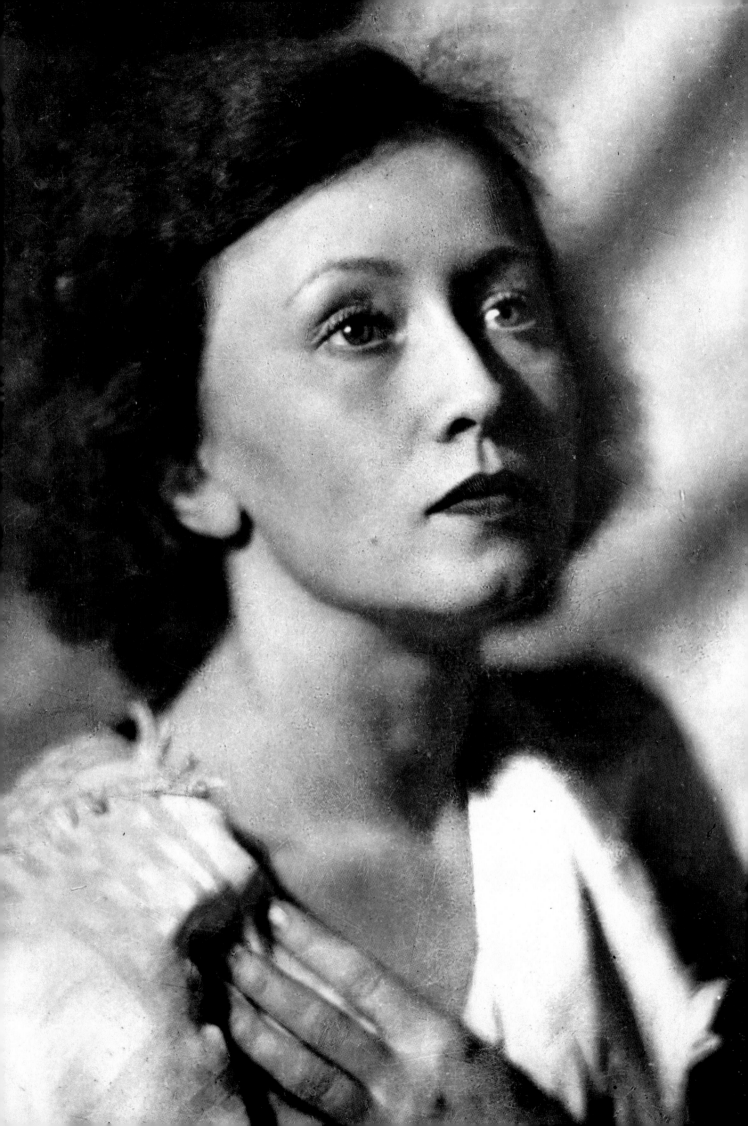

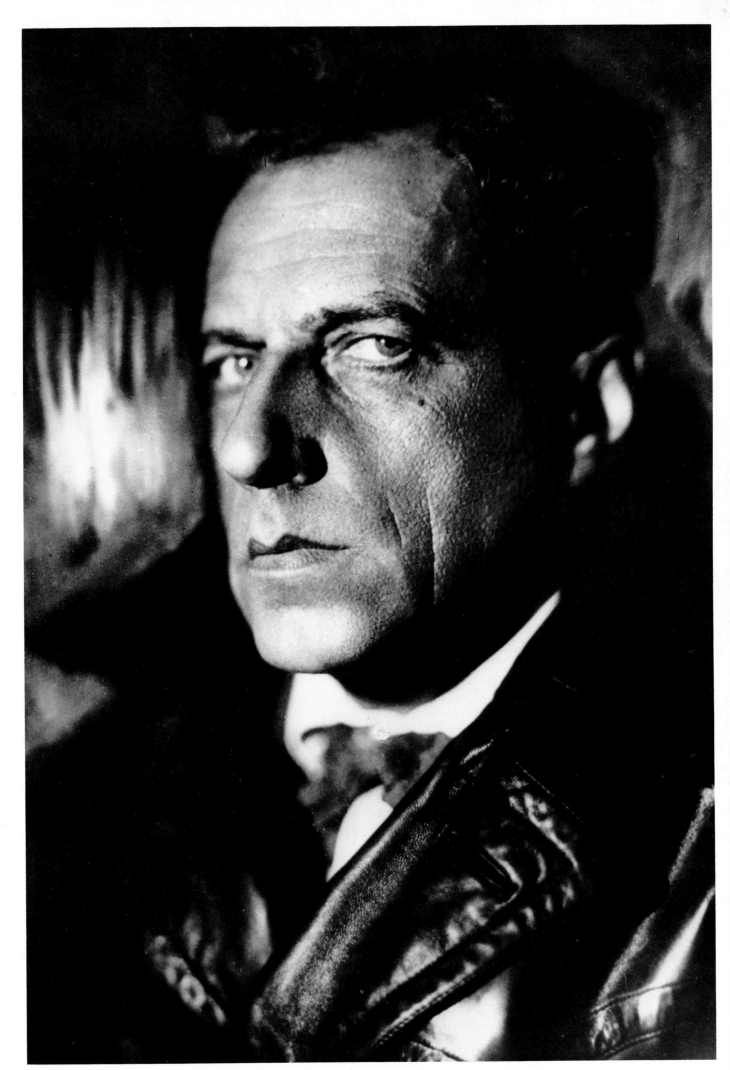

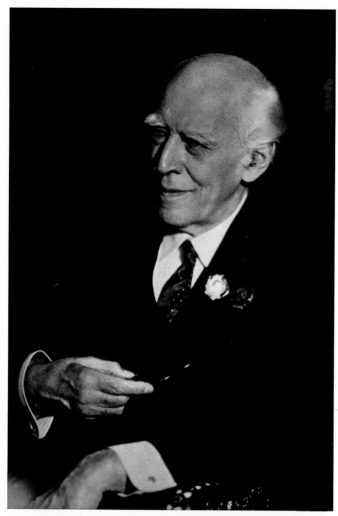

269 Mihail Nappelbaum. *Konstantin Stanislavski* 1942

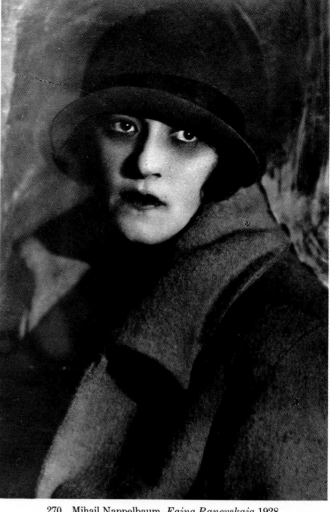

270 Mihail Nappelbaum. *Faina Ranevskaja* 1928

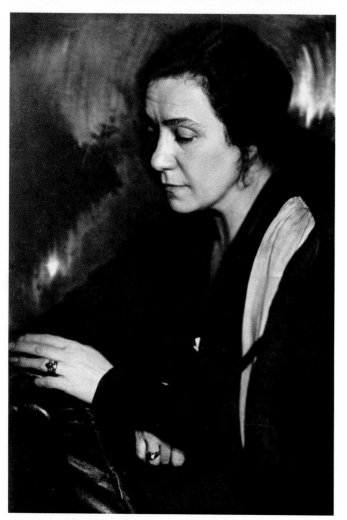

271 Mihail Nappelbaum. *Vera Pašennaja* 1932

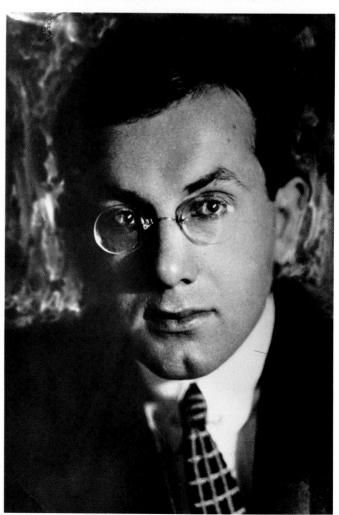

272 Mihail Nappelbaum. *Igor Iljinskij* 1934

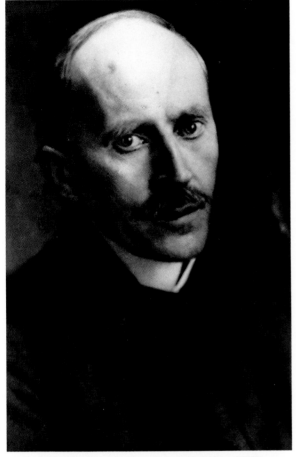

273 Mihail Nappelbaum. *Romain Rolland* 1935

274 Mihail Nappelbaum. *Maxim Gorkij* 1931

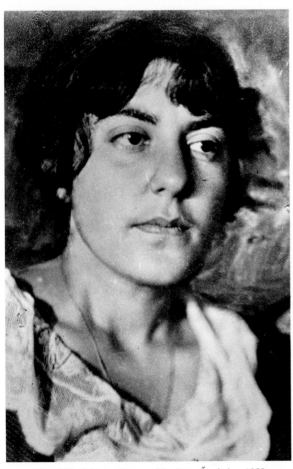

275 Mihail Nappelbaum. *Marietta Šaginian* 1923

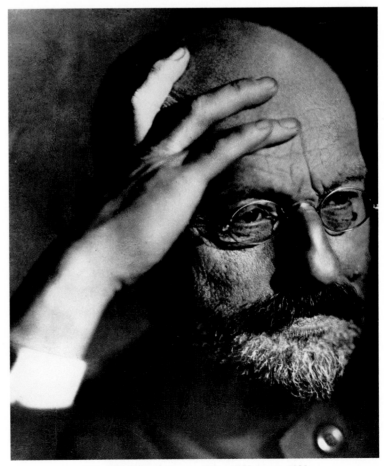

276 Mihail Nappelbaum. *Vikentij Veresaev* 1926

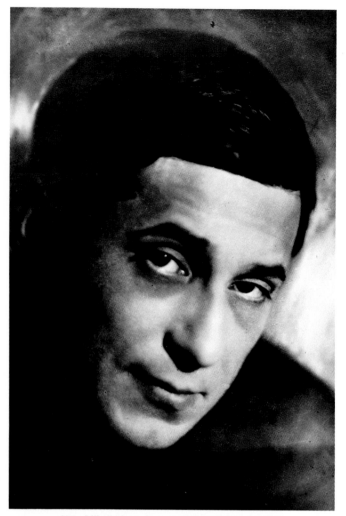

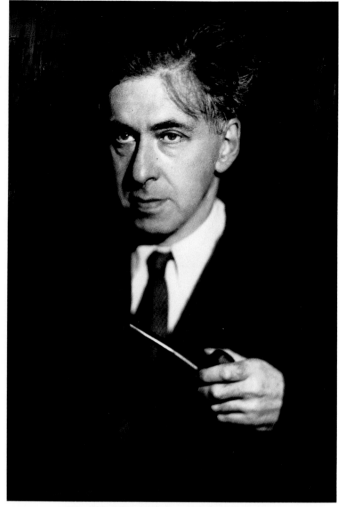

277 Mihail Nappelbaum. *Mihail Zoščenko* 1924

278 Mihail Nappelbaum. *Ilja Ehrenburg* 1945

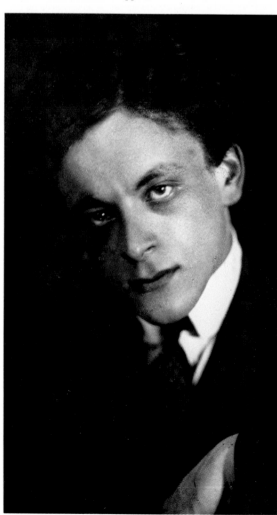

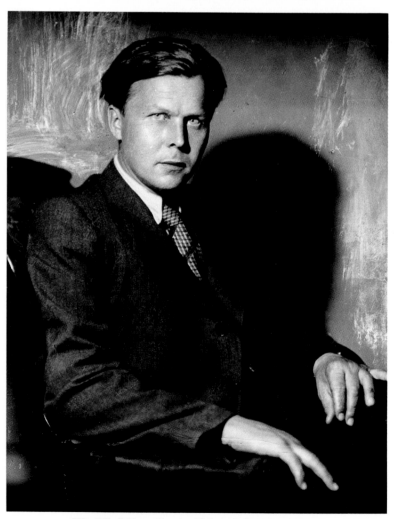

279 Mihail Nappelbaum. *Lev Luntz* 1921

280 Mihail Nappelbaum. *Aleksandr Tvardovskij* 1942

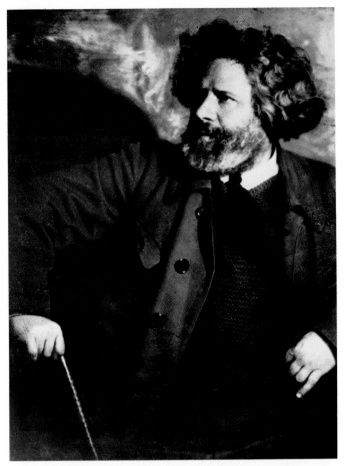

281 Mihail Nappelbaum. *Maksimilian Vološin* 1928

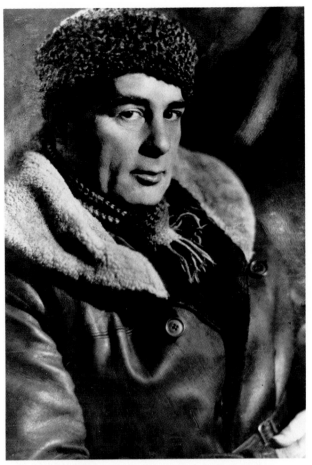

282 Mihail Nappelbaum. *Aleksandr Tyšler* 1934

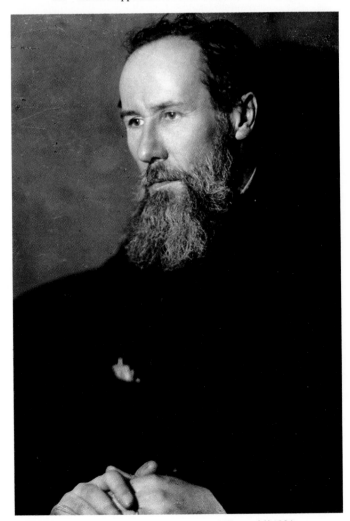

283 Mihail Nappelbaum. *Alexej Favorskij* 1924

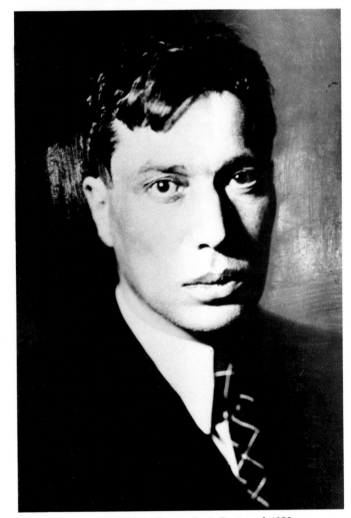

284 Mihail Nappelbaum. *Boris Pasternak* 1926

285 Dmitrij Debabov. *Edouard Tissé, Grigorij Alexandrov, S. Komarov* 1926

286 Dmitrij Debabov. *Sergej Eisenstein* 1926

288 Olga Ignatovič. *Sergej Obrazcov* circa 1930

287 Olga Ignatovič. *Sergej Obrazcov* circa 1930

289 Abram Sterenberg. *Jurij Eremin*

290 Abram Sterenberg. *Vladimir Majakovskij*

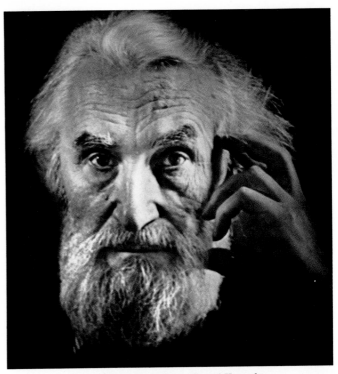

291 Abram Sterenberg. *Sergej Konenkov*

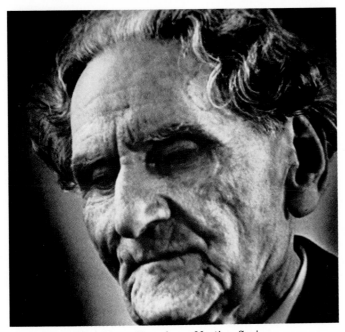

292 Abram Sterenberg. *Martiros Sarian*

293 Abram Sterenberg. *Džambul Džabaev*

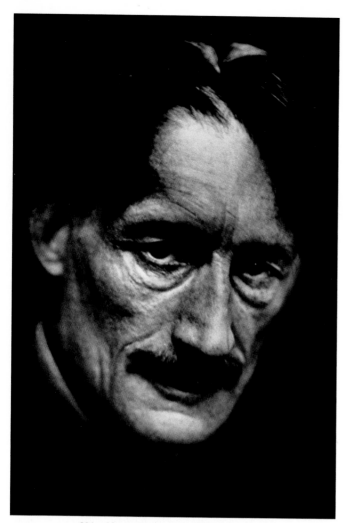

294 Abram Sterenberg. *Henri Barbusse*

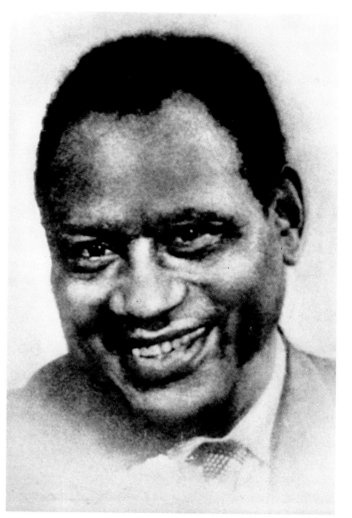

295 Abram Sterenberg. *Paul Robeson*

296 Georgij Petrusov. *Rabindranath Tagore* 1927

297 Arkadij Šajchet. *Dmitrij Šostakovič* circa 1930

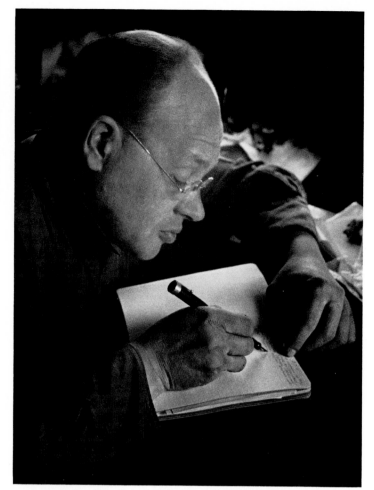

298 Georgij Petrusov. *Isaak Babel'* 1933

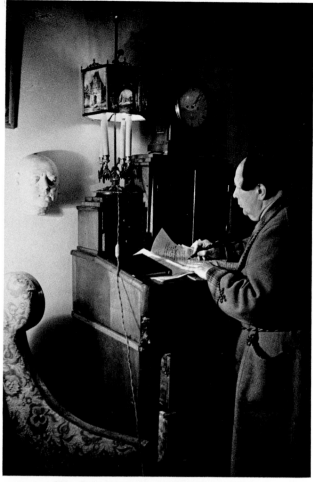

299 Georgij Petrussov. *Alexej Tolstoj* 1940

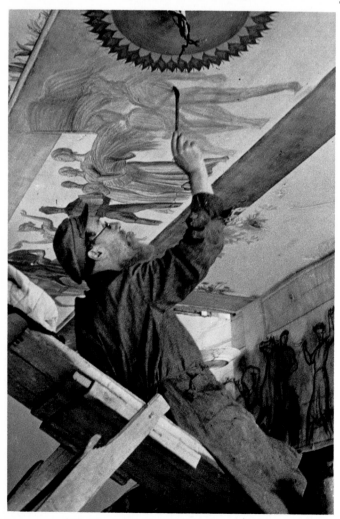

300 Olga Ignatovič. *Vladimir Favorskij* 1935

301 Dmitri Debabov. *Anatolij Lunačarskij* 1930

246

302 Ivan Šagin. *A.M. Gorkij* 1935

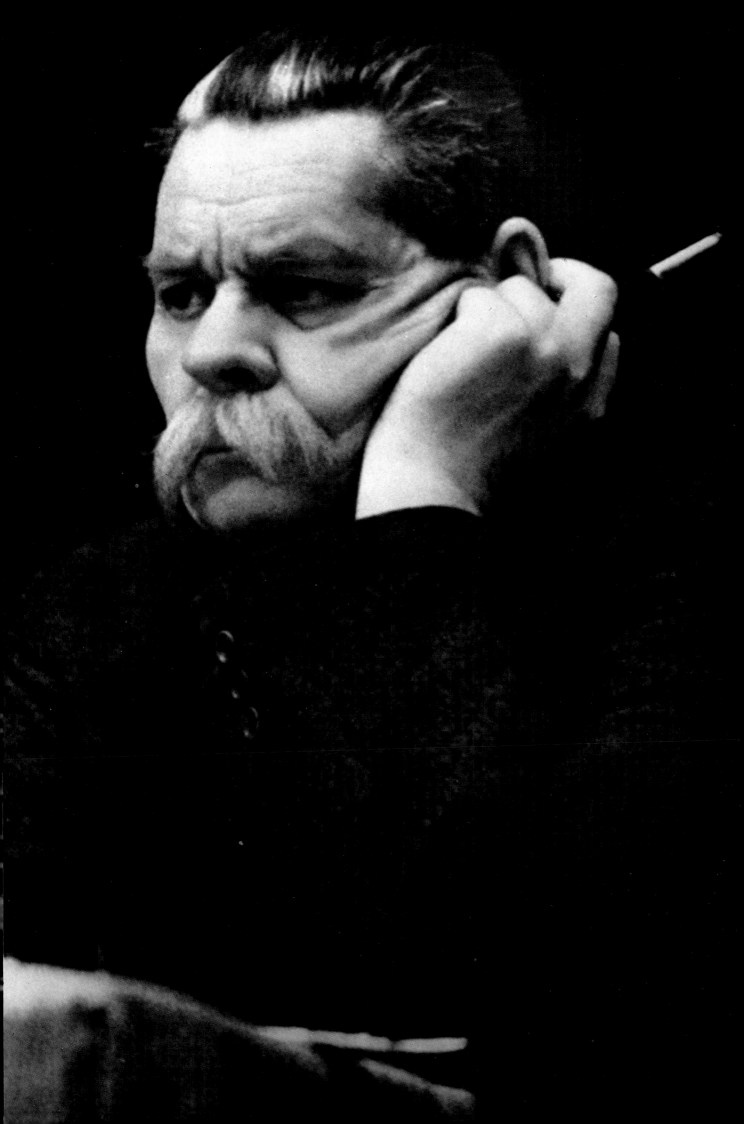

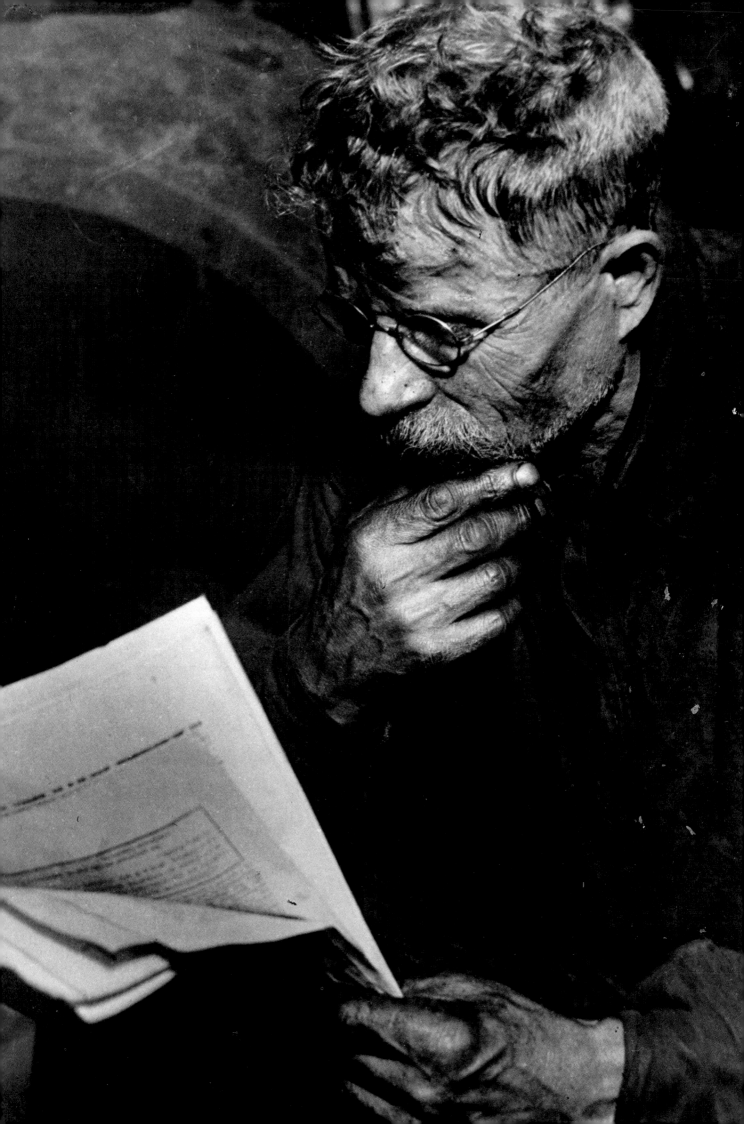

Biographies

Aleksandr Lavrentiev

Max Vladimorovich Alpert

Born in 1899 at Simferopol, Alpert settled in Odessa, where he became apprenticed to a photographer. In 1919, he volunteered for the Red Army. On returning to Moscow in 1924, he joined the *Rabochaya Gazeta* as a photo-journalist. Four years later, he was on the editorial staff of *Pravda*. In 1931, he worked for *USSR in Construction*.

Alpert was one of the photographers who, step by step, brought prestige to Soviet photographic journalism. His career as such began in 1924, when he started using a 9 × 12 'Nettel' camera. When photographing the Red Square parades, he had to retire several times to recharge this plate camera, in spite of which he still succeeded in capturing the essence of the occasion. El Lissitzky used Alpert's shots of the Dneprostroy, taken in 1931, for the *USSR in Construction* special issue on the Dneprogues (a hydro-electric plant on the Dnepr). These photographs also allowed him to produce some of his photomontages for the same issue. 'We collaborated as friends: Otsup, Savelyev, Laboda, Shaikhet, Shterenberg, Ignatovich, Langman. No, it was not competition, it was emulation.' (Max Alpert, *Sovetskoye Foto*, No. 8, 1978).

In 1929, in accordance with the first Five-Year Plan, work started on the construction of the town of Magnitogorsk and its steelworks, in the Urals. The young workers who arrived lived at first in tents, where they learnt how to read, write and acquire skills. In a work entitled *Giant and Builder*, Alpert produced a sequence of photographs concerning the life of Viktor Kolmykov, an illiterate mason who became a great constructor. Alpert returned several times over the years to photograph the town and its development, as well as photographing its earliest foundations.

In 1931, the Association of Friends of the USSR Abroad organized a small exhibition of photographs, which toured Vienna, Prague and Berlin. The exhibition, devised by Lev Mezhericher and photographed by A. Shaikhet, M. Alpert and S. Tules, was a sequence entitled *Twenty-Four Hours in the Life of the Filippov Family*. The subjects of this photo-story were a worker in the Red Proletarian factory in Moscow, and members of his family. The results attracted considerable publicity in the West, at a time when the economic crisis in the capitalist countries was at its height. The photographs showed people who were in work, who had somewhere to live, enough to eat, and the future of whose children was secure. The subsequent importance accorded to photographic reportage in the Soviet press dates from the success of this exhibition.

During the Second World War, Alpert was a correspondent for the news agency Tass. After the war, he continued working as a reporter for the Novosti agency.

Photographs by Max Alpert:
pp. 21, 22, 23, 27, 100; pls. 82, 91, 105, 106, 184, 199, 204, 205, 210, 212, 213, 214, 215, 216, 217, 218.

Viktor Karlovich Bulla

Bulla was born into a family of photographers. His father, Karl, and his elder brother, Aleksandr, were instructing him in photography many years before the Revolution. He started his career as a correspondent for *Niva* during the Russo-Japanese war of 1904–1905.

In St Petersburg, Bulla created a film company, Apollo, which specialized in historical and documentary films. During the Revolution, he was one of the young documentary photographers who recorded the events of February and October. Part of his photographic output is to be found in *The First Mounted Detachment*, an album compiled by Rodchenko and Varvara Stepanova. Many of the most celebrated shots of Lenin were taken by Bulla during Lenin's street appearances or during Comintern congresses.

The State archives have preserved more than 130,000 negatives of photographs taken by Bulla, his brother and father, as well as some thirty films.

Photographs by Viktor Bulla:
p. 2; pls. 90, 118

Dmitry Georgyevich Dyebabov

Born in 1901, died in 1949.

On Eisenstein's advice, Dyebabov took up photography. They studied together at the VGIK (University Institute of Cinematography) in Moscow. Dyebabov began taking photographs in 1926, as a photo-reporter for the magazines *Izvestia* and *Komsomolskaya Pravda*. He travelled widely, covering the new construction projects which sprang up throughout the country during the first Five-Year Plan, being accompanied everywhere by his wife, Margarita, also a photographer.

During the mid-thirties, Dyebabov travelled the Arctic with a Leica – the only camera whose shutter mechanism was unaffected by the extreme cold – and accompanied the great ice-breakers *Krasin*, *Sedov* and *Stalin* on their Arctic crossings. He thus became the 'Arctic bard' of Soviet photographic art. In 1937, on the occasion of the first photographic exhibition held in the Soviet Union, he submitted sixteen photographs depicting the far North.

Dyebabov was also the author of a journal concerning his travels, and of a book entitled *Taken with His Leica*.

Photographs by Dmitry Dyebabov:
pp. 14, 24; pls. 9, 53, 54, 67, 81, 83, 84, 109, 191, 234, 235, 236, 237, 285, 286, 301

Boris Vsevolodovich Ignatovich

Born in Lutsk (Ukraine) in 1899, died in Moscow in 1976.

In 1918, Ignatovich was working for the newspaper *Severo-Donetzky Kommunist* as a journalist, after which, in 1919, he became a sub-editor for *Krasnaya Bashkirya* in Kharkov. From 1922 to 1925, he was editor of humorous magazines in Leningrad, discovering photography finally in 1923. In 1926, he settled in Moscow, where he became one of the leading figures of the photo-reporters' association at the Press Centre. He contributed to illustrated periodicals and became editor of the journal *Bednota*.

A pupil of Rodchenko, Ignatovich adopted some of his vocabulary: foreshortenings, dynamic framing (tilted horizontals), close-ups. Several times between 1929 and 1930, he compiled photographic sequences devoted to the new industrial construction projects and destined for a special page of the review *Dazhes*. This was at a time when the fact of photographing the major technical triumphs was not only of enormous social importance, but also revealed a new reality, the essence of which lay in the discovery of certain unsuspected aesthetic categories: the graphic precision of line, the demands of geometry, the laws of visual rhythm. The reflection of an industrializing era in these categories could be achieved by focusing either upon the image of man or the image of science; hence Ignatovich's aerial photography.

From 1930 to 1932, he made documentary films, one of which was entitled *Today* and based on a script by Yesfir Shub and designs by Kukhrynisky. He also took charge of illustrations for the journal *Vechernaya Moskva*. From 1937 to 1941, he contributed to the review *Moscow in Construction* and, from 1941, the magazine of the Thirtieth Army, *Boyevoye Zhnamya*. After the war, Ignatovich turned to landscape photography, portraiture and colour photography.

Photographs by Boris Ignatovich:
pp. 12, 17, 20, 27; pls. 1, 19, 36, 37, 38, 56, 57, 58, 59, 74, 75, 77, 78, 85, 123, 129, 130, 131, 135, 137, 146, 176, 185, 187, 190, 192, 202, 222, 230

Olga Ignatovich

Born in 1901, Olga came from a family of photographers: her brother Boris and sister-in-law Elisabeth Ignatovich were also photographic journalists. Olga mostly used a Leica. During a reunion of the veterans of Soviet photography which was held in Rodchenko's studio, she defined the latter's contribution to the art as follows: 'He taught us to perceive objects and events from an unexpected angle. He succeeded in extracting the essence of time through the medium of the photograph.' (*Sovetskoye Foto*, No. 8, 1979).

Her speciality and favourite genre was the group portrait; one could say that she captures moments of simultaneous action, a conversation for example, or a meeting, or a victory. For Olga Ignatovich, portraits are a means of concretizing a reportage, of showing a human being at a given moment. By this means, portraits of individuals become portraits of different social types: the writer, the artist, the worker. Such photographs, with their clearly delineated social and documentary content, corresponded to the needs of the newspaper *Bednota*, the magazines *Narpit* and *Prozhektor* and, later, the newspaper *Vechernaya Moskva*, for all of which Olga Ignatovich worked as a photo-journalist.

Photographs by Olga Ignatovich:
pp. 20, 99; pls. 69, 240, 287, 288, 300

Yakov Khalip

Born into a theatrical family in St Petersburg in 1908, Khalip settled in Moscow in 1921, where he studied at the State Institute of Cinematography and became an admirer of the photography of Rodchenko, Semyon Fridlyand, Max Alpert and Arkady Shaikhet.

In 1921, Khalip graduated as a cameraman, and from this year onwards he was to work as an assistant cameraman and stills photographer. He also began working as a news photographer, for *Pravda*, *Izvestia* and *Krasnaya Niva*.

Aleksandr Rodchenko and Varvara Stepanova frequently commissioned photographs from him, for their photo-album *The Red Army* and on behalf of *USSR in Construction*, during the years 1938–1941.

On several occasions, Rodchenko designed the image centrings of Khalip's composition sketches, and the resulting photographs almost exactly match the sketches. In his photography, Khalip cleverly succeeded in juxtaposing foreground and background, while at the same time relating both to the overall theme, through his use of composition and content. The informal apprenticeship received from Rodchenko was responsible for this photographic sensitivity, which Khalip employed to perfection in his most expressive works. He also became one of the most adventurous and enterprising of photographers.

In 1938, on board the ice-breaker *Taymir*, Khalip succeeded in reaching four shipwrecked Soviet polar explorers on the Papanin ice field. Having taken his photographs, he developed them on the ice-breaker and sent the prints by plane to Murmansk. The very next day, his reportage appeared in the newspapers. Rodchenko and Stepanova, who were responsible for the content and layout of an album devoted to the conquest of the North Pole, used Khalip's photographs for the central section.

During the Second World War, Khalip served at the front as correspondent for *Krasnaya Zvezhda*, from 1941 to 1944. After the war, he worked for *Ogonyok*, *Smena*, and, from 1954, for *Sovietsky Soyuz*.

Photographs by Yakov Khalip:
pp. 14, 24; pls. 55, 60, 173, 174, 175, 177, 232

Eleazar Langman

Born 1895, died 1940.
Photographs by Eleazar Langman:
p. 13; pl. 71

Mikhail Salomonovich Nappelbaum

Born in Minsk in 1869, died in 1958.

In 1884, Nappelbaum was already frequenting Boretti's photographic studio.

In 1887, he left Minsk to set out on a protracted journey through the Soviet Union, Poland and the United States, where he worked successively in New York, Philadelphia and Pittsburgh. He only returned to Minsk in 1895, to set up a photographic portrait studio.

Nappelbaum was a portrait photographer whose role in the history of Soviet photography may be compared with that of Nadar in France. He recorded the features of the entire artistic intelligentsia of the twenties. He photographed remarkable individuals: writers and poets like Blok, Gorky, Romain Rolland and Ehrenburg; artists like Tatlin; public figures like Lenin, Krupskaya, Lunacharsky, the journalist-diplomat Vorovsky, etc.

He participated in the 1928 exhibition *Ten Years of Soviet Photography*, both in the section entitled 'Vladimir I. Lenin Seen through Photography' and in the section 'Art Photography', to which he submitted more than twenty portraits.

In 1958 Nappelbaum wrote a book, *From Craft to Art*.

Photographs by Mikhail Nappelbaum:
pp. 15, 25; pls. 92, 102, 241, 258, 259, 260, 261, 262, 263, 264, 265, 267, 268, 269, 270, 271, 272, 273, 274, 275, 276, 277, 278, 279, 280, 281, 282, 283, 284

Pyotr Adolfovich Otsup

Otsup was born in 1883 in St Petersburg, where he began his career in the studio of V. Zhasvoyna, and was already a seasoned photographer well before the Revolution. From 1900 to 1917, he was working for magazines like *Niva*, *Rodina*, *Ogonyok*, the *Iskra* and *Solntse Rossii*. He gravitated towards news photography and it was he who succeeded in capturing the most characteristic and intense moments of the October Revolution, its fighting, its barricades, the funerals of its heroes, its demonstrations, etc. Although his camera was static, one senses in his photographs the fiery and dynamic atmosphere of the revolutionary days.

Otsup subsequently proceeded to photograph the leaders of the new socialist government. As a result, the world has been able to scrutinize the features of Lenin, Sverdlov, Dzerzhinsky, Kalinin, Budyonny, Frunze, Voroshilov. In spite of the difficulties of on-the-spot camera work (Otsup's portraits were nearly always, in fact, documentary photographs), the lack of light and the primitive nature of the photographic equipment available in the early twenties, Otsup's work displays high technical quality even today. He was also a photo-journalist at the front during the Russo-Japanese war of 1904–1905. His portraits of Lenin were mass-reproduced and millions of copies printed. His photographic work as a whole comprises some 40,000 negatives.

Photographs by Pyotr Otsup:
pls. 86, 87, 89, 94, 95, 96, 97, 98, 100, 101, 104, 107, 110, 111, 112, 113, 114, 117, 122, 136, 144

Nikolay Makarovich Petrov

Born in Korsakovo in 1892, died in 1959.

The son of a Korsakovo peasant, Petrov became an apprentice in the studio of Scherrer and Nabholz in Moscow on the eve of the Revolution. He was a soldier during the First World War, after which he enlisted in the Red Army and became an instructor in the All-Russia Executive Committee.

He was a pupil of the 'old school' of reporter-photographers like A. Savelyev and K. Kuznekov. In 1924, he became photo-correspondent for the newspaper *Izvestia*, which he supplied with photographs for the next forty years. This is why his work concentrates on political events such as demonstrations, parades and daily news reports. He also liked to record the different aspects of Moscow as a city. He was one of the first to utilize the upper part of the frame, for example in his photograph of the Sukharev market taken around 1920, just before the construction of pavilions to a design by Melnikov in 1924.

During the Second World War, Petrov was a photographer at the front, for *Izvestia*. After the war, he turned to colour photography.

Photographs by Nikolay Petrov:
pls. 11, 12, 13

Georgy Petrusov

Born 1903, died 1971.
Petrusov started his photographic career as a reporter on the construction site of the Magnitogorsk foundries, but his main experience as a photographer was gained in the thirties while working with the collective formed around *USSR in Construction*. His photographs depicting the life and work of the first farming cooperative were taken for that magazine. As a war photographer at the front, he reached Berlin with the Soviet forces during the Second World War.

Photographs by Georgy Petrusov:
p. 25; pls. 198, 296, 298, 299, 303

Aleksandr Mikhaylovich Rodchenko

Rodchenko was born on 23rd November 1891 in St Petersburg, and attended the Kazan art school between 1910 and 1914. Here he was taught by Feshin and Georgy Medvedev, and met Varvara Stepanova, who was later to become his wife. Next, he went to the Stroganov art school in Moscow, where he pursued his studies in painting, designed objects, participated in the IZO Narkompross (People's Commissariat of Education for the Plastic Arts) and made hanging constructions. He was subsequently one of the founders of INKHUK (Institute of Artistic Culture) in 1920 and taught at the VKHUTEMAS (Higher State Art-Technical Studios). In 1922, he worked on Dziga Vertov's weekly newsreel *Cine Eye*, and made photomontage illustrations – from photographs taken by Shterenberg – for Mayakovsky's poem *Pro Eto* (*About This*), which was published in 1926.

It was at this moment that Rodchenko began to be interested in the possibilities afforded by photography, which corroborated all his opinions about art, the death of painting, the necessity to foresee a collaboration between artists and technicians. Between 1923 and 1928, he worked on the magazine *Lef*, later *Novyi Lef*, together with his wife and many other artists and writers.

Photography became one of the most important activities in his life. He began by taking portraits, then moved to reportage. In 1926, he worked as a designer on Kuleshov's film *The Journalist* and, in 1927, on the film *Moscow in October*, and created the stage-sets for a number of plays produced by Meyerhold. He took part in the exhibition *Ten Years of Soviet Photography* held in Moscow in 1928.

In 1930, Rodchenko joined the art group 'Oktiabr', one of the important movements in the photographic and cinematic art of the period. In 1933, he worked on the magazine *USSR in Construction*, which he founded with Stepanova and for which he periodically made photographic reportages, like the series on the White Sea Canal, and designed issues and covers. He commissioned and influenced the work of many young photographers, such as his pupils Georgy Petrusov, Yakov Khalip, Boris and Olga Ignatovich. At the Photographic Union, he gave courses on composition. He designed the photo-album on the Red Army and another entitled *Ten Years of Uzbekistan*.

Aleksandr Rodchenko was a great theoretician of modern photographic art. On his death in Moscow on 3rd December 1956, he left behind important notes and archives on his work.

Photographs by Aleksandr Rodchenko:
pp. 8, 10, 11, 12, 13, 17, 18, 19; pls. 2, 6, 10, 14, 17, 18, 20, 21, 22, 23, 24, 25, 26, 27, 28, 30, 31, 32, 33, 34, 41, 42, 43, 44, 45, 46, 47, 48, 49, 50, 51, 62, 63, 72, 73, 79, 80, 120, 126, 127, 157, 158, 159, 160, 161, 162, 163, 164, 165, 166, 167, 171, 172, 178, 179, 180, 181, 193, 194, 195, 196, 225, 242, 243, 244, 245, 246, 247, 248, 249, 250, 251, 252, 253, 254, 255, 256, 257

Ivan Mikhaylovich Shagin

Born in Yaroslav in 1904, the son of an impoverished peasant, Shagin left home young to earn his living as a seaman aboard a Volga steamboat, and subsequently as a worker in Moscow. During this time, he started working as a press photographer, for *Nasha Zhizn*, *Kooperativnaya Zhizn*, *Komsomolskaya Pravda*, and for the publishing house Selkhoziz.

Much later, in 1950, Shagin was to work for Igosiz Books, for Sovietsky Khudozhnik Books, Progress Publishers, and for the Novosty press agency. During the thirties, however, he was more interested in advanced photographic techniques, both in their social application and in their cultural content.

Shagin was particularly successful at creating impeccable images out of snapshots taken during Red Army manoeuvres. He photographed the Soviet air force and navy for illustrated works and for the magazine *USSR in Construction*.

Early on, he had adopted the 'foreshortened' compositional technique characteristic of Rodchenko, and continued to employ it for his portraits. In his reportages, he preferred a frontal composition, as it allowed him to draw attention equally to the whole surface of the photograph.

Photographs by Ivan Shagin:
pp. 26, 99, 100; pls. 7, 168, 169, 182, 223, 233, 238, 239, 302

Arkady Samoylovich Shaikhet

Shaikhet was born in Nikolayev in 1898 and settled in Moscow in 1918. He belonged to the older generation of Soviet documentary photographers. Beginning work in 1922 as a retoucher and portrait photographer, he became a photo-reporter for *Rabochaya Gazeta* and, from 1924 onwards, for the weekly magazine *Ogonyok*. During the thirties, he contributed to *USSR in Construction* and *Illustrierte Zeitung*. His first photo-reportage was *Twenty-Four Hours in the Life of the Filippov Family*, in the German magazine *AIZ*.

In 1928, Shaikhet submitted more than thirty genre and documentary photographs to the exhibition *Ten Years of Soviet Photography*. Expressing the poetic and symbolic power which the world of work exerted upon him, Shaikhet became increasingly interested in its social iconography, and photographed peasants looking for work in the city, the 'children's houses' (orphanages), Kalinin receiving rural delegates, the first electric light-bulb, the first Congress of Worker Correspondents, etc. Similarly, he displayed technical skill not out of formal considerations as such, but as a means of discovering a new world. Thus, his photographs of the inauguration of the Turkestan–Siberia railway, of the peasants discovering technology, of the first automobiles.

During the Second World War, Shaikhet was a photo-correspondent for the newspaper *Frontovaya Illustratsya*.

Photographs by Arkady Shaikhet:
pp. 21, 22, 23, 27, 99; pls. 3, 4, 5, 8, 15, 16, 35, 61, 66, 68, 70, 93, 99, 108, 119, 121, 124, 125, 133, 138, 141, 147, 149, 150, 152, 153, 154, 155, 156, 170, 183, 186, 200, 201, 203, 207, 208, 209, 211, 219, 220, 221, 226, 227, 228, 229, 297

Arkady Vasilyevich Shishkin

Born in 1899 in Kukarka (Vyatka), Shishkin learnt the métier of photographer in Kazan, then settled in Petrograd. After the February Revolution, he opened a photographic studio in Yekaterinenburg. The war intervened: he became a volunteer in the Red Army, and in 1922 returned to Kukarka, where he worked as a journalist for a variety of small newspapers. Shishkin was a village photographer. He recorded the peasant life of the Vyatka region for magazines and newspapers, in particular for the Moscow *Krestianskaya Gazeta*.

In 1923, he carried out one of the first photo-reportages, using an 18 × 24 camera with glass plates. In 1928, Shishkin acquired a Leica. He documented the evolution of the Soviet village, from peasant farm to kolkhozes, and in his role of attentive observer, photographed the various aspects of rural life: incidents and events, domestic utensils, animals, the appearance of new techniques.

After the war, which he spent as an ordinary soldier at the front, Shishkin provided *Krestianskaya* with photographs on a wide variety of subjects: landscapes and portraits, still-lifes and reportages, as well as poster photography.

Photographs by Arkady Shishkin:
pls. 40, 65, 76, 134, 142

Abram Petrovich Shterenberg

Born in 1894 in Zhitomir, Shterenberg learnt the photographic métier at an early age and began working on commissions. After the First World War, he worked in the Studio of B. Kapustiansky in Tashkent, then decided to settle in Moscow, staying with his brother David Shterenberg, a famous painter who worked in the IZO section of the Narkompross under Anatoly Lunacharsky. Shterenberg was a master of portrait photography, a technical virtuoso and a gifted artist. In 1927, he submitted about fifty examples of his work to the exhibition *Ten Years of Soviet Photography*, mostly portraits.

Unlike Nappelbaum or Zhukov, Shterenberg never retouched the backgrounds of his photographs to give them a more 'artistic' painterly look. He managed to convey the essence of a face by playing with the contrasts of clear and blurred contours, the different positions of the head, the direction of the look and the sculptural possibilities of light and shadow.

Shterenberg worked for the agencies Russfoto, Unifoto, and Soyuzfoto, and was a member of the 'Oktiabr' group. After the war, he continued working for the press agency Novosty.

Photographs by Abram Shterenberg:
pp. 15, 16; pls. 52, 289, 290, 291, 292, 293, 294, 295

Anatoly Vasilyevich Skurikhin

Born in Kotelnich (on the Vyatka river, today Kirov) in 1900, Skurikhin later settled in Moscow.

In 1928, he published his first photographs in the magazine *Sovetskoye Foto*. From 1930, he worked as a photographer for the newspapers *Komsomolskaya Pravda* and *Izvestia*. His favourite theme was to become the dynamics of industrial development in the USSR during the first Five-Year Plan. Every modification in social life, technique and culture was felt at the time as a novelty in the strongest sense of the word, as something never seen before. This is why the word 'first' is found so often in the captions to the photographs of Shaikhet, Ignatovich, Rodchenko and Skurikhin; for instance, the latter's *The First Radio in the Countryside*.

Photographs by Anatoly Skurikhin:
pp. 19, 26; pls. 64, 188, 189, 197, 206, 224

Jakob Vladimirovich Steinberg

Born 1880, died 1942.

Known as 'the photographer of Petrograd', Steinberg was, like Otsup, working as a photographer well before the Revolution. In 1913, he was taken on by *Solntse Rossii*. He worked as a reporter for the first illustrated Soviet newspapers, *Plamia* and *Yuni Proletari*. His photographs of the Red Guards from the Putilov factory patrolling the streets of Petrograd, which date from November 1917, were used, together with many more of his photographs, by Rodchenko and Stepanova in their photo-album *The First Mounted Detachment* in 1917. In spite of the static nature of his shots, Steinberg's photographs possess considerable inward force and intensity. More than 6,000 of Steinberg's negatives have been preserved in the Leningrad State Archives.

Photographs by Jakob Steinberg:
pls. 115, 116

Georgy Anatolyevich Zelma

Zelma was born in 1906 in Tashkent. By 1921, he was already in Moscow photographing the city with an old Kodak. He became the correspondent for the Russfoto agency in Tashkent.

His most expressive photographs were those taken in Uzbekistan. He started his career using a 13 × 18 travelling camera without a shutter, taking exposures by lifting the lens cap. Afterwards, he obtained a pneumatic syringe shutter which he fixed directly on to the lens. His photographs were published in the newspaper *Pravda Vostoka*. He tackled subjects which exemplified social facts, such as the discarding of the veil, the appearance of the first gymnasts or the international women's day in Tashkent. From 1928, he was using a Leica, with which, during the thirties, he photographed construction workers and miners of Donbass, Uzbekistan and Moscow, as well as themes commissioned by Rodchenko and Stepanova for the magazine *USSR in Construction*. 'We must search out the individuals who figured in previous reportages; second meetings of this kind often provide excellent material', he said during a reunion of the veterans of Soviet photography which was held in the studio of Rodchenko and Stepanova (*Sovetskoye Foto*, No. 8, 1978). Zelma worked for the newspapers *Krasnaya Svesda* and *Izvestia*, and for the agency Soyuzfoto.

He made two reportages with Roman Karmen: *The USSR Seen from the Sky* and *Ten Years of the Yakutsk SSSR*. He was a war-correspondent for *Izvestia* during the Second World War. Afterwards, he began working for the Novosty press agency and for *Sovetskaya Zhenshchina*.

Photographs by Georgy Zelma:
p. 24; pls. 29, 39, 128, 139, 140, 143, 145, 148, 151, 231

Pavel Semyonovich Zhukov

Born in Simbirsk in 1870, died in Leningrad in 1942.

Zhukov was taught photography in the studio of Konstantin Shapiro, where he practised the art of portraiture. When he set up his own studio, he benefited from the support of the St Petersburg Academy of Arts.

He photographed numerous artists and writers, including Anton Chekhov, Leo Tolstoy and Tchaikovsky. After the October Revolution, he began taking portraits of political figures. Although widely known for both his artistic and documentary photography, Zhukov only photographed Lenin once, seated in a chair: two versions exist, one of which stops at the waist, the other at the knees. These are good examples of the limited depth of field provided by cameras of the period. As in so many of his photographs, Zhukov here focused on the important part, the face, and in particular the eyes, which are looking straight ahead. All the rest, the background, even the silhouette, are wrapped in a vague mist or blur. During the thirties, Zhukov became a photo-journalist. During the Siege of Leningrad, he was killed by an artillery grenade, which destroyed his house and a great many negatives. However, the State Archives have preserved a large part of his work.

Photographs by Pavel Zhukov:
p. 11; pls. 88, 103, 132

Bibliography

For ease of reference in libraries, the international system of phonetic transcription has been used. Titles of books have been transcribed, with their translations given in parentheses. Articles in magazines and exhibition catalogues are given in translation only.

Alpert M.V., *Bespokojnaja professija* (*A Restless Profession*), Moscow, Iskusstvo, 1962.

Baltermantz I.D., 'The Artistico-Documentary Image in Photographic Journalism' in *Vestnik MGU*, 2nd series 'Žurnalistika', 1975, No. 3.

Boltjanskij G., *Očerki po istoriji fotografiji v SSSR* (*Studies in the History of Photography in the USSR*), Moscow, Goskinoizdat, 1939.

Evgenov S., *Abram Sterenberg*, Moscow, Goskinoizdat, 1941.

Fotožurnalist i vremja (*The Press Photographer and His Time*), Moscow, Planeta, 1975.

Kagan M.S., *Morfologija iskusstva* (*The Morphology of Art*), Leningrad, Iskusstvo, 1972.

Lenin V.I., *O literature i iskusstve* (*On Literature and Art*), Moscow, Khudožestvennaja literatura, 1979.

Lunačarskij A.V., *Kino na zapade i u nas* (*Cinema in the West and in Our Country*), Moscow, 1928.

Moholy-Nagy L., *Živopis ili fotografija* (*Painting or Photography*), Moscow, Ogonjok, 1929. Translated from the German.

Morozov S.A., *Fotografija kak iskusstvo* (*Photography as Art*), Moscow, Znanije, 1970.

Morozov S.A., *Fotografija sredi iskusstv* (*Photography among the Arts*), Moscow, Planeta, 1971.

Morozov S.A. *Sovetskaja khudožestvennaja fotografija 1917–1957* (*Soviet Artistic Photography 1917–1957*), Moscow, Iskusstvo, 1958.

Nappelbaum M.S., *Ot remesla k iskusstvu* (*From Craft to Art*), Moscow, Planeta, 1972.

Selezneva T.A., *Kinomysl 1920 h godov* (*Cinematographic Thinking in the 1920s*), Moscow, Iskusstvo, 1972.

Sovetskij fotografičeskij almanah (*Soviet Photographic Almanac*), annual publication under the general editorship of V. Mikulin, published by the magazine *Sovetskoje foto*, Moscow, Ogonjok, 1928, 1929, 1930.

Volkov-Lannit L.F., *Aleksandr Rodčenko risujet, fotografirujet, sporit* (*Aleksandr Rodchenko Draws, Photographs, Discusses*), Moscow, Iskusstvo, 1969.

Volkov-Lannit L.F., *Iskusstvo fotoportreta* (*The Art of Portrait Photography*), Moscow, Iskusstvo, 1974.

Volkov-Lannit L.F., *Istorija pišetsja objektivom* (*History is Written with a Lens*), Moscow, Planeta, 1971.

Volkov-Lannit, L.F., *V.I. Lenin v fotoiskusstve* (*V.I.Lenin in Photographic Art*), Moscow, Iskusstvo, 1969.

Series of monographs, Moscow, Planeta:

Alexandrov A. and Šajhet A., *Arkadij Šajhet*, 1973.

Volkov-Lannit L.F., *Boris Ignatovič*, 1973.

Karmen R., *Max Alpert*, 1974.

Sozinov V., *Ivan Šagin*, 1975.

Vilenkin B., *Georgij Zelma*, 1978.

Fomin A., *Arkadij Šiškin*, 1979.

Vartanov A., *Georgij Petrussov*, 1979.

In the magazine *Sovetskoje foto*:

Koltsov M., 'For Soviet Photography', January 1926.

Lunačarskij A., 'Our Culture and Photography', January 1926.

Brik O., 'Photography versus Painting', February 1926.

Šklovskij V., 'Photography and Its Tonality', July 1926.

Mežeričer L., 'The Place of Photography in the Press and in Society', February 1929.

[In 1931–1932, the magazine appeared under the title *Proletarskoje foto*]

Šajhet A., Alpert M., 'How We Photographed the Filippovs', April 1931.

Tretjakov S., 'From Photographic Sequence to Prolonged Photographic Observation', April 1931.

Žerebtsov B., 'Photo-Reportage – of the Artistic Variety', January 1935.

Langman E., 'Creative Research', May/June 1935.

Rodčenko A., 'The Master and the Critic', September 1935.

Rodčenko A., 'Transformation of the Artist', May/June 1936.

Morozov S.A., 'On the Path of Realism and Populism', February 1936.

Lukjanov P., 'Photography and Related Arts', March 1937.

Sosfenov I., 'Fundamental Problems of Photographic Art', May/June 1938.

Christie L., 'Remarks on *USSR in Construction*', February 1940.

Vartanov A., 'Document and Artistic Image in Photography', March 1967.

Morozov S.A., 'Against an Outdated View of Art', April 1967.

Karmen R., 'Photo-Reportage Was My Passion', March/April 1971.

Čudakov G., 'The Photo-Story. The Genre and Its Limitations', June 1972.

Čudakov G., 'A Great Joy – Work (The Work of M. Alpert)', March 1979.

Čudakov G., 'The Reporter and Life (The Work of G. Zelma)', March 1982.

Čudakov G., 'The Lessons of Arkady Shaikhet', March 1982.

Čudakov G., 'Press Photography: Content, Form, Genre Structure', August/October/December 1982.

In *Fotograf*, a review of applied photography:

Lunačarskij A., 'Photography and Culture', January/February 1926.

Ermilov N., 'The Fiftieth Anniversary of the Photographer M.P. Dmitryev', March/April 1927.

Dosekine A., 'On Artistic Photography', January 1929.

In the magazine *Novyi Lef*:

Volkov-Lannit L.F., 'A Plea for the Objectivity of the Lens', July 1928.

Rodčenko A., 'The Paths of Contemporary Photography', August 1928.

Exhibition catalogues:

Ten Years of Soviet Photography, Moscow, 1928.

Exhibition of Works by Masters of Soviet Photographic Art, Moscow, 1935.

First Exhibition of Photographic Art in the USSR, 1937.

Index of Names

The publishers would like to thank Konstantin Dolgov, president of the VAAP,
and Valentin Vasilenko, representative of the VAAP in France,
Margarita Ussenkova and Mikhail Privesentiev,
officials of the VAAP in Moscow, without whose help this book would never have appeared,
and Aleksandr Lavrentiev for his commentaries on the works of Rodchenko
and for compiling the biographies.

On the occasion of this book's first publication in French,
and in collaboration with Editions Sers, Paris,
an exhibition was organized by the Union Centrale des Arts Décoratifs,
with the aid of the French Ministry of Culture.
The exhibition was held in the Musée des Arts Décoratifs in Paris between
17th March and 30th April 1983.